COMPLETE GUIDE TO
DRAWING & PAINTING

READER'S DIGEST

COMPLETE GUIDE TO DRAWING & PAINTING

The Reader's Digest Association, Inc.
Pleasantville, New York/Montreal

A READER'S DIGEST BOOK

First printing in paperback 2008

Designed and edited by Eaglemoss Publications, Ltd.

Copyright © Eaglemoss Publications Ltd. 1997
Based on *The Art of Drawing & Painting*

The credits and acknowledgments that appear on page 288 are hereby made a part of this copyright page.

Cover designer: Mabel Zorzano

Library of Congress Cataloging-in-Publication Data

Complete guide to drawing & painting / [designed and edited by Eaglemoss Publications Ltd.].
288 p. : 111. (some col.) : 31 cm
Includes index.
–At head of title : Reader's Digest.
ISBN 978-0-89577-956-4 (hardcover)
ISBN 978-0-7621-0935-7 (paperback)
1. Drawing–Technique. 2. Painting–Technique. I. Reader's Digest Association. II.
Eaglemoss Publications Ltd. III. Title: Reader's Digest.
NC730.C63 1997
741.2–dc21 96-52461
Rev

Previously published under the same title in hardcover (978-0-89577-956-4).

We are committed to both the quality of our products and the service we provide to our customers.
We value your comments, so please feel free to contact us.

The Reader's Digest Association, Inc.
Adult Trade Publishing
Reader's Digest Road
Pleasantville, NY 10570-7000

For more Reader's Digest products and information, visit our website:
www.rd.com (in the United States)

Printed in China

3 5 7 9 10 8 6 4 (hardcover)
1 3 5 7 9 10 8 6 4 2 (paperback)

Contents

Introduction

I'm a firm believer that anyone can learn to draw or paint. But you can't expect simply to pick up a pencil or paintbrush and start to draw like Leonardo da Vinci or paint like Van Gogh. All the great artists had to work at their craft, and you'll have to do the same.

The first step is to learn the fundamentals of drawing and painting. Just as you have to learn vocabulary, spelling, and grammar in order to speak or write a language, so too in art you have to learn to handle the tools of the trade and to develop certain skills in order to produce a good picture.

Learning to draw, getting perspective right, knowing how to mix colors, and much, much more – these things are the spelling and syntax of art. *Complete Guide to Drawing and Painting* sets out to show you all the basic skills and techniques you will need.

The book is divided into a number of chapters that deal with the important disciplines of art. We begin with drawing, which needs a good deal of practice – ideally every day! You'll also learn about color and composition – these are important no matter which media you work in. Certain techniques, however, are specific to a particular medium, so drawing implements, watercolors, oils, acrylics, and soft pastels are all covered separately.

You'll learn new methods that you can use at once to improve your work, and discover shortcuts to accurate picture-making. Find out how to make objects appear to advance or recede, and learn new ways to add texture to your paintings – scratching into the paper, scraping paint off, or layering it on.

The techniques in this book are the artist's tools. You can use them in your own way, developing your own styles and systems of working. Remember, reading this book is only a starting point. With practice you'll master these techniques, unlock the creativity within you, and learn to express your ideas and feelings through your art. So pick up your materials and get going. Good luck, and above all, enjoy yourself!

Stan Smith

Stan Smith

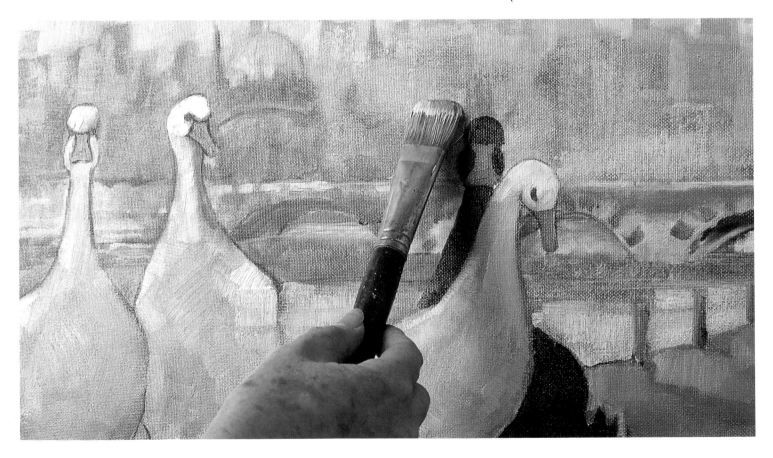

CHAPTER ONE

—

LEARNING TO DRAW

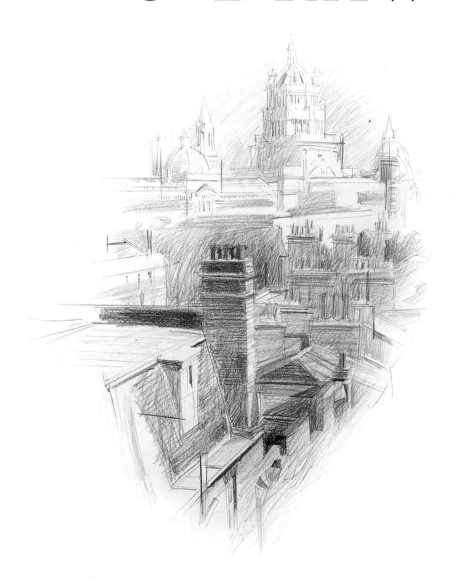

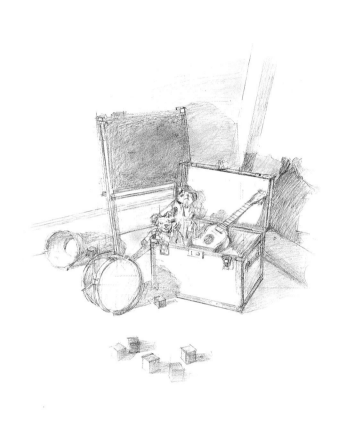

LIGHT AND TONE

To set you on the road to drawing three-dimensional forms convincingly, Stan Smith introduces you to light and tone.

▲ This special drawing course is devised by Stan Smith, an established artist with wide teaching experience.

His paintings are regularly exhibited throughout Europe, often as one-man shows.

I know it sounds perfectly obvious, but without light you can't see a thing. Think of someone going into a totally dark room. Naturally you blunder around, bumping into the furniture. But as soon as you turn on the light, you can see everything in detail: perhaps a pine chest of drawers, a round waste paper basket or a lumpy armchair. One glance gives you a vast amount of information about shapes, forms, textures and distances. What enables you to interpret all this information are the many shades of light and dark – the

> *Study your subject through half-closed eyes before starting to draw.*

tones, in fact. In the real world there are many tones, from white at one extreme, through a large number of medium tones (which can be seen as a range of grays), to black at the other extreme. At first, it's difficult to see tone since colors, patterns, shadows, and different light sources confuse things. But if you squint your eyes and concentrate, you'll find that the lights and darks are exaggerated and easier to identify. (It helps if you look at a black and white photograph, where all the information is expressed only in terms of tone.)

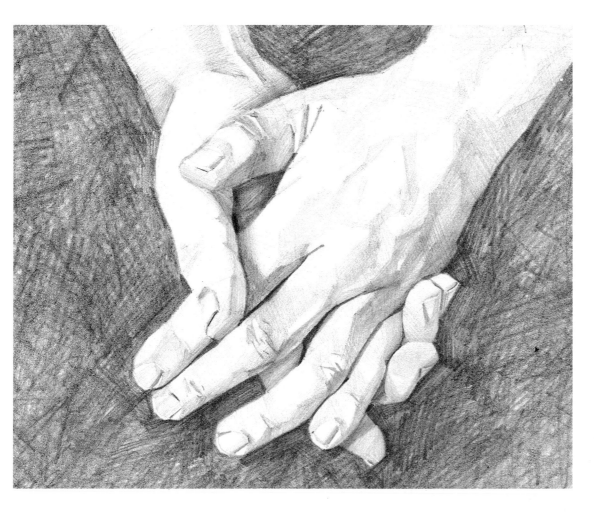

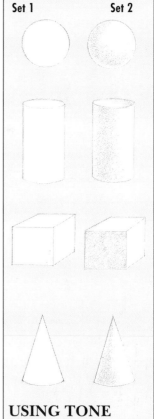

Set 1 Set 2

USING TONE FOR 3-D
You can see the dramatic effect tone has from these two sets of shapes. The first set looks flat. But as soon as they are shaded, you can see them as solid, three-dimensional forms.

◄ Learning to describe form by using lights and darks as well as this takes practice.

"CLASPED HANDS" BY IAN SIDAWAY

A tonal strip

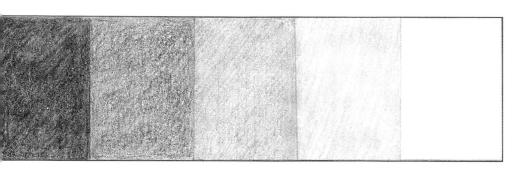

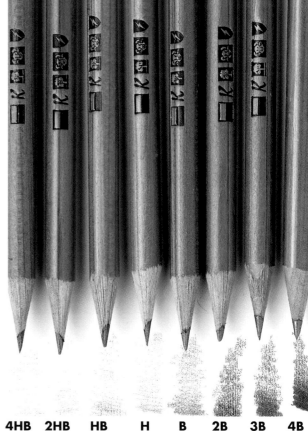

4HB 2HB HB H B 2B 3B 4B

▲ Before you start drawing, it helps to try out a few marks on a scrap of paper. Choose several different strengths of pencil – here I've picked a good range, from 4B (very soft) to 4HB (very hard). Draw a few lines using the pencil point and the side of the pencil; do the same with shading, pressing lightly and then more firmly.

I think you'll find it helpful to refer to this range of marks when you begin a picture.

MY THREE GOLDEN RULES
● Draw what you see, not what you know to be there, even if you think it looks peculiar.
● Don't focus on one part of the drawing at a time. Develop the entire drawing and keep the whole thing moving.
● Remember that in an exercise the process is much more important than the finished picture.

The minimum number of tones you need to achieve a three-dimensional effect on paper is just three – white, black and medium gray. These make for a strongly contrasting image. Five tones give more subtle effects. And the more tones you build in (up to 9 or 10, say), the more three-dimensional it becomes.

By seeing – and then interpreting – the tones carefully you can begin to depict solid forms convincingly in your paintings and drawings.

To help you see how tone works, make a tonal strip like the one I've drawn here. Draw five squares on a sheet of white paper, then, using a soft 4B pencil, color the last one black. Working back along the squares, shade each one a lighter shade of gray until you reach the final square – which should be left white. (You may find it a lot easier to put a medium gray in the center, then work lighter and darker tones on each side.)

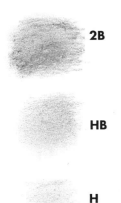

2B

HB

H

▲ Smudging is a very useful technique. Make some pencil marks, then soften and blend them by rubbing gently with your finger. This gets rid of hard lines and results in greater subtlety of tone and texture. Keep the scrap of paper handy in case you want to check some marks later on.

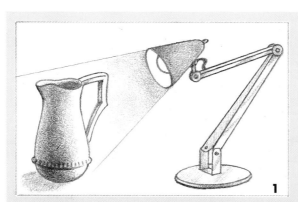

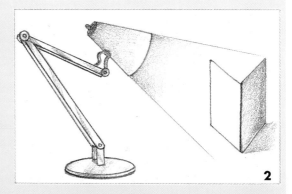

TRY THIS FOR TONE
Seeing tone clearly takes practice, so I find this experiment helps. Put a white pitcher or cup in a darkened room, then light it from the side with a single light source – a desk lamp, for example (**1**). You can see that the pitcher has a very bright side nearest the lamp and a very dark side furthest from it. Also notice, in particular, how the light travels across the curving side of the pitcher, creating a gradual transition between the strongest lights and the darkest darks.

Now try the experiment again, this time folding a small piece of white cardboard and standing it up so that one flat surface is at a right angle to the light, with the angle of the fold facing you (**2**). Again, you can see one bright surface and one dark surface – but this time the transition between the light area and the dark area is abrupt, creating a crisp "edge" along the fold. Look for these transitions in your subject while you are drawing.

Drawing in tone – bowl of eggs

This simple still life of some eggs in a pottery bowl helps you to see and draw tones (five have been used here). It also makes the most of the lovely range of grays you can get with just three different pencils – one hard, one soft and one in between.

Eggs are a good subject: they're small enough to put on a surface near your drawing where you can study them closely, and you can draw them almost life size. Their smooth surface and curving shape show how a range of lights and darks make things look three-dimensional.

Set up your group in good natural light – by a window for example, but not in direct sunlight. If you use artificial light, a single table lamp provides good areas of contrasted light and dark tones. But keep an overhead light on as well or the bright light shining from your lamp will be too harsh and cast severe shadows. This makes it difficult to see the tonal gradations.

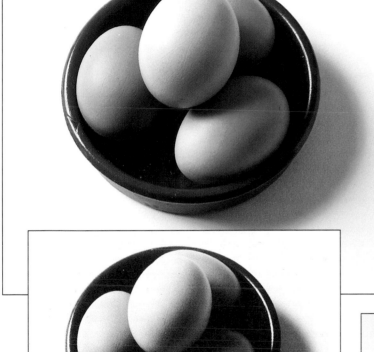

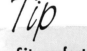

◄ **1** The color photo shows that the sides of the eggs facing the main light source are light in tone while the sides facing away from the light are darker. (The black and white photo, shown below left, helps you see the main tones without the distraction of color.)

It's best to work in natural daylight, but it will change while you work as clouds and sun alternate outside. Don't worry. Simply draw what you see and if the light changes, alter your drawing as needed.

Tip

Sit comfortably
Sit where you can see both the eggs and the paper without moving your head. You want your eyes to move easily between subject and drawing, checking one against the other. Spend more time looking at the subject than the drawing.

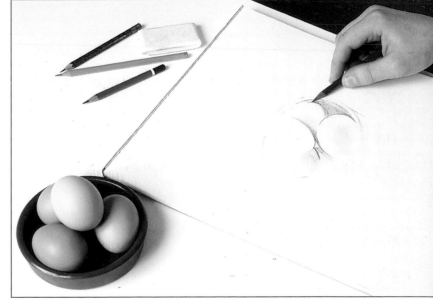

► **2** I worked directly on a pad, which provided a firm surface, but you could fix your paper to a board with thumbtacks or masking tape. Start near the middle of the sheet of paper.

Looking at the group, sketch in the eggs and bowl with the point of the H pencil. Don't press too hard – you only want a light mark. Let your eye travel around the subject, comparing shapes.

Squint your eyes, look for the dark tones between the eggs and shade these in with the side of the HB pencil. For graduated tones, blend the pencil marks with your finger. Don't rub too hard. Refer to your tonal strip (on the previous page) to help you identify the five main tones.

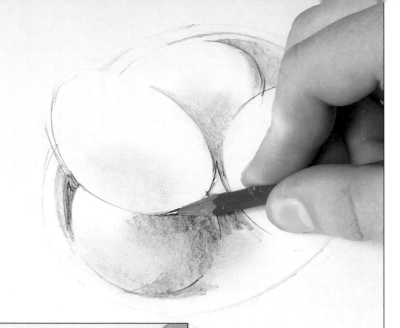

◀**3** Continue working in the same way, developing the entire surface of the drawing. Let your eyes skip across to the subject and back, all the time assessing the relative lightness or darkness of each area.

For this drawing, I chose just three pencils: an HB for the medium tones; an H, which is much harder and gives a lighter, crisper mark; and a 4B, which is softer and darker.

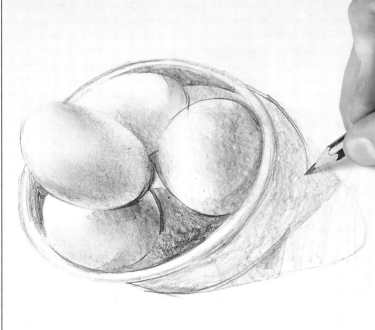

◀**4** Put the medium tones on the top surface of the eggs with the HB pencil, then smooth them with your finger. Soften the medium tones toward the light areas and make them heavier toward the darker areas.

I used the paper itself to provide the bright white highlight areas on the rim of the dish and where the eggs catch the light. Develop the dish using a medium tone. Although the dish is darker in color than the eggs, notice that it is not the darkest tone – you find that in step 2, between the eggs and outside at the base of the dish.

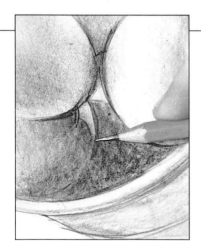

◀**5** Continue to intensify the depth of tone in the base of the dish, using the soft 4B pencil (don't press too hard with this pencil or you'll get a line that's much too dark).

▶**6** In my final drawing the graduated tones I've used create solid-looking eggs that sit convincingly in the bowl.

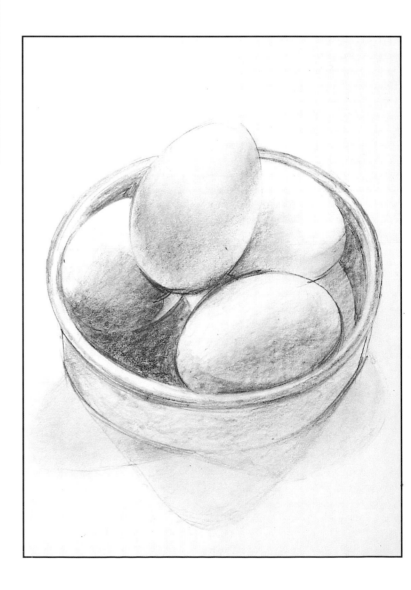

LOOKING AT LINE

Stan Smith demonstrates how you can use the freshness and directness of line only to describe form.

In the demonstration so far, I've used shaded tonal areas to describe form. You will see that patches of tone can create the illusion of a solid – in that particular case, a bowl of eggs . This time I'm going to show you a different technique – using line only.

Whether you are drawing in pencil, charcoal or ink, you can use line to capture not only light, tone and shadow but texture as well. This means a convincing line drawing is usually more sophisticated than it looks. Don't be put off by this, though – line has a great range of beautiful qualities. And with some practice you'll soon learn to harness them.

> *Line is so versatile – you can do a fine, tight, closely observed description or simply put a line around an idea – like a cartoonist.*

hand flat on a piece of paper and draw around it. But in order to make a drawing of a solid, you have to describe the contours of surfaces too. A good line drawing should lead the eye in and around the object. To do this you need to make the lines work really hard. An HB pencil can produce a great range of lines of different quality: rich, dense, shiny, black lines, delicate gray ones, thick lines, thin lines, elegant, flowing, rhythmic lines, and broken, stuttering ones. First I'll show you how to achieve some of these qualities and then I'll use some of them in a simple still life drawing.

The qualities of line

Think of line and you'll probably think of outline – the kind of result you get when you put your

▼ The artist has used a variety of lines in this simple ink drawing. Fairly thick, considered curves describe the outline of the plate in the front. Much lighter, quickly drawn straight lines stand as the prongs of the forks, while thick rhythmical lines capture the decorative edge of the napkin.

A little cross-hatching adds some light and shade, but the forms themselves are drawn in contour and outline.

"TABLE SETTING" BY JOHN CRAWFORD-FRASER, INK ON PAPER, 6 X 6IN

OUTLINES AND CONTOUR LINES

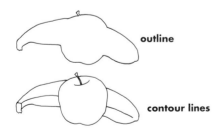

outline

contour lines

When you are drawing with line it's essential to understand the difference between outlines and contour lines. You can see the difference if you look at the two drawings above. In the top one the apple and banana are drawn in outline only, giving simply a silhouette of the two objects, with no details at all. In the bottom one, contour lines describe outlines as well as the basic forms of the two objects – including the dimple and stalk in the top of the apple.

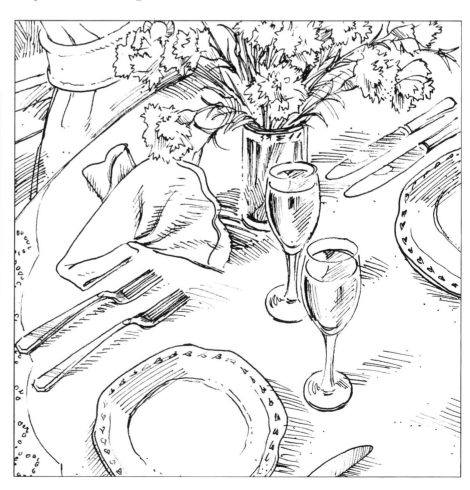

Irises in a Coca-Cola bottle

The quality of the line you produce depends very much on the support. A soft pencil on a heavily textured paper appears soft, whereas the same grade of pencil on smooth paper appears quite hard. Good quality cartridge paper is ideal for most drawing. If you want a slightly more textured surface, try working on a piece of NOT watercolor paper.

The hardness of the pencil is an essential factor and you should never be afraid to change to a different grade during a drawing if it will help you. You can vary the tone of a line either by using a harder or softer pencil or by varying the pressure. So, for example, you might take an H or 2H and press very lightly to give a pale gray. More pressure might give you a line no darker than a medium gray. If you used a 3B and applied light pressure you'd start where you left off – with a medium gray – pressing harder to build up to a rich, dense black. In fact, an HB is often a good general-purpose grade to start with.

To some extent, the scale of the drawing should determine the drawing medium. The bigger the surface, the larger, bolder and darker your lines need to be. A surface bigger than about 20 x 30in is starting to get too big for anything other than very soft pencil. A surface of 8 x 12in or 8 x 15in is manageable, giving you control with a somewhat tight feel.

Common-sense should always prevail. Try to keep your drawing clean. If you are going to work over the whole drawing, be careful not to get graphite on the heel of your hand and then smear it over the surface you are working on. If you have to lean on your drawing, slip a piece of clean paper under your hand. When you've finished your drawing you should apply a fixative or at least protect it by covering it with a piece of thin paper.

YOU WILL NEED

☐ A sheet of good quality 12 x 16in cartridge paper

☐ Two pencils – HB and 2B

☐ A craft knife to sharpen your pencils

☐ Kneaded eraser; fixative

Different qualities with an HB

1. A thin, continuous line of consistent tone made with a sharp point and an even pressure.

2. A line varying in thickness and intensity, made with a sharp point by changing the pressure.

3. A thick line varying in tone across its width, made with the side of the point.

4. A fluid line made by keeping the pencil flowing as smoothly as possible.

5. A discontinuous, stuttering line made up from short, quickly made marks.

6. A shaggy line made by drawing from the wrist and moving the pencil back and forth.

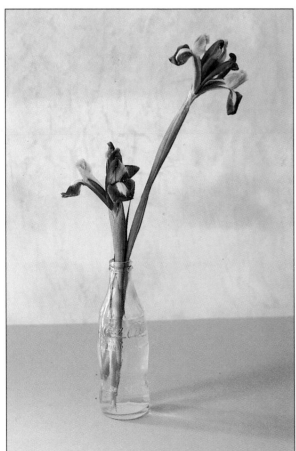

◄ **The set-up** So many everyday objects become enchanting when interpreted through the eyes of the artist. Here I've chosen a very simple motif to work from – two irises in a Coke bottle.

It's the combination of the natural and man-made that makes this subject interesting. The symmetry and brittleness of the glass bottle contrasts with the natural, living forms of the flower heads and stems.

Notice how the light plays on the bottle and how the glass modifies the shapes within.

▼**1** Starting with your HB pencil, simply draw the bottle. Look carefully at its circular cross-section. When seen in perspective this becomes oval and it's important to get these ovals right – particularly at the base and the neck. Notice how the fluid quality of the lines suits the smooth texture of the glass. Don't overdo the name on the bottle – just suggest the lettering, or else it will dominate the drawing.

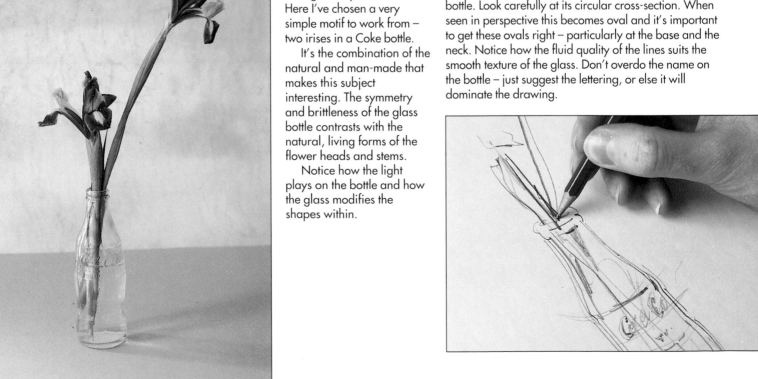

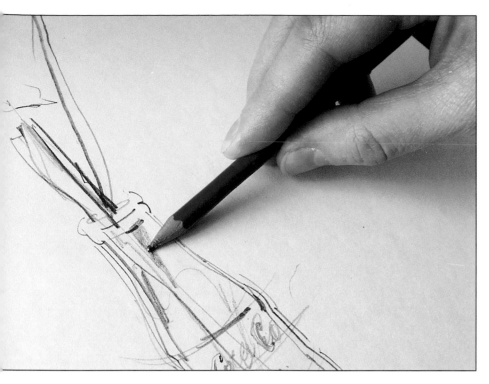

◄ **2** I've put in part of the stalks with a fairly blunt pencil using a confident, flowing line – stronger in tone than those of the bottle in order to give a sense of the color and growth. By drawing away from the ellipse you can get them to shoot naturally from the neck.

Keep working over the whole drawing. At this stage I've left the stems outside the bottle and, using the same pencil, started to strengthen the stems inside – this is to give a sense of continuity.

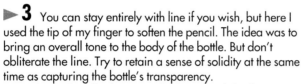

► **3** You can stay entirely with line if you wish, but here I used the tip of my finger to soften the pencil. The idea was to bring an overall tone to the body of the bottle. But don't obliterate the line. Try to retain a sense of solidity at the same time as capturing the bottle's transparency.

A clean, dark fluid curve in the base, and shadows on the table help to make the bottle look as though it is resting on something.

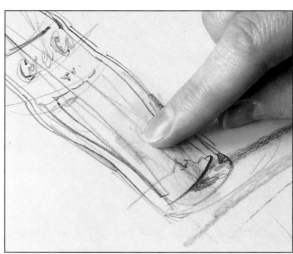

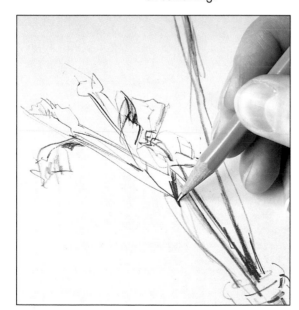

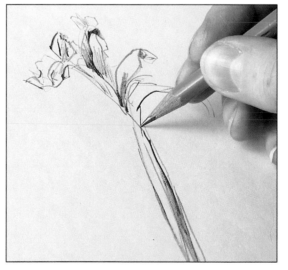

Tip

Bread eraser
After carefully blending areas of tone with your finger tip, you can use a kneaded eraser to take out some of the smudging to give lighter tones and highlights. But if you don't have a kneaded eraser, a piece of clean, white sliced bread kneaded into a little ball works equally well.

▲ **4** Now draw the flowerheads with the 2B pencil. Freer use of a soft, sharp pencil helps you keep a crisp, fresh feel. This is where you can really change the tone and thickness of a line so it appears to move in and out of the paper. Look at the curve on the left hand edge of the middle petal. The nearest part is stressed to bring it forward, while the "back" is less emphatic.

▲ **5** Remember that although the petals are curled flat surfaces they still have form. Try to capture this by using all the qualities of line at your disposal.

I've sharpened the pencil again so that I can get a really thin, concentrated line flowing from the point – almost like ink! Compare this with the much thicker but softer line in the petal above.

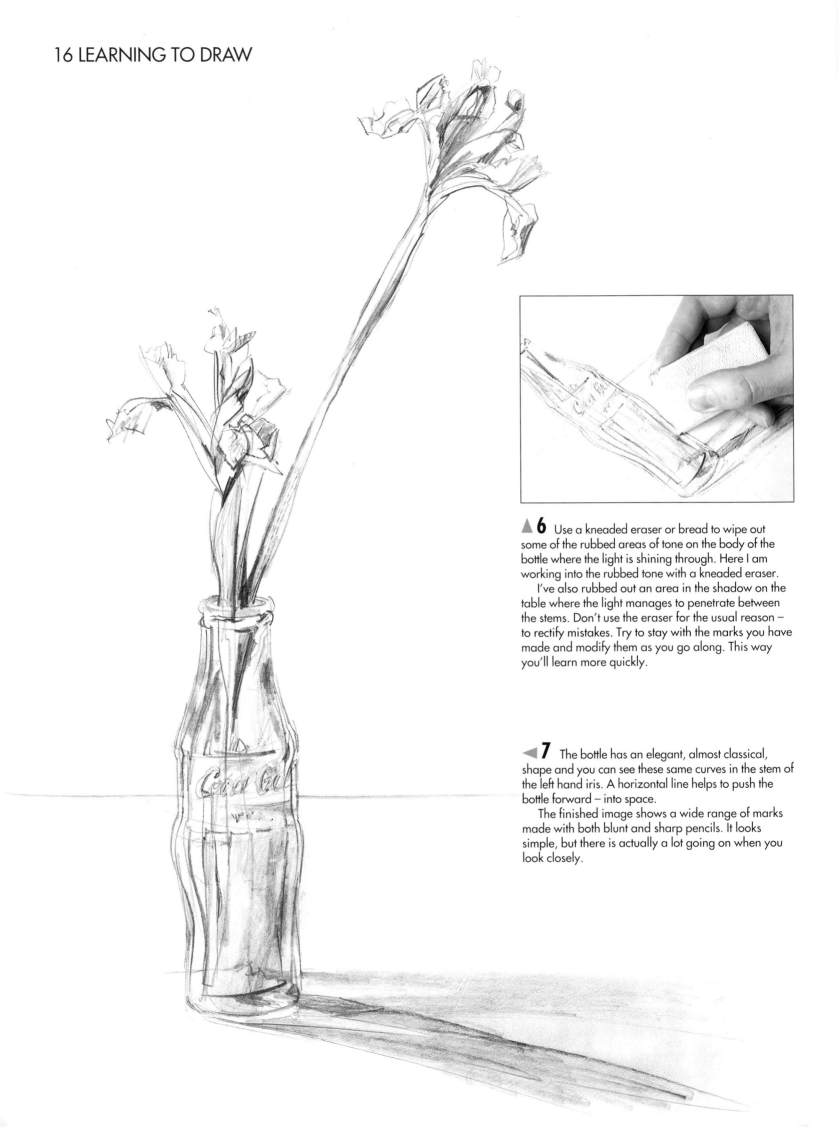

▲**6** Use a kneaded eraser or bread to wipe out some of the rubbed areas of tone on the body of the bottle where the light is shining through. Here I am working into the rubbed tone with a kneaded eraser.

I've also rubbed out an area in the shadow on the table where the light manages to penetrate between the stems. Don't use the eraser for the usual reason – to rectify mistakes. Try to stay with the marks you have made and modify them as you go along. This way you'll learn more quickly.

◀**7** The bottle has an elegant, almost classical, shape and you can see these same curves in the stem of the left hand iris. A horizontal line helps to push the bottle forward – into space.

The finished image shows a wide range of marks made with both blunt and sharp pencils. It looks simple, but there is actually a lot going on when you look closely.

DRAWING FROM THE SHOULDER

Drawing is as much a physical as a mental activity. Here Stan Smith explains how to make your shoulder work for you.

I said on page 14 that the scale of your drawing should help you choose the medium you draw in. So if you are working on a surface larger than 20 x 30in, a soft medium – such as charcoal, or, at the very least a 3 or 4B pencil – would be a reasonable choice. Another factor related to the scale and the

> *You don't get anything simpler than this – I'm sure it is the way the cave men drew. It's a good way of freeing yourself up.*

medium is the type of drawing movements you make.

In general, sweeping gestures from the shoulder allow you to make generous marks, well suited to large scale work. The more confined movements of

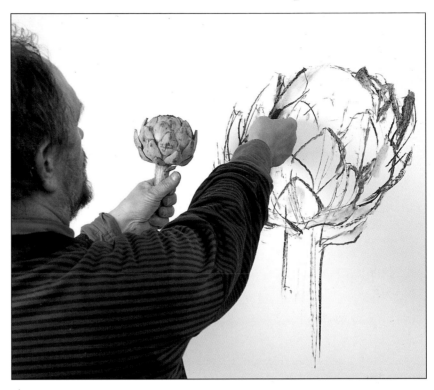

▲ Work on an easel if you have one or simply tape a large sheet of paper to the wall. If you've chosen a small subject – such as an artichoke – I suggest you hold it at arm's length to get a good overview.

YOU WILL NEED

☐ A 16 x 22in sheet of good quality cartridge paper

☐ A large drawing board, easel or wall space

☐ Thick sticks of soft willow charcoal

☐ Binder clips, tape

☐ Kneaded eraser

☐ Fixative

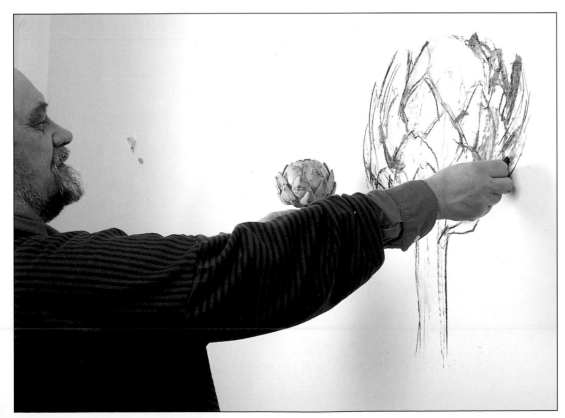

◄ Adopt a stance similar to that of a darts player. With your feet planted firmly on the ground, use your whole arm to capture the rhythms in your subject. Remember to look for the light, tones and shadow.

your wrist enable you to describe precise marks of the kind called for in detailed, small scale drawings. For example, you'd find it natural to draw on a sheet of 8 x 11in (210 x 297mm) paper using an HB pencil, ball point pen or dip pen, using mainly wrist and elbow movements. But you should feel equally at home working on a sheet of 16 x 22in (420 x 594mm) paper with a stick of soft, thick charcoal, Conté crayon or oil pastel using shoulder and elbow movements.

In fact the wrist, elbow and shoulder don't operate entirely independently, and any drawing, whatever its scale, requires some input from all three. But you can certainly put emphasis on drawing from either the shoulder or the wrist. As you'll see, the results are entirely different.

Here an artichoke makes an attractive subject, but you could choose any convenient object. If, like the artichoke, it is fairly small, you'll have to make a larger interpretation. (I've drawn the artichoke about five times life size so the scale is appropriate for drawing from the shoulder.)

As always, look carefully at your subject but don't fuss with detail. Explore and enjoy the range of movement your shoulder allows and use it to give a straightforward account of what you see.

SOLVE IT

Thick or thin?

Sweeping gestures made from the shoulder tend to put quite a bit of pressure on the charcoal. If you use a hard, thin stick it will probably break. So for working on this scale I recommend a soft, deep black charcoal of a good thickness — at least 1/5in (5mm) diameter, say. This way you can even use a fairly long stick if you wish — making full use of its length as an extension of your arm.

▶ This is the finished charcoal drawing (top). I've made use of vigorous downward movements of my whole arm to describe the artichoke's scales. A little smudging helps to convey its globular form. You can still maintain great sensitivity when working from the shoulder. Notice that where the light strikes – on the left – I've made the marks less dense, while on the right side they're richer.

A smaller, pencil drawing made within the compass of the wrist and elbow (inset) has a much tighter feel (bottom right).

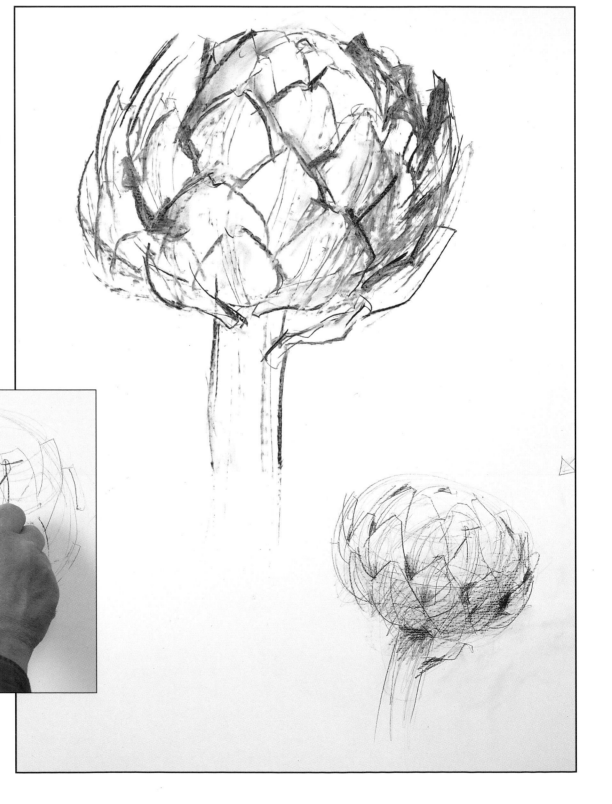

LOOKING AT NEGATIVE SHAPES

Stan Smith explains what negative shapes are, why they're essential to composition and how you can use them to draw more accurately.

Spaces between the forms – the solid parts – of the subject of your drawing can create some very strong and interesting shapes. These are called "negative shapes." They are important because they contribute to the composition – playing just as great a role, in fact, as the positives (the solids). And they enable you to check the accuracy of your drawing. Make the best use you can of negatives. When composing a still life, don't concentrate merely on the objects. Pay attention to the spaces between them. You can change the spaces by moving the objects away from one another, closer together or by turning them around. Don't forget that altering your viewpoint changes the shapes too. A slow, observant stroll around your subject might reveal

> ❝ *The positives make the negatives and the negatives make the positives.* ❞

some attractive negatives (useful for landscapes, where you can't move hills and trees).

Think negative to run a quick visual check. For example, imagine a drawing of three oranges trapping a tri-angular space between them. The oranges look fine, but what about the shape between? If it's too small, too large or the wrong shape, then one or more of the oranges isn't drawn correctly. A moment's careful study enables you to spot flaws and correct them. If all the positives and negatives are right, then your drawing must be accurate.

DID YOU KNOW?

Tree shapes
*Most trees are rich in negatives, their branches overlapping to create a wealth of shapes.
The Dutch artist Piet Mondrian knew this and used the tree as a theme in his paintings. You can see his use of negative shapes in his expressionistic rendering of "The Red Tree" (1908-10) and even more so in the more abstract "Gray Tree" and "Apple Tree in Flower" (1912).*

▶ Try to spot the negative shapes in this portrait (right). You might like to check them on the thumbnail sketch (above).

Negatives are a good guide in figure drawing. Shapes such as the division between the legs or, as here, those trapped in the crook of an elbow can help you get the limbs and posture right.

"MRS JASON HICKLIN" BY HENRY HAGGAR, CHARCOAL ON PAPER, 14 X 14IN

Bicycle parts

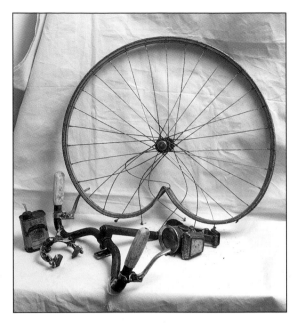

► **The set-up** Sometimes the old rather than the new provides the most interesting subject and often you don't have to look far to find it. The cobwebbed corner of an outhouse yielded these rusty bicycle parts. (Notice that the broken wheel holds a very fine negative shape.)

Arrange your group, paying careful attention to the shapes trapped between the objects. Walk around it, watching the shapes change as you go. Choose a viewpoint from which the negatives look strong and interesting in their own right. Shadows sometimes divide the negatives, so take those into account too.

► **1** Look at the set-up. The composition has two main components – the wheel and the cluster of items below and to the left. Draw the rim of the wheel with a generous sweep of the arm. Then, working loosely and lightly from the wrist, draw the cluster of objects.

Make sure everything fits on the paper. If it doesn't, scale down slightly – as I did. Check to see that the negatives trapped by your group and the edges of the paper work properly.

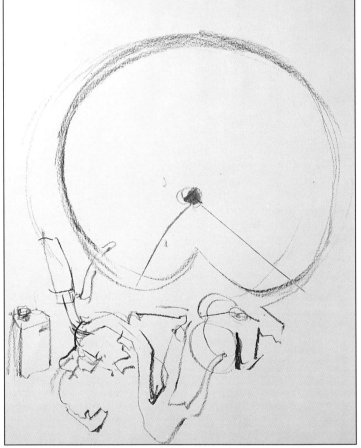

▲ **2** Once you are satisfied with your group and the shapes around it, start to consolidate things.

Look at the set-up and you'll notice that there aren't any very heavy masses. The slender forms are almost linear and divide the light background into abstract shapes.

Capture these with the careful use of line. Start by strengthening the hard rim of the wheel with a firm gray line. Try to retain the rhythm and symmetry of this elegant form by using the full sweep of your arm again.

◄ **3** Do the same for the handlebars, light, oilcan and brake assembly in the foreground. Where forms have more mass, use the tip of your finger to smudge the line and give a range of grays. Leave untouched the very lightest areas – such as the the nearest brake lever and the rim around the face of the light.

Indicate just a few of the spokes. You can get the equivalent of the straight, slender ones by turning the charcoal on its side and making a thin incisive line – as I'm doing here.

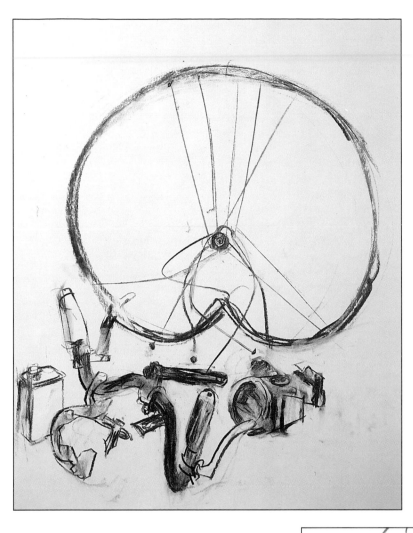

◄ **4** By now, most of the negatives should be obvious: the one below the wheel but above the handlebars; the triangle trapped within the left-hand curve of the handlebars; the shape between the nearest hand grip and its brake lever and the face of the light; that enclosed by the brake calipers; and the ones to the right of the oilcan and under the handlebars. Then there are the larger spaces within the wheel and around the whole group.

▼ **5** Your drawing isn't meant to be a technical one, so try to preserve the looseness as it develops, never completing one area before moving on to another.

You can see in the foreground that although the drawing is still fairly loose, I've tried to convey a sense of texture – the ribbed hand grips as opposed to the smooth bars – and even a sense of color by using lighter tones on the grips.

▼ **6** The wheel serves as the focal point and carries connotations of motion and rhythm. Look at the wheel in the set-up and you'll see that some of the spokes are straight and orderly, while others flail from the crumpled rim. Try to capture this precisely in your drawing.

Before you draw the spokes, count them. This helps you space them correctly and, though you might not want an exact copy, it should prevent you from making silly mistakes.

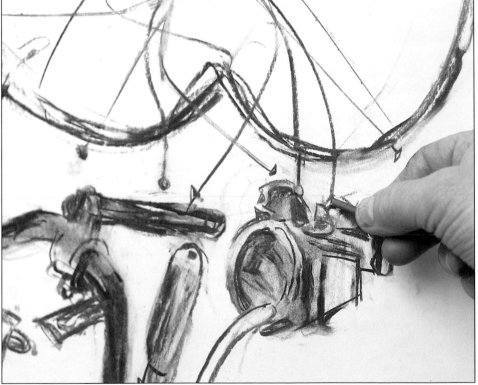

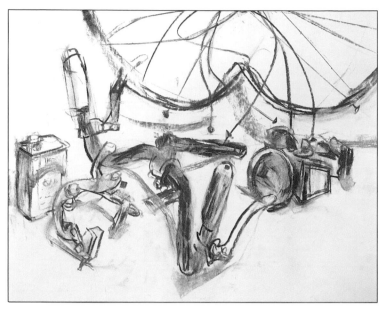

◄ **7** Here the shadows can work for or against you. In one respect they help by setting the objects firmly on the horizontal plane, but they can muddle the composition, bisecting some of the good negative spaces. If they are interfering with your drawing, try playing them down or, for the purpose of this exercise, leave them out entirely.

▼ **8** I completed the drawing using the side of the charcoal to skim some shadow inside the wheel.

The smoothness of the paper has helped me to keep a wide range of tones from the white of the paper itself, through grays to a rich black – something that's difficult if the paper is rough because the grays tend to be too dark.

The negative shapes play a particularly important part in this spacious composition, but you'll benefit by thinking negative in every drawing or painting you do.

Tip

Oil slick

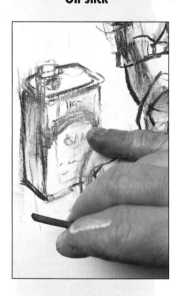

There's an easy way to get a good impression of the design on the oilcan. Use the tip of your charcoal to touch in a brief outline of the design, then add a few scribbles to stand for any writing.
Soften the charcoal with the tip of your little finger. By rubbing it to the right tone you can even convey a sense of different colors on the can.

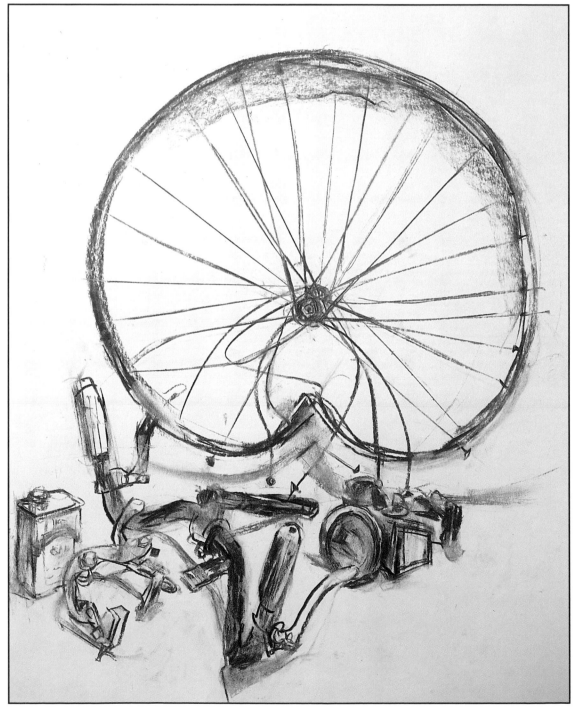

MAKING MEASURED DRAWINGS

The sight of an artist standing in front of his model, holding a pencil at arm's length and squinting at it might be a familiar one. But what's he supposed to be doing? Stan Smith tells you.

Your pencil is a convenient instrument for taking precise measurements from your chosen subject and transferring them to your paper. This method is particularly useful when you are drawing such complex subjects as the rooftop scene I've chosen for the exercise – but you can use it for figure drawings and still lifes too.

> *This is a good way of getting absolute assurance that the proportions in your drawing are correct.*

In this exercise, measuring helps in two ways. First, it prevents your eye from being deceived by the effect of perspective on scale. For example, the tower on the horizon is taller than the chimney in the foreground. But on the two-dimensional surface of a photograph the height of the tower is less than the chimney. (You can check this with a ruler.) This should hold true for your drawing too, but it's just the sort of anomaly that's easily overlooked. Measuring can alert you to it.

Secondly, by taking a few preliminary measurements, you can pinpoint key features that'll keep your drawing on course as it develops. So, for example, you won't find later on that you have room for only three rooftops where in fact there should be four.

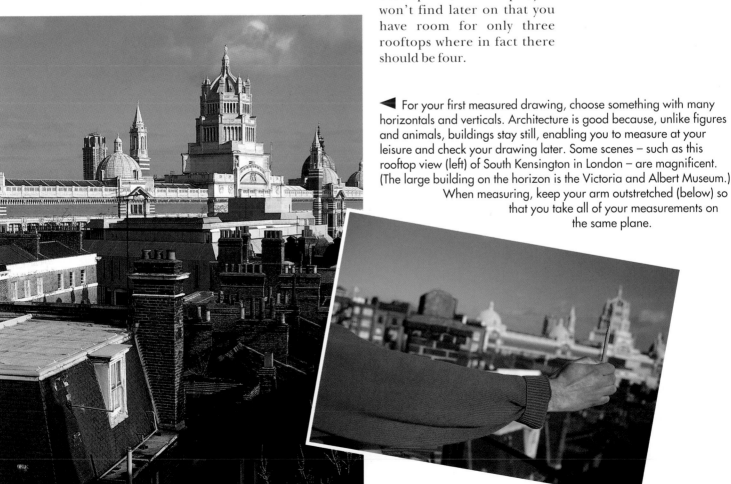

◄ For your first measured drawing, choose something with many horizontals and verticals. Architecture is good because, unlike figures and animals, buildings stay still, enabling you to measure at your leisure and check your drawing later. Some scenes – such as this rooftop view (left) of South Kensington in London – are magnificent. (The large building on the horizon is the Victoria and Albert Museum.) When measuring, keep your arm outstretched (below) so that you take all of your measurements on the same plane.

YOU WILL NEED

☐ A new HB pencil

☐ A sheet of 12 x 16in cartridge paper

☐ Drawing board and thumbtacks or tape

☐ Colored pencils

South Kensington rooftops

Try your hand at measuring horizontals and verticals. Stand far enough away from your subject so that you can work on the received scale – that is, you can put marks down directly without having to scale up or down to fit them on the paper. (Scale is something we'll look at later but at this stage it's a good idea to keep things as simple as possible.)

Where you need an angle – the slope of a roof, for example – pinpoint each end of the line by taking horizontal and vertical measurements and then join the points together (see Tip, page 26).

Taking measurements from your subject

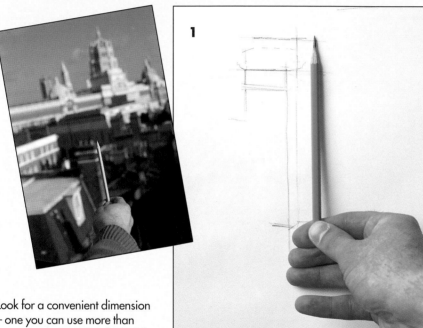

Look for a convenient dimension – one you can use more than once. I'm going to use the height of the chimney as my yardstick (**inset**). Hold your pencil at arm's length so it falls alongside the chimney. Line up your pencil tip with the top and slide your thumbnail down your pencil until it meets the base. Keeping your nail in place, transfer this measurement to your drawing (**1**). Measure horizontally in the same way by turning your pencil 90° (**inset** and **2**).

Work across your drawing, repeating key measurements. Here (**3**) I'm laying the height of the chimney on top of itself. This takes me almost to the top of the tower. I've used the width of the chimney (**inset** and **4**) as a key dimension for the horizontals. (Notice that this is equal to the width of the dome. One-to-one relationships like these provide short-cuts to accuracy.)

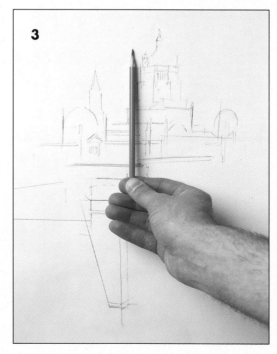

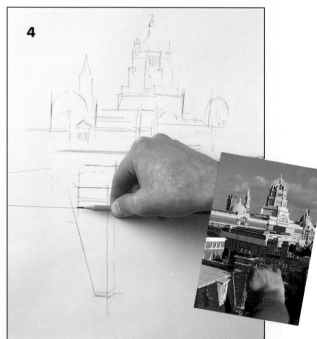

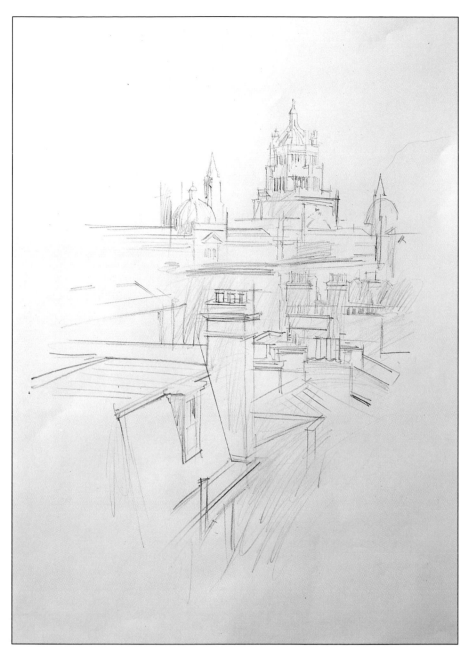

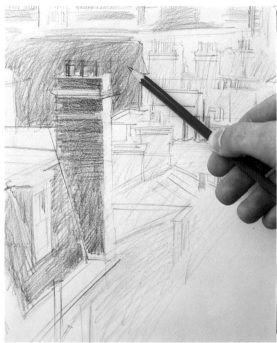

◄ 1 With the exception of oddities like the leaning tower of Pisa, most buildings stand vertically – upright. Make sure the verticals in your drawing are vertical! If you think it'll help, use a ruler – it's quite acceptable to do so as long as you remember you're making a creative interpretation and not an architect's mechanical drawing.

▲ 2 Once you are satisfied you've got the basic proportions right, you can develop your drawing with colored pencils. But don't think of it as "coloring in." Redraw, measure and edit where necessary, playing down features of less importance.

Here I'm mixing color optically – scribbling with the pencil so that strokes of different color lie beside one another.

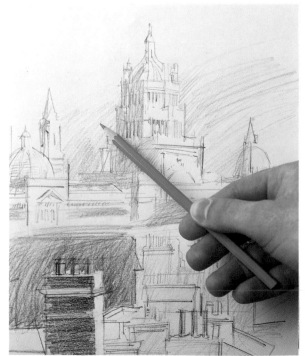

◄ 3 The effect of aerial perspective and strong sunlight means the foreground is in high contrast and warm in color, while the background appears hazy and the colors cooler.

The chimney is a warm red-brown, the shadow in the middle distance a fairly warm purple, while the sky is a pale tone of cool blue, against which the white tower sings out. The shadow on the side of the tower is a stronger tone of the same blue as the sky.

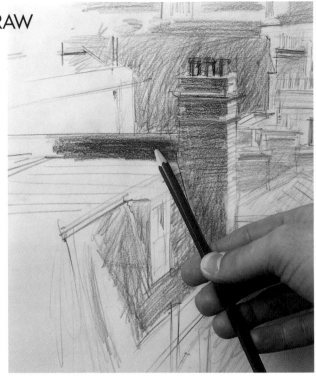

Tip

Extending a line
Many of the pencil lines in my drawing stick out beyond the buildings. This is deliberate. By extending some of the lines in your drawing you'll find it's easier to pinpoint the ends of angled lines. In fact you might find you need to add verticals and horizontals that don't exist. (The verticals are known as plumb lines.) Both are useful aids to construction.

4 Here I'm putting a dense purple shadow in the foreground to encourage your eye to linger awhile before moving on.

Pencil marks made in random directions promote a lively feel but if you want to describe a plane then let your marks conform to the direction of the plane. Notice how the ocher marks on the side of the chimney show that it's built up in layers and that the plane lies at a right angle to the front of the chimney.

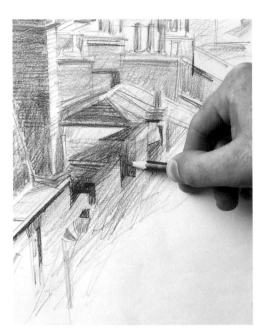

5 Here I'm using the equivalent of a burnt umber to chisel out some recesses in the foreground. If they'd been in the middle distance or background, because of the negating effect of haze (which is particularly strong in a city), they probably wouldn't be significant and I'd have left them out. In the foreground, though, you expect accents and it's important not to leave them out.

6 You'll notice that I haven't drawn the whole scene. I've left out the area of deep shadow you can see on the right in the foreground of the opening photo. Instead, a smooth curve leads your eye up the right side of the drawing to the towers in the background.

If you've got the tones and colors right, then foreground, middle distance and background should all hold together. In other words, the middle distance shouldn't fight with the foreground.

DRAWING FROM THE WRIST

The saying goes that "small is beautiful." Here, Stan Smith finds a use for those left-over pencil stubs and shows you how to make an intimate study of a small natural subject.

I've mentioned the importance of matching your drawing movements to the medium you are using and to the scale at which you are working. On pages 17–18, I used large, sweeping gestures from the shoulder to make a bold charcoal drawing on a sheet of 16 x 22in (420 x 594mm) paper. The treatment was compatible with the subject: a large bronze sculpture. This time I've chosen a small subject – an intimate group comprising two shells and a starfish – and I'm going to make a small drawing. Look for a similar subject so you can try this exercise for yourself.

Working full-size, your drawing should fit easily on a sheet of 12 x 16in (297 x 420mm) paper; it might even fit on a sheet of 8 x 11in (210 x 297mm). For a drawing of this size, your range of drawing movement needs to be more confined. The answer lies in your wrist.

Movements made within the compass of your wrist are naturally small, which means that you can make small, controlled marks. While these might be too fussy and tentative for a large drawing, they're perfect for small, detailed studies. Subjects of natural history spring to mind – flowers, birds, skulls, rocks, fossils, shells and starfish, for example – but any small object of interest would lend itself to this kind of "wristy" approach.

You should choose a compatible medium. Pencil,

> 66 *If you've worked over all of your drawing, it should finish itself – often when you least expect it* 99

dip pen and ink, ballpoint or fiber-tip are all suitable. But for this exercise I would recommend pencil: not a new pencil, however, which might be rather too long and cumbersome in the hand, but a short one – a stub.

The advantage of a short pencil is that you can hold it so the point falls directly under your palm, and in this way use your wrist to describe tight curves and circles. Give it a try. If you don't have a pencil stub, cut a couple of inches off a new pencil, thus creating a second pencil at no extra cost!

▼ These delightful studies of flowerheads display great sensitivity and a masterful handling of line and shading. Even on the smallest scale, it's important to try to get some rhythm into your drawing.

Wrist movements (combined with some elbow) are perfectly suited to small, detailed studies like these. They afford just the right degree of freedom for describing small curves with fluidity. Look at the petals and leaves here – you can see the rhythms at work.

"STUDY OF SWEET VIOLETS" BY LEONARDO DA VINCI, INK ON PAPER, 7¼ X 8IN

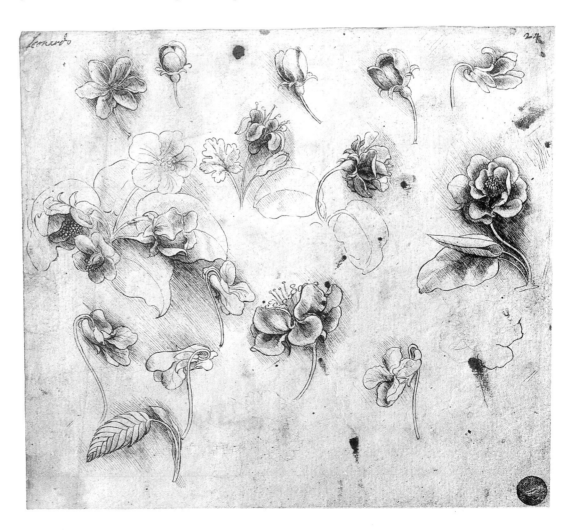

Shells and starfish

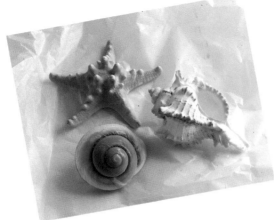

YOU WILL NEED

☐ A sheet of good quality 12 x16in cartridge paper

☐ Two pencil stubs: HB and 3B

☐ A pencil eraser

▲ **The set-up** With lots of detail and texture to explore, this group – comprising the shell of a land snail (bottom left), starfish and sea shell – makes an excellent subject. In fact, any of these would have served on its own. The creased paper on which they rest catches the light, dividing the surface into good shapes.

Tip

Stump-wise
Don't throw away those pencil stubs that seem to accumulate in your drawers and jam jars.

Save them for your next wrist drawing. As long as you don't overdo it, they can be useful for putting detail into large drawings too.

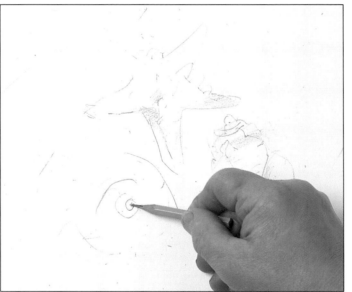

▲ **1** Make sure your group fits on the paper. To this end, I've drawn two diagonals with my HB pencil. These pinpoint the extremities of the group.

Next, start to scribble in the forms, drawing sensitively and looking for the negative shapes between them.

◀ **2** The spiral shell is from a Haitian snail, and its beautiful, curled form is perfect for a wrist drawing. I've moved my pencil aside to show you my marks, but if you keep your pencil under your palm, and locate it over the center of the shell, you should be able to draw it using a single circular motion of your wrist. Make sure your spiral goes in the right direction. Like virtually all snails, this one has a right-hand spiral.

▶ **3** Use the full range of marks at your disposal, holding the pencil upright to make fine, tracing lines – such as those in the spiral – or, as I'm doing here, angling the tip slightly to give a thicker, softer line. Try blending some of these soft lines to make patches of subtle tone.

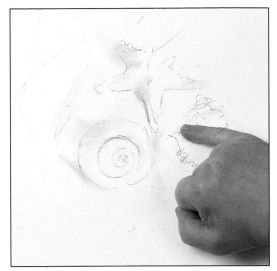

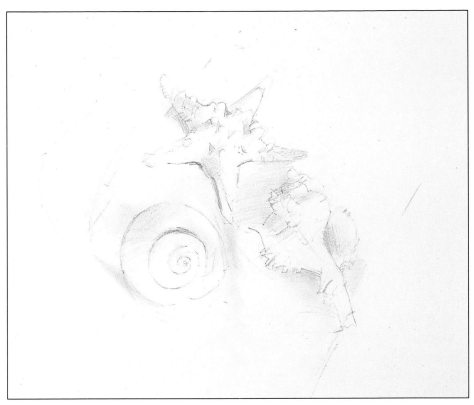

4 Although the lighting is fairly strong, the subject is so delicate and pale in color that many of the tones in my drawing are light or medium grays. To get these, rub the shaded areas with the tip of your little finger, so the pencil strokes blend together. At this stage, it's best to understate things. Later, you can add contrast to your drawing by using a softer pencil to introduce darker tones.

5 At this stage, everything is still in a state of flux. Notice that the snail's shell is tilted forward slightly, so you can see more of the back than the front. To capture this, I've drawn the spiral closer to the front of the shell. And by wrapping contours around the shell and blending them together, I've tried to describe its cylindrical form.

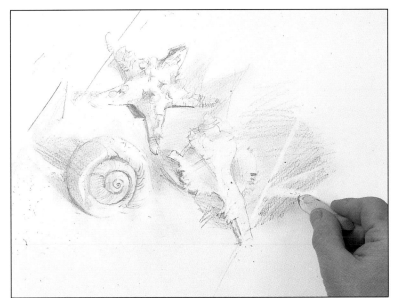

6 After some heavy blending using my thumb, I'm working back into the rubbed areas with an eraser. The idea is not to mimic the creases in the paper but to give an equivalent – a shorthand that captures the energy of these angular lines. You'll notice that I've wiped into the snail shell too, to give the highlight. Look carefully at your own subject and try to see where you can use an eraser.

7 Draw with your eyes **and** mind open. Ask yourself: why is this shaped the way it is? The conch shell once housed an animal. A predator, it lived in the Indian Ocean feeding on clams – into which it drilled holes. Its offensive appearance was meant to deter large crabs.

This hostile world is a far cry from the mantelpiece on which it ended up. Nevertheless, I'm using the 3B pencil to make my shell look spiky and fearsome!

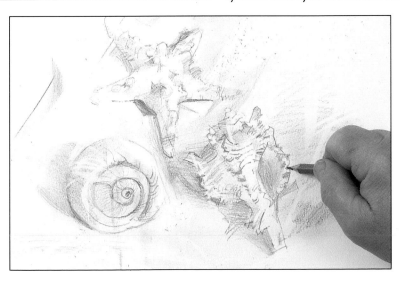

SOLVE IT

Thick and thin

It can be very hard on your paper if you use extra pressure to make your pencil lines darker, and such lines are also hard to remove. Instead, keep a selection of different pencils handy. Start with an ordinary HB pencil, then emphasize dark areas with softer pencils, like the 3B used here. Likewise, mix sharp and blunt pencils to vary the thicknesses of the outlines. This also helps to give your picture more variety.

▶ **8** The snail shell is hard, but, unlike the conch, it's smooth and shiny. Instead of the abrupt marks you used for the conch, try to get a more fluid feel. I made the line at the front too emphatic, so I'm softening it with an eraser.

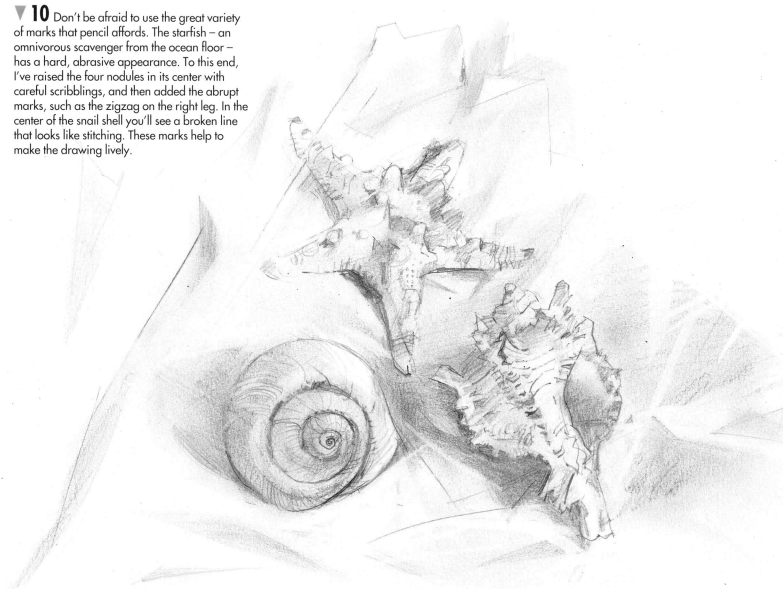

◀ **9** Look at the set-up and you'll see that the lightest tones on the shells are often close to those in the background; edges are lost and one thing appears to melt into another. Here I'm using the eraser to soften the top of the snail shell so that it blends into the background.

▼ **10** Don't be afraid to use the great variety of marks that pencil affords. The starfish – an omnivorous scavenger from the ocean floor – has a hard, abrasive appearance. To this end, I've raised the four nodules in its center with careful scribblings, and then added the abrupt marks, such as the zigzag on the right leg. In the center of the snail shell you'll see a broken line that looks like stitching. These marks help to make the drawing lively.

INTRODUCING FIGURE DRAWING

The human figure provides the artist with what is perhaps the most exciting challenge of all. But where do you start? Stan Smith lends a guiding hand.

You might find the thought of drawing people rather daunting. This is not surprising. Whether clothed or not, the human form is complex. Furthermore, because we see people around us every day, we can usually tell when a figure is drawn badly – even if we can't say what's wrong with the drawing. However, I want to show you a way of conceptualizing the figure that makes it as simple to draw as a bowl of eggs. This approach is as follows.

In your drawing you want to create the illusion of a solid figure in space. You know how to use light, tone, reflected light and shadow to do this for simple geometric forms – such as cylinders. So, if you can reduce the figure to simple geometric equivalents, then, by observation, and armed with a little knowledge of proportion, you should be able to draw a solid figure.

You'll see from my drawings that the figure can indeed be reduced to a series of interrelated cubes, spheres, cylinders and cones. Mannequins like these can help you to understand and draw human figures. You can use them to resolve problems associated with a particular pose before you start a more representational drawing, or use them in their own right as the basis for a drawing. With a solid underlying structure in place, you can flesh out your mannequin, into a nude, or, by wrapping a costume around the forms, make a clothed figure.

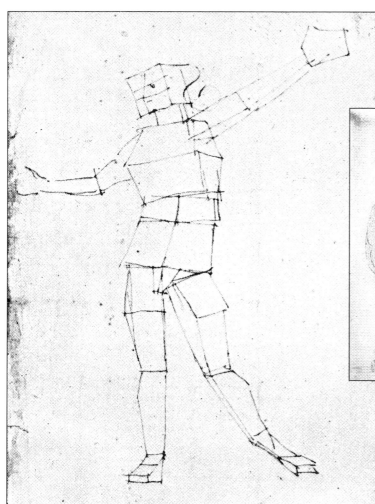

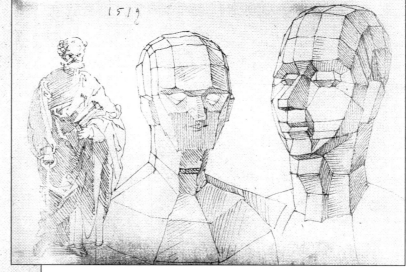

◀ ▲ The idea of reducing the figure to geometric forms is not a new one. As early as the 16th century, the German artist Albrecht Dürer was experimenting with drawing the figure (left) and features of the head (above) as a series lof cubes in his "stereometric" man.

FIGURE STUDIES BY ALBRECHT DÜRER, INK ON PAPER

Constructing the figure

In **1** you can see how, in general, the neck, torso, pelvic region, arms and legs can be reduced to tubes. The pelvis tilts forward. The head sits on a column – a cylinder – and this also tilts forward so the forehead and chin protrude. The head is heavy, so the neck has to be thick enough to support it – although not usually a bullsize neck.

In **2** differences emphasize the forms. The torso is a tube – flattened slightly at the top to take the neck and narrowing toward the waist. The pelvis is still a tube but it spreads to take the joints of the thighs. Remember that the body is symmetrical around the central division (drawn down the middle of the trunk). In **3** you can see that the arms hang so that the tips of the fingers come about halfway down the thighs. (The hands, fingers, feet and toes can be reduced to

▼You can achieve a good equivalent of the figure using basic geometric forms (1 and 2, below). In Western art it's conventional for the light to come from above and from one direction. Here (2) I've drawn the figure as though there were a single light source above and to the left.

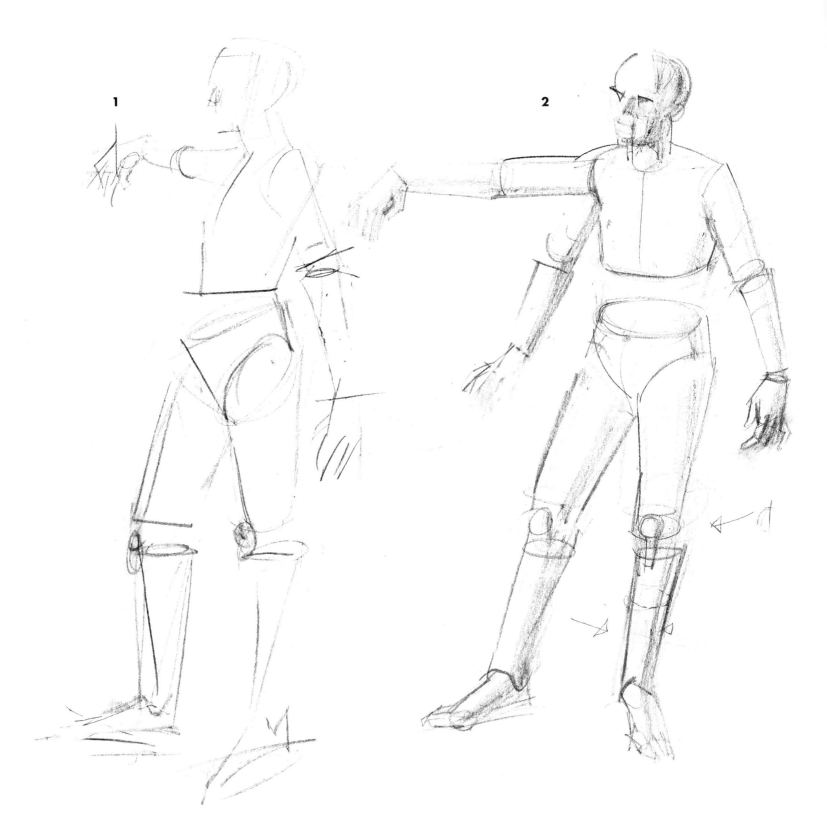

1

2

geometric equivalents in the same way as the major parts of the body. We'll study them in detail later in this chapter.)

The figure in **4** is standing in the classic three-quarter pose – turned slightly from the profile toward the observer. Notice how the far half – beyond the central division – appears smaller than the front half when seen in perspective.

It's easiest to start with static figures. But geometric equivalents are very useful for summarizing figures in motion (**5**).

▶ Correct proportions are essential to good figure drawing. If you make the arms too short, for example, the figure doesn't look convincing. If you make them too long they become gorilla-like.

Theoretical knowledge can help but there's no substitute for observation. You can get an idea of where an elbow is in relation to the whole arm, say, by looking at yourself in the mirror.

3

4

◀ The figure is symmetrical around the central division. Seen in three-quarter perspective, the far half appears smaller. The raised arm appears to travel into the space behind the figure. This is achieved by making the cylinders conform to the rules of perspective. To this end the farther arm is actually made shorter than the nearer arm (it is foreshortened), although you see it as being the same length.

The fingers are tubes radiating from the flattened box of the palm. The thumb works in opposition to the fingers so the hand can grip. The feet can be thought of as arched platforms. They're quite small but, because there are two of them and they can be positioned separately, the body's weight can be distributed in a variety of ways.

5

▲ This figure is seen in motion – as if it were high-stepping or kicking a ball. Notice how the limbs tend to move in opposition to each other for balance – the right leg and left arm, for example. The limbs are able to move because of the skeleton's joints, the contraction of the muscles providing the force.

Knowledge of the skeleton and its musculature gives a deeper understanding of the human form but is best used only when you need it.

Constructing a head and features

At this stage, when it comes to drawing the head, don't think of a person's face and its expressions – smiling, frowning, laughing, crying, for example; think, instead, of a solid mass in space. This way you should avoid falling into the trap of drawing a superficial mask with added hair. (We'll look at expressions and likenesses later.) Having said this, always try to draw the features – don't leave a blank mask.

Notice that, like the body, the features are dispersed evenly around a central division. The head is symmetrical – and the distance between the eyes is about the width of an eye. Studying heads in photographs – newspapers and magazines, for example – or your own in the mirror, can be very helpful.

▲ The nose is the most prominent feature. Think of it as constructed from a cylinder penetrating a sphere – at the end – with quarter spheres attached on each side for the nostrils.

► The aim of constructing the figure from geometric forms is to make it appear three-dimensional. So always think of the head as a solid object in space.

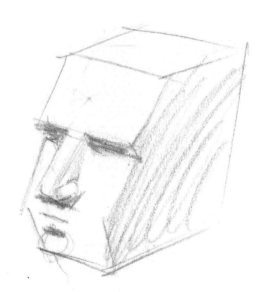

► Of course, the features don't sit on the surface like those of a cartoon character. They are integrated into the surface – as though they had been chiseled out of a solid block of wood.

▼ The cranium is a spherical structure that protects the brain and forms a large part of the total mass. The features are dispersed symmetrically around a central division – just as the limbs are.

▼ The rules of perspective apply to the features in the same way they do to the body. The far half appears smaller and the distance between the eyes – one eye's width – is foreshortened.

▼ Light coming from above forms pools of shadow in the eye sockets, and under the nose, upper lip, lower lip and chin. They form a kind of code for a face that is instantly recognizable.

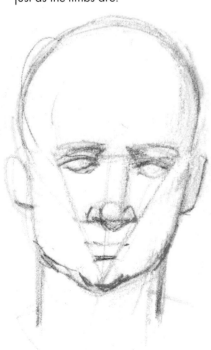

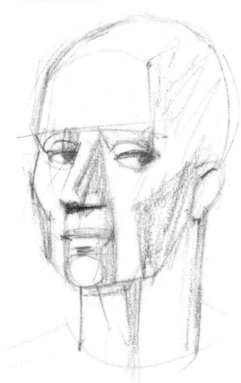

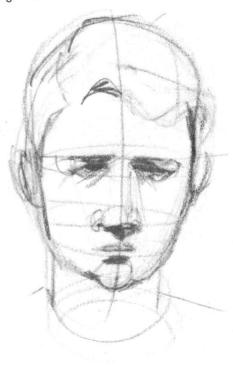

PLUMB LINES AND HORIZONTALS

Stan Smith dips into the toy chest and comes up with another method for accurate drawing. Here he explains how to draw as if you were looking through an imaginary grid.

"BALLET DANCER IN POSITION" BY EDGAR DEGAS, 1872, SOFT BLACK GRAPHITE WITH BLACK CRAYON AND WHITE CHALK ON PINK PAPER, SQUARED, 16⅔ X 11⅛IN (COURTESY OF THE FOGG ART MUSEUM, HARVARD UNIVERSITY, BEQUEST OF META AND PAUL J. SACHS)

One useful aid to accuracy is to draw as if you were looking through a sheet of glass with a squared grid on it. This helps you notice vertical and horizontal lines and relationships. For example, say you are looking at a house from a fixed viewpoint. The corners of the building and the sides of the windows are vertical. The ridge of the roof and the windowsills are horizontal. All these lines might appear in your finished drawing.

However, if you were looking through a grid you'd notice other things. You'd see that a vertical through the chimney pot coincides

> ## 66 *Imagine you are looking through a sheet of glass with a grid on it.* 99

with the plant pot on the lawn and that a horizontal through the plant pot also travels through the garden gnome. You'd see that if you extended the vertical edge of the window, it would pass through the milk bottle on the doorstep and that the broken guttering is hanging at an angle of precisely 45°. You might even notice that the house is exactly five front doors high. In other words, imaginary as they are, these verticals and horizontals help you to relate one feature to another. With practice you'll be able to visualize lines like these, pick out the significant ones and use them as construction aids in your own drawings.

▶ This drawing has probably been "squared up" prior to making a painting – a procedure we'll look at later – but you can see just how certain features relate. A vertical through the dancer's left shoulder falls plumb through her left elbow and hand and down the sole of her right foot. Her hands are positioned so that a string held between her fingertips would be perfectly horizontal.

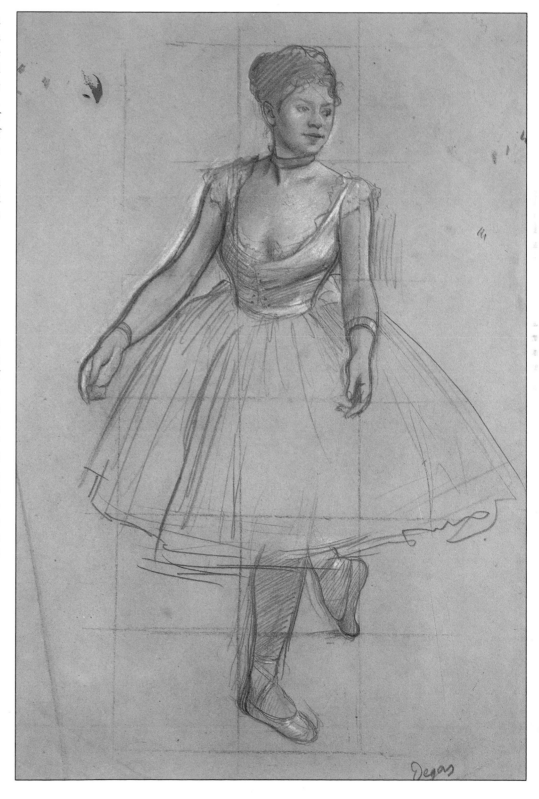

The toy chest

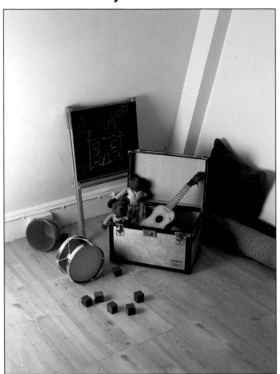

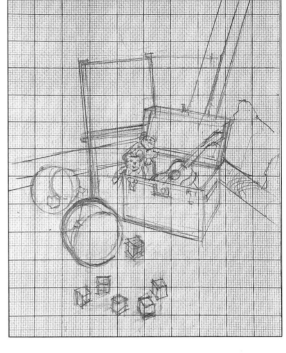

YOU WILL NEED

☐ A range of pencils:HB to 4B

☐ A good quality sheet of 12 x 16in cartridge paper

☐ A kneaded eraser

☐ Drawing board and easel

▲ **The set-up** Choose a subject with some straight lines and regular curves. This makes the job of recording edges, pinpointing intersections and estimating angles far easier. These toys comprise mostly geometric forms and they're more suitable for this exercise than, say, a bunch of flowers. I made a quick drawing on some graph paper. You can think of the squares as being like an imaginary grid. Look along the lines and notice which features coincide. (Try the vertical through the drum.)

◄ **1** Your starting point depends on your subject and viewpoint. But in general look for one helpful vertical and one horizontal. I dropped a plumb line from the top right corner of the blackboard down to the tip of the foremost teddy bear's right ear. I've positioned it right of center on my paper, so the drawing should fit. But just to make sure, I used my pencil to measure horizontally (see page 24) from the vertical to the outer rim of the bucket at the extreme left.

► **2** To get the angle of the left side of the blackboard, draw in the vertical first. Look at the set-up and you'll see that a plumb line dropped from the top left corner of the board hangs through the left side of the drum. The leg of the board cuts the drum just right of center. I know where the top of the board is because I've already measured it. So it's a simple matter to join up the two points.

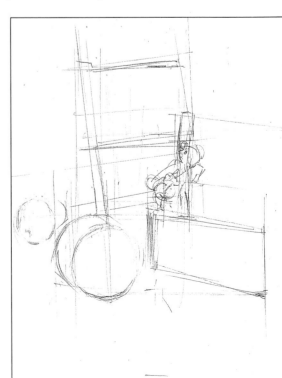

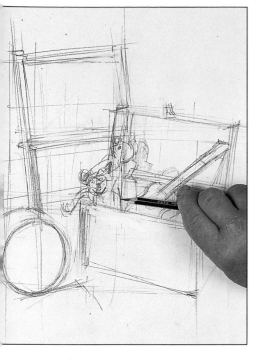

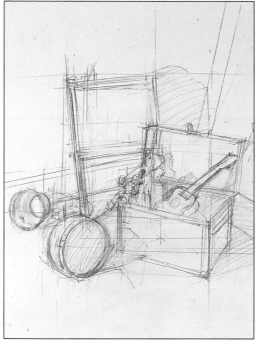

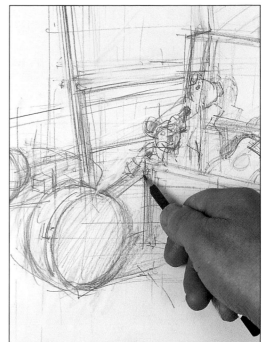

▲ **3** Look for coincidences – where the length of one object or gap is equal to the length of another, or twice its length or half its height, say. Relationships like these provide short cuts to accuracy. Here the height of the front of the chest is roughly equal to the height of the drum.

▲ **4** Often shadows are as important as the objects that cast them. For example, the shadow behind the drum runs across the floor and up the side of the chest. It describes these surfaces and links them together. Other shadows help to create the atmosphere of an attic corner.

▲ **5** The small triangular gap, bounded by the drum, chest and shadow of the leg of the board, serves to anchor my viewpoint. Negative shapes like this should remain constant as you draw. If they appear to have changed, your head isn't in the same position as it was when you started.

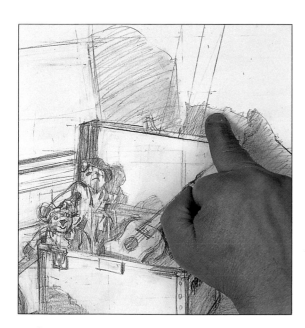

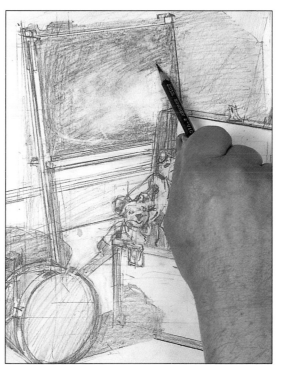

Tip

Deconstruction
It might take a few tries to wrestle a line into place. Once you've succeeded, don't rub out the "wrong" ones right away – they remind you of

the route you've taken. If you remove them too soon you might lose your way. In fact, a few construction lines in the finished drawing can often add to the effect.

▲ **6** I'm rubbing back into the areas where I had outlined and shaded the shadows, using my fingertip to make soft, uniform grays. This helps to emphasize the contrasts and make the whole thing look more solid. It's a good idea to clean up your drawing first, though.

▲ **7** After rubbing the blackboard to make a soft gray, I tried to indicate the house by drawing into it with a kneaded eraser. The eraser proved too clumsy so I decided to leave the board blank and let the dark tone convey an impression of its color.

▶ **8** I usually recommend paying attention to foreground objects early on. But there are exceptions. Here the building blocks are much simpler than the toy chest. So it makes sense to get the chest right and then add the blocks. I've positioned them by dropping plumb lines from the central group (inset). As a result of perspective, the blocks in the foreground appear larger than the one close to the chest. Notice how I've taken care to make the blocks' shadows consistent with those in the group.

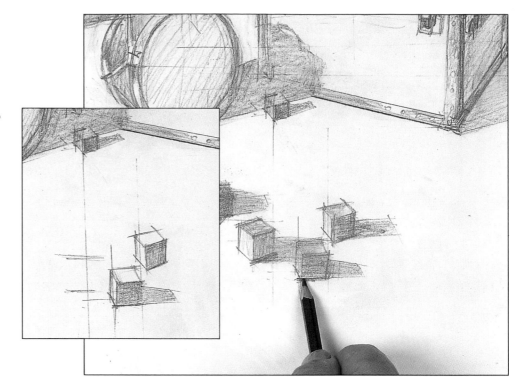

▶ **9** If you've used your vertical and horizontal guidelines to good effect, and drawn and measured accurately, then all the objects should fall into place. Here the toys fit comfortably into the chest without being cramped or appearing too isolated. The building blocks, drum, bucket and chest appear to sit on the same plane. A grid dropped over my drawing (below) shows that it's pretty close to my original sketch.

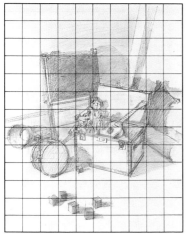

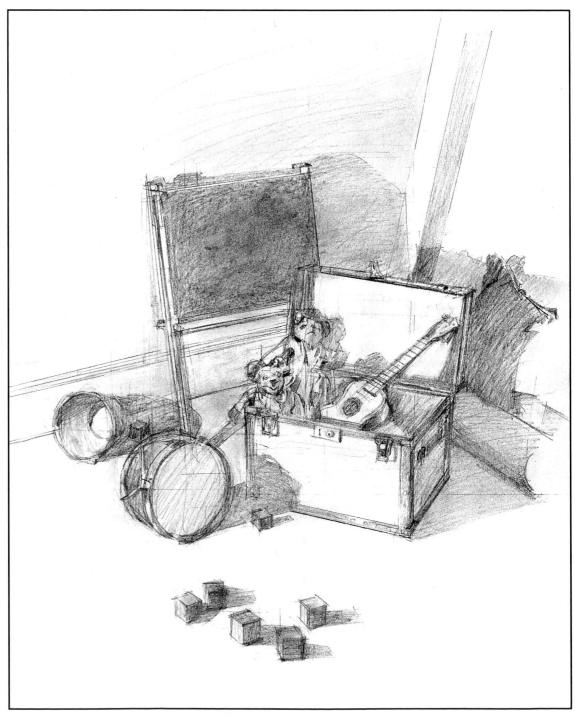

CHECKS FOR ACCURACY

A place for everything and everything in its place Stan Smith pulls out all the stops to help you draw more accurately.

Whether you are going to make an objective architectural study, a factual account of a court-room scene or trying to draw a freehand circle for an abstract composition, your work will benefit from accurate and sensible drawing. Here I recap the methods I've mentioned so far and suggest some new ones.

As a general guide, concentrate on proportions and spatial relations early in a drawing. You can address such

> ❝ *If whatever you are drawing has a function, bear this in mind.* ❞

things as detail, color and texture later but no amount of cosmetic fudging compensates for poorly assessed masses and spaces.

Draw logically – if you are drawing a cheese grater, for example, make the grater in your picture look as though it would cut cheese. In other words, if whatever you are drawing has a function, bear it in mind.

▶ Use check marks to position key features. Don't worry if they show at the end – construction marks tell you something about how a picture was made. Here, red and black checks are an integral part of this artist's painting.

"ORANGE TREE 1" BY WILLIAM COLDSTREAM, OIL ON CANVAS, 36⅓ X 28⅓IN, COURTESY OF THE TATE GALLERY, LONDON

Use mechanical drawing aids, such as rulers and triangles, if you feel you need to but remember that in themselves they do not guarantee accuracy.

In any case, technical skill is no substitute for vision and originality. If accuracy is all you are after, you might be better off with a photograph. Ask yourself just how accurate you need to be and set your limits within the scope of what you are trying to achieve.

Nine checks

When making any objective drawing use measurements, horizontal and vertical (plumb) lines, negative shapes, logic, space and time to help you.

Measured drawing (see pages 23–26) is a good method for keeping your drawing on track. Use a pencil held at *arm's length* to take measurements and transfer these to your paper. Look for a convenient unit of measurement. For example, if you are making a figure drawing, the length of the head – measured from the crown to the chin – would be a better choice than a finger (too small) or leg (too large). The length of the arm might be three and a half heads, say. Always take your measurements from precisely the same spot.

Horizontal and vertical (plumb) lines (see pages 35–38) drawn through and beyond key features help you to relate these features precisely. To draw a line at an angle, pinpoint both ends using horizontals and verticals and

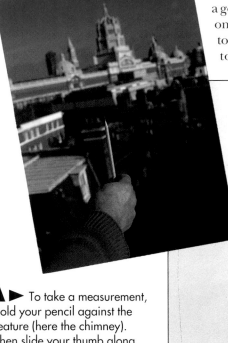

▲▶ To take a measurement, hold your pencil against the feature (here the chimney). Then slide your thumb along the pencil to record it. Transfer this measurement to your drawing (right). Here the height of the chimney serves as a vertical unit of measurement for other parts of the roofscape.

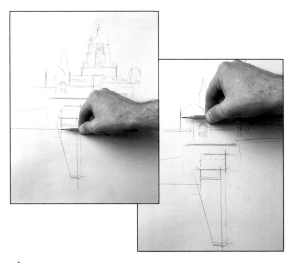

▲ The width of the chimney (above left) serves as a useful horizontal unit – the width of the chimney and the diameter of the small dome are equal (above right). Measuring helps prevent your eye from being deceived by changes in scale due to perspective. For example, the Victoria & Albert Museum is monumental, the chimney comparatively small. The museum's large tower appears only slightly larger than the height of the chimney in the foreground – as it should.

EXACT NEGATIVES

Not only do the negative shapes between objects play an important role in composition, they're a good guide to accuracy too.

Look at the little shape between the lower eggs here. If I make it too small, too large or the wrong shape in my drawing, then I know that I've got one or more of the eggs wrong. Similarly, the shape between the eggs and the side of the bowl helps me to draw the ellipse accurately.

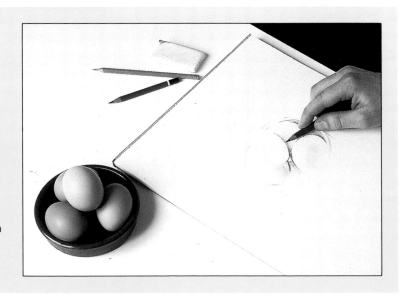

then join the points together. It's a method that works in tandem with measured drawing.

Negative spaces (see pages 19–22) serve as a means to double-check the positive shapes in a drawing. If the negatives aren't right then neither are the positives!

Turn your drawing on its head to get a new viewpoint. This helps you to spot mistakes that your eye has become used to. Don't limit yourself by merely looking – you can achieve interesting results by turning your paper upside down!

Reverse the image by viewing it through the paper to spot flaws. This method is particularly useful for drawing symmetrical shapes – such as an ellipse at the top of a jar. By reversing it, any errors suddenly appear in a direction opposite that to which you have become accustomed – the mistake should jump out at you!

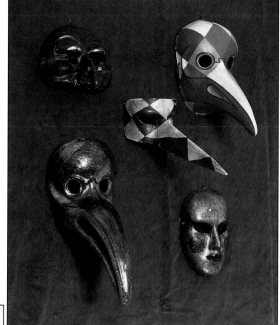

◀ These Venetian masks make an intriguing and dramatic subject. Even though they are masks rather than real faces, it's still important to draw them carefully, observing the rules of perspective. Although I ended up using very wet paint extremely loosely to make a colorful picture, I underpinned it with a steady charcoal drawing.

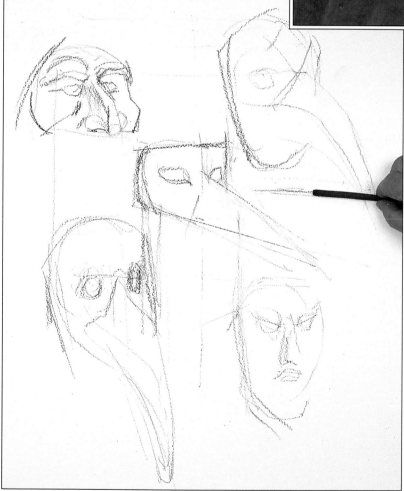

▲ A plumb line dropped from the center of the beak of the mask in the center falls down the left side of the oval-faced mask below. A horizontal line drawn from the bottom of the eye of the center mask will cut across the tip of the nose of the mask to its right. These coincidences helped me to position the masks in correct relation to one another.

A LOGICAL CONSTRUCTION

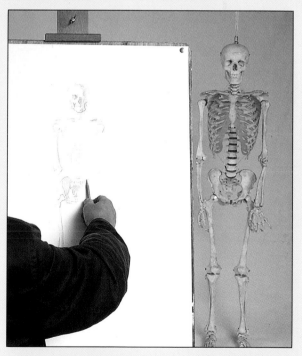

Whether you are drawing a motorbike or a figure, you should be at least aware of what's going on under "the skin." This doesn't mean it's necessary to train as an engineer to make a good drawing of a bike or as a surgeon to draw a good figure, but it does mean you should draw sensibly, putting parts in the correct relationship to each other – making the bike look ridable and the figure solid and capable of supporting its own weight.

A mirror image produces a similar result. Prop up your drawing in a corner of the room, walk to the other side and view it through a small mirror. Apart from spotting errors (verticals not being upright, for example) – you should get a fresh and unbiased impression of your composition.

Let logic be your guide and, where necessary, count the features in your subject – the number of chimney pots, windows or columns in a building, say, or the number of supports holding up a bridge. Certainly, you should always avoid the sort of mistake that puts five fingers and a thumb on a hand!

Stand back from your drawing and view it from a distance from time to time – it's always surprising how obvious errors suddenly become when you do this.

Return to your drawing after an hour and you can often see precisely what's wrong with it and correct it immediately.

TAKE A FRESH LOOK

Symmetrical curved figures such as circles and ellipses can be tricky. You might not even notice there's anything wrong. What's required is a fresh look. Take the cylinder here, for example.

Turn the drawing upside down and you see that the ellipse at the bottom (was the top) isn't symmetrical and that the sides of the cylinder are skewed to the right and do not lie parallel.

Looking through the paper gives you another perspective. Now the whole figure skews to the left. If you can recognize your mistakes then you're halfway to fixing them.

▼ If you are working on an opaque painting or making a faint drawing on a thick sheet of paper, you won't be able to see your image through the support. In this case, simply use a mirror to view it in reverse.

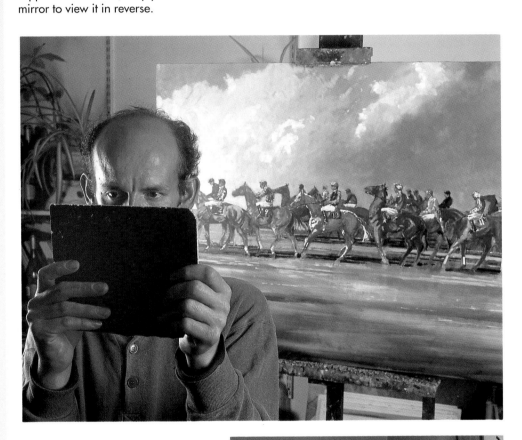

► A mirror image gives you an entirely new look at your picture. Not only does it allow you to see that the verticals, say, aren't upright but it presents the composition in a fresh light and, in the case of a good self-portrait, enables you to see yourself as other people see you! Try propping your drawing up in one corner of the room and looking at its reflection in another.

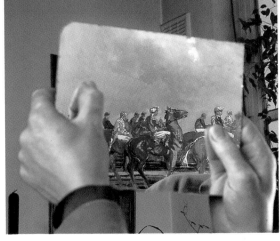

UNDERSTANDING COLOR

INTRODUCING COLOR

Every painting has color as one of its main ingredients and the challenge for any artist is how to handle it successfully.

We all have a color sense that is uniquely our own and is reflected by the colors in our home, the colors we like to wear, and so on.

These subjective likes and dislikes trigger an immediate response in you when you look at the colors in a painting, and of course when you choose your own color schemes.

Composing with color

Everything has a color – even if it is only black or white – and the challenge for all artists is how best to interpret the colors around them with the paints on their palette.

Color is an important part of any composition. This is not just because of the emotional qualities of color – it is also because of the powerful physical effect colors can have. Composing successfully with color requires a good grasp of why – and how – colors can affect one another.

Colors are often described as being either "warm" or "cool." The warms are yellow, red and orange while the cools are blue, violet and green. (Remember that the terms *warm* and *cool* are relative – there are warm blues and

cool reds.) The idea of color temperature is based on an emotional response rather than a physical reality, but is invaluable to the artist. Warm colors appear to advance toward the viewer while cool colors recede. You can use this – and create an illusion of space in a picture – by putting cool colors in the background and warm ones in the foreground.

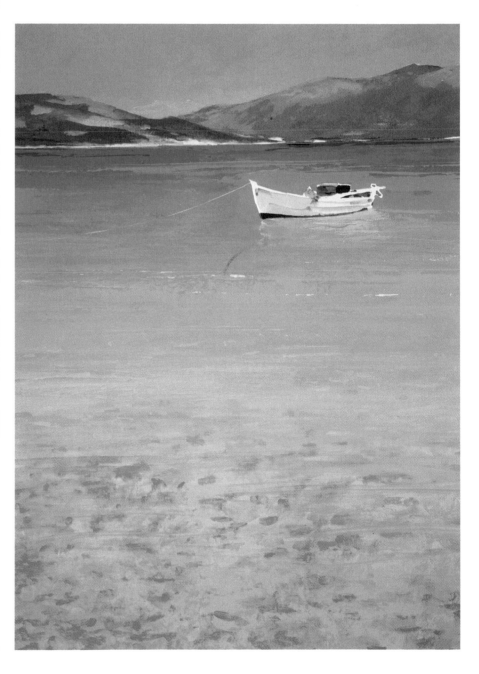

▼ Masterly use of warm and cool colors is the key to the sense of depth in this painting.

"CLEAR WATER – GREECE" BY DONALD HAMILTON FRASER, OIL ON PAPER, 21 X 15IN

The language of color

Every color has three qualities: hue, tone and intensity, and the everyday word *color* combines these three qualities.

Hue is a color's name – red, yellow or blue, for example. A color's lightness or darkness is referred to as **tone**. Adding black to a hue makes it change gradually toward dark; adding white changes it gradually toward light.

The gradations toward dark are called **shades**, the gradations toward light are called **tints**. Both shades and tints describe tone.

Intensity refers to the brightness, or brilliance, of a color. A hue of strong intensity seems vivid, while a hue of low intensity appears dull. Dull, in this sense, doesn't mean dreary – it is simply the opposite of bright.

Note

Later chapters look in detail at the different ways of using color – composing with color, color mixing, and using its qualities to get the atmosphere you want. There will also be more details on the color wheel and how the position of individual segments indicates the way those colors interact.

The color wheel

One of the most useful devices for understanding color is the color wheel – a circular diagram designed to show not only how colors can be mixed to create others but also how they are related to each other.

The three key colors on the wheel are the **primaries**: red, yellow and blue. These are important because they are "pure" colors. This means that they cannot be mixed from any other color combination.

Between the primaries on the wheel, you find orange, green and violet. These are called the **secondaries** because each one is made by mixing two primaries. Red and yellow produce orange; yellow and blue make green; red and blue create violet. By mixing any primary with an equal amount of the secondary next to it, you create another group – the **tertiaries**. Blue and green, for example, make blue-green.

Technically it is possible to mix an infinite range of colors from the three, pure primaries by blending them in varying amounts. But this isn't really practical for artists because it takes too much time.

▼ This basic color wheel shows the primary and secondary colors. Primary red, yellow and blue are separated from one another by the secondaries – orange, green and violet. The colors in one half of the wheel – red, orange and yellow – are "warm." "Cool" green, blue and violet make up the other half.

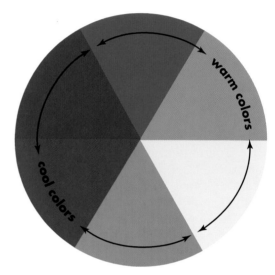

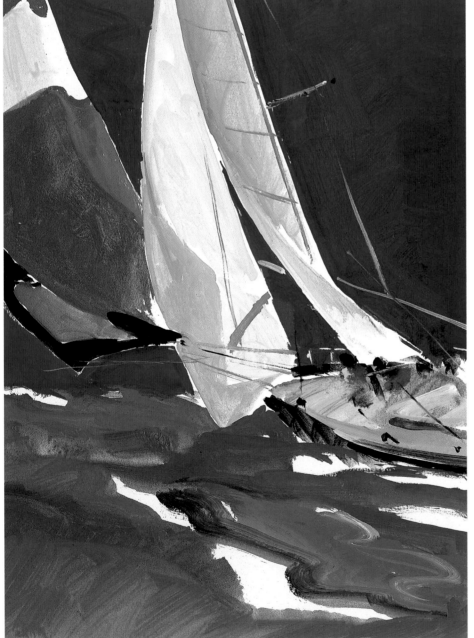

▲ In this detail from the previous page, the tiny touches of almost pure red, blue and yellow – the three primaries – instantly draw your eye. In the same way, the yellow hull (left) carries your eye into the heart of the picture.

◄ Action and excitement explode from this painting. The vibrant colors in the top half of the picture produce great energy and tension – enhanced by the surprising crimson of the sky.

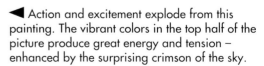

"SPINNAKER" BY DONALD HAMILTON FRASER, OIL ON PAPER, 19 X 14IN

COMPLEMENTARY PAIRS

You rarely see colors in isolation in a painting. The important thing is how they interact. Some have such a close relationship they can be grouped together – in complementary pairs.

Complementary colors are pairs of colors linked in a fundamental way. Laid side by side a pair of complementaries has the most powerful and intense effect on each other, the one heightening and intensifying the other. Reds look redder – they positively sizzle – placed next to their complement green, and blue seems more vivid and vibrant with orange nearby. Using such pairs next to each other can inject great zest and vitality into a painting.

The term *complementary* comes from what happens when you add together any such pair of colors. They result in what is called a complement – meaning, in this sense, something complete. In theory, what they produce is black – but in practice, because no color is ever absolutely pure, it's actually more like gray or brown. When you mix complementary pairs in

OPPOSITES ATTRACT

You can tell at a glance which colors are complementary by taking a look at the basic six-segment color wheel (left). Here you'll find them arranged directly opposite each other. This shows you that red is the complement of green, yellow is the complement of violet, and blue that of orange.

The color wheel is made up of the three primary colors (red, yellow and blue), with the three secondaries alternating in between. The primaries are the most important colors for the artist. In theory, you can mix any color from them – the three secondaries, for instance. These are made by mixing two primaries together: orange is made from equal quantities of red and yellow; green is mixed from yellow and blue; and violet is a combination of blue and red.

An easy way to remember the color wheel sequence is to think of the colors of a rainbow.

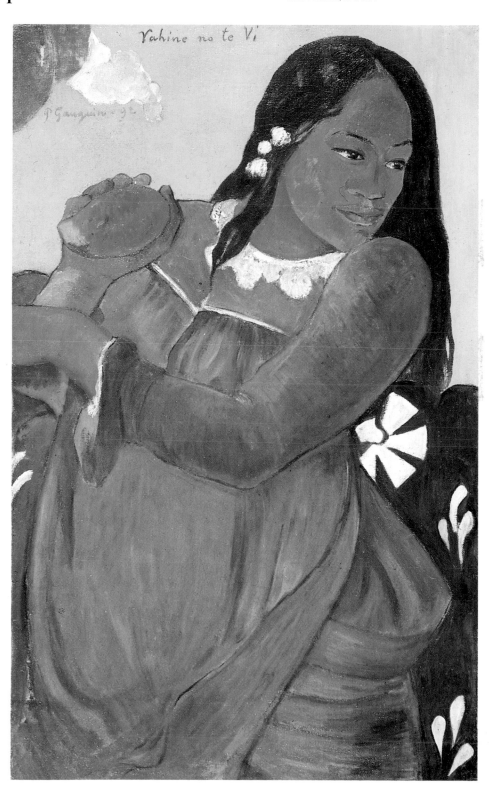

▼ Large flat areas of complementary violet and yellow, and smaller areas of red and green, give this painting tremendous visual excitement.

"VAHINE NO TE VI" BY PAUL GAUGUIN, OIL ON CANVAS, 28 X 18IN

Vahine no te Vi

P. Gauguin 92

SEE FOR YOURSELF – THE AFTER-IMAGE EFFECT

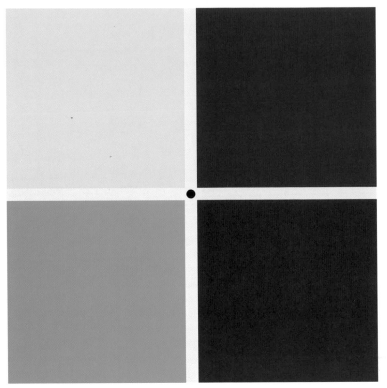

You can take advantage of the way the human eye works to see the complementaries of the four colors shown here.

Stare for about a minute at the dot in the center of the colored square above. Then switch your gaze to the dot in the gray square below. In each section you'll see the complementary of the color in the corresponding section of the first square. In place of the red in the top right hand square, for instance, there'll be green, then clockwise you'll see orange, red and blue.

This is called successive contrast – after looking at the original colors for a while, your eye automatically sees their complementaries.

varying proportions you can produce a marvelous range of neutral colors that give depth and subtlety to your painting.

Learn a few simple rules on the way complementaries interact and you are equipped to make maximum use of color in your own work – and to see how artists handle it in their individual ways.

▶ Opposite, placing the red hat in a background of complementary green instantly draws the viewer's attention – it's the focal point of this painting.

"STILL LIFE, WOODEN TOY" BY DONALD HAMILTON FRASER, OIL ON CANVAS, 28 X 36IN

HOW PRIMARIES AND SECONDARIES COMPLEMENT EACH OTHER

The relationship between primaries, secondaries and complementaries is best shown by the double color wheel below. The primaries are in the central wheel, and the secondaries in the outer one. Notice that the complementaries are still opposite each other.

What this double wheel also shows you is that the complementary of a primary is a secondary made up of the two other primaries. For example, the complementary of red (a primary) is green (a secondary made from the other primaries yellow and blue).

Looking at it the other way around, the complementary of a secondary is the primary color of which it is *not* made. Thus, the secondary orange, which is made up of the primaries red and yellow, is the complementary of the remaining primary blue.

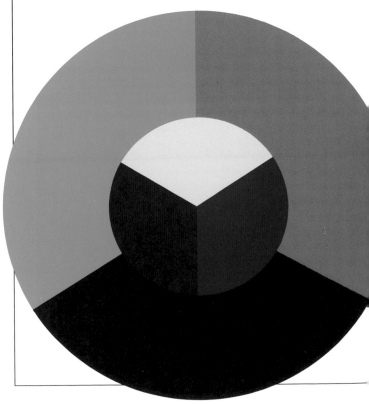

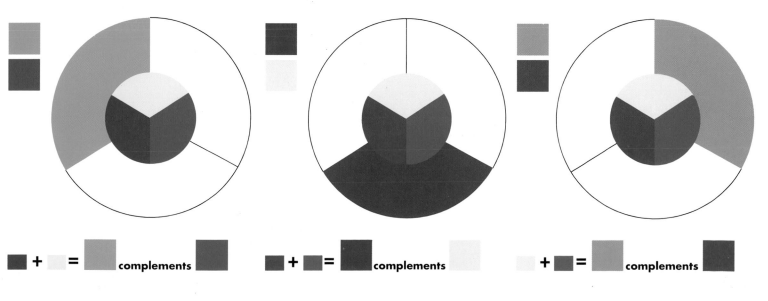

give a red apple a green shadow

Putting theory into practice

With the theory of complementary colors securely under your belt, you can now look at one of its many uses.

Shadows are too often treated as unimportant areas of a picture, just needing to be covered with the same gray paint all over. No wonder they can turn out looking flat and dull. To produce lively shadows, the rules are simple. Paint them the complementary color of the object. So, for an orange, paint a blue shadow; for a red apple, a green shadow; and for a banana, a violet one. (You don't have to pick the brightest colors for this – muted ones work very well.)

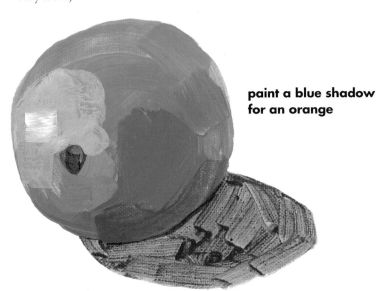

paint a blue shadow for an orange

do the banana's shadow in violet

▶ Take a leaf out of this artist's sketchbook when composing a still life. Set against the blue background the orange vibrates.

"ORANGE AND BLUE STILL LIFE" BY CAROLINE MILLS, WATERCOLOR ON 300LB BOCKINGFORD PAPER, 30½ X 22½IN

USING COMPLEMENTARIES

As you have already seen, complementary colors are very closely linked. But their powerful influence on each other isn't always obvious. Side by side they enhance each other, but when mixed together they produce muted, subtle effects.

Love it or hate it, the effect of the blue and orange in the picture at right is certainly eyecatching. And no wonder – when the artist, Ernst Ludwig Kirchner, chose to put this complementary pair next to each other he was using the maximum color contrast available to any artist. This contrast is so effective because of a process known as simultaneous contrast, which has to do with the way the human eye works.

When you look at a color your eye actually sees its complementary as a "shadow" right next to it – although you're not aware of this. So when you look at blue you're also seeing orange. What happens when that complementary is really there (as in the Kirchner painting) is that both colors look brighter and more intense: in effect, you're seeing two layers – the paint itself and, on top of that, the shadow from its complementary next to it. You can see this for yourself by doing the exercise with the blue squares below.

▼ Sizzling complementary relationships are used effectively throughout this painting, especially in the dressing gown. But notice also how red is set off by green.

"SELF-PORTRAIT WITH MODEL" BY ERNST LUDWIG KIRCHNER, *ca.*1913, OIL ON CANVAS, 59 X 39⅛IN, KUNSTHALLE, HAMBURG

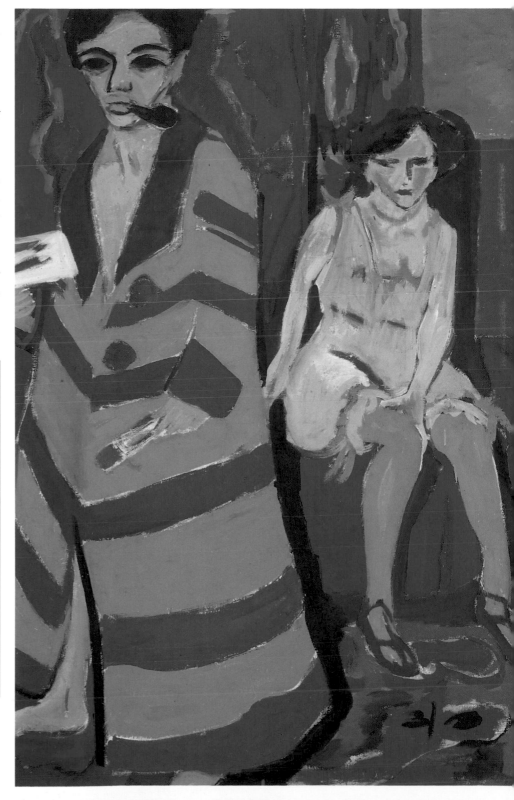

SEEING TWO BLUES?

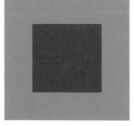

Look carefully at the two blue squares in the center – are they the same color or not?

They are in fact identical, but the one on the left looks bluer because it's surrounded by orange, its complementary – the two colors influence each other. As you look at the blue square on the left, you take in the orange next to it. Because of the way your eye works, you also see a "shadow" of complementary blue all around the orange, which intensifies the blue. This doesn't occur with the other square because violet and blue aren't complementary.

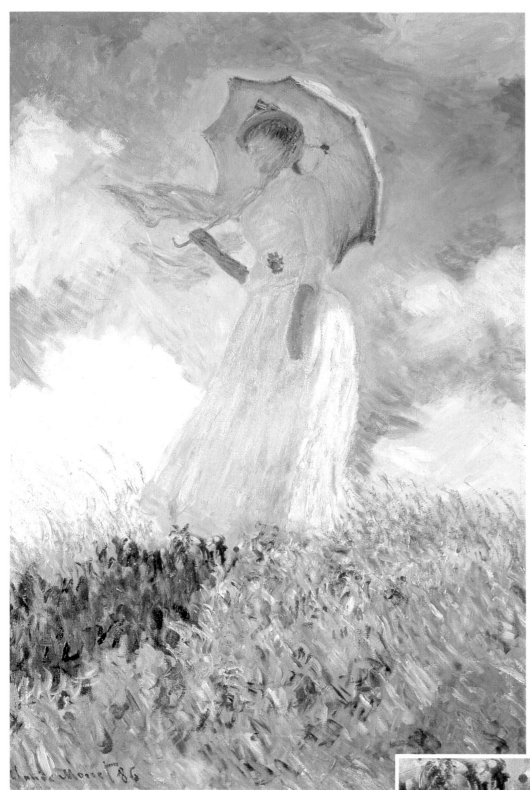

Putting theory into practice

You can utilize simultaneous contrast to add zest to your painting. Introduce touches of red or reddish brown into areas of green foliage or grass and you make them look more lively. Place a pair of complementaries strategically and you can draw the eye to a focal point. Dab a single touch of complementary red in a field of green and it glows

The other side of the coin

Simultaneous contrast is not the only influence complementary pairs have on each other. Mix them together and they have quite a different effect – they neutralize each other, producing a whole range of grays. These are no ordinary grays, however – muted and subtle, they're more interesting and useful than the rather steely grays derived from black and white.

Take complementary red and green, for example. By mixing these in varying quantities you get dirty red and grayish green, earthy colors that resemble sienna and ocher. Add white to each of the mixtures, and you create a series of beautiful, delicately colored grays.

These neutral grays are very effective and a delight to use, providing a foil for brighter, more vibrant colors. They have an inherent harmony and are never strident.

Putting theory into practice – again

A simple rule to draw from all this is that when a color looks too dominant in your painting, you can soften it by adding a little of its complementary. For example, you can subdue a glaring red with green.

What's more, with muted and earth colors you can also take advantage of the complementary influences. Try pairing a red ocher with a cerulean blue (which is greenish) for instance, or a muddied yellow-green with a mauve-gray. You can see this effect in action by turning back a couple of

▲ This picture is a symphony of complementary contrasts. Patches of reddish brown in the grass (enlarged in inset) make the grass look greener and livelier. And the cool blue of the sky and the warm ocher of the grass are reflected in the woman's dress.

"WOMAN WITH PARASOL, TURNED TO THE LEFT" BY CLAUDE MONET, 1886, OIL ON CANVAS, MUSÉE D'ORSAY, PARIS

AMAZING GRAYS

ultramarine

cadmium orange

Winsor red

viridian

Winsor violet

cadmium yellow deep

ivory black

Chinese white

Payne's gray

Mix complementary pairs together and you produce wonderful neutral grays, more subtle than the steely versions made from mixing black with white or those that come ready mixed in pans or tubes.

▼ No paint box gives you the luscious palette of pearly neutrals seen in this picture – they are achieved by mixing. What's more, some of the loveliest neutrals are made from complementary pairs.

"THE TULIP" BY FRED CUMING, 1993, OIL ON BOARD, 32 X 24IN (COURTESY OF BRIAN SINFIELD GALLERY, BURFORD, GLOS)

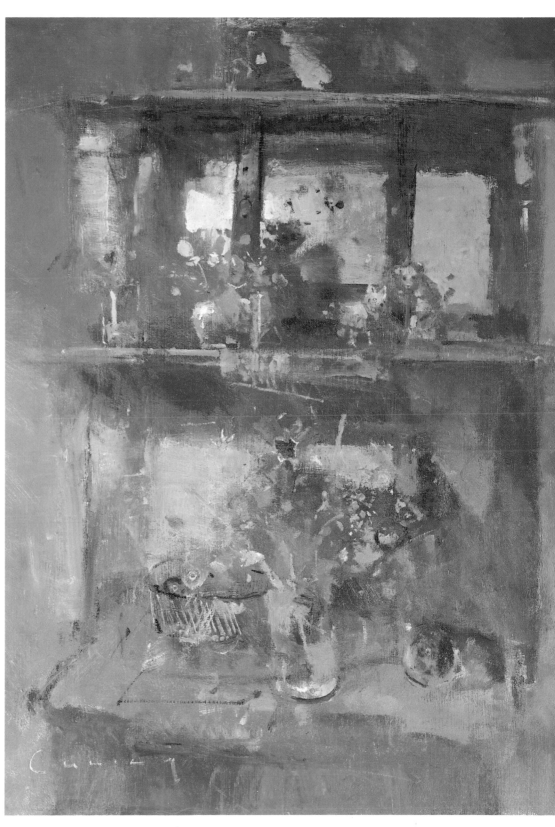

pages and looking at the vibrating complementary pair in the top right-hand corner of the Kirchner painting.

Optical color mixing

A group of 19th-century painters – the Pointillists – made use of complementary influences for quite different purposes. They wanted to create color that captured the luminosity of light. To do this they laid down dots of two (often complementary) or more colors with minimal regular spaces in between.

Seen from a distance these spots are blended by the eye to make a new color, which is much more brilliant and vibrant than the equivalent color produced by mixing pigments. This process is called optical color mixing – and you can try it yourself, placing dabs of red next to green, yellow next to violet, and orange next to blue, for example.

▶ Dots of color create an image that seems to scintillate above the picture plane. Here there are no very dark tones. Instead form is modeled by playing off warm and cool colors – blues and lilacs in the shadows and warm yellows and oranges where the form catches the light. In the straw hat of the title, dots of complementary blue and orange, and yellow and violet add a particularly luminous quality.

"THE STRAW HAT" BY THEO VAN RŸSSELBERGHE (COURTESY OF WHITFORD & HUGHES, LONDON)

TERTIARY COLORS

So far we've looked at a six-color wheel, made up of primaries and secondaries. It's now time to expand the range with another group – the tertiaries.

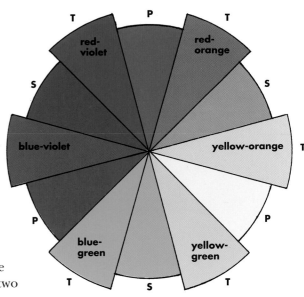

P = Primary; S = Secondary;
T = Tertiary

▲ The 12-color wheel of three primaries, three secondaries and six tertiaries is the most useful one for getting to know color because most people can visualize all 12 colors accurately.

To create a tertiary all you have to do is mix a primary with an equal amount of one of the secondaries next to it on the six-color wheel. If you combine red with its neighbor to the right – orange – you get red-orange; and if you combine red with its neighbor to the left – violet – you get red-violet.

By adjusting the proportions of the primary and secondary you can create a whole range of interesting "intermediate" colors – for example, a red-orange that is more red than orange, or a red-violet that is more violet than red (in which case, you'll probably call it violet-red).

When you've mixed each primary and each secondary you get a 12-color wheel, with a tertiary between each primary and secondary. All these – including the tertiaries – can be described as "pure" because they're all mixed from just two primaries.

The primaries are the most visually stable of all the colors, but the gradations between them are less so. That's because the

▼ A colorful yet subtle effect is created here by the palette of tertiaries – blue-greens, green-blues, and the russets and burnt oranges of the Chinese lanterns.

"STILL LIFE WITH POTS AND CHINESE LANTERNS" BY SARAH SPACKMAN, 18 X 20IN, OIL ON CANVAS

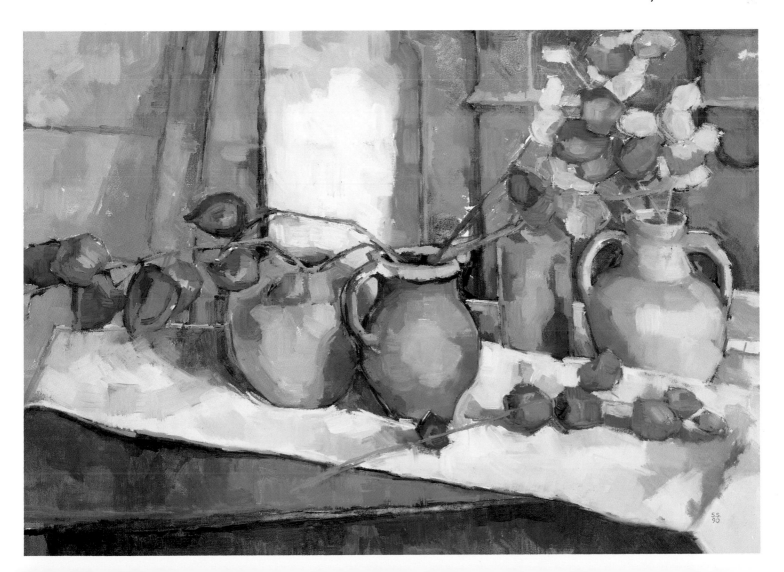

NAME THESE COLORS

Try naming the swatches of color below. Some of them are easy, some of them not so easy. Now, which are the tertiaries?

Identifying tertiaries is easy. When you're of two minds whether it's blue or green, say, the chances are it's a tertiary. And as soon as you refer to nature – with colors like jade and lime green – it's more than likely you are naming a tertiary. These are all tertiaries, apart from the top blue and bottom yellow.

▶ Here tertiary blue-greens and turquoises sing out, set off by the neutral tones of the white bed linens and the muted colors of the walls. Touches of russet and orange provide a warm contrast.

"FIONA IN THE TURKISH GOWN" BY JOHN WARD, CBE, OIL ON CANVAS, 36 X 50IN

secondaries and tertiaries are made up of two primaries and one color in the mixture tends toward just one of them. In many ways, though, these intermediate hues are more subtle, expressive and dynamic than the primaries. This is why artists so often work with them, saving the primaries for specific and limited applications.

Now we'll look at the tertiaries in turn, two colors at a time.

The blue-greens and yellow-greens

This family of colors has several interesting characteristics. First, there are a lot of them. Second, there is great debate about exactly where the border between blue and green lies.

Most color confusion occurs in this area; and even people who possess acute color perception disagree about whether a color is more blue than green. From this we can draw one of the rules of color – it's fickle, and context is always influential in the way it's perceived. You may well have to re-assess a color you believe to be turquoise on seeing a turquoise that is entirely different.

The semiprecious stone turquoise does indeed lend its name to a particularly intense version of the greenish blues. Aquamarine also gives its name to this color range, as does

emerald. There are also the cerulean blues of an azure sky and the jade of the Mediterranean.

Then there are the iridescent blue-greens of a peacock's tail and a mallard's neck feathers, and the lovely soft blue of a duck's egg. From these are derived colors like celadon (a grayish green taken from the glazes used on Chinese pottery), Nile green (from the Nile River) and pistachio.

Turning to the yellow-green side of the range, you find the acid greens of lime green and apple green, and the bright shades of beech leaves and new grass in spring.

The yellow-oranges and the red-oranges

This range gives us some delicious fruit colors – cheerful and sunny. Think of peaches, apricots and tangerines. Also included are warm earth colors like terra-cotta and brick red.

Again, they are difficult to identify in isolation – a color that looks pinkish in one context can look yellow against a reddish background. One person's peach may be another's apricot.

The red-violets and blue-violets

In nature these are fruit and flower colors – plum, grape, violet, heather and lavender. There are also earthy shades like puce.

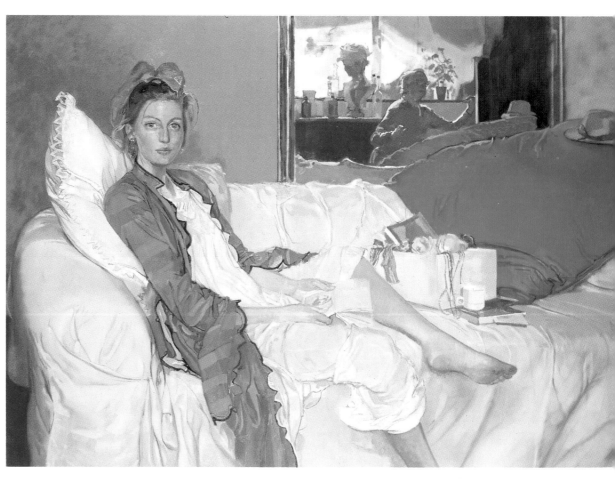

WARM AND COOL COLORS

All colors have a temperature, whether it's warm, cool or somewhere in between. This is no arbitrary description, however. There's general agreement about which are which.

From the beginning of this chapter, you'll be familiar with the idea of the six-color wheel divided in half. One side of it contains the warm colors – red, yellow and orange – and the other the cool – blue, violet and green.

To most of us these two sets of colors have familiar associations. Reds, yellows and oranges conjure up sunlight and fire, while the blues and blue-greens evoke snow and ice, sea, sky and moonlight.

But the theory of color temperature isn't quite so black and white! Within the warm half and the cool half of the color wheel there are degrees of warmness and coolness.

Warm "cools" and cool "warms"

Take the reds, for example. In the nine-color wheel at right there's both a hot red and a cool red. The hot red is cadmium red because it tends toward warm orange. By comparison alizarin crimson is relatively cool because it is next to cool/intermediate violet on the color wheel.

It's the same story with the yellows. Cadmium yellow pale is warm because it is adjacent to warm orange. And lemon yellow is cool because it is located next to cool green on the wheel.

Secondary colors, too, are warm or cool. Green is cool, as it comes from a mix of cool yellow and cool blue. Orange is warm because it is derived from warm red and warm yellow.

The effect of adjacent colors

A color may appear all the warmer or cooler depending on what it's next to. This is especially true of violet, which is an in-between color (made from cool blue and warm red). Next to a warm color such as red it appears cool, while next to a cool color such as blue it appears warm. Similarly, if you saw a patch of alizarin crimson in a painting of cool blues and greens, you'd probably describe it as "hot."

Using color temperature

It would be wrong to dismiss color temperature as just another theory. In the hands of an artist, it becomes an indispensable tool. That's because in general terms warm colors advance (come toward you) and cool colors recede (move back). You can capitalize on this to describe three-dimensional form (see next page).

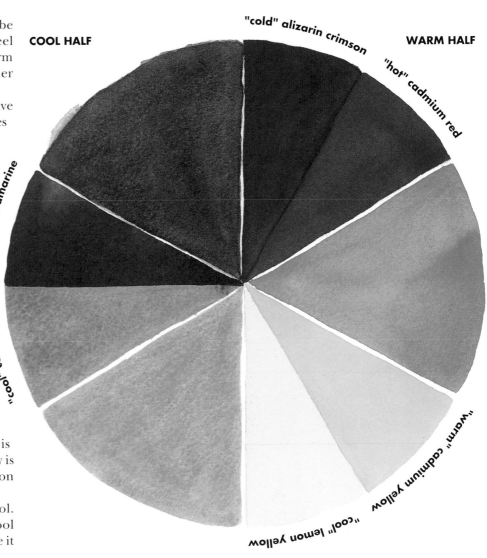

COOL HALF

"cold" alizarin crimson

WARM HALF

"hot" cadmium red

"warm" ultramarine

"cool" cerulean blue

"warm" cadmium yellow

"cool" lemon yellow

DID YOU KNOW?

Physical effects
Color temperature isn't all in the mind. In a controlled experiment, people set the thermostat in a blue room 4°C higher than the one in a red room.

SEE FOR YOURSELF

You can see for yourself how warm colors advance and cool colors recede by looking at the two squares below. The warm red one seems to move forward while the cool blue one seems to move back.

Most of us are familiar with this idea from interior design – to make a room feel warm and cozy we paint the walls red. Paint them light blue and the room is transformed into a cool and airy space.

▶ The roundness of these two oranges is beautifully conveyed by the skillful use of warm and cool watercolors. There are obvious areas that travel forward – the oranges and reds – and other areas that travel back – the blues and greens – where the forms tuck under.

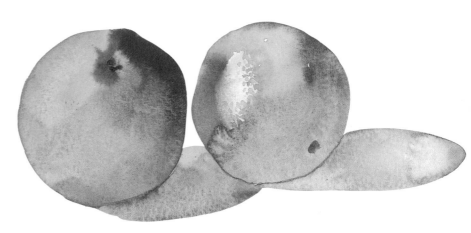

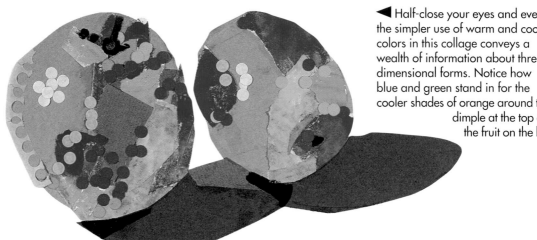

◀ Half-close your eyes and even the simpler use of warm and cool colors in this collage conveys a wealth of information about three-dimensional forms. Notice how blue and green stand in for the cooler shades of orange around the dimple at the top of the fruit on the left.

▶ The limited palette of warm and cool colors describes form while giving the girl's flesh a luminous quality.

Notice the yellow tones on the subject's right shoulder (they also warm her right buttock), and the pink flush where the weight of her body meets the mattress and where the arm and torso meet. In the small of the girl's back bluish lilac tones describe the way the forms flatten out. And in the foreground, folds of golden fabric pull that area right up to the picture plane.

"RECLINING NUDE" BY VICTOR PASMORE, OIL ON CANVAS, 12 X 16IN, 1942

STARTING TO MIX COLORS

So much for the theory of color. Now the fun really starts and you can get down to the nitty gritty of mixing your own colors from a palette of six paints.

There comes a point for most things when reading is no substitute for doing. This is certainly true of color theory. When you come to the end of this chapter, get out your paper and paints and give color mixing a try!

Where practice and theory part

As you've been reading this chapter, chances are you've stopped to ask yourself the following question: why, if the three primaries can be mixed to produce all other colors, do I need more than a tube of red, yellow and blue, plus a tube each of black and white?

The answer is that there is no such thing as a "pure" pigment primary. Approximating to each primary there may be as many as 16 tube colors, and these all have one thing in common – a bias toward one of the adjacent secondaries. Take the reds, for example: the tube color cadmium red has a bias toward orange, while another, alizarin crimson, tends toward violet.

All this is highlighted when it comes to mixing the three secondaries – violet, orange and green.

◀ In this abstract landscape much of the color is almost pure pigment, used straight from the tube. But the artist has done some mixing, both on the palette and on the canvas.

The colors he used are ultramarine, spectrum red, cadmium orange and Winsor green – a particularly sharp transparent green that you can't produce by mixing.

"LANDSCAPE" BY JOHN BARNICOAT, 30⅛ X30⅛IN, OIL ON CANVAS, 1993

Mixing pure secondaries and muted secondaries from "six" primaries

From the six-segment color wheel you've seen that you need three primaries to make three secondaries. So much for the theory, now for the practice.

In fact you need two versions of each primary – one that tends toward the secondary on one side of it on the color wheel and one that tends toward the secondary on the other side. With red, for example, you need one that tends toward orange (to make orange) and another that tends toward violet (to make violet). With only one red, you'd have one secondary that was correct and one that was wrong.

The same is true for the two other primaries. You need a violet blue and a greenish blue, and an orange yellow and a greenish yellow.

Pure secondaries For pure secondaries you need two primaries that tend toward the secondary in

Pure secondaries and muted secondaries

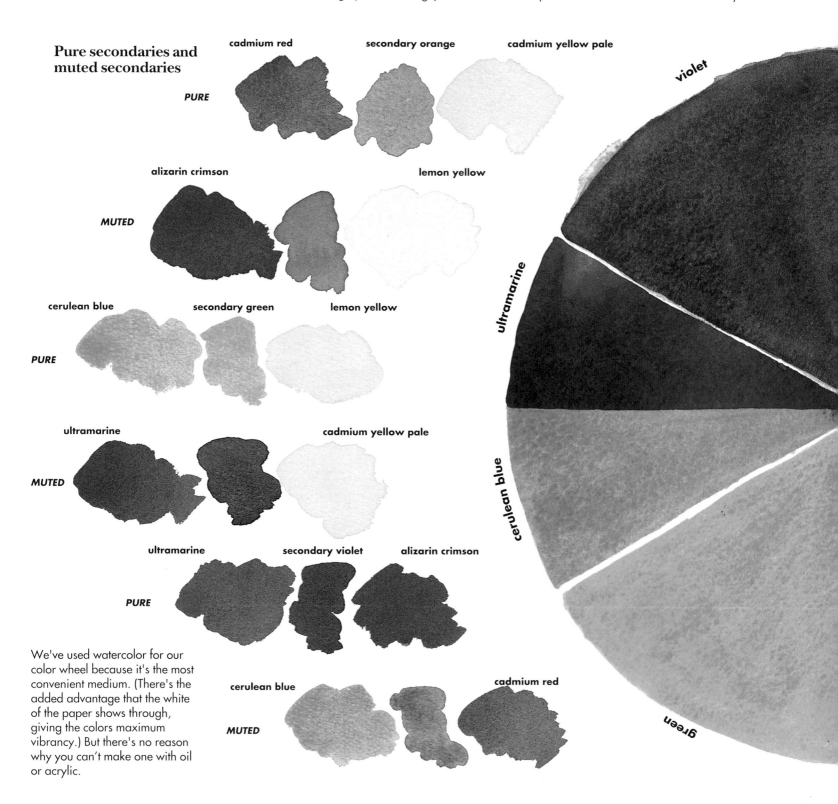

cadmium red secondary orange cadmium yellow pale

PURE

alizarin crimson lemon yellow

MUTED

cerulean blue secondary green lemon yellow

PURE

ultramarine cadmium yellow pale

MUTED

ultramarine secondary violet alizarin crimson

PURE

We've used watercolor for our color wheel because it's the most convenient medium. (There's the added advantage that the white of the paper shows through, giving the colors maximum vibrancy.) But there's no reason why you can't make one with oil or acrylic.

cerulean blue cadmium red

MUTED

violet

ultramarine

cerulean blue

green

between them. Therefore, an *orange* red (cadmium red) and an *orange* yellow (cadmium yellow pale) produce a strong orange that approaches secondary orange.

Muted secondaries Mix together a red and a yellow that are farther apart on the color wheel and the results are very different. A violet red (alizarin crimson) and a greenish yellow (lemon yellow) make a burnt orange.

That's because alizarin crimson and lemon yellow approach a complementary relationship – you've already seen how complementary pairs mixed together neutralize each other (see pages 51–54).

Secondaries like burnt orange are described as muted, neutral or muddy. Don't be put off by the names – these colors are useful and attractive. It's just that they are not pure secondaries.

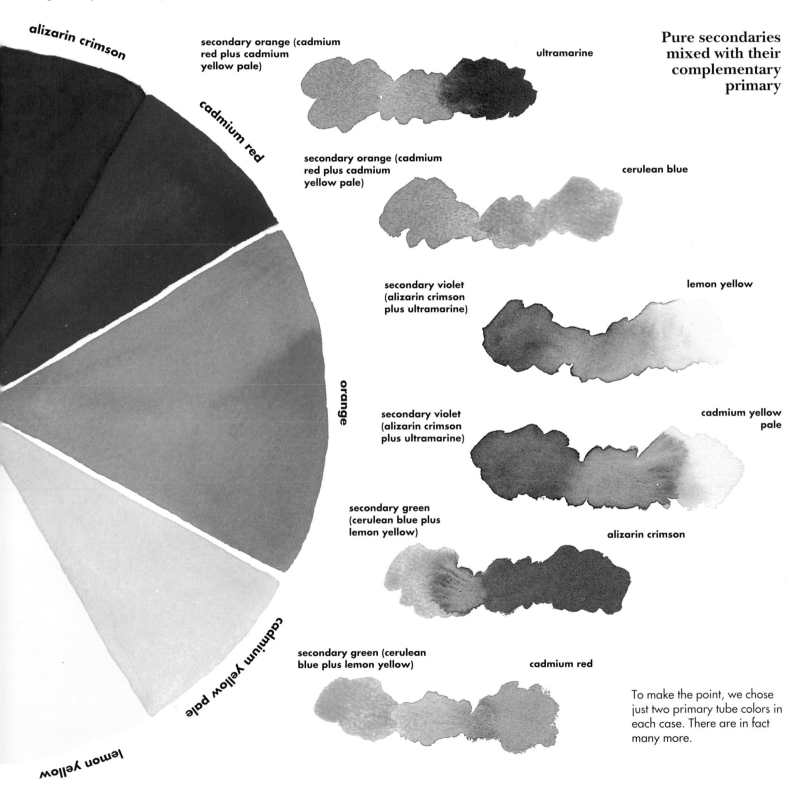

alizarin crimson

cadmium red

orange

cadmium yellow pale

lemon yellow

secondary orange (cadmium red plus cadmium yellow pale)

ultramarine

secondary orange (cadmium red plus cadmium yellow pale)

cerulean blue

secondary violet (alizarin crimson plus ultramarine)

lemon yellow

secondary violet (alizarin crimson plus ultramarine)

cadmium yellow pale

secondary green (cerulean blue plus lemon yellow)

alizarin crimson

secondary green (cerulean blue plus lemon yellow)

cadmium red

Pure secondaries mixed with their complementary primary

To make the point, we chose just two primary tube colors in each case. There are in fact many more.

▼A rich but subtle palette of warm and cool muted colors provides a foil for the brilliant unmixed red of the parasol.

Some of the pearly grays are mixed, while others have been created by laying one color on top of another.

"THE RED PARASOL" BY KEN HOWARD, OIL ON CANVAS, 40 X 48IN, COURTESY OF MANYA IGEL FINE ARTS, LONDON

Doing it yourself

If all this sounds complicated, be reassured – it is much easier to grasp when you've done it yourself. And as you do, you'll acquire an understanding of how mixing color really works. You'll also have an extremely useful palette of six colors at your disposal: cadmium red, alizarin crimson, ultramarine, cerulean blue, lemon yellow and cadmium yellow pale.

Before you start, get everything ready. Remember, you'll use a lot of water and paper towels because neatness is essential. Always clean your brush before you put it into a pan of color or wash, and keep a separate jar for mixing washes.

First of all, mix the pure secondaries from the pairs of recommended primaries. Then try the muted secondaries. Mix ultramarine and cadmium yellow pale together, for instance. You'll end up with a color that may not be a pure secondary but that is nonetheless an interesting muted green.

You've already seen neutral grays made from mixing complementary pairs (see pages 51–54). The swatches of color used there were all brand-name pigments. Do the exercise yourself now, but instead of resorting to tube or pan colors for the secondaries, make use of the pure secondaries you've just mixed.

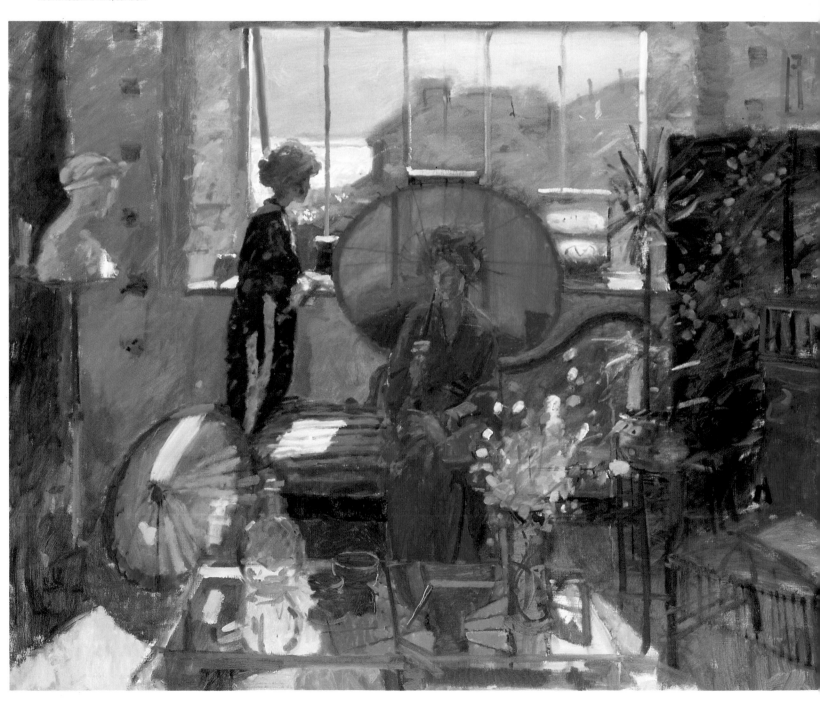

OPTICAL COLOR MIXING

With the arrival of the Impressionists in the 19th century, there was a dramatic break with tradition. It centered on the way this group of artists used their colors.

Until the Impressionists, artists had gone about the business of mixing colors in the usual way – on the palette. Then there was a revolution.

It started with a Frenchman, Michel-Eugène Chevreul, who in 1839 published his scientific discoveries about color. Among his observations was the theory of optical color mixing – the idea that colors could be mixed in the human eye.

For the artist, the implications of this were tremendous, and the Impressionists rushed to put theory into practice. They set out to paint the effects of light knowing that optical color mixing could help them capture special luminous qualities. These were qualities that could not be achieved by mixing paints on the palette, where the more you blend them, the more a black-brown color tends to emerge.

Instead the Impressionists used pure, simple colors, laying them down in tiny dabs side by side on the canvas. Viewed from a distance, these speckles of "broken" color merged. A mixture of red and yellow strokes, for instance, actually appears orange, and the paint surface as a whole is lively, vibrant and scintillating.

▲ As director of dyeing at a tapestry workshop, Chevreul identified a problem – colors weren't registering their full effect. It had nothing to do with the dyeing, however. He discovered that colors placed side by side have an impact on each other – a phenomenon known as simultaneous contrast (see pages 51–54).

► Optical color mixing appears in an exaggerated form in the work of Pointillist painter Georges Seurat.

In his later paintings – such as this picture – he laid down tiny dots of brilliant color, intending them to mix in the viewer's eye. Here they produce intermediate tints more luminous than those you get from pigments mixed on a palette. Meanwhile close-up, the picture surface is just a mosaic of dots. Try placing the life-size detail (above), for instance.

"THE HARBOR AND QUAYS AT PORT-EN-BESSIN" BY GEORGES SEURAT, 1888, OIL ON CANVAS, 26¾ X 33¾IN

▶ Turn-of-the-century "Fauve" painters, such as Vlaminck, were eager to explore optical color mixing. His early paintings are characterized by small strokes of intense primary and secondary colors laid down with glimpses of bare canvas in between.

Here the brushstrokes follow and describe forms: small dashes and dots for fallen leaves; long, bold marks for the tree-trunk; and flowing strokes for the smaller branches.

"PAYSAGE AU BOIS MORT" BY MAURICE DE VLAMINCK, OIL ON CANVAS, 1906, 26 X 32½IN, © ADAGP, PARIS AND DACS, LONDON 1994

Note

Other systems of optical color mixing include:
• an underpainting or toned ground showing through;
• scumblings (thick and thin), where you apply paint over white, a toned ground or previous paint layers;
• hatching – a system of criss-crossed lines of colored pencil or pastel;
• oil applied in dabs, strokes, or dashes.
In some media – such as colored pencils or pastels – you can't really blend color so you *have* to use one of the optical color mixing techniques.

Pointillism

Chevreul's ideas dominated the use of color by artists such as Vincent van Gogh and Camille Pissarro. But it was Georges Seurat who applied the theory of optical color mixing in the most scientific and exacting way.

He carried it to extremes, building up whole pictures from tiny dots (points) of color – a technique known as Pointillism or, less commonly, Divisionism. Close up, you can see the individual dabs and dots, but stand back and they merge to present a rich and lively color.

Seurat died young and this exacting system of working didn't last long. But it left an important heritage, creating greater freedom for artists. Such freedom led to uses of color never explored before, particularly in the work of a group known as the Fauves.

The Fauves and afterward

The Fauves were a group of artists who painted at the turn of the century. They included Matisse, Vlaminck and Derain and they earned their name – which means *wild beasts* in French – because of their way of painting.

Their works were brilliant and highly colored, with wild, exaggerated, heightened colors placed side by side. They painted cool shadows in cobalt blue, and delicate fleshy pinks in bright scarlet. These were colors that expressed their feelings as well as describing what they saw.

But it's perhaps in the paintings of the Post-Impressionists such as Vuillard and Bonnard that broken color can be seen best. Working from the mid 1880s to the early 1900s, they employed color in an exciting way, using individual brushstrokes to break up color.

▶ This study by Seurat was painted three years before the one on the previous page. Here he uses broken color, but with a greater variety of brushstrokes. Horizontal dashes of paint describe the surface of the water, while small dashes of color laid in many directions are used for the grass (notice the touches of complementary red here, too).

"THE SEINE AT COURBEVOIE" BY GEORGES SEURAT, OIL ON CANVAS, 1885, 32⅛ X 25⅞IN

Breaking a color

You may come across another meaning of the term *broken color*. It's one that's been around for centuries and it involves mixing, but mixing on the palette rather than on the canvas or in the eye.

To "break" a color means to add a small amount of another color to it. You break red when you add a dash of yellow to it and end up with a warmer, brighter, broken red. You don't break red when you mix it with more than a touch of another color – fifty-fifty with yellow, say, to make orange.

▲ In this painting the artist uses broken color, but far more freely and less rigorously than Seurat, for example. The color is applied in a variety of ways: wet paint is worked into wet paint; in other places it is scumbled loosely over underlying color; and in others touches of crisp impasto add emphasis.

"ST MARTIN'S" BY GARY JEFFREY, ACRYLIC ON PAPER, 22 X 26½IN, COURTESY OF LLEWELLYN ALEXANDER FINE PAINTINGS, LONDON

In 1910 there was an exhibition in London called "Manet and the Post-Impressionists." It brought bold new ideas to the British public and led to the foundation of the London Group, which included such artists as Harold Gilman (see left), Walter Sickert and Wyndham Lewis.

◀ To create this image the artist used vigorous brushstrokes and somewhat dry paint dragged over underlying paint layers. The patches of paint are large and widely spaced, so that the more closely you approach the painting the more it dissolves. Seen from a distance, however, it is resolved. The picture has a fresh, shimmering and luminous quality.

"GIRL BY A MANTELPIECE" BY HAROLD GILMAN, OIL ON CANVAS, 12 X 16IN

GRAYS AND COLORED NEUTRALS

Neutrals are some of the most useful and versatile colors on the artist's palette – and what's more, they are easy to handle.

So far we have looked at the fully saturated hues on the color wheel – the primaries, secondaries and tertiaries. But for the artist – and the interior decorator – the complex colors we call neutrals or grays offer a more fascinating palette. There's a glorious range to choose from. Indeed, some of the best colorists, such as Sickert and Bonnard, really display their quality in their use of neutrals.

In artistic terms, a neutral is a color that has been muted, grayed, dulled or softened so that it is no longer pure (fully saturated) but still has an identifiable hue. The neutrals encompass an enormous range of beautiful colors, from slightly muted purples, olive greens and shades of terra-cotta, to the gray and brown neutrals we tend to associate with stone and sand and the sky on an overcast, dull day.

Some pigments are naturally neutral. The most obvious examples are the naturally occurring earth colors, such as yellow ocher, raw sienna, raw umber and terre verte, and also earth colors that have been heated to produce new colors – burnt umber and burnt sienna. Colors such as Venetian red, Indian red and Mars red, which are based on iron oxides, are also neutrals.

A range of neutrals

There are many ways of neutralizing a color. The best way is to mix your color with its complementary. Take a look at the color wheel, overleaf, and you can see how this works. The

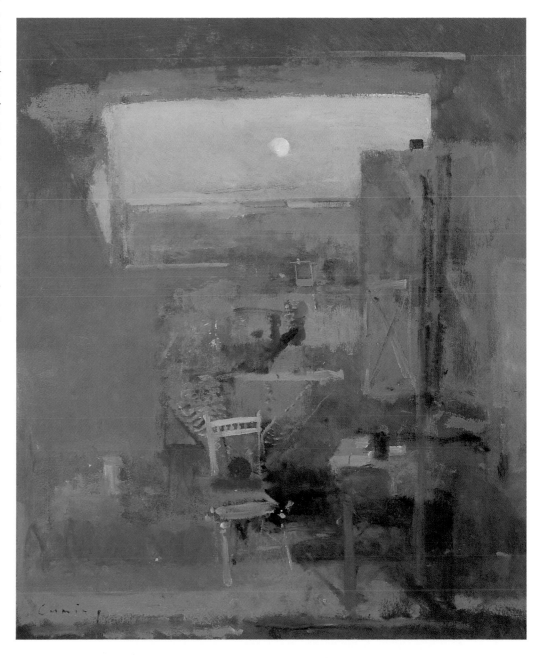

▶ If you study this picture section by section, you'll find a putty color, a pale, cool gray, a lilac-gray, a rust brown and so on – all colors that are difficult to describe. But what a wonderfully subtle evocation of shifting evening light the artist has created. And notice how the touches of unmixed color glow against the neutral ground – turquoise, lemon, red and orange.

"THE STUDIO, EVENING" BY FRED CUMING, OIL ON CANVAS, 24 X 20IN (COURTESY OF THE BRIAN SINFIELD GALLERY, BURFORD, GLOS)

► The colors on the outer ring of this color wheel are "pure" colors – the primaries (we've used a warm and a cool version of each), secondaries and tertiaries. These are the most saturated colors, which can be modified but not intensified. (A pure orange can be made redder or yellower, for example, but it can't be made more intensely orange.) The middle ring contains the colored neutrals, while the colors in the center are grays and browns. These have all been made by adding more and more of the complementary color.

▼ Sickert was a master of color and often used a subtly orchestrated range of lovely neutrals as a base to give emphasis to strategically placed touches of gorgeous color. Look how bright the golden yellow of the ornamentation is in this painting.

"THE OLD BEDFORD MUSIC HALL" BY WALTER RICHARD SICKERT, 1894-95, OIL ON CANVAS, 22 X 15¼IN

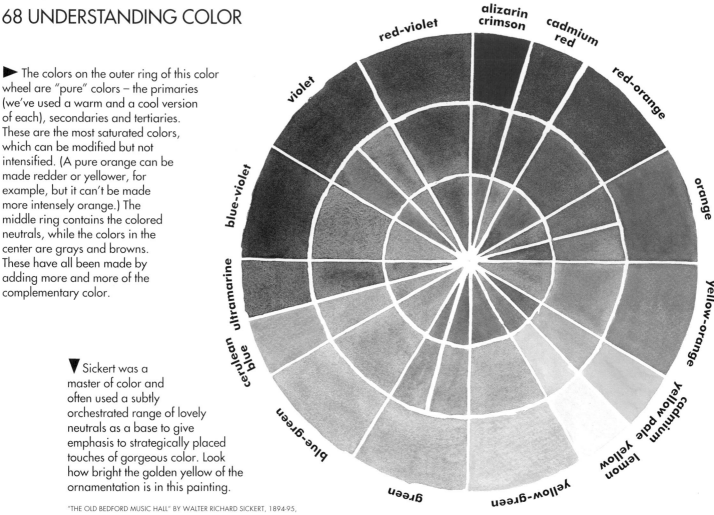

colors around the outside are "pure" colors – the primaries (red, yellow and blue), the secondaries (orange, green and violet) and the tertiaries (the remaining colors). Each color is mixed with its complementary in the middle ring, and then with more of its complementary in the center of the wheel. Notice how this makes each color grayer or browner.

If you mix a neutral in this way it will have a certain amount of each primary in it – although not in equal proportions. Look at the color wheel again and you can see how this works. Yellow is opposite violet (which contains blue and red), and if you mix these together to make a neutral, you've used all the primaries. Try it yourself, using any of the colors on the wheel. Remember, secondaries and tertiaries contain two primaries each.

You can also neutralize a color (or reduce its saturation) by adding a little white (to make a tint or pastel) or a little black (to make a tone).

Using neutrals

Color is a very personal thing. Set two artists in front of a subject and they will select a different range of pigments and interpret the subject with a different palette of mixes. Some people opt for a high-keyed, vibrant palette, others choose a more subtle, muted range of colors. Your mood, your intention and the subject itself will also

◄ Tertiary blue-greens and green-blues, slightly muted, provide a vivid but cool foil for the warm, earthy flesh tones of the models. These aren't pure, saturated hues, but neither are they dull or dingy.

They illustrate very well the lively and vibrant colors provided by the range we call the colored neutrals. Notice how bright the splash of red in the foreground looks, yet it is a muted terra-cotta rendered vibrant by its context. Also notice the way it vibrates against the bright splash of aquamarine on the back of the woman on the right.

"THE TWO MODELS" BY TOM COATES, OIL ON CANVAS, 36 X 36IN

▼ Walter Sickert was an exceptional colorist. Here he demonstrates that paintings that exploit neutrals can be wonderfully colorful – he is concerned with the contrast between natural and artificial light, the individual and the crowd, the public and the private.

Muddy greens, lilacs and rich, earthy reds provide a subdued foil for candy pinks and touches of bright lime green. In this context small patches of color acquire a significance out of proportion to their size.

"BRIGHTON PIERROTS" BY WALTER RICHARD SICKERT, 1915, OIL ON CANVAS, 25 X 30IN

► The overall impression of this painting is of a sunny landscape. The colors look brighter than they are because of the play of complementaries – the blue-violet roofs against yellow bushes, and the orange tinges in the hills against greenish fields and bushes.

"BURLY COBB'S HOUSE, SOUTH TRURO" BY EDWARD HOPPER, OIL ON CANVAS, 23¾ X 36IN (WHITNEY MUSEUM OF AMERICAN ART, JOSEPHINE N. HOPPER BEQUEST)

▼ This painting has an almost abstract quality, although the subject of the painting is realistically described.

Again the painting is colorful – warm, rich browns and earth colors set off by cool, slate grays and grayed whites. Here the neutral palette holds many disparate objects together so that you see the subject as a whole, rather than as a series of isolated elements.

"STUDY IN BROWNS AND GRAYS" BY PAUL NEWLAND, WATERCOLOR ON PAPER

exert an influence. While a vase of flowers in sunlight suggests a vibrant palette, a moody interior would probably be rendered in more somber, muted tones. Basically, you can choose whatever suits your mood, style and subject – you might even decide to exaggerate colors (as Van Gogh or Gauguin did).

An all-neutral palette

By muting or neutralizing colors you reduce their saturation. Because they are less intense, these colors have a natural harmony and are, in many ways, easier to handle than colors at full intensity. It takes great skill to balance a palette of fully saturated colors, each of which will vie for attention.

If you use muted colors you will naturally achieve a sense of harmony. A painting in primarily pastel colors will have an intrinsic coherence – the colors will go well together and nothing will jar. Although neutrals are, in many ways, easier to use, you also run the risk of producing an image that is lacking in emphasis.

You can create emphasis within a muted (neutral) palette by exploiting contrasts. The main ones are complementary contrasts, contrasts of temperature and contrasts of tone. These are important in any painting, but in a painting that contains colored neutrals and grays, they are even more significant. So an earth red in a field of complementary muddy green will have almost as much impact as the contrast of bright

red and green in a more saturated painting. Lilac and blue shadows will give solidity to warm brick walls and figures. (The cool neutrals are grays, while warm neutrals are browns.) In paintings that are very low-key, the nuances of tone are restricted – very subtle shifts in light and dark are required, and in many cases will be emphasized by playing off warm and cool colors.

Artists like Gwen John and Giorgio Morandi produced exquisite paintings using a limited range of subtle, muted colors. They delight us with their infinitely subtle variations of color and by the way warm and cool colors are used to describe form and suggest space. Their work has a wonderfully delicate and restrained quality. This same quality can be seen in the work of Fred Cuming on page 67.

Neutrals as a foil

You can also use muted colors to draw attention to stronger, more intensely saturated colors. In a rich and vibrant palette of bright, pure colors, the eye is constantly distracted, because each color demands attention. But a dash of a bright pastel

▲ By carefully selecting her viewpoint and simplifying the subject, this artist emphasizes the decorative, abstract quality of the vase of tulips on a table. The cool neutral palette creates a peaceful image; look closely and you will find many subtle nuances of color and tone.

"WHITE TULIPS" BY ANNE-MARIE BUTLIN, OIL ON CANVAS, 15 X 11IN

◀ Whistler used very fluid paint mixed with plenty of medium that he called a "sauce." It was so fluid that he often worked on the floor to prevent it from running off. His atmospheric and mysterious images were pulled from the paint surface with sweeping brushstrokes.

This palette of dark blue-grays evokes the confusion of twilight. The color of the lights draws the eye to the tall ships, while a few reflections call attention to a group of shadowy figures standing on the quayside.

"NOCTURNE; BLUE AND GOLD; VALPARAISO" BY JAMES ABBOT MCNEILL WHISTLER, OIL ON CANVAS, 37⅛ X 27⅞IN

DID YOU KNOW?

Costly theme
Whistler painted several variations on his Nocturnes theme (see left). However, they were not well liked. On seeing his "Nocturne in Black and Gold, the Falling Rocket," Ruskin accused Whistler of "flinging a pot of paint in the public's face." Whistler sued him and won, but he won only a farthing (the smallest amount he could have been awarded) and the costs left him bankrupt.

pink will really stand out against a field of muted pinks and grays, and its impact will be much greater than its intensity and size.

If your painting lacks emphasis, you might find that by softening some of the background areas you give the focal points more importance. You could do this by mixing a bit of the complementary color on to the background, for example, or by overpainting with an earth color equivalent.

The artist Walter Sickert was a master at introducing surprising touches of color into his paintings – and yet when you study them carefully, these apparently bright colors are in fact quite restrained. By placing them within a neutralized field, he really makes them speak.

◀ Washing dancing on a line in a pretty street makes an enchanting motif. The warm, sepia tones of the masonry provide a muted background for the blues and rusts of the washing, which seems quite bright in comparison. The artist uses a restricted palette to create an image that is restrained but engaging.

"PITIGLIANO" BY ALISON MUSKER,
WATERCOLOR ON PAPER, 15 X 11IN

▶ Tom Coates uses a range of warm and cool neutrals to describe the dissolving, shimmering forms of Venice on a wet winter's day. The warm brown of the support provides local color in some areas – as in the fabric of the Doge's Palace – but in others it acts as a unifying element and a warm contrast that gives impact to the blues and grays.

"THE DOGE'S PALACE, WINTER" BY TOM COATES,
OIL ON BOARD, 14 X 18IN

COMPOSING PICTURES

FORMAT – FIRST THINGS FIRST

One of the first decisions you make at the start of a picture is how to compose it – how you put together and arrange its different parts.

The basic element of any composition is the format (shape) of your support. This can greatly affect the mood, and even the final success of your painting, so before you start, make sure you take time to consider which shape is best for your subject. It can be any shape or size you want, but at first you may prefer to stick to formats that are already well established.

A choice of two

There are two traditional formats – portrait and landscape. Both are based on the rectangle. When the longer side is upright the support is described as "portrait." Placed the other way (horizontally) it is called "landscape."

The names reflect the fact that the upright one is used most often for portrait painting, while the horizontal one is traditional for landscapes. In fact, you'll also find that most supports come ready made in these shapes.

There are sound practical reasons for these choices: using the horizontal format for depicting a landscape means you can fit in a wide, sweeping view. Using the vertical format for portraits means that you can follow the naturally upright human shape and – if you want to – focus on the subject matter since there is little peripheral space.

▶ In a classic portrait, the eyes are automatically sited quite high in the painting, and the upright format naturally leads your eyes up to meet the eyes of the sitter – conveying an instant feeling of intimacy.

"PROFESSOR FRANCIS CRICK OM, FRS, BSc" BY TOM COATES, WATERCOLOR, 16 X 12IN

◀ The upright format of this picture focuses attention on the dramatic figure of the Arab and helps to enhance the close relationship between the man and the fine horse he is leading.

"ARAB AND RIDER, PUSHKAR FAIR, RAJASTHAN" BY CAROLYN PIETS, WATERCOLOR, 12 X 17IN

▶ The horizontal format can convey a great feeling of space and calm in a painting of a landscape.

"EVENING" BY JOSEPH FARQUHARSON (1846-1945), OIL ON CANVAS, 18 X 30IN

portrait (vertical) format

◀ A quick way of seeing which format is best is to make a frame with your hands and then squint through it at your subject. The advantage of this is that you see your subject matter in isolation without the confusion of things around it. Here's the upright format shape for the Arab and horse painting above. Try it the other way as well...

Using format for effect

Format is important because certain shapes convey messages to the eye that the artist can exploit. For example, a tall, thin, upright rectangle tends to lead the eye up toward the top, which is where the main point of interest – the face – is. And a long, thin, horizontal format often gives a feeling of peace and quietness. The flowing horizontal lines across the picture are soothing and relaxing, and the wide horizons convey a sense of space and calm.

You can also use these shapes to create different effects. Some artists choose to paint a portrait on a "landscape" support, while others prefer a "portrait" format for landscapes. It depends on your subject, and how you wish to present it. For example, a running figure fits well in a landscape format, which allows the subject space to run into and gives a strong sense of movement to the picture. And a landscape in which the

sky is to be the dominant factor may look best in the upright portrait format.

If these shapes are used in the wrong way they can give false messages to the eye – that is, they can lead the eye away from the focus. It's not a good idea to use a portrait format that leads the eye to the top of the paper if the action is at the bottom. The whole picture will fail to capture the mood you are trying to convey. With a little common sense, and a basic understanding of format, avoiding this kind of pitfall is easy.

When you have chosen a format, ask yourself why you have picked that one, and how you're going to make use of it. Think about the empty space in your picture. Is there too much or too little, or just the right amount for the mood you want to create? Follow your instincts, and try looking at your subject in different ways. The aim is to create a picture that is satisfying to look at and conveys a sense of excitement and pleasure.

▶ …and you should get an instant feeling of what looks right. In the painting above, the landscape format helps to evoke an atmosphere of serenity and peace.

Quickly sketch your subject using several formats if you are still not sure what works best.

landscape (horizontal) format

◀ There's no cast-iron rule that you must use a horizontal format for a landscape. If the subject dictates an upright shape, then make the most of it — as in this painting where the focus is fixed firmly on the meandering stream.

"WATER MEADOWS" BY GRAHAM PAINTER, WATERCOLOR, 31 X 21IN

▼ There are also very good reasons for painting a portrait of someone in a horizontal format. A reclining figure fits naturally into this shape, and makes a graceful, relaxed image.

DETAIL OF "MRS WINSTON CHURCHILL WITH HER DAUGHTER, SARAH" BY SIR JOHN LAVERY, OIL ON CANVAS

PLACING YOUR MAIN FOCAL POINT

Follow a few useful guidelines and you'll soon develop an eye for where to position your main focal point. But before you start, consider all the options open to you.

Every picture needs at least one focal point – a point that draws the eye – otherwise the eye wanders from one spot to the next without knowing where to linger. So before you compose your picture it's always a good idea to ask yourself why you're doing it.

What has made you respond to the topic? Do you have a clear subject in mind? And what exactly is it you want to capture on paper or canvas?

When you know the answers you can start thinking about composition – and about what happens if you start manipulating focal points, placing them first in the center and then trying them off-center.

Going for the center

Generally, most people put the main focal point in the middle of the canvas most of the time. It's where the eye naturally looks first and therefore is the obvious spot for the important elements of a picture. It also creates a restful, well balanced image.

Because of this, a central focal point is particularly effective for something symmetrical – such as a classical building. Traditionally artists have still often slightly offset a central focal point to avoid an uncomfortable "cleavage" of the support that would otherwise occur.

However, you may find that composing too many pictures with centrally placed focal points could start to look static and dull. Many paintings and drawings look stronger with the main interest to one side. This also ensures that you avoid repetition in your pictures.

▲ Placing the main focal point in the center is a perfectly valid option, particularly where you want to stress symmetry. All the same, slightly offsetting it avoids an uncomfortable "cleavage" of the picture.

"MADRID, SPAIN" BY TOM MCNEELY, 1989, WATERCOLOR ON PAPER, 22 X 30IN

Why is composition so important?

Composition is often overlooked by people but the importance of good composition can't be emphasized enough. By arranging the elements of a picture carefully you manipulate the viewers, enticing their eyes to travel around the painting's surface while also providing them with places to rest. The viewers look first at one part of the picture, then at another, roaming around or lingering as you intend. With a well composed image you can create a sense of excitement or produce a feeling of calm.

In this chapter on composing pictures, we look at the subject of where to position the main focal point and how to lead the eye.

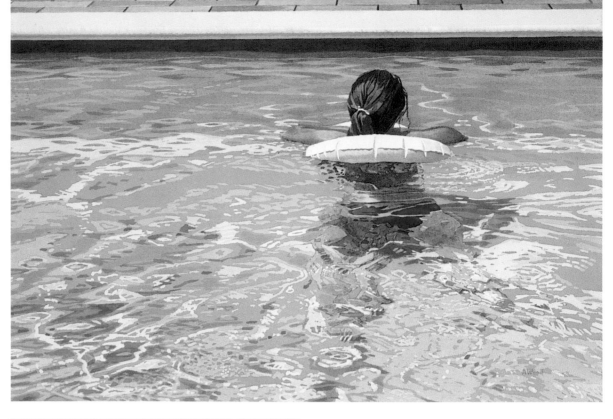

▶ With the main focal point on a vertical third your eye is guided around the picture – to the figure and across the swimming pool and then back to the figure again – rather than resting in the center.

"VILLA POOL" BY ANDY WOOD, 1983, WATERCOLOR ON PAPER, 10 X 14IN

▶ Whichever format – vertical or horizontal – you choose, putting the rule of thirds into practice creates a stimulating picture that's pleasing to the eye. Interestingly, here – as in the picture above – the head is still the focal point of the picture even though it's shown from behind.

"THE BACK OF CHARLIE" BY HENRY SCOTT TUKE, PRIVATE COLLECTION

The rule of thirds

The classic way to create a satisfying composition is to divide an image into vertical thirds in your mind, and then position the main focal point roughly on one of the dividing lines.

This works whether you use a horizontal or a vertical format. The focal point doesn't need to be precisely on one of the lines. But by placing it off-center like this you often create a more dynamic image than one with central emphasis. It's dynamic because it makes your eye move around the picture when you look at it.

Using the rule of thirds also lets you show a subject in context. A central subject usually needs to fill the picture to have any impact, while an off-center one reveals the setting. Even when the subject is quite large its surroundings show.

Horizontal thirds

But it's not just vertical thirds that make a good composition – you can also divide the picture into horizontal thirds. In a landscape, for instance, it can be distracting to have the horizon chopping the picture in equal halves (although it is possible to make this division work). By placing the horizon one third of the way from the top of a picture – or one third of the way from the bottom – you have an easy formula for a satisfying arrangement.

◀ Although your inclination might be to paint the horizon right across the center of a picture, you can see how dramatic the effect is when it's placed on a horizontal third, especially at the bottom. Here the large sky creates a feeling of airiness.

"WILD POPPIES" BY ROSALIE BULLOCK, WATERCOLOR, 12 X 17IN

▼ Sometimes what looks like a random design by the artist is actually a careful organization of picture elements. The large amount of foreground in this picture puts the reclining woman on a horizontal third at the top, creating a feeling of remoteness from the viewer. Notice also that she is on a vertical third too, as is the lowest point of the sofa.

"MADAME HESSEL AND HER DOG" BY EDOUARD VUILLARD, 1910, OIL, 29 X 34IN

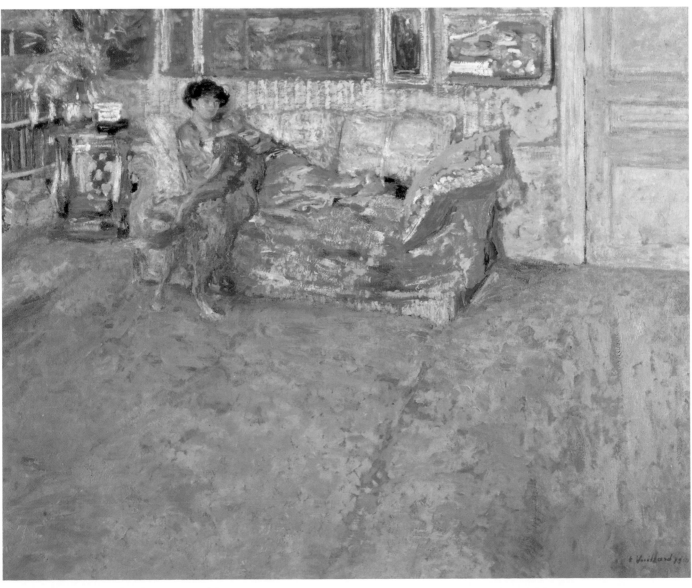

Moving subjects

Another reason for placing the main focal point off-center is that when it's a moving subject it seldom looks right placed in the middle of the frame. It's not only a question of balance, but also that a moving subject needs space to move into – this could be space within the painting or, as shown below, it could be space beyond the frame.

As well as involving the viewer, a subject with space in front of it suggests activity and direction. This is why pictures of moving figures or objects often have the main focal point off-center, with space on the side of the frame or just beyond it for the object to move into.

► A centrally placed moving subject tends to feel static. To imply movement it should be placed to one side.

Here the artist has created a sense of movement by placing the boat far to the right so that it is cropped by the edge of the picture. In this way she suggests the space beyond the picture into which the vessel is moving.

"SCARBOROUGH SPA" BY BRENDA BRIN BOOKER BY COURTESY OF FIVE WOMEN ARTISTS, PLUS, 1993, ACRYLIC ON BOARD, 15 X 17½ IN

LEADING THE EYE

Guiding the viewer's eye to the focal point of your picture is easy – when you know how. Here are some of the most useful and common devices for achieving it.

One of the most important influences you, as the artist, have on viewers is to lead their eyes to the focal point of your picture. Most of the time you can pull this off with deceptive ease.

With a path

Make the most of a path, road, river or railway line to lead the eye to an important point. It's best if you "break" the picture frame with it, meaning that the path should point out at the viewer and disappear into the depths of the painting, *beyond* the picture plane and to your focal point.

The eye has no trouble being guided in this way because paths are associated with travel – the eye naturally follows a path to see what and where it is leading to. The painting below illustrates this.

Fences, walls, hedges and even buildings all have strong, straight lines or serpentine shapes that you can take advantage of. What's more, you probably won't have to "create" one of these to do the job for you. It's more a question of seeing the possibilities and making adjustments so the composition works.

If you are painting or drawing directly from the landscape, for example, you can shift your position until you can see a wall or stream in a useful way. Perhaps by moving a bit to the right or left, or crouching down to change your viewpoint, you can make the wall appear to lead to a building on which you want to focus.

▼Nothing in this painting is coincidental. The path leads the eye from the space this side of the picture plane into the picture space beyond. From there a serpentine path takes you right up to the horizon, where you see the focal point, the horse of the title.

"VALE OF THE WHITE HORSE" BY RONALD MADDOX, WATERCOLOR, 15⅓ X 21⅓IN

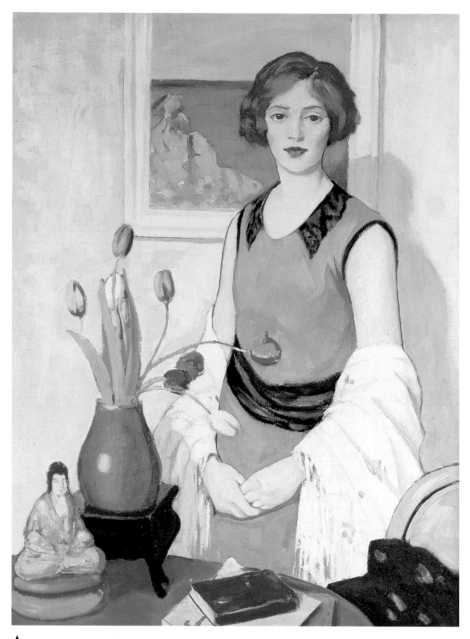

Experiment with various compositions by making rapid thumbnail sketches. You may find you need to remove a tree or shift it slightly sideways so that the connection between the wall and building becomes clearer.

Another naturally occurring feature with a strong line is the horizon. This may be a straight horizontal – as in a seascape – but it could just as easily be undulating curves in a hilly area or steeply pitched angular shapes in a mountainous region.

In all these cases, you can use the outline to draw the eye from the edge of the picture to a focal point.

Framing the focal point

One way to draw attention to a special area of a picture is to frame it in some way. In a landscape you could use a pair of trees, a single tree with overhanging branches or an avenue of trees forming a tunnel. A bridge is yet another possibility – make use of its span or spans as individual frames.

Interiors, too, offer a host of framing opportunities. Doorways and windows in particular create a picture within a picture. But there are also more classical architectural devices such as porticos, arches and niches.

Color and tone

You can use a carefully placed area of color very effectively. Try setting off a bright color with muted tones, for example, or use a "hot" color in an otherwise cool picture and vice versa. Even the smallest dash of color can have a dramatic impact much greater than its size.

▲ Your attention is drawn to the woman's head by the framed picture behind it. In effect she's framed twice – once by the frame of this painting and again by the landscape on the wall.

"PORTRAIT WITH STILL LIFE" BY GEORGE TELFER BEAR, OIL ON BOARD, 40 X 30IN

► A dot of hot red stands out in a field of predominantly muted color – an example of a little doing a lot.

"VENETIAN LAGOON" BY HERCULES BRABAZON BRABAZON, WATERCOLOR AND BODY COLOR ON PAPER

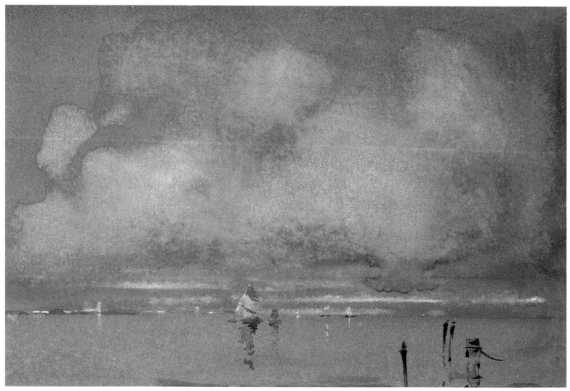

SPACE IN PAINTINGS

The world exists in three dimensions. But how do you convey this sense of space on a flat support such as paper, canvas or board?

Over time many conventions have evolved for describing space and for indicating the relative location of objects in that space. This visual language varies from culture to culture.

The art of ancient Egypt, for instance, sought to provide the maximum amount of information. To that end, faces were portrayed in profile, with eyes seen frontally. The torso was also painted frontally, but the legs, feet and arms were shown in profile.

The visual language we use today derives from the Italian Renaissance, which started in the 14th century. It depends on representing the appearance of things as seen from a single, fixed

POSITION IN THE PICTURE

The farther away an object is, the higher in the picture you place it. This was one of the first devices used by artists to convey an impression of distance. You'll see it a lot in medieval paintings.

viewpoint in space. It's a system that's called single-point perspective. In recent years many artists and artistic movements have deliberately broken away from the Renaissance commitment to this single-point perspective. Cézanne, for instance, separated space into basic planes and shapes without maintaining a fixed viewpoint. The Cubists went even further and showed several views of an object at the same time.

Here, though, we look at some of the devices you can use to indicate space, and location in space, in your pictures. Which one you choose depends on the subject and your intentions. You might, for instance, be delighted by the shapes and colors within a still life group. You could draw attention to these shapes and colors by simplifying the tonal arrangements and flattening the forms. This would emphasize the abstract qualities of the arrangement and do much to play down spatial arrangements.

RELATIVE SIZE

Things look smaller when they are far away and larger as you get closer to them. So when you draw three trees that are the same size in real life but are disappearing into the distance, you render them in different sizes. The viewer automatically judges the smallest one to be farther away than the largest one.

▶ In this delightful painting the spatial descriptions are secondary to the abstract and decorative elements. But there are clues. The white horse cut into the chalk hillside is larger than the real horse in the field, but we understand that it is farther away simply because it is higher up in the picture area and nearer the horizon.

"WHITE HORSE WITH WHITE HORSE" BY RUTH STAGE, OIL ON GESSO BOARD, 20 X 25IN

COMPARISON WITH THE PICTURE FRAME

The relationship between an object and the picture frame can also give you information about spatial arrangements.

If you crop an image – especially if the subject now "breaks" the frame – the viewer sees the subject as close to the picture surface. (Think of a tree very close to a window.)

On the other hand, if you place the subject in the middle of the picture area, the viewer assumes that it is farther away from the picture surface. The small size of the tree in this situation also helps to reinforce the feeling of distance.

tree close up

tree farther away

► By cropping the sunflower heads in this picture the artist leaves the viewer in no doubt that they are close to the picture surface. The apparent difference in size between the foreground flowers and those in the background creates a dramatic sense of recession.

"SUNFLOWERS" BY GODFREY TONKS, CHARCOAL, COLORED INKS AND PASTEL, 22 X 30IN

DID YOU KNOW?

Your point of view
Most children instinctively draw objects from the viewpoint that gives the most information. They draw a house from the front, but a truck from the side – because it's from there that you can see the cab, trailer and wheels.

OVERLAPPING OR INTERPOSITION

When objects are almost behind one another, you overlap them. The picture at near right is generally seen – according to convention in Western art – as three complete trees, one behind the other. But you could also interpret it as three adjacent shapes: one complete tree, and behind it two others with bites taken out. It's a measure of how completely – and unconsciously – we accept the convention that most of us simply don't see these three adjacent shapes.

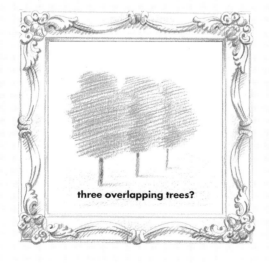

three overlapping trees?

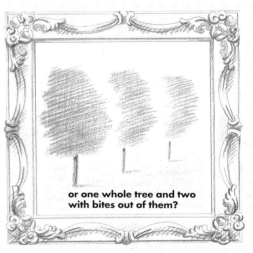

or one whole tree and two with bites out of them?

TEXTURE GRADIENT

The closer you are to a textured surface the coarser – more detailed – it seems. When you're painting a tree in the foreground you show as many of the individual leaves as you can. When you're painting a tree in the distance, you make a greenish, untextured blur instead. You can use this device together with atmospheric perspective (see below) to create a convincing sense of space in landscapes.

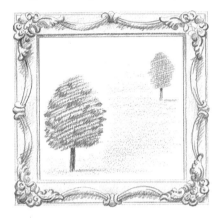

◀ The dabs of bright color in the foreground of this picture are larger and more defined and have more texture than those in the background. Texture becomes a useful device for emphasizing the foreground rather than the background, and suggests recession in an immediate, clear way.

"UNTITLED NO. 124" BY TREVOR NEAL, OIL ON CANVAS, 22 X 18IN

ATMOSPHERIC PERSPECTIVE

Objects in the distance not only appear smaller, they also seem less bright and less clear. When you're painting trees in the foreground they're vivid green. Those in the distance, however, have a bluish quality.

▲ Atmospheric perspective helps create a sense of recession in landscape paintings in which there are no obvious linear elements to give you clues. By making the hills on the horizon paler and bluer than those in the middle distance, the artist has created the illusion that they are farther away. The more detailed texture of the trees in the foreground brings that area forward.

"LAKE GARDA" BY GRETA FENTON, WATERCOLOR ON PAPER, 22 X 12IN

◀ Many pictures by the surrealist artist Magritte are disquieting because they challenge our assumptions about the way we see and understand the visual world. Here two subjects are shown realistically – a room and an apple. But by putting the two together, Magritte creates an ambiguity – are we seeing a tiny room with a normal-size apple in it, or is it a normal-size room with a huge apple?

"THE LISTENING ROOM" BY RENÉ MAGRITTE, 1958, © ADAGP, PARIS AND DACS, LONDON 1994, OIL ON CANVAS, 15 X 18IN

TONE

Light reveals form, so the way you disperse light and dark tones around an object gives clues to its shape and solidity. In fact, you can create images that appear to have volume and take up space by using tone only – as the second of the two trees shown at right demonstrates.

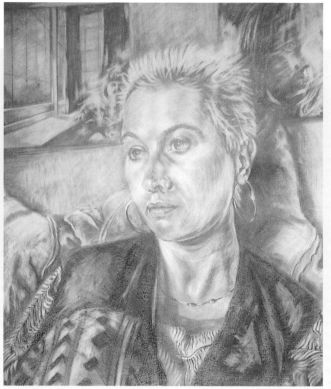

► In this sensitive head and shoulders study in graphite, the play of light and dark across the forms is rendered mainly in tone – with little help from line. Careful modeling with many subtle light and dark tones has enabled the artist to create the illusion of a convincingly solid, three-dimensional image.

"SALLY" BY JACQUELINE HINES, GRAPHITE ON PAPER, 28½ X 23¾IN

LINEAR PERSPECTIVE

This is one of the best-known clues to depth. Put simply, it means that parallel lines appear to converge as the lines recede horizontally away from you. It calls for the distortion of objects. For example, the laws of single-point perspective turn the sides of a cube into trapezoids. And a circle (eg. a plate) becomes an ellipse. Usually we see this distortion of objects as perfectly "realistic."

cube – horizontally receding sides appear trapezoidal

circular plate – appears elliptical when viewed from an oblique angle

◄ This well known painting is famous for its inspired use of single-point perspective. It's not just that the trees nearest the horizon appear smaller than those nearest the viewer. You'll find that lines drawn through the tree tops on either side of the road appear to descend toward a point on the horizon, while lines through the tree bases appear to ascend to the same point.

"THE AVENUE AT MIDDELHARNIS" BY MEINDART HOBBEMA (REPRODUCED BY COURTESY OF THE TRUSTEES OF THE NATIONAL GALLERY, LONDON), OIL ON CANVAS, 40¾ X 55½IN

PERSPECTIVE MADE EASY

Far from being as daunting as most people think it is, linear perspective is really very simple. What's more, you'll find you probably have a fairly good grasp of it already.

The basic principles of linear perspective are mechanical and very straightforward. Once you've mastered them, you can put them to use freely and creatively

You may argue that your perspective drawing is already excellent, working as you do from pure observation. But a thorough knowledge of linear perspective still comes in handy because it helps you understand what you see. What's more it's an invaluable aid for troubleshooting and for correcting mistakes. Let's look at what linear perspective is all about.

Linear perspective is simply a system for creating the illusion of three-dimensional space on the flat surface of a support. When done successfully, the relative position and size of objects is the same in the picture as in real life.

One of the most striking examples of linear perspective is the way parallel lines – such as the top and bottom of the side of the building in the picture below – seem to join together at a point on the horizon.

Before we can look deeper into perspective we need to define a few terms (see overleaf).

▼ The workings of basic linear perspective are easy to grasp. Imagine you're looking out a window at a building, and drawing on the glass. The building is parallel to the window, with its sides at right angles. Notice the way the top of the side slopes *down*, while the bottom of the side slopes *up*.

eye level (same as horizon line)

ground plane

Ground plane, horizon line and eye level

The flat extension of the ground you're positioned on is the **ground plane**.

The height of your eyes from the ground is your **eye level** – it always coincides with the **horizon line**. When you're sitting down you can see less of the ground plane, and the horizon line seems nearer than …

… when you're standing up. Standing up, you can see more of the ground plane and the horizon line seems farther away.

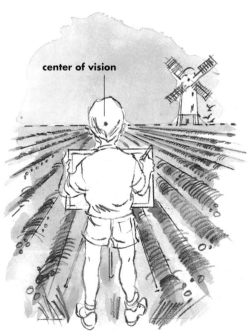

center of vision

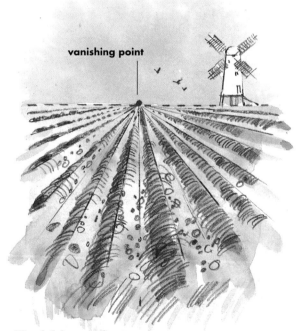

vanishing point

Center of vision

A child sees less of the ground plane than a standing adult, but about the same as a seated adult.

The point on the horizon line that is directly in front of the viewer's eye is called the **center of vision**.

Vanishing point

The point on the horizon line at which parallel lines – like those of the furrows – seem to converge is the **vanishing point**. The vanishing point for all lines that recede at right angles from the picture plane coincides with the center of vision.

ONE-POINT PERSPECTIVE

Looking again at the picture on the opening page of this chapter, you can see that the converging lines of one side of the building meet at the vanishing point. This point is the same as the artist's center of vision and it's also at his eye level and on the horizon line.

This sort of perspective is known as one-point perspective because the converging lines of one side of the building can be extended to meet at one point (the lines of the front of the building always remain parallel, however, because of your viewpoint).

One-point perspective is sometimes called central, or parallel, perspective and it's the simplest form of linear perspective. Later in this chapter we'll look at two more complex forms of linear perspective.

► This witty picture plays games with the illusions used in conventional painting, especially with the idea of the picture plane.

"THE DOMAIN OF ARNHEIM" BY RENE MAGRITTE, 1949, OIL ON CANVAS, 39¾ X 32½IN

Defining a few terms

The picture plane is an imaginary vertical plane that coincides with the surface plane of your picture. Another way to visualize it is as a sheet of glass between you and the subject. On the next page you can read more about the picture plane.

The ground plane is the horizontal plane that you, the viewer, are positioned on (or imagine you're positioned on).

The eye level is the height of your eyes from the ground as you view the scene. A tall person's eye level is obviously higher than a short person's, and an adult's is higher than a child's.

Eye level defines how far you can see – if you are taller or higher up you can see farther than if you are shorter, sitting down or crouching.

The eye level assumes you are looking straight ahead. It does not change when you tip your head back or look down. It simply tells the viewer how high up you were when you did the drawing.

The horizon line is the line at which the sky meets – or appears to meet – the ground. It coincides with your eye level, so if your eye level changes it affects the horizon line. If you are tall or high up, for instance, you can see farther so the horizon appears to be farther away. If you are short or crouching, you can't see quite so far so the horizon appears to be nearer.

The vanishing point is the point on the horizon line at which parallel lines seem to converge.

The center of vision is a point on the horizon that is directly in front of the viewer's eye.

▼One-point perspective performs two functions in this painting – it creates a sense of space and acts as a compositional device. The building is the focal point of the picture and it's placed in the upper third of the painting, leaving the lower two-thirds relatively empty. The pollarded tree at the front connects foreground to background, while the converging rows of vines ensure that the eye is led to the building.

SEE FOR YOURSELF – THE WINDOW PICTURE PLANE

Demonstrate for yourself the principles of linear perspective by looking through a window and tracing what you see. You need a sheet of transparent material such as glass, Lucite or – as we used here – acetate (it's available from art stores). It doesn't matter which; this is just an exercise. You also need something to draw with – a chinagraph pencil, a permanent marker or some acrylic paint and a brush.

Fix the transparent material to the window with tape – this is now your picture plane. Close one eye and start to trace what you see. You'll have to stand very still or you'll find the drawing begins to wander. It's a good idea to select a particular line as your base point – the corner of a building, say. Establish this base point and keep checking that the drawn line is over the actual line.

Continue with the tracing. When you have finished you will find that parallel lines do converge, and that your drawing obeys the rules of perspective and is a convincing depiction of the scene.

More one-point perspective

When it comes to drawing and painting, you're as likely to be working indoors as outdoors. So the question of getting the perspective right in your work is just as important.

One-point is the simplest kind of perspective, and you can put this into action indoors by standing in a square or rectangular room.

Position yourself with your back exactly at the center of one wall. Now look at the far end. Notice how the side walls appear closer together the farther away they are from you. If the far end

wasn't there at all and the side walls went on and on, they'd appear to meet. The place they'd seem to meet at – the *one point* of *one-point* perspective – is known as the vanishing point (see **step 1** in the illustrations below).

Now, still with your back to the wall, move toward one side of the room. You're still seeing one-point perspective (because the far wall is parallel to the picture plane), but your view is rather different. That's because your center of vision has moved with you (see **step 2**).

◀ **1** With your back at the middle of one wall, look at the far wall parallel to it. Notice how the side walls appear to converge, and how the lines below your eye level slope up, while those above it slope down. If these lines were to continue beyond the far wall, they'd appear to meet, and that point is called the vanishing point. Notice how the vanishing point is at your eye level and also at your center of vision, which is the point directly opposite where you're standing.

[Diagram: ceiling, eye level, center of vision, vanishing point, left wall, right wall, far wall, ground plane, you are here]

▼ **2** With your back still against the wall, move to one side. Your whole view has now changed. As you moved, your center of vision moved with you. The vanishing point has moved as well. It's still at eye level, but the lines of the side walls now converge at different angles – more steeply on one side than on the other.

[Diagram: ceiling, eye level, center of vision, vanishing point, left wall, right wall, far wall, ground plane, you are here]

▲ With a window in the far wall, you can see that the vanishing point of the converging side walls is on the horizon line – proof, if proof were needed, that the horizon line always coincides with your eye level.

[Labels on illustration: eye level, vanishing point, horizon line]

Now over to you – draw a room in one-point perspective

Here's the right wall of a room in one-point perspective. To complete it, you need to extend the converging lines of the wall and find the vanishing point (it's the same as your center of vision). Then draw in:

☐ the left wall
☐ the far wall
☐ a window in the far wall
☐ the horizon line, or your eye level

If all goes well, draw a door in the left wall, a window in the right wall, and the floorboards of the ground plane. And if that presents no problem, draw another sketch where your center of vision is to one side of the room, as it is in step 2 on the previous page. See how simple one-point perspective really is!

One-point perspective plus

Useful as one-point perspective is, it doesn't cover all situations. That's because the far wall of your room isn't always parallel to the picture plane. But before we go into that, let's look at the table with the box on it in the foreground of the room below.

If you were drawing the table, the rules of one-point perspective would apply because its front edge is parallel to the picture plane. When it comes to the box, though, it's an entirely different story.

Looking at the box, you can see two sides at the same time, and neither of them is parallel to the picture plane. The box is in fact drawn in *two*-point perspective, and you can read more about that on the next page.

▶ With its converging sides, and front edge parallel to the picture plane, the table is clearly in one-point perspective. But what about the box on top of it? It has *two* sides with converging lines and therefore two vanishing points. We call this *two*-point perspective. See the next page for more about it.

Two-point perspective

In the sketch below, you can see two sides of the same building. You could of course see two sides of the building in the one-point perspective sketch (see pages 89–92), but the difference here is that *both* sides have converging lines because neither is parallel to the picture plane. And with two sets of two converging lines there have to be two vanishing points – one on either side of the building.

Notice that both vanishing points are on the same horizon line, which means they're also at the viewer's eye level. (Notice, too, that all vertical lines stay parallel.) This time, though, neither vanishing point coincides with the viewer's center of vision.

You may ask how our room looks in two-point perspective. Well, to get two vanishing points you have to imagine moving into one corner of the square or rectangular room and looking from there directly into the opposite corner. The converging lines of the right wall would meet at some point far to your left, while those of the left wall would join at some point on your right. Both these points would be at your eye level and on the horizon line. And neither of them would be at your center of vision.

▼ When you're depicting a building that isn't parallel to the picture plane, you have two-point perspective. That's because the visible sides both have converging lines – these meet at *two* separate vanishing points. Both vanishing points are on the horizon line and at your eye level. Neither coincides with your center of vision.

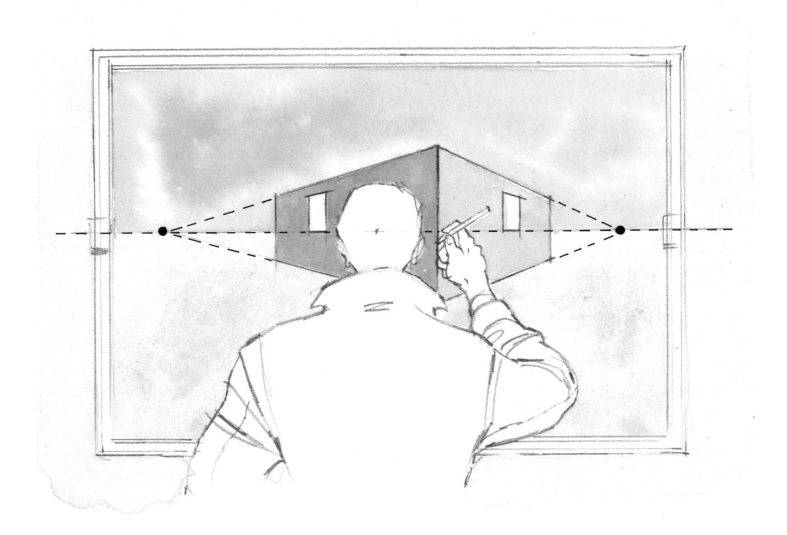

▲ In this gouache painting of a view of farm buildings in northwestern England there are two vanishing points – both outside the picture area.

Very important are the precise angles at which the lines of the roof and those of the walls ascend or descend to the vanishing points. These can be measured with a pair of angle-measuring scissors, which you can read about on pages 97–100.

Three-point perspective

If you stand at the bottom of a tall building such as a skyscraper or church tower and look up, you'll find that the vertical lines are converging. In addition to the two vanishing points of two-point perspective, then, there's a third vanishing point – making this three-point perspective.

You also see things in three-point perspective when you have a bird's eye view, looking down on a tall building from an even taller one.

Three-point perspective isn't something you come across all that often – but you might, especially if you were producing a technical perspective drawing of a building.

There are occasions when you might choose to ignore three-point perspective, such as when you're drawing a row of tall houses from a viewpoint across the street. This is acceptable.

► Imagine looking at a tall building in two-point perspective and then glancing up. In addition to the vanishing point to your right and the one to your left, you now have a third one, way up in the sky where the converging verticals of the building meet. This is three-point perspective. As you might guess, its applications are fairly limited.

Getting the angle right

Getting perspective right is often just a matter of observing and drawing angles correctly. In the case of a building viewed from the front, this is straightforward because most of the angles are right angles (90°). But when you're looking at the same building in two-point perspective, life becomes more complicated – because all the angles are now greater or lesser than 90°. This is where a pair of angle-measuring scissors comes in handy. Fortunately they're very simple to make, and even easier to use.

Tip

Check your perspective

You may have seen artists holding up a pencil to the scene they're drawing. This has as much to do with

getting angles right as it does with measuring, which you can read about in **Making Measured Drawings** on pages 23–26. (See also the Nine Checks on pages 40–42.)

2in (5cm)

10in (25cm)

◀ **1** To make a handy pair of angle-measuring scissors, all you need is a piece of stiff cardboard and a paper fastener. Cut the cardboard into two strips about 2in (5cm) wide and 10in (25cm) long. Attach the two strips tightly with the paper fastener. You're now ready for action.

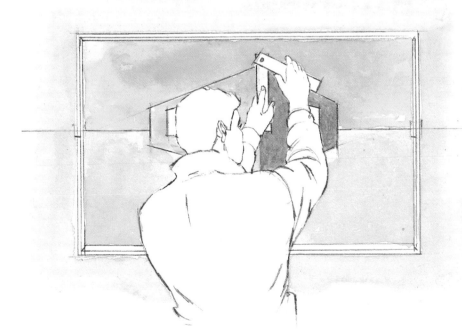

◀ **2** To use your pair of angle-measuring scissors, start by imagining there's a sheet of glass vertically in front of you. This is like the window picture plane you read about in Composition 8.

Now hold out the scissors at arm's length. Most important, make sure they're flat against the imaginary sheet of glass.

Use your other hand to move the two arms of the scissors until they match the angle you're interested in – here it's the line of the roof compared with a vertical line. Remember, the scissors should be flat against the imaginary glass.

▶ **3** Holding the scissors tightly so you don't lose the angle you've just measured, transfer them to the right spot on your canvas. Align the vertical scissor-arm with the edge of the canvas, then draw in the angle. You now have the correct angle for the rooftop!

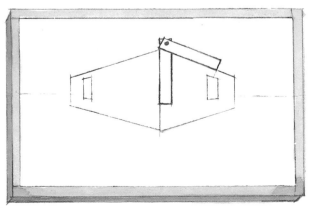

Aerial perspective

A simple, effective way of creating the illusion of space in your landscape painting is to mimic aerial perspective.

Aerial perspective – sometimes called atmospheric perspective – describes the way the atmosphere affects light traveling through it. Far from being a vacuum enveloping the world, the atmosphere is actually made up of gases, moisture and tiny particles, and these have an impact on light.

There are several effects of aerial perspective, all of which vary with location, time of day and time of year.

● Among the most notable of these effects is the

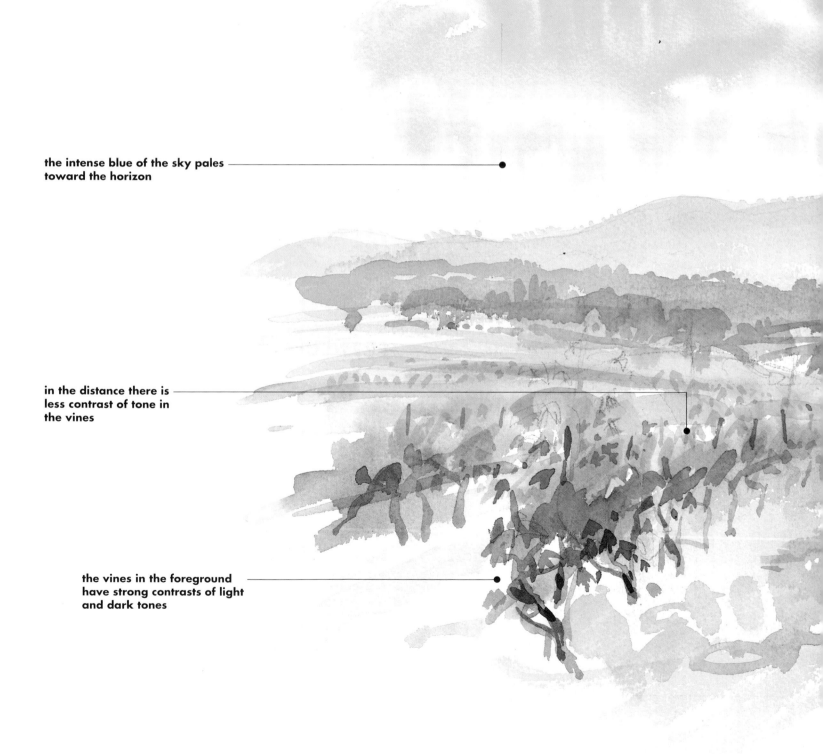

the intense blue of the sky pales toward the horizon

in the distance there is less contrast of tone in the vines

the vines in the foreground have strong contrasts of light and dark tones

way colors appear cooler and bluer with increasing distance – check for yourself.

● They also seem less bright, so a red fire engine appears browner and less red as you move away from it.

● What's more, there's less contrast between the lightest and darkest areas of an object.

● And its outlines and details appear increasingly blurred and ill defined.

Below is a landscape painted in watercolor by our artist. In it he makes good use of the effects of aerial perspective to create a convincing sense of space. We have annotated the painting to show you exactly how he did it.

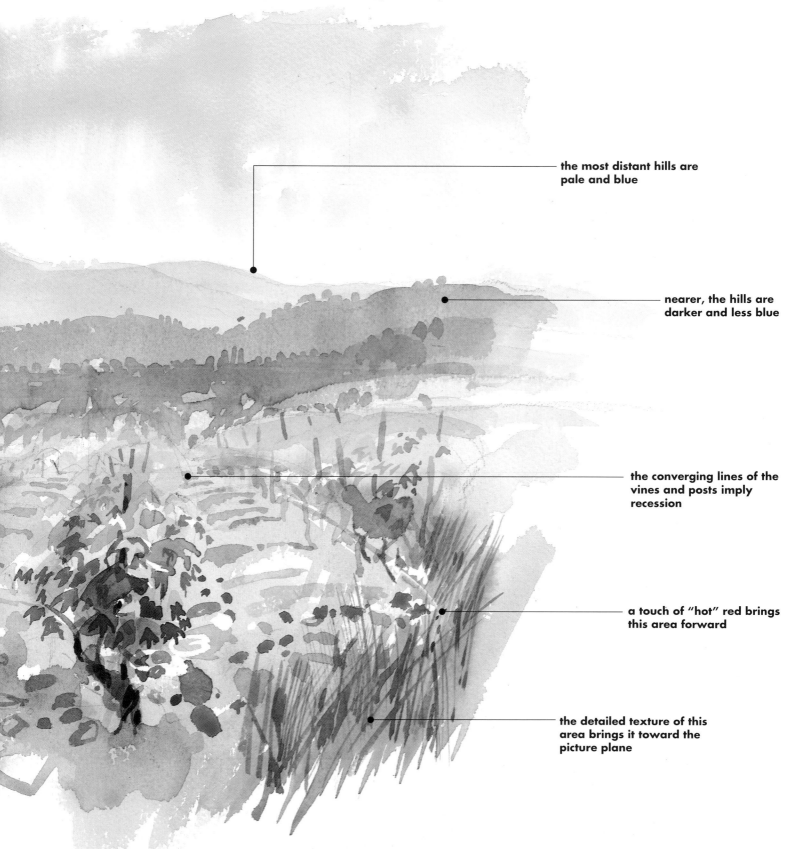

the most distant hills are pale and blue

nearer, the hills are darker and less blue

the converging lines of the vines and posts imply recession

a touch of "hot" red brings this area forward

the detailed texture of this area brings it toward the picture plane

Turner and aerial perspective

Aerial perspective gives you the opportunity to introduce light and space into landscape paintings that might otherwise offer few clues to spatial arrangements. It's a device much exploited by Turner, one of England's greatest and most influential painters.

Joseph Mallord William Turner (1775-1851) was a genius with light. His later landscape paintings in particular have a fleeting, insubstantial quality in which forms are dissolved by light so there are few solid objects, and details are hard to make out. Sunlight is dispersed through a misty, hazy atmosphere and the subject is enveloped in – and devoured by – dazzling light.

It was Turner's treatment of light that attracted the interest of the Impressionists and Post-Impressionists. Both Monet and Pissarro visited London in 1870-71 and Turner's influence can be seen in their work. Like him, they were concerned with the scrupulously exact observation of nature, and the most fleeting phenomena of light.

The French artist Henri Matisse (1869-1954) said of Turner: he "lived in a cellar. Once a week he threw open the shutters, and then, what incandescences! what dazzle! what jewelry!"

▼ This painting is full of ambiguities – just as you begin to find the forms of the sailing ships, they appear to dissolve on the shimmering surface. There is, however, a definite sense of space and recession, with your eye traveling over the water and away to the pale horizon.

"PEACE: BURIAL AT SEA" BY JMW TURNER, 1842, OIL ON CANVAS, 34⅘ X 34⅖IN, TATE GALLERY LONDON

CREATIVE CROPPING

Usually all the compositional decisions are made at the beginning of the picture-making process, but sometimes it's not until later that you realize how things could be improved.

However carefully you plan a composition, there can be times when you want to make changes at a later stage. Your picture might look too symmetrical, perhaps with a horizon line passing through the exact center; or it might be unbalanced, with too much empty space on one side. Both problems may be too fundamental to change with paint or pencil, but both can be solved with judicious cropping – literally chopping off part of the picture to improve it.

Successful cropping may involve nothing more than trimming a narrow band off one edge of a picture. Or it can be more radical – you may decide to remove a substantial area from two or more sides. (On a more creative note, it's not unknown for artists to cut a picture in two, getting two pictures from one. You might even decide to cut up a large picture and make it into several smaller pictures.)

Cropping can be creative and fun – a positive part of picture making – and it's also useful as a damage-control exercise. Some artists crop their pictures quite frequently, finding it gives the images new energy and vitality. However, cropping should never become a habit or a substitute for planning a composition properly in

the first place. After all, you won't always be able to rectify a bad composition by cropping it.

When you crop a painting or drawing you are effectively creating a new composition – the principles are exactly the same as those for good composition. You can crop at any stage in a painting or drawing, but it's important to think carefully about what you want to do, and why.

Once you've decided to crop, stand back from the work and take some time to plan the new

▼Although this portrait works well as it is, the artist thought that he might crop the picture just below the girl's elbows or even crop near her head and shoulders (below left) to create a more eye-catching and focused image.

"LYDIA" BY DENNIS GILBERT, OIL ON CANVAS, 30 X 25IN

composition. If the work is small enough, use L-shaped brackets, moving them about until you frame the composition you want. On a larger work, it's easier to use strips of cardboard or paper to mask out the unwanted edges.

Don't make your crops too drastic at first. If in doubt, cut off too little rather than too much. You can always trim off a bit more, but you can't put back what you've already taken away.

Watercolors don't allow you to make major changes because you can't paint over or remove color. When things go drastically wrong with a watercolor, cropping is the only available means of making significant changes. Fortunately, works on paper and thin cardboard are easy to crop.

Once you have decided where you want to cut, use a T-square to get a perfect right angle with the edge of the paper. Draw the desired cutting line

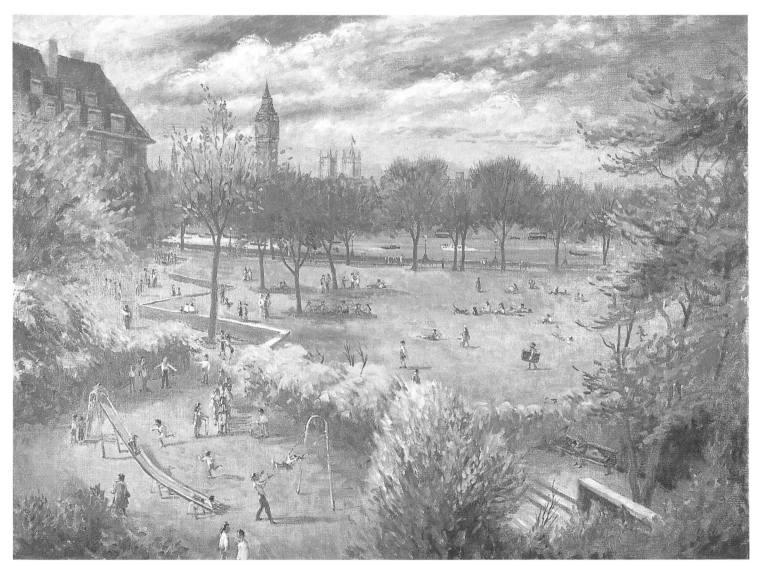

▲ This painting of the Festival Gardens on the South Bank of the Thames is packed with many cropping possibilities. If required, it could be made into many successful but smaller paintings instead of one large one.

"BIG BEN" BY DENNIS GILBERT, OIL ON CANVAS, 40 X 30IN

▶ Don't fall into the trap of thinking only in terms of standard portrait or landscape rectangles. Long and thin or short and wide formats can be really eye-catching. This view of the river seen through trees, for example, makes a delightful cameo.

◄ This crop concentrates on the most recognizable landmark in the painting – the Houses of Parliament on the other side of the river. Notice that the river cuts the picture horizontally along one of the thirds, and the clock tower is also placed off-center, creating a pleasingly natural balance.

▼ This area plays just a small part in the painting, so it's probably not the first thing that would come to mind as a composition in its own right. However, by moving the L-shaped brackets around, the artist discovered its potential. Notice how our attention is drawn by the children in the front and how we are led by the zigzagging wall through the trees to the river.

▼ The slide was the focal point for this attractive scene in the playground area of the gardens. If the artist wanted to, he could isolate this portion and make two or three other pictures out of the rest of the painting. In fact he could get all four of the compositions on this page out of the one painting.

▼ A secluded spot in the garden provides privacy for this pair of lovers. The picture captures a fleeting moment in the couple's lives, and reminds us that the larger painting comprises a series of incidents in the lives of the characters shown. Each incident could make a painting in its own right.

lightly with pencil, then take a second look to make sure you're cropping in the right places. Cut paper and thin card with a scalpel or craft knife held against a metal ruler. Avoid scissors – they don't produce a really straight line.

Acrylics and oils With opaque media, such as oil and acrylic, compositional changes are usually made with the paint itself by rubbing back or overpainting. However, there may be occasions when you want to change the size or proportions of the support, or to chop off part of the composition without altering the work you've already done.

Paintings on plywood or hardboard can be cropped, but the paint must be completely dry. You will need a fine saw – an electric jig saw on a "0" setting is ideal, or a tenon saw if you are doing it by hand. The sawn edge will be slightly jagged, especially on the underside, so make sure your painting faces upwards as you saw. Smooth the sawn edge with fine sandpaper – framing the picture will hide the sawn edge.

► Like the painting on the previous pages, this picture of Piccadilly Arcade in London includes many people involved in their daily routine, some of whom could be the focus of a painting. The different architectural areas of the picture could also be separated. For example, the top of the painting, from the arcade sign upward, would make an interesting picture.

"PICCADILLY ARCADE" BY DENNIS GILBERT, OIL ON CANVAS, 40 X 30IN

▼ This crop focuses on the lower right corner of the painting, including two police officers, one of whom is pointing to a mysterious gentleman in a fur hat. His portfolio gives him away – he is the artist who painted the picture. If you study the painting on the previous pages, you'll see that he appears in that scene too!

◄ This is an obvious part of the painting to isolate. There's plenty going on in the foreground, with the woman collecting for charity and the man with the bouquet of flowers who is clearly waiting for someone. The diagonal of the arcade is also a good compositional device to lead the viewer farther into the scene.

WORKING FROM COLLECTED MATERIALS

AIDS TO COMPOSITION

A good composition will help you hold the attention of the viewer. Here we look at some simple devices to help you select, edit and decide what to emphasize.

Many artists' tools are expensive, so it's nice to find ones that are useful yet cheap. Two such tools are a viewfinder, which can be made from cardboard, and a pair of L-shaped brackets, also made from cardboard.

A viewfinder is basically a piece of cardboard with a rectangular hole in the middle – like a picture mat – that helps you frame and isolate your subject. A landscape subject, for example, is daunting because you are presented with so many possibilities – you can select from a 360° panorama and any point from the ground at your feet to the sky above. A viewfinder makes the process much easier. By scanning the vista through this cardboard frame, you can isolate small sections and consider their picture-making potential.

A viewfinder is useful for considering almost any subject – an interior, a landscape or even a figure study. In fact, once you've used a viewfinder, you'll feel lost without one.

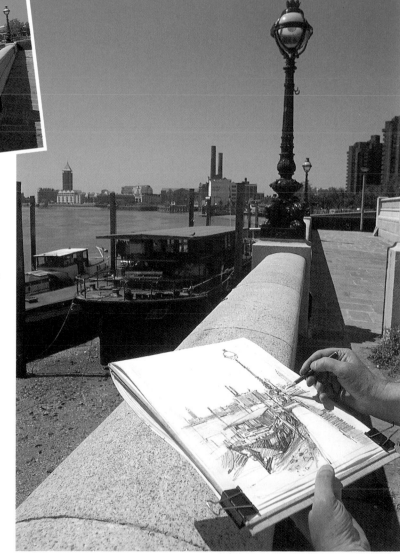

▲ A viewfinder is a useful tool that enables the artist to assess his options quickly. Yet it's inexpensive and easy to make for yourself from cardboard.

Our artist's version measures 8 x 6⅘in with a central opening of 4⅘ x 3⅜in (the frame was 1½in wide all around). He divided his viewfinder into a grid with rubber bands that makes it easier to assess positions. The rubber bands are a third of the way in along each edge of the aperture, and are held in place by grooves cut in the cardboard.

▶ Our artist made three quick thumbnail sketches before deciding that this was the composition he wanted for his painting. A large sketch, with a few color scribbles, backed up with a photograph, is all he needs as reference for a painting.

A viewfinder enables the artist to consider the way the image will fit within the rectangle of the support. Should the subject occupy the center of the support or fall on the third? Should it break the paper at the top or bottom or is it more effective if it is contained within the picture area? By bringing the viewfinder toward you, you'll be able to see more of the vista – and less as you hold it farther away from you. A few thumbnail sketches will record what you see so that you can compare the options or even revisit them at a later date.

You can also use your viewfinder to experiment with different formats – will the composition be most effective as a portrait or landscape, or even as a square?

L-shaped brackets are simply L-shaped pieces of cardboard that you can form into an adjustable rectangle or square, using binder clips or your fingers to hold them together (see below). The great advantage of this sort of viewfinder is that you can manipulate the Ls to create larger or smaller windows, or to change the format from a long rectangle to a square. The Ls can also be dropped over compositional sketches in the field to check the composition. Or you can use them to isolate a section of a drawing to see how it will work as a painting.

Your hands provide the easiest "viewfinder" and will cost you nothing at all. You can frame an image between your thumbs and forefingers (below left) but this method is not as easy or as effective as using brackets or a viewfinder.

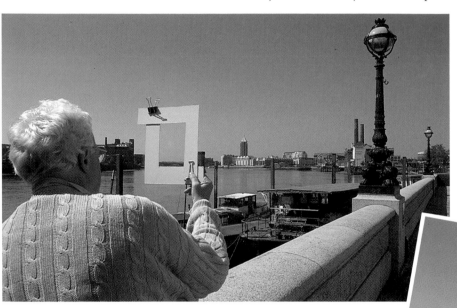

▲► Our artist assessed the scene through his L-shaped brackets, which he formed into a viewfinder. He held them together with the binder clips he uses to hold down the pages of his sketchbook on windy days. His Ls were 2⅖in wide, with legs 8in long.

▲► Your fingers and thumbs make a makeshift viewfinder (above) which you can use if you haven't got a viewfinder or pair of Ls handy.

A viewfinder is easy to use and if you divide the aperture with rubber bands or threads it will help you position the important features of your sketch (right). Our artist put rubber bands a third of the way in from each edge. This is also helpful if you wish to position your subject in accordance with the rule of thirds.

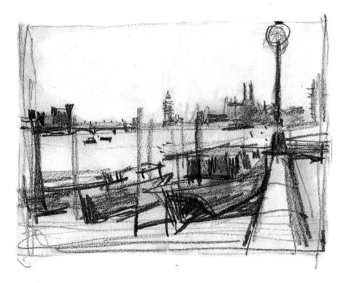

◄ A quick thumbnail sketch showed our artist where the basic elements of the view would fall in a landscape format.

► Here our artist tried a portrait format. He decided that he liked the strong vertical element of the river wall and lamp from his first thumbnail sketch, so he kept this in, but he didn't add any more to the height of the composition – he merely cropped into the landscape version.

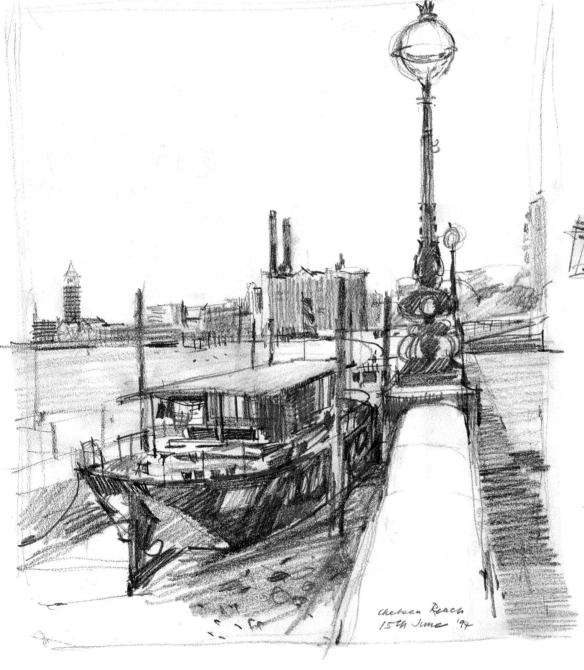

▲ For his third thumbnail sketch, our artist decided to show more of the area to the right of the lamp, bringing the lamp farther into the picture.

◄ Our artist liked his last thumbnail sketch best so he prepared a larger, more detailed version, adding a little color for reference. He believes it is very important to name and date his sketches for future reference.

Chelsea Reach
15th June '94

Thumbnail sketches

Even when you're fairly happy with the view through your viewfinder, it's worth doing a few thumbnail sketches of alternatives so you can consider different options. Work quickly, looking for basic geometric shapes, repeated shapes and angles, and the way areas of light and dark are distributed across the picture.

Light is an important element in any painting or drawing, so use your thumbnails to consider the direction of light. Squint your eyes and look for the areas of light and dark. Scribble these in broadly so they read as abstract patterns. If the light is behind you, the color will be heightened but the modeling of forms will be minimized. Side lighting, on the other hand, highlights the three-dimensional quality of the subject.

► A camera is a very useful tool, which you shouldn't overlook even when you are sketching in situ. Although it's always better to paint from life, your photographs will provide excellent additional information about details and colors.

Our artist had an old Polaroid camera, which meant that he could check his photos immediately and compare them with the scene.

▲ Our artist was attracted by the strong lines and wonderful color of London's Albert Bridge, a little way up the Thames River from where he made his previous sketches. He used his Ls to assess the format.

▲ This suspension bridge is much more difficult to draw than it looks because of the complicated arrangement of cables and the angles of the towers, bridge and steps. Our artist used the elastic bands on his viewfinder to help him.

► Then he tried a landscape format. This gives the bridge more context than the tight square format he tried first (above).

WORKING FROM PHOTOGRAPHS

If the scene you want to paint is constantly changing or highly complex, if the weather is inclement or if you have simply run out of time, then a photograph is definitely in order.

There's nothing new about using a photograph as a reference. More than a century and a half ago, Turner (1775-1851) saw some of the very earliest photographs. He was so captivated by a print of Niagara Falls, which showed the effect of refracted light on frothy water, that he was inspired to try the same effect with paint. The resulting studies of light and color are generally considered to be the direct forerunners of Impressionism and one of the major influences on painting today.

Since then photography has had a direct influence on many other artists, including the French painters Corot (1796-1875) and Courbet (1819-1877). Both worked from photographs – Corot learned from photographs how to create the impression of light using tiny flecks of white paint; Courbet preferred a photograph to real life because he felt it provided him with a more objective image.

Today artists have all the benefits of advanced photography – color film, fast film, zoom and wide angle lenses, and so on. The drawback is that the photos can take over, and the artist can rely too heavily on them. They should never become a substitute for looking at the subject itself.

▼ Courbet is known to have used several photographs as references for this complicated painting. They helped him achieve the realism that he is famous for.

"THE PAINTER'S STUDIO", 1854-5, BY GUSTAVE COURBET, OIL; ON CANVAS, 143⅓ X 239½IN

▶ If you take a series of connecting pictures, like these, you can connect them to form a wonderful panorama with plenty of detail. You can even continue to take shots until you have a full 360° view. These composite photographs make excellent reference material.

Making the most of photographs

The rectangular format of a photograph is not necessarily the best shape for your composition. So to give yourself more scope for manoeuver, don't cramp your subject; allow yourself more background area than you think you'll need, so that you can play around with the composition later by cropping into it.

The other thing you might try is to compile a series of pictures, giving you good details of a large area. To do this, just stand in one spot and take several pictures, moving your camera round so that each picture just overlaps the one before – you can get a full 360° view this way. You can also move the camera up and down to take in more sky and land. When the prints are assembled you will have a panoramic jigsaw, which you can paint as a single large picture or pick and choose from, exactly as if you were working from life.

If you have a projector at home, you may like to consider using slides instead of prints. Slide colors are usually more natural because the transparent image retains the qualities of light and shade. The flattening effects found in printed photographs are thus minimized.

◀ For this photomontage, all the photographs were taken from one spot – except the picture of Canterbury Cathedral. Nevertheless it fits in convincingly, and the resulting picture by John Harvey (below) captures the changing scene that you would see as you approach the cathedral.

Canterbury. Kent — John Harvey

Why work from a photograph?

There are many occasions when working from a photograph is simply easier than working from the actual subject. For example, light and weather are very changeable, and you might start a landscape painting in brilliant sunlight only to find that the light has changed dramatically and you are painting in the pouring rain. Not only are you getting very wet, but suddenly the scene in front of you is completely different from the one you started painting. And even if you are working indoors, the light can shift, your model may change position or your flowers may wilt.

A photograph taken before you start work gives you a permanent record of the subject and enables you to complete the work in your own time. You might even consider investing in a Polaroid camera so you can see your pictures right away. Then, if you are painting outdoors, you can take a picture of the sky, say, and use the photograph as a

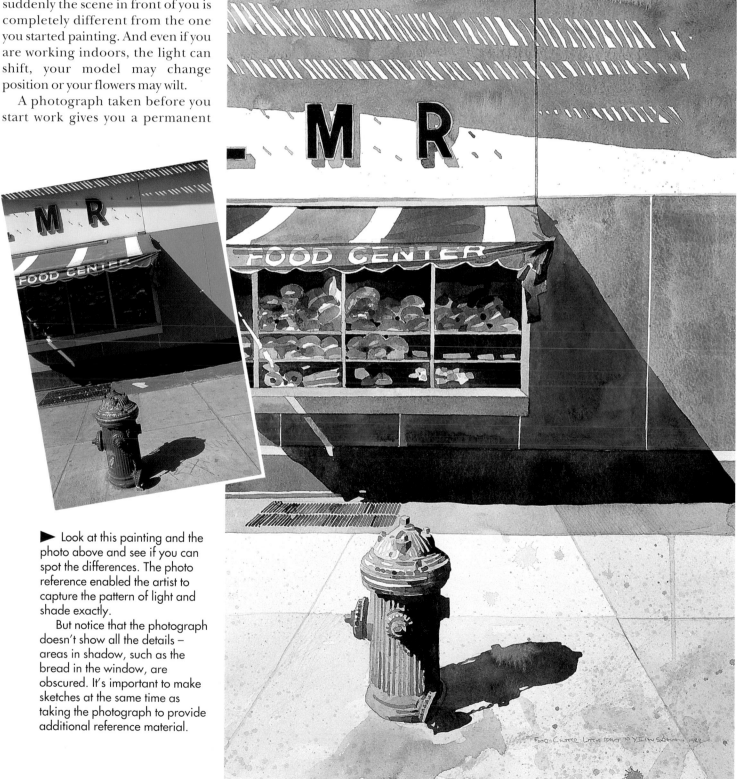

▶ Look at this painting and the photo above and see if you can spot the differences. The photo reference enabled the artist to capture the pattern of light and shade exactly.

But notice that the photograph doesn't show all the details — areas in shadow, such as the bread in the window, are obscured. It's important to make sketches at the same time as taking the photograph to provide additional reference material.

reference to paint the sky exactly as you first saw it, even if the clouds have completely blown away by the time you get to putting in the details.

Perhaps a camera is most useful when there is a lot of movement in a scene. Think of a busy market scene, with people rushing around, of ships swaying to and fro at sea or cars zooming around a race track. If you want to capture any of these subjects, you'll find it much easier to freeze them in a photo. And even for something like a portrait, you can use a camera to freeze that elusive smile on a young woman or the sleepy expression of a child.

You may also want to use photographic references if your subject is very difficult. Have you ever looked at a painting of waves or a babbling stream, or marveled at the rippling surface of a David Hockney swimming pool? And did you wonder how the artist managed to recreate the effect of moving water so convincingly? You will find these effects much easier to paint if you have a photograph showing clearly the patterns of light, shade and color on the surface of the water. The moment is fixed in time, enabling you to

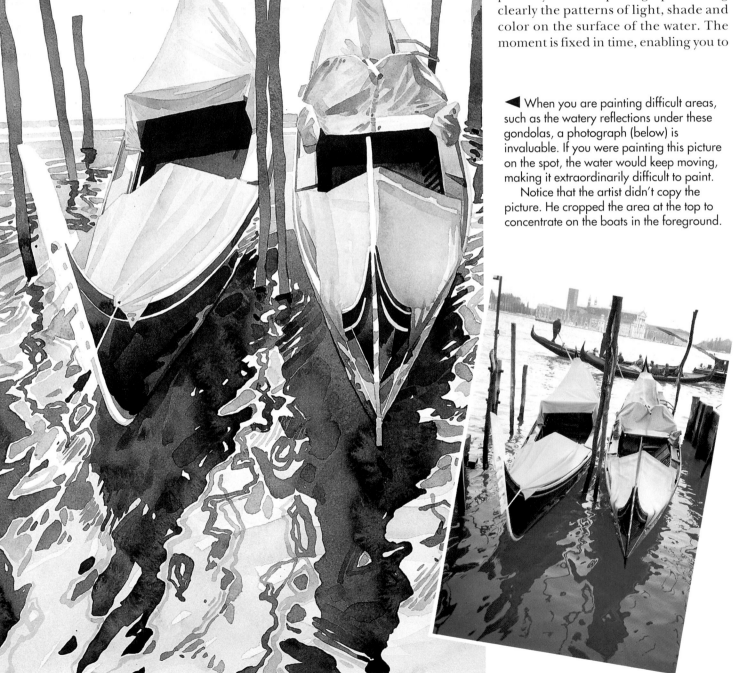

◀ When you are painting difficult areas, such as the watery reflections under these gondolas, a photograph (below) is invaluable. If you were painting this picture on the spot, the water would keep moving, making it extraordinarily difficult to paint.

Notice that the artist didn't copy the picture. He cropped the area at the top to concentrate on the boats in the foreground.

study the subject at leisure and make thoughtful decisions about the best way to capture the effect of movement in your painting or drawing.

On vacation your camera can again prove invaluable. Not enough time to finish a painting or even to start one? A quick sketch backed up by a few photographs should give you enough information to make a painting at home.

It's a good idea to carry your camera with you whenever possible to back up your sketches. Use it to photograph any incidents or scenes that interest you and to record details of everyday subjects – anything you feel might be included in a future painting. This way you will build up a personal collection – a source of subject matter to draw on at a later date.

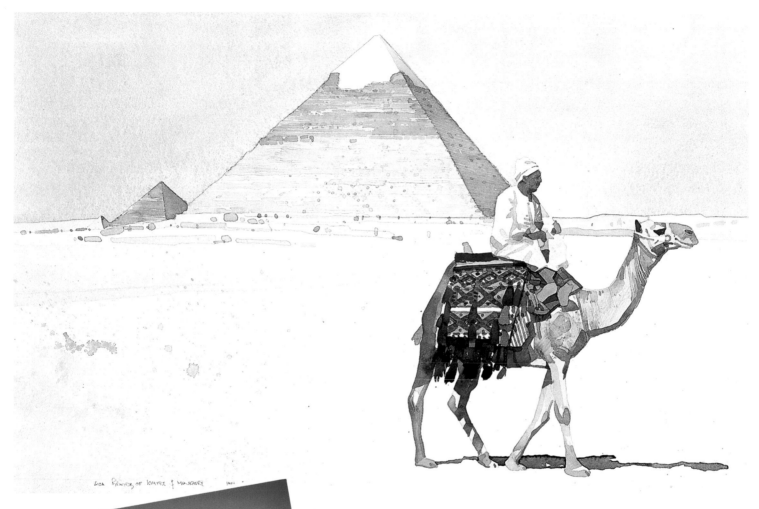

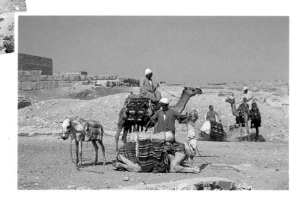

▲ You can use your photographs to have some fun with your paintings. Here the artist took two photos, one of a pyramid (left) and the other of a man on his camel (below). Then he combined these elements from each picture to make a much more exciting painting.

THE PHOTOGRAPHS AND PAINTINGS ON PAGES 113–115 ARE BY IAN SIDAWAY

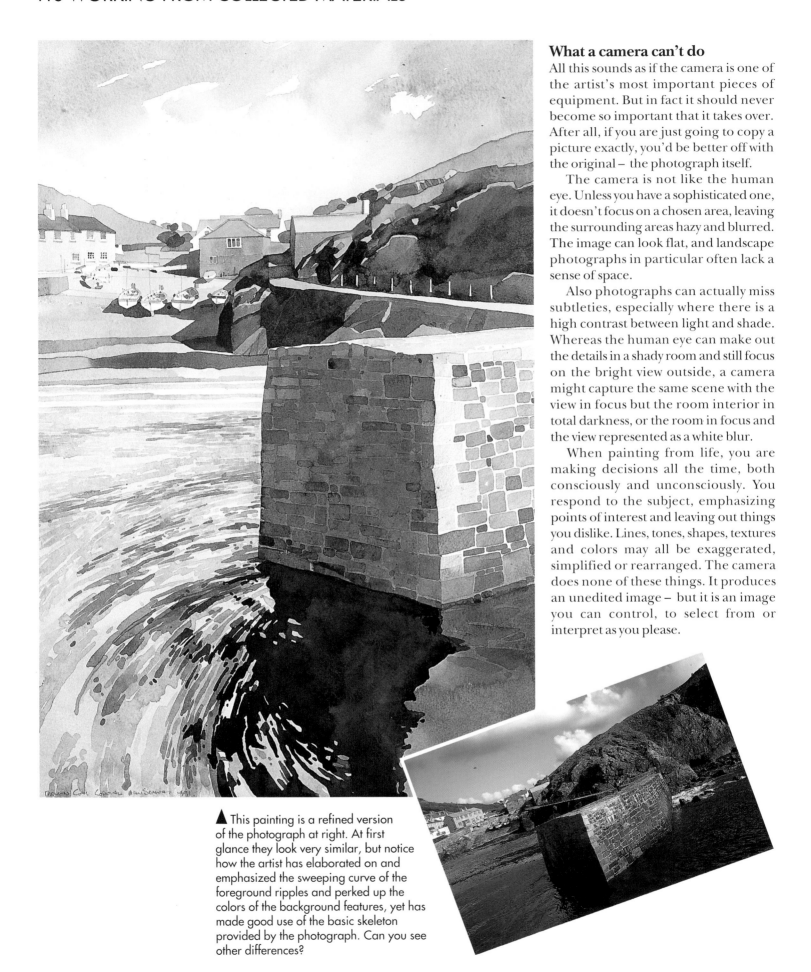

What a camera can't do

All this sounds as if the camera is one of the artist's most important pieces of equipment. But in fact it should never become so important that it takes over. After all, if you are just going to copy a picture exactly, you'd be better off with the original – the photograph itself.

The camera is not like the human eye. Unless you have a sophisticated one, it doesn't focus on a chosen area, leaving the surrounding areas hazy and blurred. The image can look flat, and landscape photographs in particular often lack a sense of space.

Also photographs can actually miss subtleties, especially where there is a high contrast between light and shade. Whereas the human eye can make out the details in a shady room and still focus on the bright view outside, a camera might capture the same scene with the view in focus but the room interior in total darkness, or the room in focus and the view represented as a white blur.

When painting from life, you are making decisions all the time, both consciously and unconsciously. You respond to the subject, emphasizing points of interest and leaving out things you dislike. Lines, tones, shapes, textures and colors may all be exaggerated, simplified or rearranged. The camera does none of these things. It produces an unedited image – but it is an image you can control, to select from or interpret as you please.

▲ This painting is a refined version of the photograph at right. At first glance they look very similar, but notice how the artist has elaborated on and emphasized the sweeping curve of the foreground ripples and perked up the colors of the background features, yet has made good use of the basic skeleton provided by the photograph. Can you see other differences?

A DAY AT THE ZOO

Join Stan Smith at Regent's Park Zoo in London for a fruitful, educational and enjoyable day's drawing.

The beauty of a zoo is that you have a rich, varied and virtually inexhaustible source to draw from. There are over 500 species of animal here and some – such as the Sumatran tiger – have become so scarce that the only place you are ever likely to meet them is in a zoo.

Armed with sketchpads, pencils, kneaded eraser, Conté pencil and a few tubes of paint, we're going to wander around, sketching whatever takes our fancy. The idea is to make quick sketches rather than detailed drawings, aiming to capture the spirit and character of the type of animal in question. (Later, if you want to make pictures, you'll find sketches like these indispensable.) Now subjects that pace or swing, bound, swim, slither, waddle or pounce – in short, moving subjects – present a special challenge, but with a little forethought you can imbue your drawings with movement and life.

Often, a line of just the right rhythm and stress laid along the animal's underbelly or

◀▼ With no bars, a low wall on which to rest my pad and an obliging juvenile jackass penguin, this enclosure made a convenient first port of call (left). I drew a preening pair (below) but didn't see any swimming birds.

▼ A fluid line down the belly, a more considered silhouette over the head and beak and an abrupt line down the back of the stubby, flipper-like wing give the dynamics of this fellow (below left). Scribbled tone adds bulk and form.

▲ These two sketches took about a minute each (above) and they're just the kind of scant but lively images that would add spirit to a more carefully composed picture.

back is worth a hundred tentative marks, and with practice you can often sum up the whole gait with one line. This makes the job of fleshing out the animal in tone and adding a few lines to describe movements of legs and tail, say, much easier. I'll show you quick ways of recording colors too.

Animals often repeat patterns of behavior – some frequently. So if you are drawing the haunches of a big cat, for example, you probably won't have to wait long before you see them adopt a similar position. Finally, remember that the animal has survived because it has evolved and however peculiar it looks, its characteristics serve a need – allowing it to feed, evade predators and breed. So if you are drawing a bird of prey, say, make the hooked beak look as though it is capable of tearing flesh, and if you are drawing a jackass penguin, make it look like a strong-swimming fish eater rather than the head waiter at your local restaurant!

> *" Remember the animal has survived because it has evolved. "*

Head and shoulders above the rest

◀ **Snapshot** This pair of giraffes were galumphing around their enclosure when I arrived but soon settled down together under their acacia tree. As such they make a rather attractive couple.

Before you start, sit and watch your beast for a minute or two to gain an insight into its mood and behavior. If it is preening or feeding (like one giraffe here), its movements will be confined.

▶ **1** Draw the giraffe on the left pretty much as you would take it in if you looked at it for the first time (see snapshot). Try it – follow the line from the head down the back of the neck to the rump and then down the back leg. Then look to the front leg and back up to the head. (Notice that the head doesn't hold your attention until you've taken in the rest of the animal – probably because it's so small). By scribbling on some rich, brownish red pencil you can quickly add bulk and hint at the overall color.

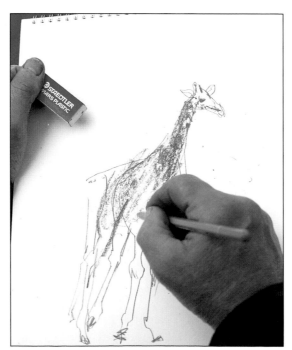

◀ **2** A giraffe's markings camouflage it from predators such as lions, and each animal has a unique pattern. You can't hope to describe it fully, so just draw a few of the patches as I'm doing here. Work briskly rather than frantically – just quicken your pace.

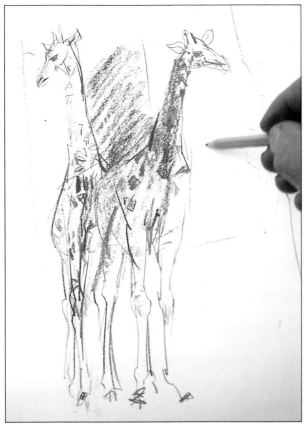

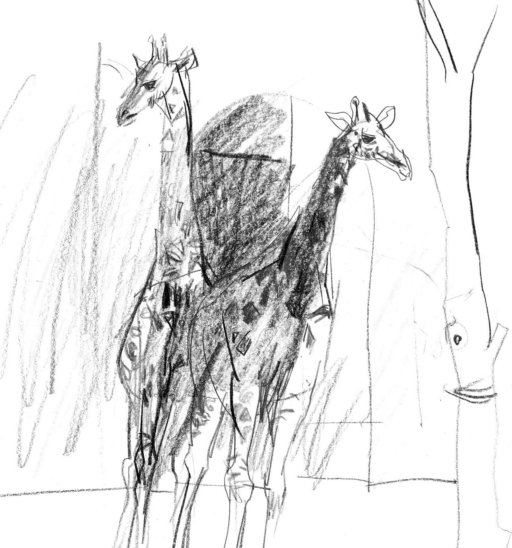

◀ **3** If the animals move (as mine did), don't worry. You aren't aiming to freeze a moment in time, and there's no fixed set-up to work from. In any case, false starts on the same page can help to capture the rhythm of a movement or facets of an animal's character.

Bear in mind what I said about the function of an animal's parts. A giraffe's legs might be long but they aren't spindly. (Look at the joints of the front legs in the snapshot.) Likewise, the neck is extremely flexible and powerful – capable of wielding the head to deliver a club-like blow, in fact!

REMEMBER THE COLOR

One way to record the color of these fish is to scribble with colored pencils. Another way is to write notes. Try inventing your own descriptions for colors. You might base them on food – pickled cabbage red, toffee brown, butter yellow or sherbet lemon, for example.

◀ **4** If you have time, try to get in a little of the animal's surroundings. In this case the tree and arched doorway give a sense of scale (more so if I had included the edge of the slates on the roof – see the snapshot). Scale is important with small animals such as birds and insects too, not simply with sixteen-footers like these.

Used intelligently, vegetation can be particularly useful. For example, if you are drawing an orangutan standing on a branch, not only is it logical to draw the support but you can use the branch to show off the highly dextrous grip of the ape's foot.

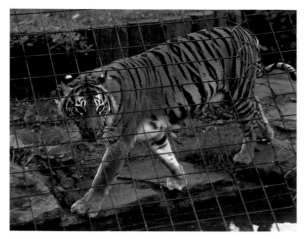

Tyger tyger...

◀ **Snapshot** The tiger must be one of the most beautiful animals on earth. Sadly, in many areas it has been hunted virtually to the point of extinction. (Cures for acne, laziness, impotence and fevers caused by ghosts are among some of the uses to which various parts of these animals have been put.) The closeness of this female and the regularity of her movements made her a perfect subject.

▶ **1** I've used a clean cotton rag dipped in turpentine and some "burning bright" cadmium orange oil paint to wipe in the rough shape of the head, shoulders, legs, rump and tail. Now I'm working back into it with black Conté pencil. The rag and paint method is great for moving subjects because you can capture the movement so quickly – poking your fingers into the rag and using it like a finger puppet to control the paint, or scrunching it up to apply it more haphazardly.

Don't smother the animal in paint – try to hint at the form by grading the tones. Use Conté or charcoal for adding detail and tightening your drawing (inset).

▼ The rag and paint technique is quick and fun. Give it a try but if you are working with oil paint, use good-quality, heavy cartridge paper. (You could try acrylic paint if you prefer but remember that it dries quickly – which means you can't move it around as easily as oil paint.)

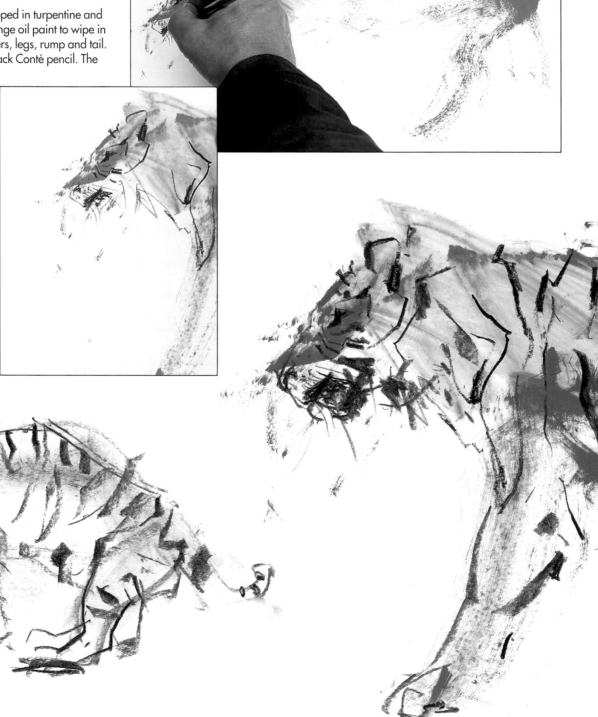

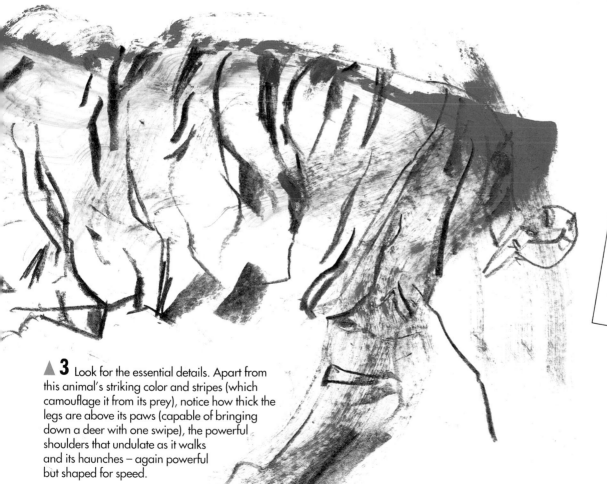

▲**2** By leaving the lower half of the flank white and using the stripes as contours, I'm able to give a sense of the animal's form as it tucks under the belly and, luckily, I can even hint at the color of its belly. The tiger continued to pace as I worked but often returned to the same spot, allowing me to gather more and more information each time.

▲**3** Look for the essential details. Apart from this animal's striking color and stripes (which camouflage it from its prey), notice how thick the legs are above its paws (capable of bringing down a deer with one swipe), the powerful shoulders that undulate as it walks and its haunches – again powerful but shaped for speed.

You may find a large sketchpad cumbersome. A pocket-sized sketchbook works very well and has the advantage of not attracting unwanted attention. You can use it instead of, or in addition to, a camera.

Beauty in the beast

It isn't always the highest profile performers – the apes, big cats and elephants, say – that make the best subjects. Birds, reptiles, fish and even insects can be equally fascinating to draw – and sometimes easier. Snakes and lizards tend to keep very still and because they are housed in small spaces and behind glass rather than bars, you can scrutinize them in minute detail. Fish, too, will often provide the most beautifully shaped and colored subjects.

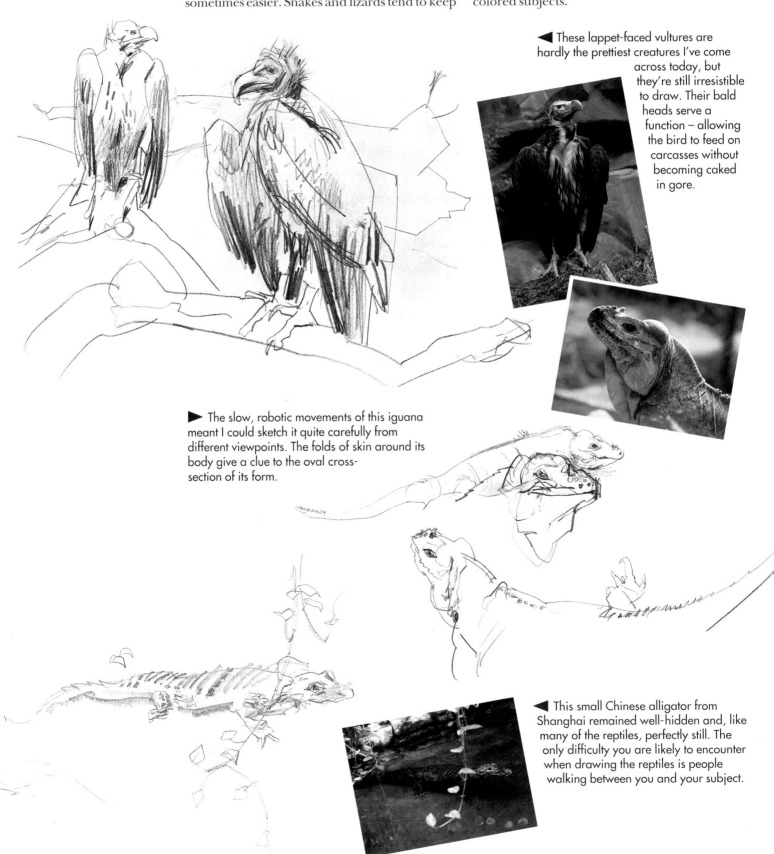

◀ These lappet-faced vultures are hardly the prettiest creatures I've come across today, but they're still irresistible to draw. Their bald heads serve a function – allowing the bird to feed on carcasses without becoming caked in gore.

▶ The slow, robotic movements of this iguana meant I could sketch it quite carefully from different viewpoints. The folds of skin around its body give a clue to the oval cross-section of its form.

◀ This small Chinese alligator from Shanghai remained well-hidden and, like many of the reptiles, perfectly still. The only difficulty you are likely to encounter when drawing the reptiles is people walking between you and your subject.

FROM START... TO FINISH

The inspiration to paint a picture can come at any moment, so make the most of the time you have to gather material that will help you produce a finished work.

An inspirational scene – perhaps a beautiful summer landscape or a busy street market – may make your fingers itch to get started on a painting or drawing. But, as any artist can tell you, a good rendition of a setting needs some solid reference material to work from.

For artists the material gathered in their sketchbooks is an invaluable source of inspiration and information. This raw material can be used as the basis for a painting, or as a reference for details within a painting. It may be worked up immediately or at a later date – maybe even several years later. And in most cases the final image will be developed from several sources, the artist making adjustments, editing and adding in order to create a successful composition.

▼ Sketch No. 1 This is our artist's "jumping off point": a first, quick, unedited sketch of the street scene as he saw it, with buildings, people and trees in place.

Note that he has included details of shadows and tones. Studies like these are a great help when it comes to making the tones in the final picture look convincing.

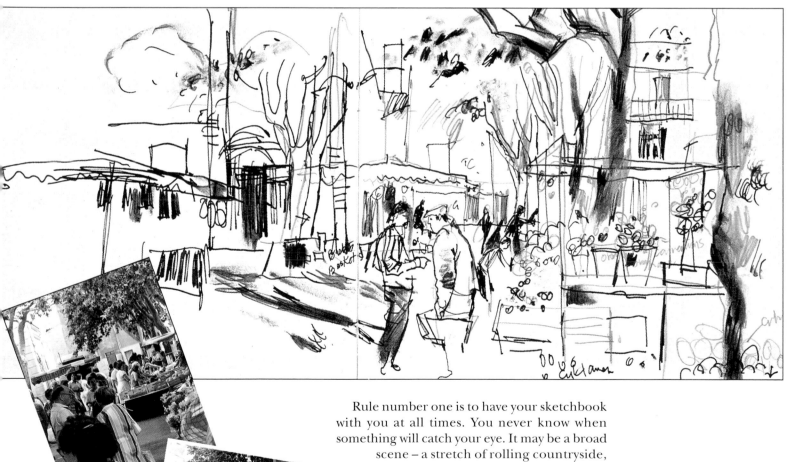

► Snapshots not only record what's going on in the scene, they also make excellent color references.

Rule number one is to have your sketchbook with you at all times. You never know when something will catch your eye. It may be a broad scene – a stretch of rolling countryside, say, or a railway station where you are waiting for a train. Or it could be a detail, a single figure sitting on a park bench, or a dog asleep in a doorway, caught in a shaft of sunlight. Whatever it is – jot it down. Don't worry if you are

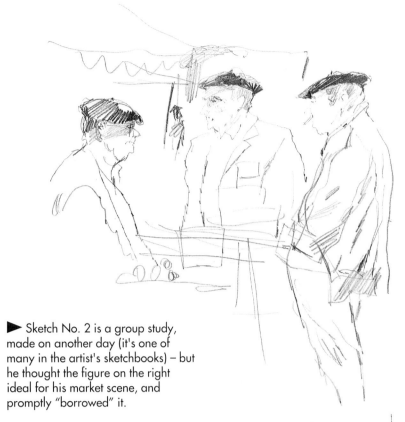

pressed for time; even the simplest notes will help you to call a scene to mind later.

If possible, carry a camera with you as well as a sketchbook. A few pictures of the scene from different angles give you alternative views, and snapshots record all details, providing you with factual references. Similarly, pick up any relevant postcards or posters you can find.

With all or some of this material you can develop a finished painting or drawing back at home. The important thing is to make a picture that works – that is well structured, entertaining and captures the quality of the scene that first drew your attention. The picture is your invention so don't be afraid to put things in, leave things out or move items around. In the example shown here, for instance, the artist has taken a

► Sketch No. 2 is a group study, made on another day (it's one of many in the artist's sketchbooks) – but he thought the figure on the right ideal for his market scene, and promptly "borrowed" it.

▼ Sketch No. 3 The artist made this study in his studio. He's combining several elements from various sketchbooks and also exploring composition, mapping out a strong, almost square format and placing the big tree boldly in the center.

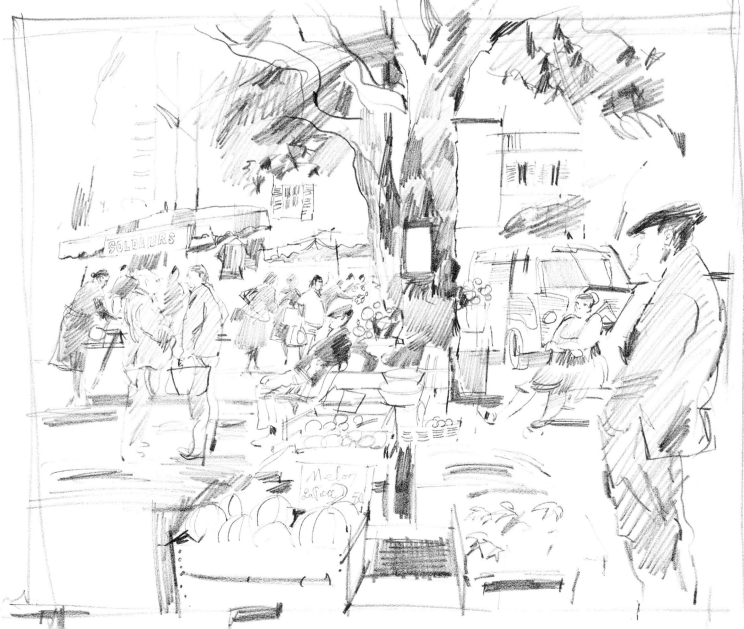

figure from an entirely different location and successfully incorporated it into his composition.

For the sequence of images on these pages, our artist has made the most of a series of trips to France in which he filled several books with sketches. The main thing to note is that he has made free use of material from different sketchbooks, working up some in his studio and trying out a variety of different compositions. He then incorporated all the images he wanted into his final picture. The result beautifully captures the essence of a busy French street market.

Putting it all together

The detailed sketch (No.1) on page 123 is an unedited record of what the artist saw. He noted the main elements of the scene: the location of the market stalls, the trees, the buildings in the background and some of the figures. He also indicated some areas of light and dark – for example, the dark tones on the tree trunks and foliage and the shadows cast by the two figures in the foreground.

Our next sketch (No.2) is one of many of various people, places and objects that the artist made on vacation. This group study was made on a different occasion from the first sketch, but he "borrowed" one of the figures (the man on the right) for his final drawing.

Study No.3 was made later, in the artist's studio. At this stage he was eager to explore the compositional possibilities of the market scene, combining elements from several sketches, and experimenting with a square format. In particular, he tried out a bold composition – placing the big tree near the center of the image to divide the picture plane in two.

The more detailed study (No.4) was also worked up in the studio from drawings made on different occasions in the sketchbook. He was interested in the relaxed figure of the man on the bench, as well as in the shape and texture of the melons. Both were successfully included in the final picture.

Drawing No.5 (next page) is based on sketch No.3. The artist has decided to aim for the composition with a strong central axis. He has developed the row of vegetables, leading the eye from the foreground to the tree in the middle distance. He has also refined some

details, including the windows and the shutters on the buildings in the background and the foliage of the tree. He decided to make things less symmetrical by placing the foreground figure on the right hand side, moving it farther to the right so it didn't crowd the woman sitting on the car bumper.

In drawing No.6 you can see how the artist has finally brought together information from a variety of sources. His colors came not only from memory but also from reference notes and snapshots taken on the scene.

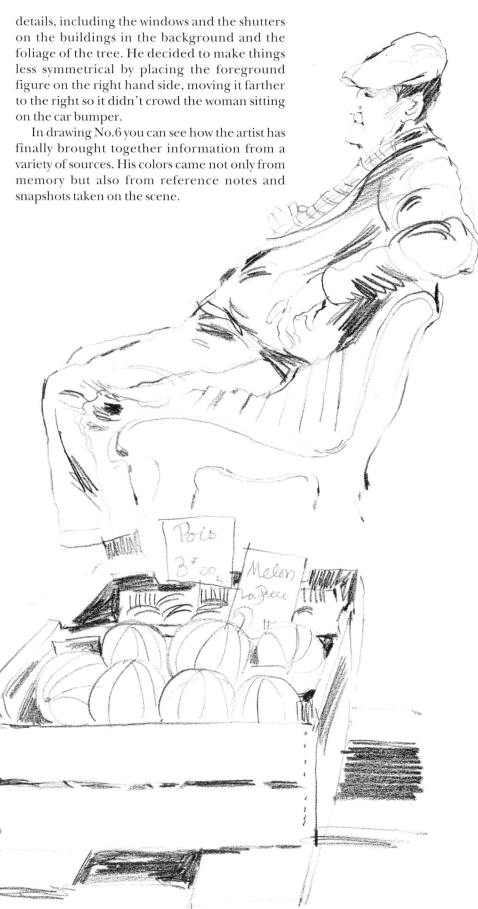

► Sketch No. 4 Two more studies from the artist's sketchbooks. He worked them up from quick jottings before including them in the composition shown opposite.

▶ Sketch No. 5 Here the artist has resolved his composition, retaining the strong central axis he tried in Sketch No. 3 by developing the display of vegetables that now helps to lead the eye from the foreground to the tree in the middle distance.

He has also inserted detail in the buildings at the back and in the tree foliage.

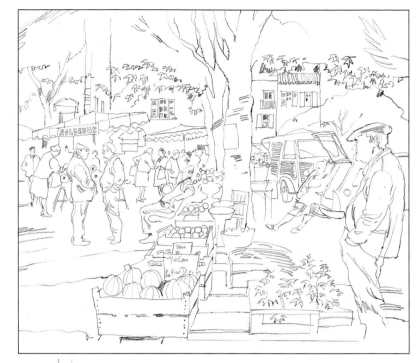

▼ No. 6 Colored pencils provide a bright, fresh medium that reflects the informal, bustling nature of our artist's favorite French street market.

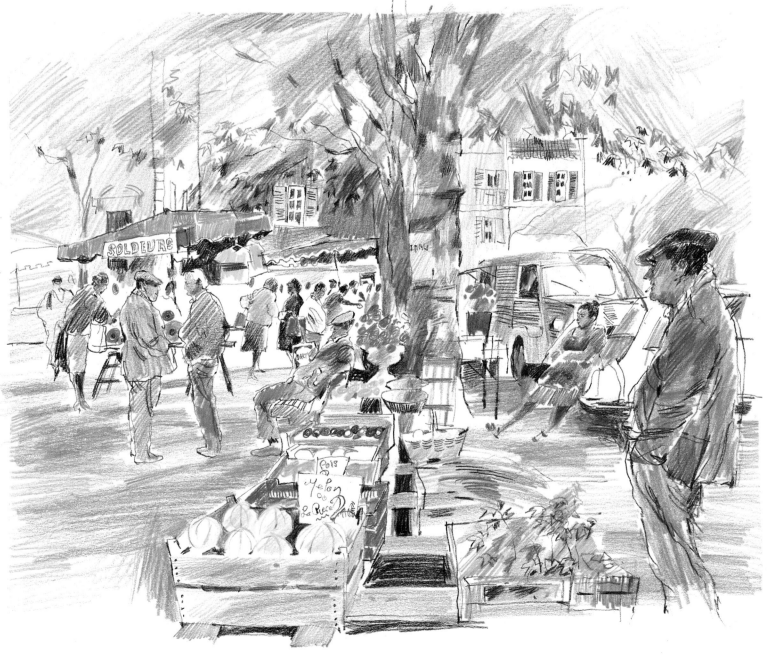

BABIES AND YOUNG CHILDREN

Whether absorbed in play, mesmerized by a new discovery, grinning mischievously or sleeping peacefully, the innocence and freshness of young children are a delight to capture in your sketches.

Childhood is a fascinating subject to explore, even if you're not a parent yourself. The results can be touchingly sentimental, sometimes humorous and always appealing. And if you do have children, you'll get an invaluable personal record of their development that they'll be pleased to own one day.

Besides their highly individual characters, young children provide a source of wonder. Consider the semi-transparent quality of their skin with its delicate tones and textures; their rounded features and soft coloring; their rapidly growing bodies and developing skills; their range of expressions; and last but not least, their incredible vitality.

► The fluid pencil lines in this lovely sketch pick out the form of the baby's body inside the folds of the fabric. Soft pastel coloring on the face contrasts well with the bright, colorful clothes and complements the line work. The sketch catches perfectly the way young children abandon themselves to sleep.

PENCIL AND PASTEL SKETCH BY MALVINA CHEEK

► Very young babies can't move around much, which makes them easier to sketch than a three-year-old on the move. Rapid pen lines give this baby's head form, as do the shadows on the face, while outlines show the frog-like legs characteristic of young babies.

BALLPOINT PEN SKETCHES BY STAN SMITH

▼Sketching is all about seizing the moment. The artist here hasn't concentrated on details – there's no need to. His confidently drawn ballpoint outlines give plenty of information and capture this moment of peace and relaxation for mother and baby.

Look hard at the developing features of children before you start to draw. Their proportions are different from those of an adult. The cranium grows faster than the rest of the face, resulting in a large forehead. Nose, mouth and chin are small and less developed, and the jaw is soft and undefined. Ears are also large in relation to other features, and cheeks are usually full and round. As a child gets older, the nose lengthens, and the eye-line rises as the jaw develops. It's important to get these proportions right if you want your sketches of children to look convincing.

The hair of young children can range from non-existent to plentiful, wispy patches, curls or straw-like straightness. A few well-placed lines may be all you need.

Be prepared to work quickly. Attempting to keep an inquisitive and energetic child still is a lost cause! There's no point in trying to get him or her to pose – you'll get an unnatural position instead of capturing the real mood and expression, which can be done with even a few quick lines.

▲ Capturing character is simple when you look for individual habits, like this sleepyhead sucking her thumb. Notice how a few gentle strokes of graphite stick are enough to show the depth of the eye socket. Look, too, at the way the shape of the head is shown clearly, under the hair.

▲ This eight-day-old baby girl has been sketched in loving detail by her mother, whose close observation has helped her portray the tiny new-born features – puffy eyes, minuscule nose and mouth, curled up fingers and rounded chin. Even the detail on the blanket fringe has been drawn with care to give us an impression of warmth and coziness.

◄ When you have the opportunity to sketch a child unawares, you can catch some interesting angles and viewpoints. Notice how, from this extreme angle, the shape of the toddler's head is elongated. The artist uses simple, yet effective graphite marks to depict the beautiful, long eyelashes and the soft, ruffled hair.

If you want to make longer, more detailed sketches, catch your subjects when they are asleep! Even if they stir, it's likely they'll return to the same position – if not immediately, perhaps at another nap time – so you can resume your sketch. As you can see from the sketches here, children take on relaxed, abandoned positions in sleep. Try to convey expression and the smoothness of the skin as well.

As always, choose a medium to suit your subject. Stick to quick items that you can pick up and use with little or no preparation before the moment is lost. A graphite stick enables you to vary the thickness of your lines as well as block in areas of tone swiftly. A well-chosen range of graphite pencils gives you the choice of frail, light lines to dark, bold marks. If you want to use color, you'll find the delicate quality of colored pencils particularly well suited to drawing young children. You can make fine lines as well as build up areas of color quickly by scribbling and cross hatching. Charcoal, pastels, Conté crayons, chalks, technical pens and felt and fiber tips are also excellent alternatives.

GRAPHITE STICK SKETCHES ON THESE TWO PAGES ARE BY SUSAN PONTEFRACT

▲ Peace (at last) after a day's frenetic activity! Graphite stick, with its fine lines and soft shading, describes the lines and tones in each strand of hair and each fold of fabric.

◄ The beauty of sketching is that you can do whatever you want – there's no "finished" painting or drawing to worry about. Here, the artist has focused in tight on the little girl's face, concentrating on getting her expression of trusting restfulness right.

▲ This is a simple sketch, with quickly scribbled lines and areas of loose tone drawn with the flat edge of the tip of a graphite stick. Yet it is effective, showing the rounded pudginess of the cheeks and the snub nose of the toddler.

All the sketches on this page and the one opposite were done by the same artist who has five children – plenty of material for sketching!

► Several mixed studies make for full and interesting pages. Do as this artist does – begin another study as the child moves in sleep. Keep your sketchbook handy so you can grab the opportunity to continue sketches when the child returns to the same, or a similar position.

▶ Choose a colored medium and you bring an extra dimension to your sketches. The artist here chose to work in pastels which, with their softness and velvety texture, suit his subjects.

Notice how this baby's face is not simply pink, but a subtle mixture of blues, purples, grays, yellows, white and pinkish reds.

PASTEL AND COLORED PENCIL SKETCHES ON THIS PAGE BY HUMPHREY BANGHAM

◀ Although done quickly, with a view to catching the essence of an expression or effect, sketches should still include form and tone as well as line.

Color and tone are built up to great effect with loosely hatched lines. The highlights where the baby's plump cheek has caught the light help give it form, while the dark background throws the head forward to give it a convincing three-dimensional quality.

▼ Gentle strokes of overlaid colors illustrate the transparent quality of this young child's eyelids. The fine, dark lines of the closed eyes and mouth combine with subtle color to create a warm, tender and extremely expressive drawing.

DRAWING WITH VARIOUS MEDIA

THE APPEAL OF LEAD PENCILS

Lead pencils are the most familiar drawing tools of all. Perhaps that's why we don't always appreciate them for the wonderful implements they are.

Most of us learn to handle pencils as children, and then promptly forget their usefulness and flexibility. This is a shame when you consider the vast range available – from pencils so hard they produce the palest of gray lines, to soft pencils, perfect for dark velvety shading.

But it isn't only the hardness or softness of the pencil you use that affects the kind of drawing you produce. There's also the sharpness of the tip to think about, and whether it's rounded or chiseled. Add to that the amount of pressure you exert on the pencil – and the surface of the paper itself – and you're nearly there. All except for the matter of the *way* you apply the pencil of course!

Pencil lines can be soft and sinuous, vigorous and bold, or controlled and crisp. And your drawings may be subtle and detailed, with carefully graded tones, or energetic works in which the expressive flowing lines are important.

Softest to hardest

Artists' pencils come in 20 grades, ranging from the softest (8B) to the hardest (10H), with F and HB in the middle.

As a rule of thumb, hard pencils (H–10H) are best for very fine lines because they can be sharpened to the finest of

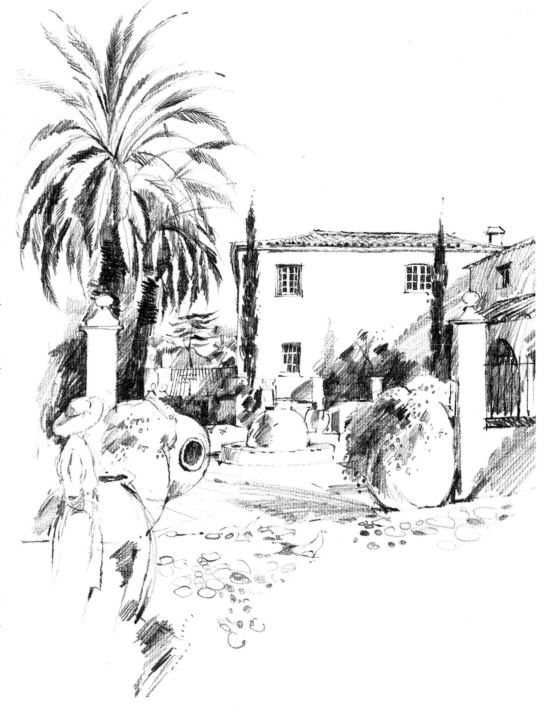

► With its range of descriptive marks, this sketch is pencil drawing at its most expressive.

"TRASIERRA, NEAR SEVILLE" BY ALBANY WISEMAN, PENCIL SKETCH, 12 X 18IN

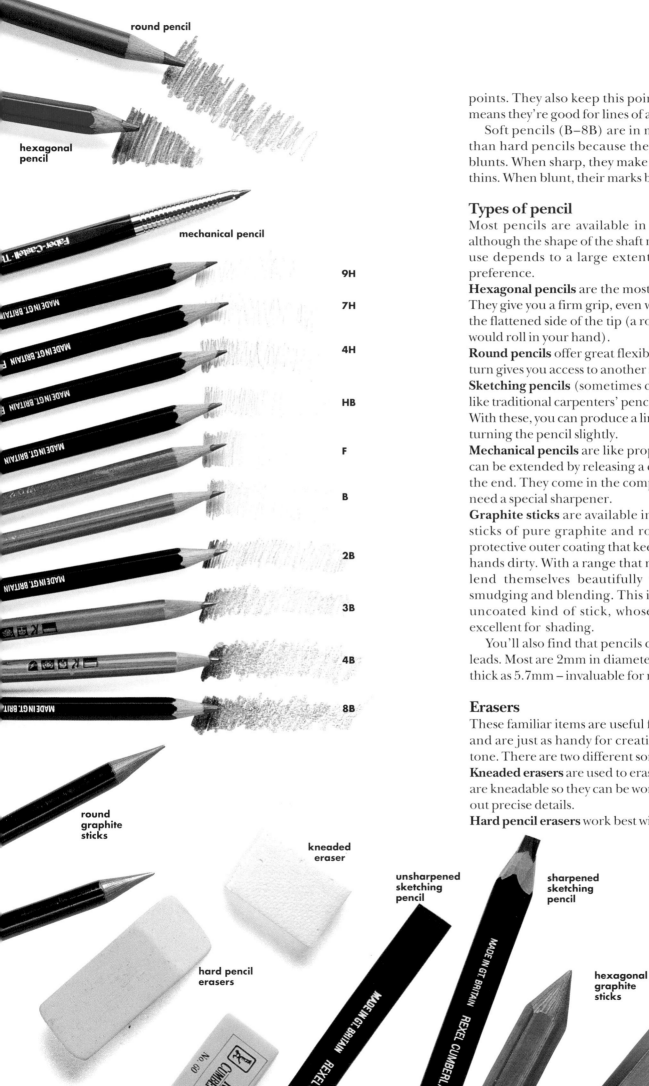

points. They also keep this point for a long time, which means they're good for lines of a constant thickness.

Soft pencils (B–8B) are in many ways more flexible than hard pencils because they have a tip that quickly blunts. When sharp, they make a fluid line of thicks and thins. When blunt, their marks become broad and dark.

Types of pencil

Most pencils are available in a standard 7in length, although the shape of the shaft may vary. Which ones you use depends to a large extent on your own personal preference.

Hexagonal pencils are the most common drawing tools. They give you a firm grip, even when you're shading with the flattened side of the tip (a round pencil used like this would roll in your hand).

Round pencils offer great flexibility because the slightest turn gives you access to another side of the tip.

Sketching pencils (sometimes called studio pencils) are like traditional carpenters' pencils – rectangular in shape. With these, you can produce a line of varying width just by turning the pencil slightly.

Mechanical pencils are like propelling pencils – the lead can be extended by releasing a clutch lock or by clicking the end. They come in the complete 8B–10H range, but need a special sharpener.

Graphite sticks are available in two forms – hexagonal sticks of pure graphite and rounded "pencils" with a protective outer coating that keeps you from getting your hands dirty. With a range that runs from HB to 9B, they lend themselves beautifully to such techniques as smudging and blending. This is particularly true of the uncoated kind of stick, whose sides and flat end are excellent for shading.

You'll also find that pencils come with different sized leads. Most are 2mm in diameter, but some have cores as thick as 5.7mm – invaluable for making bold thick lines.

Erasers

These familiar items are useful for rubbing out mistakes, and are just as handy for creating highlights in areas of tone. There are two different sorts.

Kneaded erasers are used to erase soft pencil marks. They are kneadable so they can be worked to a fine point to rub out precise details.

Hard pencil erasers work best with hard pencil marks.

One pencil does it all!

Drawing textures is a challenge for any artist, and here's a still life that abounds with them. There's the basket itself, with its mass of weaves and plaits. Then there are the intricately grained logs and bark. To capture all of these, you need just one pencil and six kinds of mark.

YOU WILL NEED
☐ A sheet of good quality cartridge paper, 18 x 24in
☐ B pencil
☐ Kneaded eraser

◀ **The set-up**

The half dozen marks you need

Practice these six marks and you'll have all you need for the *Fireside basket*. Don't devote too much time to each one, though, or you'll lose spontaneity. Instead, do them quickly, using your B pencil and a sheet of cartridge paper.

◀ **A** Hold the pencil as you would to write. Now draw short lines close together. Adjust the pressure to give three weights, and vary the direction. You'll use this *hatching* to describe bark.

◀ **B** Hold the pencil fairly lightly and draw a series of long tremulous lines. These represent the wood grain.

◀ **C** Work the side of the pencil tip to a flat edge, then lightly shade with it – let the texture of the paper show through. This represents the grain of the wood at the end of some of the logs.

◀ **D** Blunt the tip of the pencil, then make crisp black lines with it, exerting lots of pressure. This useful line adds definition.

◀ **E** Hold the pencil as in **A**, press hard and scribble. Do this in several directions and in several layers to build up good dark tones for the shadows.

◀ **F** As you hold the pencil on the paper, roll it in your hand. Then, by varying the pressure, you'll end up with a squiggly line of thicks and thins, perfect for the bark on some of the logs.

Warming up

Now you've practiced the basic pencil marks, continue as the artist did – with some warm-up sketches (there's no particular order to them).

As you're doing them, you'll have the chance to study the make up of the still life, which will prove invaluable when you come to draw the picture for real. You can also work out the best angle to draw from.

For the best results, keep your pencil fairly blunt most of the time. You'll still have to sharpen it first, though. Once you've done this, rub it back and forth on a scrap of paper or sandpaper to blunt the end slightly.

◀ You can either set up your own still life log basket or work from the photograph on the previous page. If you're arranging your own, start by positioning yourself comfortably a few feet from it. Then make sure that the set-up is well lit and that you can see it properly. Also check that you have plenty of light to draw in.

Work on a pad of cartridge paper or a single sheet attached to a drawing board with thumbtacks or tape.

▲ One of the most prominent and demanding features of the set-up is the wickerwork weave of the basket, so it makes good sense to sketch it beforehand. Start by loosely indicating the verticals, then draw in the horizontal canes.

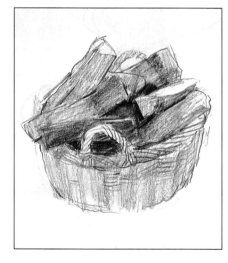

◀ This preliminary viewpoint of the set-up proved to be an awkward one, so when it came to drawing the picture the artist decided to draw from a different angle.

▲ With its loops, curls and plaits, the handle of the basket is another excellent drawing to do in its own right.

SHARPENING YOUR PENCIL

When it comes to sharpening your pencil, penknives, craft knives and scalpels have the edge over regular pencil sharpeners, whatever their design. Using a blade, you can cut away more of the wood to expose more lead, which means you don't have to sharpen the tip so often. You also have more control over the shape of the tip, making it fine, chiseled, blunt or rounded. Rubbing the sharpened tip on a sheet of sandpaper makes it even finer – or blunt.

Fireside basket of logs

Once you've practiced the pencil marks and have completed some warm-up sketches, you're ready to begin the drawing.

Equip yourself with a big piece of paper – it's good to work on a large scale. This doesn't mean you have to put in lots of detail. Instead, get into the habit of standing back from your drawing to assess it from a distance. Above all, resist the temptation to overwork your drawing.

Make your marks lightly to begin with. As with watercolor, you're working from light to dark. There's plenty of time to make things heavier as you go along, and the actual putting in of darker marks over lighter ones helps you build up interesting texture. With the B pencil and a textured paper, drawing the shading is easy. So don't press too hard or you'll make an indent that no amount of rubbing out will remove!

1 Fix the paper to the drawing board with thumbtacks or tape. Sharpen your pencil, then rub it back and forth on a scrap of paper to blunt the end slightly (you'll get the best results in this picture by keeping your pencil blunt like this most of the time).

◄ **2** Working freely from your elbow, roughly and lightly draw in the outline of the whole image, making sure your composition fits neatly on the page. Don't worry about fine detail at this stage.

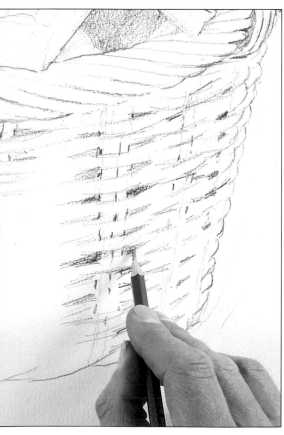

◄ **3** Draw in the twisted rim of the basket. Now start on the wickerwork itself, on the right side of the basket. Because this is actually quite a complicated design, you need to simplify it. Look closely at the basket for its broad forms. Loosely indicate some verticals first, then start to establish the horizontal canes. Don't get too caught up in working on one small section – try to keep the whole thing going at once.

Don't worry either about putting in every detail – in this version not all the shadows are there, for instance, but the eye is deceived into thinking they are.

YOU WILL NEED

☐ An 18 x 24in sheet of good quality cartridge paper

☐ One B pencil

☐ Kneaded eraser

☐ Spray fixative

► **4** With one side drawn in, turn your attention to the tones on the logs. Define the darker edges by laying in some crisp black marks with the pencil lead somewhat pointed. Shade in the shadows, but don't make them too dark yet – the texture of the paper adds to this here and there. Draw a series of lines for the grain of the wood. Roughly describe the bark with patches of scribble running in a variety of different directions.

▲ 5 Draw the other side of the basket. As before, put in the verticals first, then draw the horizontal wickers in panels, using lighter and heavier lines to indicate the different tones and shadows.

◄ 6 Now sort out the tones of the whole picture. Darken some of the shadows, for instance. It may help you to see where these are if you stand back from the drawing and look at it with half-closed eyes.

▼ 7 Hold the pencil loosely and lay in some more scribbles for the bark. Work over it in little clusters to capture the slightly varying surfaces. Create some vertical shadows on the basket by smudging the pencil lines downward with your finger.

Once you've put in the final touches, fix the drawing with spray fixative, following the manufacturer's instructions.

DISCOVERING COLORED PENCILS

If you haven't used colored pencils since you were at school, try them again. They have graduated from the classroom to the studio, and are now a refined and versatile drawing medium.

You'll be surprised by the beautiful results you can get with just a handful of colored pencils and a few basic techniques. They're good for line drawings and illustrations and you can even achieve some painterly effects with them. You can use them in either a loose, expressive way or produce some very subtle, considered works.

Colored pencils are easy to use, cheap and you don't need a lot of equipment to get started. There's no messy mixing to do, and they don't smudge easily. And the mark you make is the mark you get – unlike paints, which often dry lighter or darker. In addition, colored pencils are small and easily portable, so you can take them with you when you go sketching, and store them without trouble.

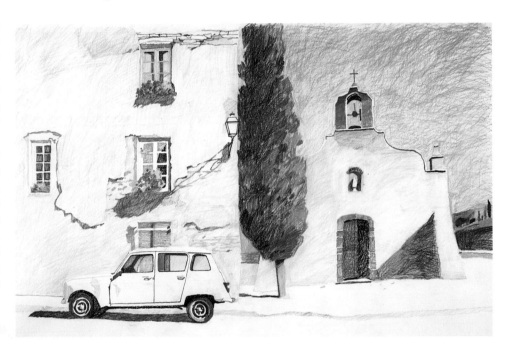

▲ Much of the charm of colored pencils comes from their sheer versatility. In this lively drawing bold, loose scribbles, pressure techniques and careful color mixing combine to portray the bright, sunny atmosphere of a French village.

"LA GARDE FRINET" BY IAN SIDAWAY, CARAN D'ACHE COLORED PENCILS ON PAPER, 23⅓ X 34IN

◄ Most art stores carry a wide range of colored pencils – some hard, some soft and in an impressive array of colors. Try out as many as you can to find the type you prefer.

You'll also be spoiled when it comes to paper. With so many tempting colors and textures, there's a perfect paper for every subject.

Two-color mixing

The color mixes here are worked in Lyra Rembrandt Polycolor colored pencils.

▲ This vibrant orange is mixed from vermilion and lemon cadmium.

▲ Mixing lemon cadmium and Paris blue makes a vivid light green. Lighten it with more yellow, or darken it with more blue.

▲ Light carmine and vermilion combine to produce a moody violet.

▲ You can make a neutral gray by laying vermilion over true blue.

▲ A cooler, darker green results from mixing Prussian blue and lemon cadmium.

▲ Viridian and vermilion combine to make a dark brown.

Hard or soft?

Some colored pencils are softer than others, depending on how much wax they contain. The "lead" or core is clay, colored with pigment and bound with wax. The higher the wax content, the harder the pencil. With a soft pencil the core is softer, so the color comes off smoothly and evenly. A hard pencil lays down color very lightly – ideal for delicate work. Try out different ranges to see which you prefer. Many artists use both types – harder pencils for fine line work and softer ones for laying areas of solid, bold color and for pastel-like effects.

You can buy colored pencils in large sets of 72, but you only really need a set of 12 to mix a wide range of colors. If you prefer to buy them loose, a good limited range of colors for mixing are ones that approximate to cadmium red, cadmium yellow, cobalt blue, ultramarine, alizarin crimson, Prussian blue, black and white.

When buying, look for well constructed pencils, with firmly set, well centered leads. Make sure color builds up quickly and uniformly without any grittiness or "squeak". You will also need a craft knife or pencil sharpener and a kneaded eraser for erasing and rubbing back.

Pressure points

As with lead pencils, you create different grades of tone by varying the amount of pressure you put

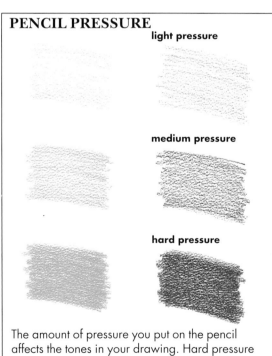

PENCIL PRESSURE

light pressure

medium pressure

hard pressure

The amount of pressure you put on the pencil affects the tones in your drawing. Hard pressure gives a dark tone; medium pressure, a medium tone; light pressure, a light tone. Use the sharp point of the pencil for fine lines. For soft lines and broad blocking in, work with the side of the core.

on the pencil. Pencil pressure also controls the final effect. Colored pencils are most often used on cartridge paper which has a slight tooth. With light pressure the color catches only on the "peaks" of the irregular surface, producing a granular finish.

Under heavy pressure the color is pushed down into the "troughs" of the paper surface. It spreads more evenly and the texture of the paper is slightly flattened so you're left with a smooth, fluid finish.

Color mixing

Colored pencil marks are semi-transparent so one color laid over another makes a third. For instance, strokes of blue laid over yellow make a green. This green is more subtle, lively and interesting than the flat color you get with a green pencil.

You can vary this green by controlling the amount of blue or yellow you put down, and modify it further by adding some strokes of brown or any other color.

Combining color mixing with different types of strokes can produce various effects, from regular and neat to loose and scribbly. Controlled cross-hatching – overlaid criss-crossed lines – produces a crisp image, while layers of free-hand scribble in two or more colors

are effective for backgrounds and large expanses. For smaller areas, use dense flecks or dots. Experiment to discover different effects.

Use the right paper

Your choice of paper governs the final result of your drawing, so give some thought to the kind you use. Cartridge paper with a slight tooth is the most popular of all. Coarser papers can take more layers of color than smoother ones. Very smooth surfaces – such as hot-pressed watercolor papers – are not suitable for colored pencil work except for fine line drawings.

▼ Colored pencils aren't exclusively for illustrations and pale, delicate subjects. In this dramatic portrait, vigorous, expressive pencil marks and imaginative use of color make a drawing bursting with energy.

"PORTRAIT OF ANNIE" BY SARAH DONALDSON, AQUARELLE COLORED PENCILS ON WHITE PAPER, 6 X 8IN

THREE-COLOR MIXING

This brownish green was made by laying true blue and lemon cadmium over vermilion. Notice that the one on the left is lighter in tone than the other. Although the same pencil pressure was applied, the color on the left is on NOT watercolor paper with a good tooth. The one on the right is on smoother cartridge paper with a very slight tooth. The different tones are the direct result of the different paper textures.

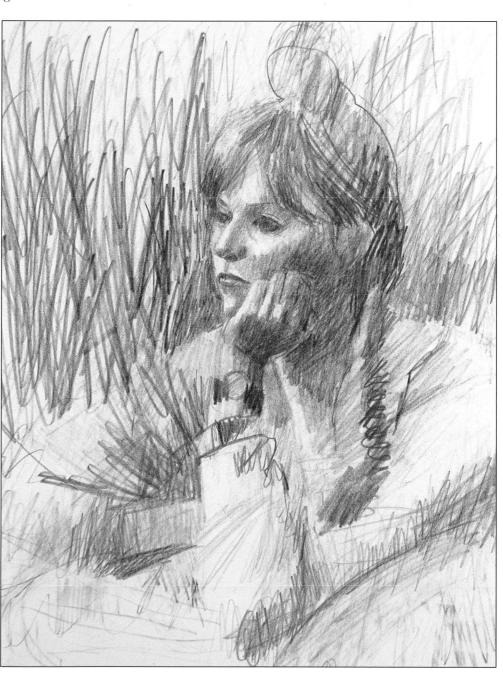

Highly textured, granular papers such as handmade and NOT watercolor paper produce equally granular drawings. These are excellent for loose, linear work but are not good for detailed work or laying areas of flat color.

Many toned and tinted papers, such as Canson and Fabriano, have a slight texture (tooth) and are excellent for colored pencil drawing. Both come in a wide range of colors.

▼ In this beautiful, carefully considered still life, the artist has captured the distinct character of many different textures – shiny metal saucepan and kettle, organic vegetables, transparent bottle and solid wooden board.

The fine detail in the build-up of form and tone shows what can be achieved with these pencils.

"STILL LIFE WITH VEGETABLES" BY JOE FERENCZY, CONTÉ COLORED PENCILS ON PAPER, 15⅓ X 20⅔IN

▲ Sensitive use of colored pencil strokes helps build up a solid shape from many different layers of blended color. The directions followed by the pencil strokes appear to "feel out" the shape of this yellow pepper.

◄ At their best, colored pencils can combine many of the qualities found in both drawing and painting. The onion and leek here are both drawn in precise detail, while the complex build-up of color on the crumpled skin of the onion adds a fine touch of realism.

USING WATER-SOLUBLE PENCILS

Water-soluble pencils are extremely flexible and a delight to use. They give you the control and precision of a pencil combined with the blending, soft edges and washes you get with watercolors.

Water-soluble pencils have all the qualities of regular colored pencils – you can use them for linear work, hatching, laying blocks of color or mixing colors optically by overlaying them. But their water-soluble quality gives them another dimension – by blending the marks with water you can produce soft gradations of color and tone, as well as areas of delicate color washes.

These pencils are ideal for colored subjects with intricate detail. For instance, they're good for drawing birds, animals and plants – flower studies can gain much from the line and wash combination.

The following three basic techniques for these pencils are simple to follow. Try laying down some color, then washing over it with a wet brush. This gives a range of blended effects and washes. Soft pencils create intense, even washes, while harder pencils give paler washes, and the drawn marks tend to remain visible.

You can also draw on damp paper, or into wet, pre-blended color. The lines are softer than those drawn dry-on-dry, and the pigment dissolves less than brush-washed color.

You can even dip a pencil into water and draw on dry paper with the moistened tip. This is only practical for small details since the tip absorbs very little water. But if you're prepared to keep dipping, you can build up areas of texture – fur or feathers, for example.

◀▲ As a general rule, water-soluble pencils are softer than conventional pencils. The degree of softness also varies from brand to brand. It's worth buying a few loose ones first to see which one suits your style. If you concentrate on linear and textural qualities, with limited areas of blending, choose a harder variety. If you like to work boldly and loosely, using larger washes, you're better off with softer pencils.

When you have chosen your pencils, spend time exploring their character. Try different papers – the results can be remarkably diverse.

Thistles and nigella

▶ **The set-up** A combination of delicate details, soft tones and a splash of bright colors make this arrangement of nigella (love-in-a-mist) and thistles perfect for a drawing in water-soluble colored pencils.

If you're interested in textures, there are many for you to experiment with here – the crisp tissue paper, the crinkly nigella petals, the spiky thistles and the solid wooden table top.

Pencil marks

 blue-gray

 Prussian blue

 smalt blue

 light violet

 bottle green

 May green

 zinc yellow

 primrose yellow

 raw sienna

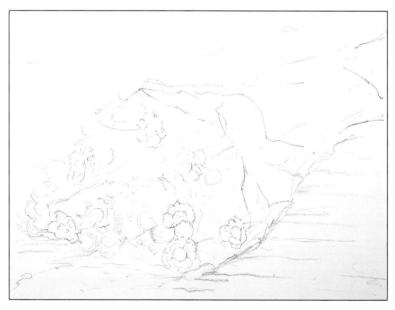

◀ **1** Start by roughly placing the objects very lightly on the paper with the bottle green pencil. Then, using Prussian blue, draw the outlines of the flowers and tissue paper. Try to show the crinkly edges of the nigella petals and the shapes of the centers. Indicate a few of the stems and circle in the main thistle heads.

Now draw the table top in raw sienna, suggesting the quality of the wood grain with irregular strokes.

▶ **2** Dampen the flat brush with clean water and start to blend the marks. Use horizontal strokes for the table top. Then do the same with the edges of the tissue paper.

Notice how the water deepens the blue lines, giving them a rich, velvety quality.

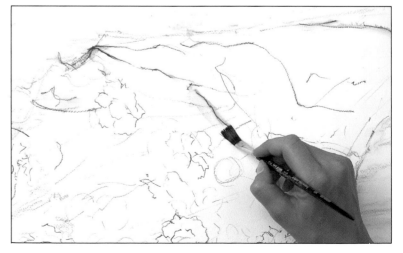

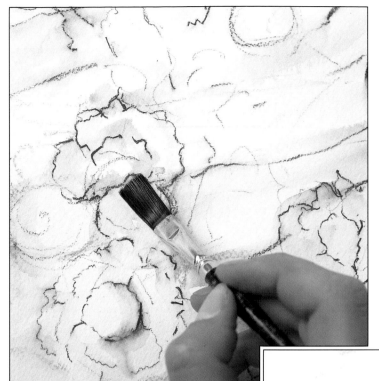

Three ways with water

▲ Draw, hatch or scribble with a pencil on some watercolor paper. Blend the color by washing over it with a wet brush and clean water.

◄ **3** Highlight some of the darker stalks, drawing them in with bottle green. Then blend the outlines of the nigella petals and centers with the brush and clean water. The color spreads out gently and unevenly, giving the flowers softly graded tones. Soften some of the outlines of the thistle heads with water too, before you begin to develop them further.

▲ Wet the paper with some clean water and a brush, then draw into an area with a dry pencil. The marks bleed, yet still retain their main shape.

► **4** Now you've laid down the basic composition, start to introduce more colors. Don't be afraid to work over the areas you've already washed down. Draw into the nigella flowers with light violet, showing the way their petals overlap. Add more stalks with the side of the blue-gray pencil, then strengthen the outlines of the thistle heads – some with light violet, others with blue-gray. Scribble these two colors onto the thistles in varying amounts, then blend in the scribbles with some clean water.

Don't use your colors according to a formula. Vary them – and their amounts – on all the flowers so they don't all look the same. This creates a much more interesting picture.

▲ Dip the tip of your pencil into some water and draw on dry paper. The wet pigment crumbles off to leave a highly textured mark.

◄ **5** Bring some brighter colors into the picture. Use May green to add lighter stalks, washing them down with clean water. Notice how this green turns toward yellow when diluted.

Now work up the flowers, starting at the bottom right of the picture. Scribble varying amounts of May green and primrose yellow onto the thistle heads for lighter tones and soften the scribbles with water. Then stroke in spikes on the thistles with blue-gray.

Add touches of primrose yellow for light tones on the nigella centers. Reinforce the petal outlines using blue-gray and bottle green. Change the pressure you apply on the pencil for varying tones.

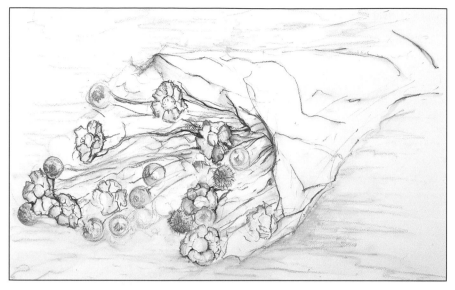

◄ **6** Put in more stems with May green, making strong, jagged lines with the side of the pencil. Remember – you can be selective about which stems to include.

Stand back and assess your progress. You now need to work around the picture in the same way as you have been doing to build up all the elements. Rest your hand on a piece of tissue paper to avoid smudging your drawing.

► **7** Develop the thistles by blending varying amounts of the same colors as before. For the spikes, use blue-gray, smalt blue and light violet. Use both greens to strengthen the stems, washing down the lines as you go. Add zinc yellow to some nigella centers.

Use your technical pens for fine details. Add dark spikes to the thistles, and outline some nigella petals. Draw fine scribbles on the petals for their crumpled texture. Add black dots to the nigella centers for texture.

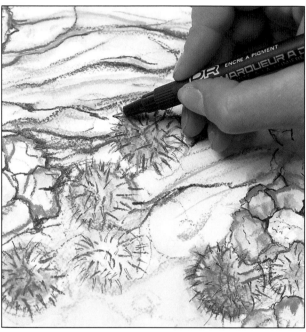

▼ **8** Build up the table top by laying more raw sienna at a different angle over the existing marks. Allow the paper's texture to show through. This contrasts well with the delicate detailing on the flowers and hints at the texture of the wood. Add more stalks with bottle green and May green.

The finished picture shows both qualities of water-soluble colored pencils. The subject demands attention to fine details, such as the tiny spikes on the thistle heads. Yet the areas of softly blended colors add a sense of delicacy to complement the subject. They also give the flowers a more rounded quality, suggesting the gentle folds of the petals.

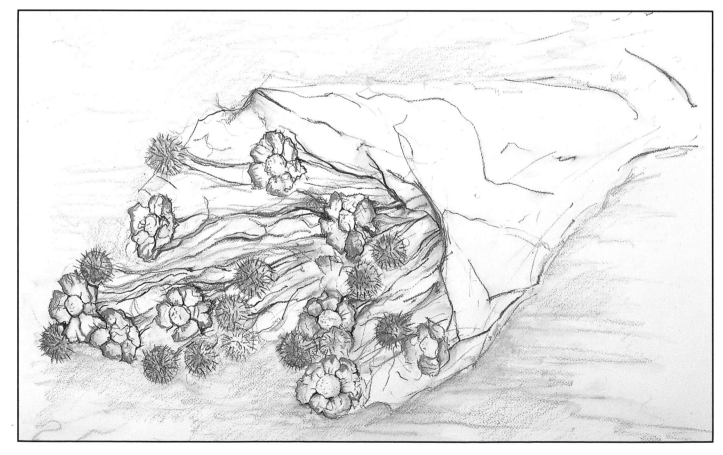

DRAWING WITH CHARCOAL

By far the oldest drawing medium still available on the market today, charcoal sticks and pencils are simple to use and lend themselves to expressive, spontaneous work.

The perfect medium for beginners, charcoal is nearly always the starting point of any art course – students are encouraged to pick up a piece and start sketching big, bold images right away. This is because working with charcoal can teach a great deal about drawing textures and creating different tonal areas – essential before starting with color. And it encourages artists to think about the subject as a whole and not about the small details.

Charcoal is made from burned vine, beech or willow twigs and is available in natural or compressed sticks, in pencil form or as a powder. Vine charcoal produces a brownish-black color, while willow and beech make a bluish-black mark.

There are varying degrees of hardness – soft, powdery charcoal blends easily and is useful for tonal areas, while the harder sticks are ideal for linear work and details.

The sticks come in various thicknesses, so you can create a range of marks – from broad, sweeping strokes to fine details. In its pencil form – sticks of compressed charcoal encased in wood – charcoal is much cleaner to use, but you soon lose the feel of the traditional sticks because you can use only the point, not the sides.

Paper and accessories

Charcoal works well with any type of matte paper with a textured surface. Don't use it on smooth or glossy papers because it won't adhere to the surface. Canson and Ingres are the best papers for drawing with charcoal, but for everyday practice charcoal paper is a suitable alternative.

willow charcoal sticks in various thicknesses

charcoal in pencil form

fine sandpaper

torchon

colored and white drawing paper

kneaded eraser

GLASSPAPER BLOCK
WINSOR & NEWTON
Made in England, London HA3 5HH
For pointing pencils, charcoal chalks etc.
7030 572

LARGE KNEADED PUTTY RUBBER
WINSOR & NEWTON
7030 618

craft knife

fixative

Aerosol
Fixative

USING CHARCOAL

Smudging Charcoal smudges easily, allowing you to produce smooth, velvety effects. Use the side of the stick to make a series of lines. Then with the tip of your finger – or with a torchon – gently rub across the charcoal from one side to the other, creating light and dark tones by varying the pressure as you work.

Cross-hatching Another way to build up tone with charcoal is by using a series of loose strokes known as cross-hatching. To practice this technique, make a series of parallel lines, then cross them with a series of others at a different angle. Vary the size and closeness of the lines to each other to produce different tones.

Soft blending Instead of smudging the charcoal with your finger or a torchon, use the wide tip of the stick to create lines and marks that blend into each other. Sharpen the tip slightly first on a piece of sandpaper, then hold the stick near the top end. Vary the pressure as you scribble so you get a range of lights and darks.

To begin, you need only a minimum of equipment – a few sticks of charcoal in different thicknesses, paper and fixative (essential because charcoal smudges so easily). Buy fixative from an art store or use ordinary hairspray.

You'll need fine sandpaper or a sharp craft knife to sharpen the point of a charcoal stick, and a kneaded eraser to create highlights and correct errors. Fingers are ideal for the job of blending, but you can use a torchon – a piece of paper rolled tightly to a point – to avoid getting your hands dirty. Cheap alternatives include tissues, scraps of cloth or cotton balls.

Wash your hands after using them to rub charcoal into the paper – the dust can become embedded into your skin and then you'll smudge the paper surface.

Experience will teach you the amount of pressure needed for the different grades of thick or thin sticks. Too much pressure on a thin stick causes it to break frequently, splattering charcoal crumbs over the paper.

◀ Charcoal is ideal for life studies because it is so easy to erase and correct mistakes. You can also create a whole range of tones with it.

This study was made with medium and thin sticks of willow (the artist finds thick sticks too bulky). Sweeping lines define the contours of the form while smudges and blended tones give the figure bulk and create an entertaining picture surface.

"WOMAN CLEANING" BY SARAH CAWKWELL, 1987, 30 X 32IN

PENS, INKS, AND PAPERS

Even experienced artists are daunted by the bewildering choice of pens, inks, and papers on the market today. Here's a selection of materials to whet your appetite and get you on the right track.

Thanks to recent manufacturing developments, there are hundreds of pens and inks available, and you can work with them in literally countless ways – from simple monochromatic drawings in traditional black India ink to detailed paintings in brilliant colors. But whatever your interests, it's important to choose the right materials for the result you have in mind.

Traditional drawing pens

Pens made from natural materials – quills, reeds and bamboo – were for many centuries the only types available. But they are still popular today because they're a pleasure to use. If you take care of them, they can last a long time. They all make their own, characteristic marks, and they're cheap, easy to handle and widely available.

▼ India ink allows you to create boldly expressive and finely detailed drawings. The artist used very fine lines for the details of the statues and decorative objects.

"VIEW THROUGH AN ARCHWAY"
BY JOHN WARD

◄ There's a wide range of nibs and papers on the market to choose from when working with India ink. Experiment with a selection of mapping, round and square nibs to find out what works best for you. To begin with, use sized papers to prevent the ink from bleeding. When you've gained more experience, move on to NOT papers.

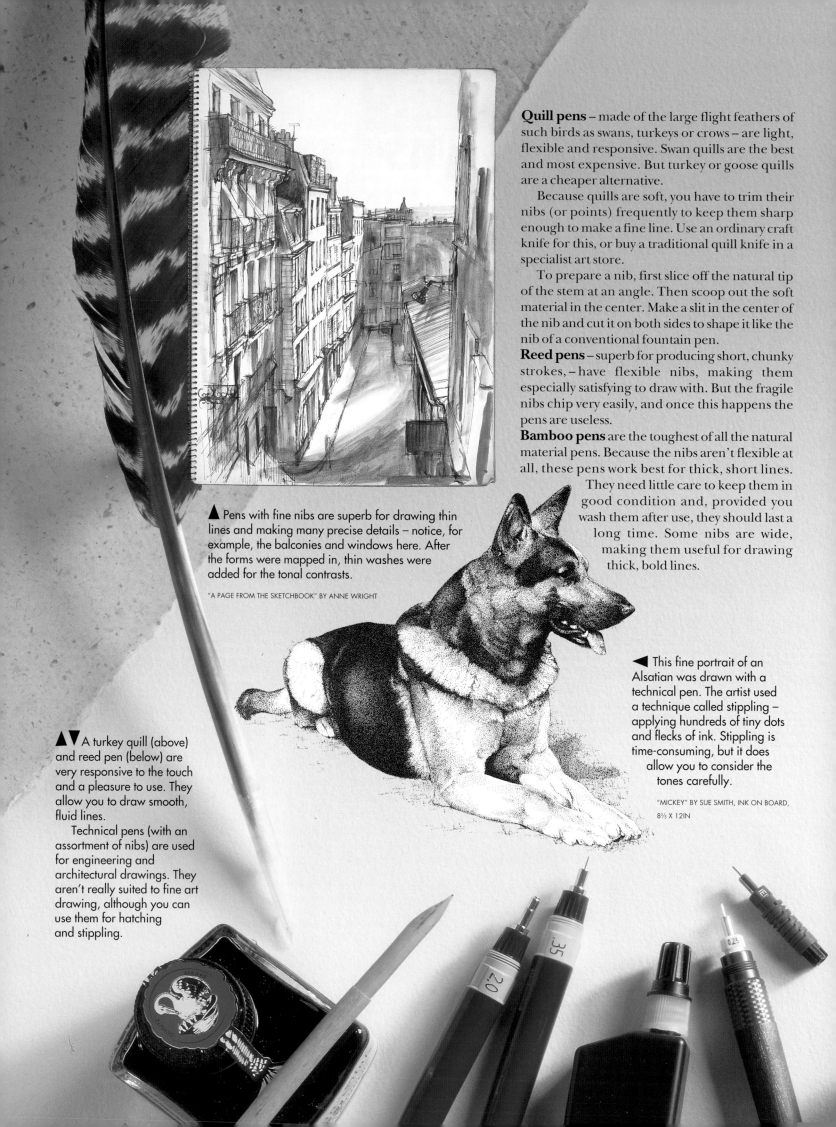

Quill pens – made of the large flight feathers of such birds as swans, turkeys or crows – are light, flexible and responsive. Swan quills are the best and most expensive. But turkey or goose quills are a cheaper alternative.

Because quills are soft, you have to trim their nibs (or points) frequently to keep them sharp enough to make a fine line. Use an ordinary craft knife for this, or buy a traditional quill knife in a specialist art store.

To prepare a nib, first slice off the natural tip of the stem at an angle. Then scoop out the soft material in the center. Make a slit in the center of the nib and cut it on both sides to shape it like the nib of a conventional fountain pen.

Reed pens – superb for producing short, chunky strokes, – have flexible nibs, making them especially satisfying to draw with. But the fragile nibs chip very easily, and once this happens the pens are useless.

Bamboo pens are the toughest of all the natural material pens. Because the nibs aren't flexible at all, these pens work best for thick, short lines. They need little care to keep them in good condition and, provided you wash them after use, they should last a long time. Some nibs are wide, making them useful for drawing thick, bold lines.

▲ Pens with fine nibs are superb for drawing thin lines and making many precise details – notice, for example, the balconies and windows here. After the forms were mapped in, thin washes were added for the tonal contrasts.

"A PAGE FROM THE SKETCHBOOK" BY ANNE WRIGHT

◄ This fine portrait of an Alsatian was drawn with a technical pen. The artist used a technique called stippling – applying hundreds of tiny dots and flecks of ink. Stippling is time-consuming, but it does allow you to consider the tones carefully.

"MICKEY" BY SUE SMITH, INK ON BOARD, 8⅓ X 12IN

▲▼ A turkey quill (above) and reed pen (below) are very responsive to the touch and a pleasure to use. They allow you to draw smooth, fluid lines.

Technical pens (with an assortment of nibs) are used for engineering and architectural drawings. They aren't really suited to fine art drawing, although you can use them for hatching and stippling.

PENS, INKS, AND PAPERS

Even experienced artists are daunted by the bewildering choice of pens, inks, and papers on the market today. Here's a selection of materials to whet your appetite and get you on the right track.

▼ India ink allows you to create boldly expressive and finely detailed drawings. The artist used very fine lines for the details of the statues and decorative objects.

"VIEW THROUGH AN ARCHWAY" BY JOHN WARD

Thanks to recent manufacturing developments, there are hundreds of pens and inks available, and you can work with them in literally countless ways – from simple monochromatic drawings in traditional black India ink to detailed paintings in brilliant colors. But whatever your interests, it's important to choose the right materials for the result you have in mind.

Traditional drawing pens

Pens made from natural materials – quills, reeds and bamboo – were for many centuries the only types available. But they are still popular today because they're a pleasure to use. If you take care of them, they can last a long time. They all make their own, characteristic marks, and they're cheap, easy to handle and widely available.

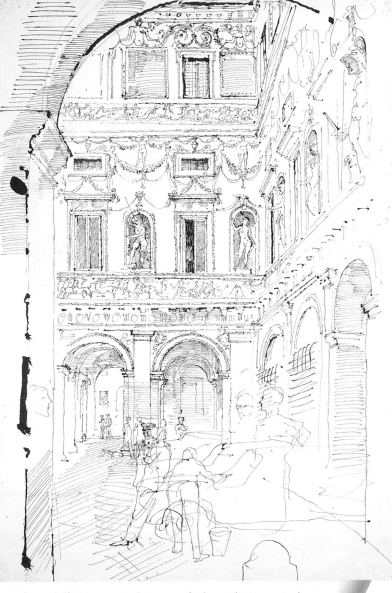

◄ There's a wide range of nibs and papers on the market to choose from when working with India ink. Experiment with a selection of mapping, round and square nibs to find out what works best for you. To begin with, use sized papers to prevent the ink from bleeding. When you've gained more experience, move on to NOT papers.

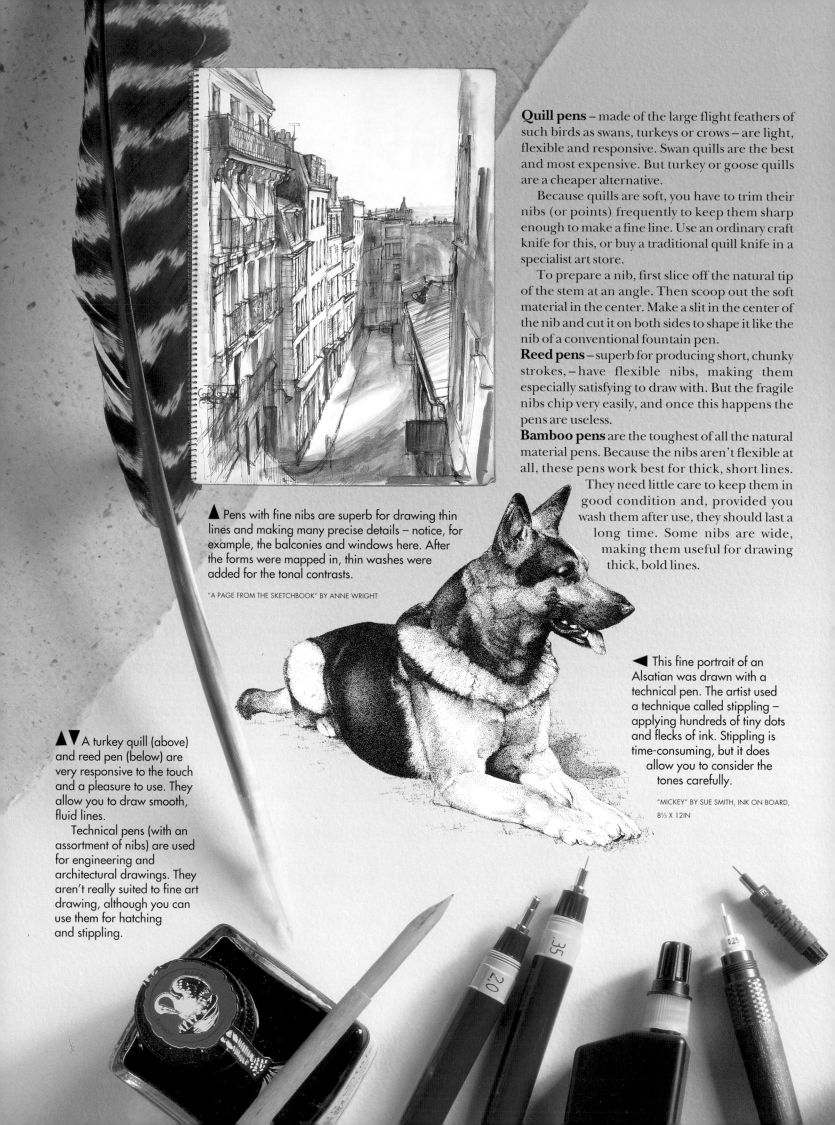

Quill pens – made of the large flight feathers of such birds as swans, turkeys or crows – are light, flexible and responsive. Swan quills are the best and most expensive. But turkey or goose quills are a cheaper alternative.

Because quills are soft, you have to trim their nibs (or points) frequently to keep them sharp enough to make a fine line. Use an ordinary craft knife for this, or buy a traditional quill knife in a specialist art store.

To prepare a nib, first slice off the natural tip of the stem at an angle. Then scoop out the soft material in the center. Make a slit in the center of the nib and cut it on both sides to shape it like the nib of a conventional fountain pen.

Reed pens – superb for producing short, chunky strokes, – have flexible nibs, making them especially satisfying to draw with. But the fragile nibs chip very easily, and once this happens the pens are useless.

Bamboo pens are the toughest of all the natural material pens. Because the nibs aren't flexible at all, these pens work best for thick, short lines. They need little care to keep them in good condition and, provided you wash them after use, they should last a long time. Some nibs are wide, making them useful for drawing thick, bold lines.

▲ Pens with fine nibs are superb for drawing thin lines and making many precise details – notice, for example, the balconies and windows here. After the forms were mapped in, thin washes were added for the tonal contrasts.

"A PAGE FROM THE SKETCHBOOK" BY ANNE WRIGHT

◄ This fine portrait of an Alsatian was drawn with a technical pen. The artist used a technique called stippling – applying hundreds of tiny dots and flecks of ink. Stippling is time-consuming, but it does allow you to consider the tones carefully.

"MICKEY" BY SUE SMITH, INK ON BOARD, 8⅓ X 12IN

▲▼ A turkey quill (above) and reed pen (below) are very responsive to the touch and a pleasure to use. They allow you to draw smooth, fluid lines.

Technical pens (with an assortment of nibs) are used for engineering and architectural drawings. They aren't really suited to fine art drawing, although you can use them for hatching and stippling.

Dip pens and their nibs

There's a wide range of nibs for dip pens on the market to choose from. Detachable steel nibs for dip pens are extremely flexible and come in myriad shapes and sizes.

Brush pens have nibs made from two wide, spatula-like plates of metal. They are excellent for making wide, bold lines and heavy shading.

Mapping pens have fine, pinpoint nibs for drawing precise detail and extremely fine lines for maps and technical artwork.

Script pens have pointed, round or square nibs and are mainly used for calligraphy, but you can use them for drawing, too. Round nibs are the most suitable for very thick work, while square ones create a fluid, ribbon-like line. Both types come in various sizes. Script nibs are split into sections so that you can change the width of a line as you draw it. Some nibs have two slits and some three for even broader work.

It takes practice to make a fluid line with a script pen. Start with a pointed, two-slit nib and work at developing tone and shading in simple sketches before you tackle the round and square heads. The variations in line width allow you to create a beautifully free style of cross-hatching.

Cartridge pens

Instead of dipping the pen into an ink well every few minutes, you can buy pens with ready-flow cartridges for convenience and easy use.

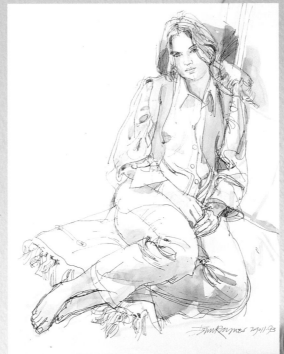

▲ In this portrait the artist used many lines to describe the form of the model. Very diluted washes of black watercolor paint provided the dark tones.

"NAOMI" BY JOHN RAYNES, PEN AND WASH ON PAPER, 21⅓ X 16⅔IN

▼ Expressive textures and tones are achieved by hatching and cross-hatching in selected areas.

"FARMHOUSE SCENE" BY GORDON BENNETT

▼ Bamboo pens (below) come in a range of sizes. They are superb for making thick, bold lines but aren't well suited to drawing very precise details. A fountain pen (above) is portable and easy to use – the perfect choice for sketching outdoors.

▲ Combining ink with other media –
pastel in this case – really helps to
bring out the details of the composition.

"CUSTOMS HOUSE, KINGS LYNN" BY JOHN TOOKEY,
PASTEL, WATERCOLOR AND INK ON PAPER, 11 X 15IN

▼ The artist worked solely with burnt
sienna ink to create this beautiful
monochromatic image.

"STILL LIFE WITH PRIMULAS" BY DENNIS GILBERT,
16 X 12IN

▲ The artist has simplified his painting to its basic tonal elements,
then worked over the architectural features with pen and ink to add
detail. Notice the variety of lines in the church – they give
spontaneity and freshness to the whole composition.

"NORTON ST. PHILIP CHURCH" BY STAN SMITH, GOUACHE AND INK ON PAPER, 15 X 11IN

▼ Use the same brushes for working with inks as you would for
watercolors. Round sables in various sizes work well – they're
responsive and can hold a lot of ink. Why not use a brush for
making whole drawings with ink? It's the
most expressive instrument you have.

◀ Skillful use of watercolor gives texture to the buildings and street, while the India ink adds detail to the bricks in the cobblestone road and the planks in the large wooden doors.

"TIMES PAST, SOUTHWARK" BY GILLIAN BURROWS, WATERCOLOR AND PEN AND INK ON PAPER, 16 X 11 IN

▼ Inks are available in many different colors – both opaque and transparent. You can apply them in much the same way as watercolors, using standard watercolor brushes or even Chinese brushes (below) for long, expressive, fluid strokes.

Technical pens have tubular stainless steel nibs in many sizes. They produce a line of even width – creating a somewhat mechanical feel. You can use them for stippling and shading, but they aren't suitable for free-hand artworks.

Refillable fountain pens You can also use fountain pens for drawing; some are marketed as sketching pens. They have a pump for drawing ink into a reservoir within the pen, and come with a fairly wide range of nibs.

India and colored inks

India ink (which actually originated in China) is pitch-black, waterproof and dries fast. The bottles are available in a range of sizes, but a little ink goes a long way. There's no need to spend a lot on huge quantities.

Chinese ink sticks come ready-ground in powder or stick form (which you have to grind yourself with a mortar and pestle). The sticks give you the freedom to make watery or thick ink.

If you want to work in color, buy a few small bottles while you develop your own artistic style and preferences. There are basically two types of inks – namely, waterproof and non-waterproof (sometimes called brilliant watercolors).

Inks offer brilliant, unparalleled colors – they are made from dyes, not pigments. You can buy both opaque and transparent colors, and they all dry very quickly. But their big disadvantage is that most fade in time. Since they aren't all lightfast, manufacturers don't recommend them for long-

▼ Brilliant concentrated liquid watercolors are water-soluble inks that aren't generally lightfast (not to be confused with watercolor paints). They come in a range of unparalleled colors with handy dropper cap bottles.

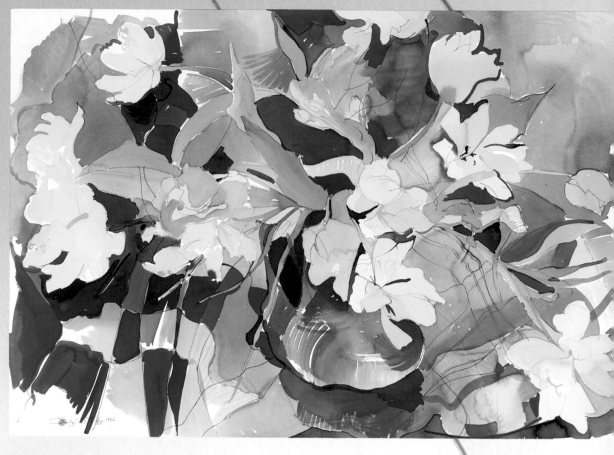

term, fine art drawings, but they are excellent for work that is to be reproduced. Don't use them for work that will be permanently displayed. "Permanent" on a label means waterproof or water-resistant, not necessarily lightfast.

Start with a small range of about six colors – we suggest lemon yellow, vermilion, ultramarine, brown, black and white. You can use these to make a wide range of other colors simply by mixing them. If you want to thin the ink, use distilled water, which has fewer impurities than tap water, but bear in mind that thinning may affect the vibrancy of the color.

Some transparent inks, such as non-waterproof India ink, are less light sensitive than permanent ones. As a general rule, drawing inks do not work well in fountain pens, although you can buy specially formulated calligraphic inks that flow exceedingly well.

You don't have to use ink on its own. With its fluidity and staining properties, colored inks add tone and atmosphere to pastel and

▲ As a result of a recent technological breakthrough, liquid acrylics are generally more lightfast than colored inks and are ideal for fine artists.

"HIGHGATE JUG, HAMPSTEAD TULIPS" BY JENNIE TUFFS, LIQUID ACRYLICS ON PAPER, 29 X 41 IN

watercolor paintings. You can also use inks in an airbrush to create pictures that have velvety smooth textures.

Papers for pen and ink work

Sized papers used to be the traditional choice for ink drawing because they prevented the ink from bleeding (or being absorbed into the paper). Today, you can buy several types of ready-stretched, coated papers and boards.

Stiff cartridge paper and NOT paper are also available. These work well, provided you allow for some bleeding at the edges of your lines. Whatever paper you choose, prepare it in much the same way as you would for a watercolor.

PORTRAIT IN DOT AND LINE

The delicacy, fine control and subtle range of marks possible with pen and ink make it ideal for portraits, helping you achieve great expression and character in your drawing.

One of the joys of drawing with a pen is the wonderful flow of ink through the nib – it means you can keep a continuous line going and call on dots, hatched, broken or continuous lines, thick and thin strokes, blobs, stipples and shading to create a huge variety of effects. And these help you render the subtle nuances of a person's features, expression, hair and skin with great sensitivity – and economy.

Remember, though, that pen and ink is very difficult to correct. The wonderful sense of fluency you achieve with pen and ink comes from the freshness and immediacy of its application, not from a labored build-up of ink. Each line must ring true from the start. Underpinning your drawing with pencil can be dangerous because once

you have made a pencil drawing you often merely reiterate – rather than re-invent – the lines, which results in a flat, "dead" picture rather than something fresh and lively.

If you want to keep a lovely fluency in your pen work, you must find a method to help you make measurements and establish the correct relationship between all the features of the face. A good way, chosen by our artist, is to begin by dotting in the main features very lightly, with no pencil work at all. The dots don't detract from the drawing, nor do they need covering up. Every mark brings its own quality to the work. Here, the dots (in very diluted ink) make a vital link from one position to another across the mask of the face.

▶ With any portrait, concentrate first on getting the relationships of the features right. The width between the eyes is critical – if you don't get that right, nothing else in the drawing will work (there should be roughly one eye's width between the eyes).

Once you've dealt with this, let yourself go and have some fun – take your line for a walk and explore the marks available!

"MARCUS" BY ALBANY
WISEMAN, PEN AND INK
ON PAPER, 16 X 12IN

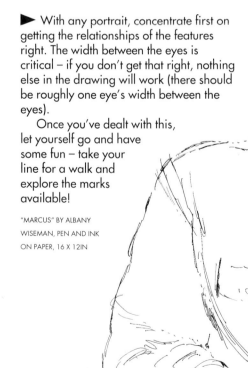

Making a mark
Practice different marks with your pen before you begin the drawing. Our artist diluted the ink with distilled water to help the ink flow smoothly and create a softer, grayer line for unobtrusive but helpful guidelines. The light gray lines can be strengthened later on if needed.

fine dotting to establish planes and positions

thin strokes for outlines and shading

tighter shading for darker shadows

scribbled lines for mass and detail

continuous line for contour and "exploration"

cross-hatching and strong, dark lines for emphasis

strong cross-hatching for the darkest tones

light swirls and dots for variety and interest

Naomi in a hat

▶ **The set-up** The hat framed our model's face attractively and produced some intriguing shadows. When working from life, take into account that the model sometimes has to move – try to make her as comfortable as possible.

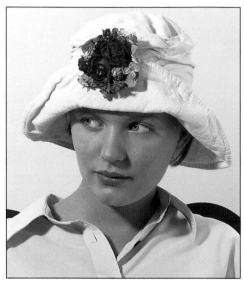

▼**1** Lightly dot in the eyes, eyebrows and the far cheekbone and the hat brim in diluted India ink. Emphasize the far eye and brow to establish the basic form. Using the dots, search for the exact relative positions of eyes, mouth, nose and cheek.

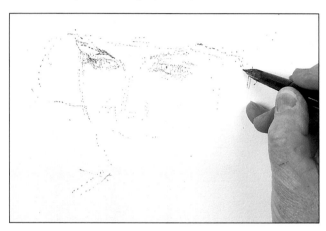

▼**2** Establish the shape of the hat and the line of neck and shoulder in light strokes, using the dots as guides. Dot in nose, nostrils and lips in darker ink. Go back to the far eye and eyebrow, strengthening them so you can read the eye sockets and the eyes traveling back into them.

▼**3** Continue drawing the hat, shading a little on the far temple. Strengthen the eyes and eyebrows again, and begin the central flower motif on the hat brim. The remaining guideline dots bring a happy freshness to the picture – rather than impede, they help your eye read the lines. There's no need to scrape them out.

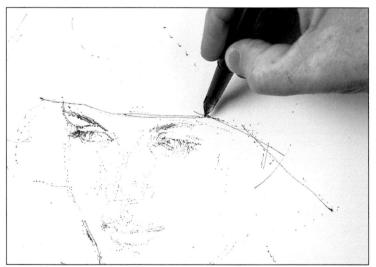

▶ **4** Now, with very diluted ink, start scribbling in the flower on the hat and the hat itself, which is very floppy against the hardness of the cheekbones and the soft chin and nose. Use very diluted ink – a light gray, very light line. Drop in a line or two at the bottom of the nose and along the far cheekbone.

▶ **5** Reinforce cheekbone and the far eye, eyebrow and eyelashes. Note that because the eye is spherical, the eyelid must travel around the sphere.

Work up the flower motif on the hat. The diluted ink is recessive while the pure ink lines now shaping the hat are assertive, creating a three-dimensional feel.

◀ **6** Strengthen the line between the lips, then sketch in the blouse. Put in the chin with a stronger line. (Note our artist was happy to correct the line of the neck.) Travel around from eyes to hat, back to the eyes and down to the mouth and chin.

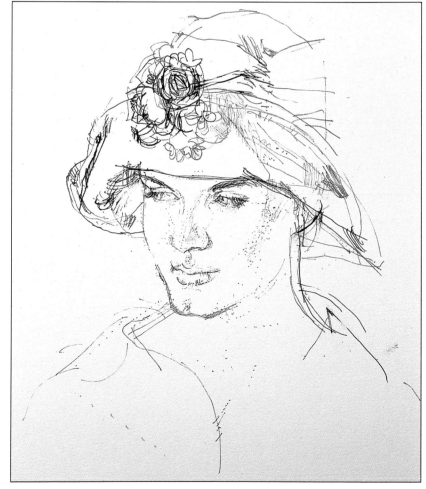

▲ **7** Return to the hat and firmly establish its shape and contours. The darker ink lines contrast well with the pale gray diluted ink marks. With all the features in place, our artist now produced a livelier, freer line – breathing a real spirit of life into the drawing.

▶ **8** Establish the shoulders and neck relative to the face in free, loose lines. Put in some assertive points – make sure the line between the lips is correct, draw in the nostrils and strengthen the near cheek.

Work up the flower in the hat in stronger, darker lines (no more diluted ink), using loose swirls and scribbles for mass and shape. Suggest the puckered band on the hat with a few angled lines.

9 Finish up final details around the neck and the side of the face. Using a fully charged pen and a bit more pressure, emphasize the lines indicating the right side of the neck and shoulder (the side nearest to you). These strong, dark, lively lines around neck, shoulder and hat point up the very careful, delicate treatment of the face itself. (If you treated the whole head like the face, it might not have so much vitality.)

10 With such economy of line, every stroke counts in this portrait, as do the lightness and darkness of the lines. Notice that there's no heavy shading to indicate tones or shadows.

Our artist has fully achieved a sense of three dimensions, at the same time suggesting the attractive character of the model. Positioning every feature in its correct place has produced an extremely good likeness, and he has retained a freshness, fluency and vitality in his use of pen and ink that gives great charm to the whole drawing.

Tip

Pen and ink tricks

Turn the pen the wrong way up, with the nib down, so you get a strong flow of ink and therefore a strong line. Dip the pen into some distilled water from time to time to improve the flow.

When diluting India ink, it's important to use distilled water — ink contains shellac, which, if mixed with ordinary tap water, causes the pigment to "separate," granulate and eventually become unusable.

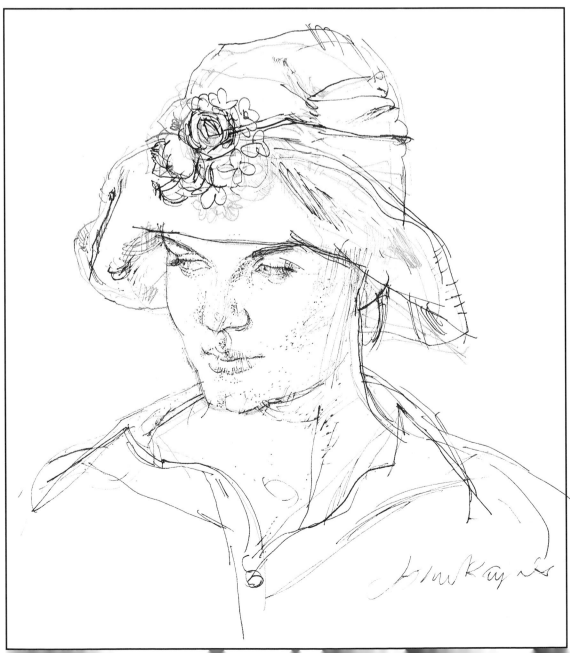

CHAPTER SIX

—

WATERCOLOR PAINTING

TOOLS AND TECHNIQUES

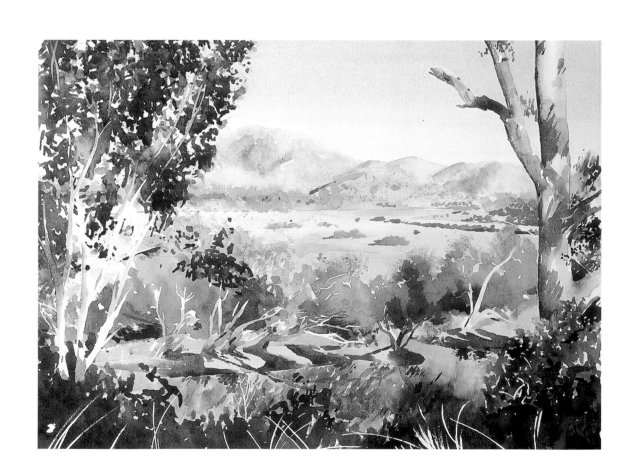

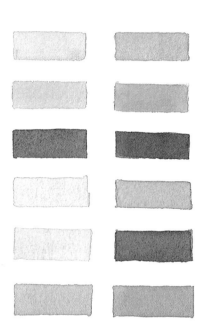

THE MAGIC OF WATERCOLOR

Watercolor is justly regarded as one of the most beautiful of all the painting media. For centuries painters have loved its freshness and translucency and today it is as popular as ever.

At its best, watercolor looks effortless. That's why so many people are tempted to try their hand at it, and why almost as many are disappointed with the results.

There are some basic principles and techniques to watercolor painting. Once you've mastered these, you'll find you can create successful watercolor pictures.

Laying flat washes, controlling colors flooding into each other and creating textures with an almost dry brush are all part of the process of discovering just how versatile watercolor is. You'll find that deliberately blurring several colors together can create some beautiful effects, while painting on damp paper produces a soft-edged look that is very appealing.

This doesn't stop you from taking full advantage of the unpredictable. Chance marks and happy accidents bring sparkle and spontaneity to your painting. When such things occur, leave well enough alone – let the picture itself "talk."

The characteristic translucency of watercolor comes from the whiteness of the paper showing through the transparent color. This is the only white available in watercolor, which is why artists choose to work mostly on white paper.

▼ All the magic of watercolor is here – transparent washes, soft gentle colors blending subtly together and sparkling white highlights.

"CHÂTEAU IN BRITTANY" BY ALBANY WISEMAN, 140LB PAPER, 18 X 24IN

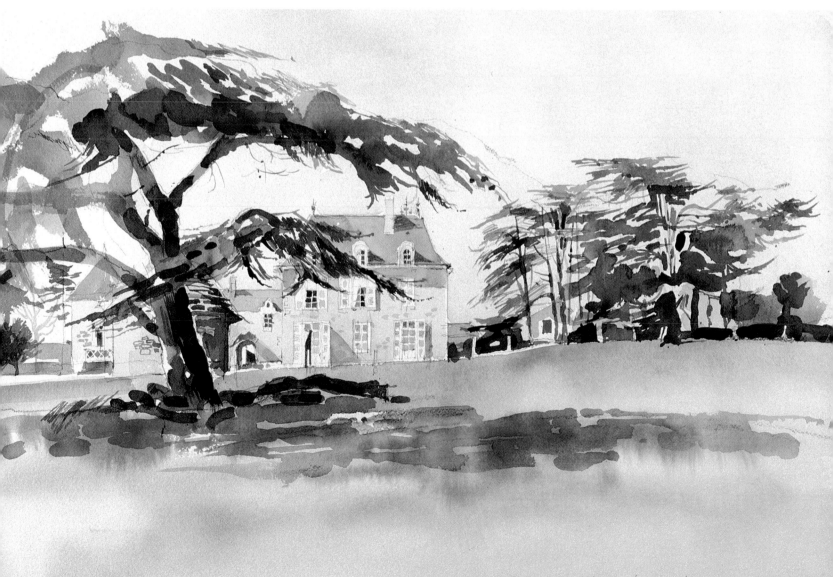

Tip

Keeping a record
As soon as you've taken the wrapping off your new pans of watercolor, paint a blob of each one on a sheet of paper and label it. Then when you pick up an unidentifiable pan, all you need to do is moisten the tip of your finger, dab it in the paint and test the color on a piece of paper. Then take a quick look at your home-made chart to tell what color it is.

BRUSH STARTER KIT

Keep things simple. You don't need many brushes to start with – one No. 12 round brush is all you need for the landscape painting on page 166. It handles washes and most other basic techniques well. For finer work you'll find a No.6 round and a No. 2 round useful. Buy all three in a sable/synthetic fiber mix – pure sables are very expensive.

Pans or tubes?

Watercolor is available mainly in two forms – semi-moist cakes of paint in pans, and soft paint in tubes. There are pros and cons to each.

Pans (and half pans) are most often available in assorted boxes of 12, 18 and 24, but they can also be bought singly, so you can have just as many or as few as you want. Useful if you need a whole range of colors, they're ideal when you want to carry only a minimum of equipment around with you.

Tubes are sold individually or in boxes. They have the edge over pans when it comes to covering large areas because you can buy big tubes and squeeze out as much paint as you need, but working on a small scale can be tedious as you constantly stop to squeeze different colors from the array of paint tubes.

Artists or students?

Whether you decide to use pans or tubes, you'll need to choose between artists' quality watercolor and students'. Be forewarned, though – it may be your pocket that does the deciding!

Students' colors are aimed at the beginner and in consequence are the cheaper of the two. All the colors are the same price.

Artists' colors, made from vastly superior pigments, cost four to six times more than students', depending on the color you choose.

Buy artists' colors if you can – with watercolor, more than any other medium, buy the best you can afford. Cheaper colors don't always produce the same effects as the more expensive ones.

One final word before you commit yourself to a choice of paints – buying a selected range of colors in a box does have distinct advantages. For a start, it is easier to transport than a bundle of loose tubes or pans, brushes and palettes. But more than this, a box keeps the paints from drying out. And many have convenient built-in mixing palettes in the lid.

Getting started

Bear in mind when starting out with watercolor that you require a *thin* wash, not a thick, opaque layer. If you use the paint straight from the tube or pan, you're liable to go through it too fast – working with watercolor paint correctly is much cheaper.

By dissolving the paint in water you create washes of different intensities – more water gives a paler wash, less water gives a deeper color. You can also use layer upon layer of transparent washes to build up the colors and shapes you want on the paper.

►Preparing a pan color wash

Using your brush, transfer a little water from the jar to one of the wells of the palette or to a saucer.

Wet the paint with the brush and mix the color well. Now load the brush with paint and transfer to the water in the palette.

Mix well, then add more paint or water as needed until you have a wash of the right color – but remember that watercolor dries paler. Test the color on a scrap of paper.

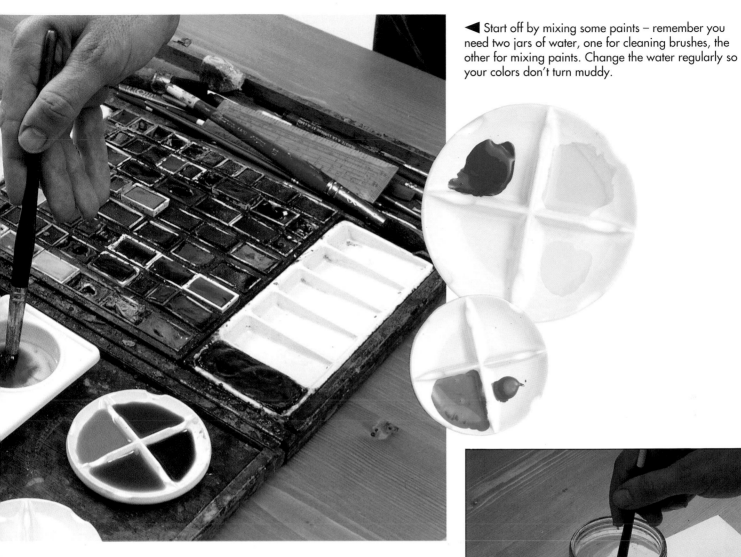

◄ Start off by mixing some paints – remember you need two jars of water, one for cleaning brushes, the other for mixing paints. Change the water regularly so your colors don't turn muddy.

► Preparing a tube color wash

Squeeze a little watercolor paint into one of the wells of the palette or into a saucer. Dip your brush in the jar and load with water. Transfer to the palette and mix well with the paint.

Add more water with your brush until you have a wash of the color you want – remember, though, that watercolor dries paler. Test the color on a scrap of paper.

Laying a flat wash

The secret of laying an even wash is to work cleanly, confidently, and without pausing. It is cheaper to use 90lb NOT paper and stretch it than to use heavier paper that doesn't need stretching. But if you don't wish to stretch paper, work on a pad of 140lb NOT, which is thick enough not to wrinkle when damp. Remove any dirt from the paper with a kneaded eraser.

Work flat or angle the board slightly to help the paint flow down the paper. Don't angle it too much, though, or your wash will end up darker at the bottom. Choose a large brush that holds plenty of paint and covers the paper with a minimum number of wide strokes. You can't get an even wash over a large area with a small brush.

Keep your water, mixing palette, and saucers together, so that you can move from one to the other without carrying your brush over the paper. Water or paint spilled on the paper can be removed but still affects the result.

▲ **1** Squeeze a dab of paint onto the palette and transfer a little to a saucer with your No.20 brush. Dip the brush into clean water and add some to the paint. Keep adding water until the puddle covers the bottom of the saucer. The more diluted your paint, the lighter your wash. If you want a darker wash simply add a little more paint from the palette. Mix plenty so that you don't run out half way through.

▲ **2** Soak the natural sponge in clean water and squeeze out the excess. Starting at the top edge, draw the sponge back and forth, working down the paper. Don't press too hard or water will run from the sponge, flooding the paper. Use just enough pressure to wet the paper evenly. Don't worry about going right up to the edge. If the paper is absorbent you may need to go over it again.

▲ **3** Apply the color wash before the paper dries. Using the No.20 brush, stir the paint and mix it well. Load the brush with paint and, starting at the top left hand corner, draw it across the top of the paper. When you reach the end, draw the brush back below the previous band. Overlap only slightly so you catch the paint above just enough to coax it down the paper. Don't stop until you reach the end.

▲ **4** When the wash is finished, place the board on a level surface and leave the paper to dry. This might take about an hour – it depends on how thick the paper is. Don't worry about small gaps between the bands of color; the dampness of the paper helps to close them. Any attempt to rework the surface while it's still damp results in flaring. As the paper dries the wash gets lighter and more even in tone.

Practicing watercolor

For this exercise it's best to work on stretched paper. If it is not stretched, even fairly heavy paper – such as 140lb NOT – it may wrinkle if it becomes excessively wet.

The aim of this exercise is to see what happens when you put wet paint on wet paper. Start by making the paper fairly damp – bordering on wet. You can repeat the exercise with different degrees of dryness and wetness later. Try a number of strokes to see what happens as the paint spreads.

There may be times when you wish the paint would stay the way it was when it was wet – but of course, it never does! Learning how effects change as the paper dries, and anticipating the result, only comes with practice.

SOLVE IT

Lifting out paint

You may find it convenient to tilt your board slightly. The drawback is that when working into a wet surface, the paint may run and come to rest against a dry edge in a small puddle. If allowed to dry the puddle forms a patch of darker color and may spoil the effect. The solution is to lift out the excess paint with a piece of paper towel. Don't overdo it though, or you'll leave a light patch.

▲**1** Dilute some sap green paint in a clean saucer with the No.20 brush – mix a good amount so that you can charge the brush fully. Wet an area of paper with a clean sponge or a large clean brush. (You may need to go over the paper a couple of times if it is particularly absorbent. Make sure the surface is clear of any specks of dust or hairs that might spoil the result.) Now drop some paint onto the paper.

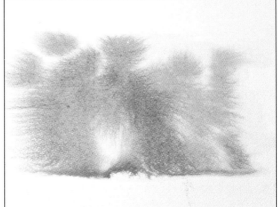

▲**2** Notice how the paint spreads immediately. Individual blobs start to join, leaving lighter areas in between. Here you can see that because the board was tilted slightly, the paint ran and collected in a line at the bottom of the wet area. Now let the paint dry.

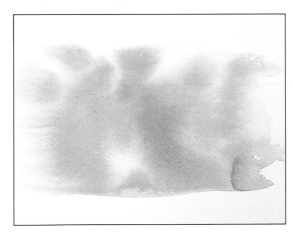

▲**3** Compare this step with the previous one and then the first one. See how much softer the shapes are now that the paint is dry. Heavy, opaque drops of color in the first step have dispersed and dried to form transparent areas of color only marginally darker than the surroundings. Here and there some of the pigment has separated slightly to give a yellowish tinge. At the bottom of the paper the paint has dried to a crisp line.

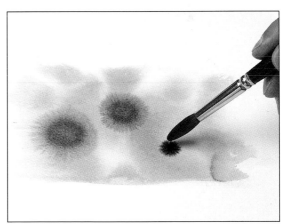

▲**4** Mix some alizarin crimson in a clean saucer, then use some more water to wet your paper again. (Notice how the green remains unaffected by the water.) Load the brush with the alizarin crimson and drop in some of the paint. See how it radiates from the tip of the brush to form brilliant circles of color – similar to ink on wet blotting paper.

Mixing colors: summer trees

To paint a simple landscape, find a pleasant view or do what our artist did and paint from the photograph he had taken.

If you've never worked with watercolor before, start by mixing up a few washes and allowing yourself time to get the feel of the brush and the paint.

Before you begin, make sure you have all the equipment at hand. Set up plenty of palettes for mixing washes, and don't forget to have two jars of water – one for mixing and another for cleaning your brush.

Our artist chose a heavy piece of watercolor paper for this painting and taped it to a board. As an alternative to a single sheet, you could use a glued pad to hold the paper taut.

He also chose a sheet of paper larger than he needed to provide space for testing colors. If you prefer, use a smaller piece and paint right up to the edges. You can test your colors on scraps of paper.

Keep things as simple as you can. Break down the landscape into broad areas of color, then work with just a limited range of paints. The large brush won't lend itself to putting in fine detail anyway.

At all costs avoid overworking – the paint and paper surface are delicate. If the paper starts to get really wet, don't panic – you can always blot it with a piece of paper towel.

Finally, have faith. It's sometimes hard to believe that everything will be all right when the paint dries, but you'll be pleasantly surprised at the final result.

1 Mix two washes for the sky – a lighter one of cobalt blue and a darker one of diluted Payne's gray. Test the colors.

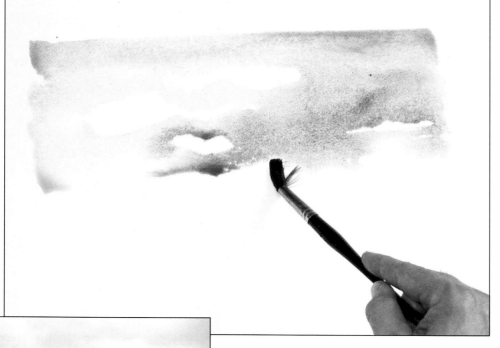

2 Load the brush with cobalt blue. Quickly lay a band of color at the top of the paper. Don't worry about covering all the paper – any white showing through will stand for clouds.

Now load the brush with Payne's gray and, starting below the cobalt band, lay the color across the paper. Angle it in all directions to get a modulated color – full of lights and darks. Allow colors to flood into one another so you lose the brush marks. Paint gray to the horizon.

To create an impression of distance here, lose some color by laying a clean wash of water over the bottom of the sky. Add warmth to the sky with a yellow ocher and Payne's gray mix. Let dry.

▲ **The set-up** Our artist used this photo as his starting point, but didn't copy it (he left the car out, for example).

3 Mix three washes for the foreground. One of sap green with a little cadmium yellow; another of sap green; and a third of sap green with some brown madder alizarin.

Working quickly, lay a band of the first mix. Then lay a band of the second mix below. As with the sky, allow the colors to flood into one another. Finally, lay a band of color with the third mix.

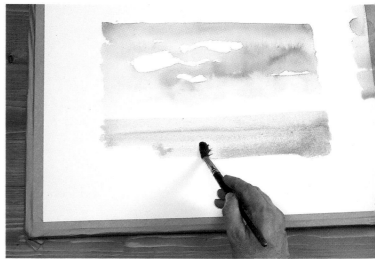

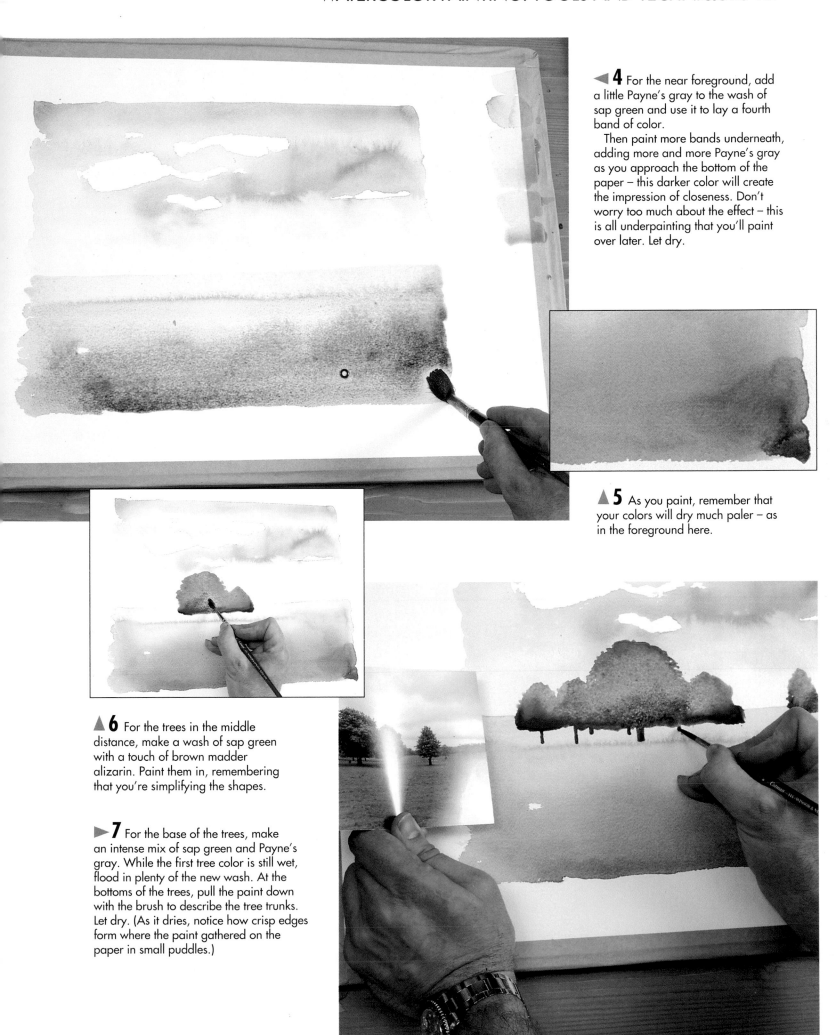

◀ **4** For the near foreground, add a little Payne's gray to the wash of sap green and use it to lay a fourth band of color.

Then paint more bands underneath, adding more and more Payne's gray as you approach the bottom of the paper – this darker color will create the impression of closeness. Don't worry too much about the effect – this is all underpainting that you'll paint over later. Let dry.

▲ **5** As you paint, remember that your colors will dry much paler – as in the foreground here.

▲ **6** For the trees in the middle distance, make a wash of sap green with a touch of brown madder alizarin. Paint them in, remembering that you're simplifying the shapes.

▶ **7** For the base of the trees, make an intense mix of sap green and Payne's gray. While the first tree color is still wet, flood in plenty of the new wash. At the bottoms of the trees, pull the paint down with the brush to describe the tree trunks. Let dry. (As it dries, notice how crisp edges form where the paint gathered on the paper in small puddles.)

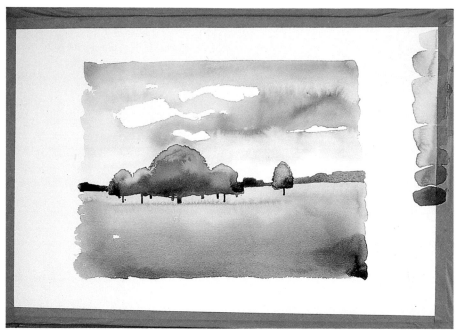

◄**8** Still using the intense mix of sap green and Payne's gray, lay in the trees on the horizon on the left. Let dry (20 minutes to half an hour).

▼**9** Paint in shadows under the trees with the sap green and Payne's gray mix.

Then, using one of your darker green washes, lay some patches of color on the trees. Avoid moving the paint around – you want puddles that will dry with hard edges to describe clumps of foliage. Paint the smaller trees in the background using the same technique.

Now step back and assess what your picture needs. Here the underpainted foreground looks rather thin and flat, so the artist added texture to it by laying more sap green and Payne's gray mix over it. Again, he didn't work it too much because he wanted some crisp edges to form. Let the finished painting dry.

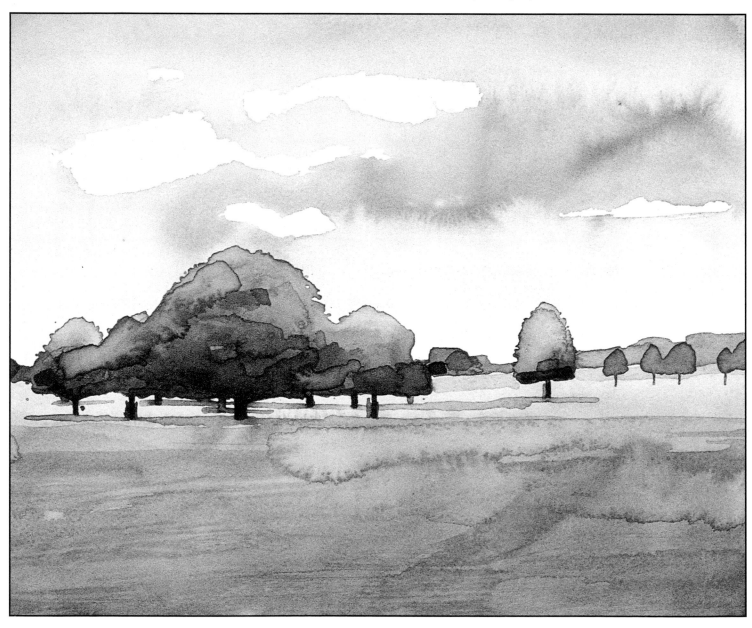

WORKING WET-IN-WET

The technique of painting wet-in-wet produces beautiful, soft, blurred colors. You can combine various wet-in-wet washes to build up form with several layers of tonal shading.

Painting wet-in-wet is simple to learn (as we saw on page 165), but the art lies in controlling it. You are dealing with liquid color on top of liquid – the mixing of two wet layers that results in softness and blurring. It's essential to start with stable, heavy watercolor paper, which prevents too much movement and soaks up the water. You must stretch the paper beforehand or, as the artist did, use a very thick 300lb sheet that won't buckle from the wet washes. Wet-in-wet blending can be controlled in various ways – for instance by regulating the amount of water or color wash you apply. The more watery the layers, the softer and more rapid the blending. You can apply a clear water wash or tint it lightly, and use contrast colors or the same color but in increasing intensity.

If you restrict the water content of the top layer you can see the top color slowly "star" out into the base watery wash. And blotting the wash as soon as it starts to blend gives a "frozen" effect with a crisper, sponged look.

▼ Large, nondescript areas, such as the background, can be transformed into lively, vigorous parts of a painting by applying washes of color to wet paper and letting the paint flow wet-in-wet.

If you want to prevent a wash from spreading where it's not needed, one good method is to leave a thin, dry white line, as our artist has done around some of the apples.

"STILL LIFE WITH APPLES" BY PENELOPE ANSTICE, WATERCOLOR ON PAPER, 21 X 14IN

Fruit and flower still life

YOU WILL NEED

☐ A 23 x 23in sheet of 300lb Rough watercolor paper

☐ Four synthetic round brushes: Nos. 12, 10, 6 and 2; and a ¾in flat wash brush

☐ Two jars of water; tissues

☐ Drawing board and tape or thumbtacks

☐ A water-soluble green colored pencil

☐ Twelve artists' quality watercolors: cadmium lemon, cadmium yellow, permanent rose, alizarin crimson, vermilion, cerulean, ultramarine, sap green, emerald, Winsor violet, indigo and black

It always helps to practice a technique several times before applying it to a real painting. Experiment with these washes until you gain a feel for what will develop. Keep a scrap of paper at hand to try them out as you paint. (Even our experienced artist used a spare piece of paper to loosen up her brushwork.) You need to start painting with a confident, large, loose stroke and the practice run can help you get rid of tension in your arm.

Watercolors dry lighter, so load plenty of color into the washes if you want strong effects. Dry watercolor can easily be revived – if you don't like the effect, or want it to appear more intense, re-wet it and repeat.

▶ **The set-up** The combination of an attractive ceramic vase, fruit and some flowers makes a classic still-life subject – here given a modern look with clear, simple lines and the contrasting brilliant blue background.

◀**1** Sketch in the composition with the water-soluble colored pencil. Start with faint direction lines, then add the main shapes with a firmer line.

Roughly cover the top three-quarters of the paper with lots of clean water. Mix a pale wash of ultramarine and cerulean and fill in the background with the wash brush. (Don't let it go over the vase, fruits or palm fronds.) Use loose strokes, pulling the color around the shapes with your brush.

▶**2** Dilute some sap green to make a thin wash. Using the side of the wash brush, stroke the color out along the palm fronds. Let the shape of the brush itself define the foliage. Try not to let the blue and green washes touch here. Leave a line of white, but if it touches slightly, just pull the resulting blur in the direction of the frond.

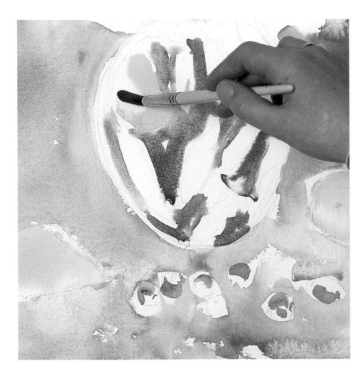

◀**3** The fruit and vase now need a base wash. Using the large round brush, mix a thin cadmium lemon and sap green wash and roughly fill in the pears. Don't allow this color to bleed into the blue. Do the same for the cherries, using a diluted red and painting partial cherry forms in curved brushstrokes.

Paint in the deeper blue of the vase, leaving the pattern unpainted, then fill in the fruit with cadmium yellow (a stronger yellow than that used for the pears). Note that this vase is almost a mirror of the larger composition but with more intense colors.

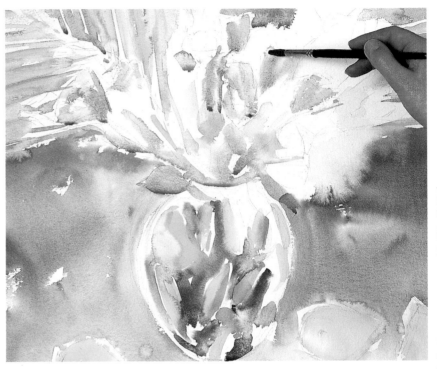

▶**4** Mix several light washes with the No.10 brush for the other fruit and leaves on the vase. Make a bluer green using emerald for some of the leaves, and try the pale lemon color already mixed for the pears on others; then create a mix of rose and crimson for the pale pink flowers and use the same mix for the cherries on the vase. Just work on the broad shapes – more details will be added later.

▼**5** Change to the No.6 brush. You now need stronger colors, but still wet enough to blur softly. Outline the flower stems in sap green and the buds in a softer, yellower green. The flowers have twisting buds, so try to show this in the outlining.

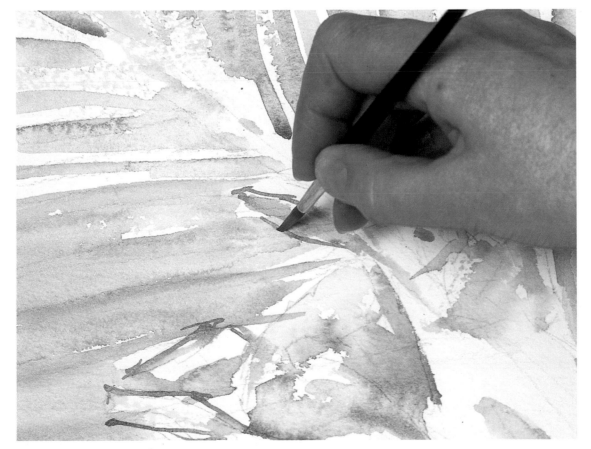

BRUSH SIZES

Different size brushes can help create variation in wet washes. You can sweep a light wash over the paper in soft bands with a large brush – ideal for skies and backgrounds. Smaller brushstrokes with intense color give a different feel – try this for varied foliage effects.

Blobs of paint produce stars that vary with the amount of water and the depth of color. Let them dry and you sometimes find unexpected little filigree patches developing later when a strong color sits on a lighter wash.

▶ **6** You are now moving on to richer washes. The preliminary light washes have been laid down, and the sharper details of the stems have been picked out, so now the stronger shapes need sharpening. Apply a darker version of the blue on the vase, and also pick out the patterns in stronger washes of yellow and green.

Mix a fairly intense blue-green wash and, with the No.6 brush, stroke in the leaves of the pink flowers. Use the shape of the brush for the stroke, pressing down for the width and off for the thin end. One stroke per leaf gives you a lovely leaf shape.

Step back now and take an overview. Check the composition. The background wash still needs to be deepened to strengthen the painting.

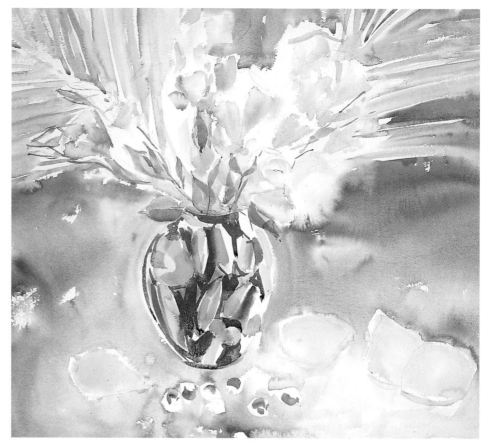

▶ **7** Apply another wash of clean water around the vase, then paint a darker but still loose blue wash on top. Use the wash brush for the bigger strokes, but take care that you don't distort the outline of the vase.

Define the shapes of the spiky palm fronds, using the No.10 or No.12 round brush to pull the darker blue wash tightly in between each leaf. At this stage you can adjust the leaf shapes, but exercise great care and control as you do so. You don't want to paint a leaf out of existence!

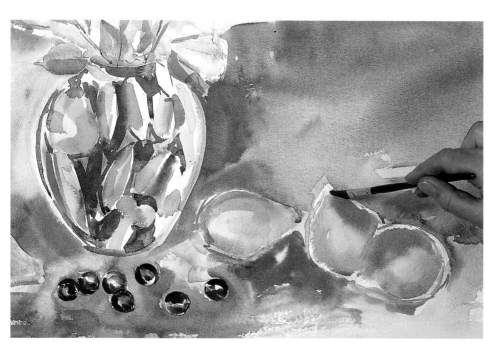

◀ **8** Now work on the fruit. First apply a darker shade of the yellow-green wash on the pears, adding cadmium yellow for a deeper color. Apply a warm red wash (alizarin crimson with vermilion) on the top side of the three pears on the right. The colors will bleed slightly, blurring the edges. Control the blurring to imitate the blush on the pear.

Paint the cherries in a darker crimson wash. These don't need the same wet blurred effect – a drier application of paint gives firm shapes. Add just a touch of violet to the crimson to deepen the color on the underneath of the curves.

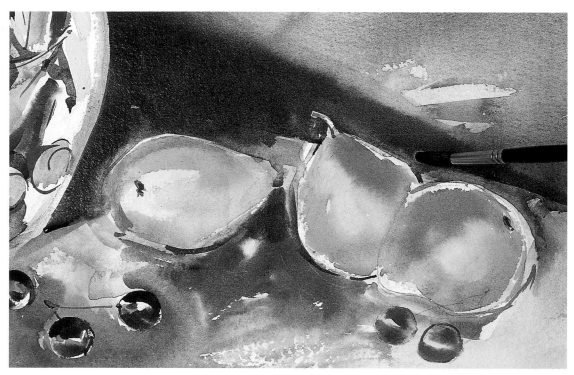

◄**9** Using your smallest brush with indigo or black, lightly touch in the stalks and dimples of the cherries and pears. With the same color make some quick flourishes around the outlines of the shapes on the vase to strengthen them.

Re-wet the right side of the background for the triangular shadow, using the wash brush and clean water. Once this water is painted on, stroke on a strong blue shadow. Make sure the edges of the stronger color blend in with the background. Soften the edge with more water if necessary.

◄**10** You may find that this deeper color unbalances the picture. Take a look at the flowers and check that they are strong enough. Our artist found that the background blue behind needed to be deeper in tone to bring the flowers forward again. She carefully painted in another blue wash behind the flowers, between the stems and petals.

▼**11** The flowers and buds also need work. Strengthen a few petals and stems with a thin, strong line in sap green, using the No.6 brush. Deepen the rose-pink wash in some areas and apply touches of violet-pink to the inside of the flowers to give them some depth.

LIQUID ADDITIVES

Various brands are available to help the washes flow. Traditionally **ox gall** was added to the water to improve flow. Now there are several modern additives (similar to detergents) that do the same thing, such as Winsor & Newton's watercolor medium. These break down the water tension, which means you can get blurring effects with smaller amounts of water, helping to keep your watercolor paper in better condition.

►**12** Strengthen the edges around some of the flowers by applying another layer of blue. Don't overpaint this – let the different blue tones show in some areas to create a halo effect around the flowers which makes them shimmer slightly.

Strengthen the blue-green foliage by adding a more intense wash to some of the leaves.

▼**13** Take a good look to see where your painting may be unbalanced. Make sure the fruit sits forward in the painting, retouching with another deeper layer of color if necessary. Notice that the pink flowers have been deepened in this way. The layers of washes start to outline each other, creating broken-color effects that contrast with the soft blurring of the backcloth. Once you are satisfied with the picture, apply one last coat of clear water over the entire painting to soften any last-minute changes.

In the finished picture you can see how well the informal and deliberately loose style complements the wet-on-wet technique.

WET-ON-DRY TECHNIQUES

**Achieve crisp, clean effects
by building transparent layers
of paint on a dry surface.**

In the wet-in-wet technique (see pages 169–174), you apply paint to a wet or damp surface. The result is a shape with a soft edge. With wet-on-dry, you work on dry paper or paint and the effect is entirely different. Shapes are sharply defined – often with a very crisp edge. Whether you apply paint with a stroke of the brush or drop it onto the paper, you can work in a far more controlled and detailed way.

The quality of an edge is important in watercolor. With wet-on-dry you can use a clearly defined edge to capture form – a close-up of a leaf, for instance, or a range of mountains.

The wetness of the paint has an effect on the result too. For example, diluted green stroked on the paper dries with an even tone. A wet blob of the same color dropped onto the paper dries with a clearly defined edge because some of the pigment tends to migrate to the edge of the shape, reinforcing the outline.

If you are new to watercolor you might be tempted to work wet-on-dry all the time – for the sake of control – but you would lose much of the joy of the medium. It's the spontaneity and unpredictability of paint on a wet or damp surface that give watercolor its special quality. So it's often good to combine both techniques – working wet-in-wet in the early stages and then applying some detail wet-on-dry to pull the painting together later on.

▼ The warmth and light of this Mediterranean scene are captured perfectly by the wet-on-dry technique.

Crisp but smooth-edged shapes describe the dappled shadows of the leaves, while the vine leaves themselves are built up from ragged-edged patches of transparent and nearly opaque paint.

"VINE SHADOWS" BY ILANA RICHARDSON, PAPER, 1992, 11⅓ X 15⅛IN, COURTESY OF CCA GALLERIES, LONDON

YOU WILL NEED

☐ An 11 x 15in sheet of stretched 90–140lb NOT paper

☐ A B or 2B pencil

☐ Three round brushes: Nos. 10, 6 and 3

☐ Several jars of clean water

☐ Mixing palettes

☐ Ruler (optional)

☐ Seven colors: cobalt blue, Davy's gray, Payne's gray, yellow ocher, cadmium orange, cadmium red, sap green

Church by the sea

▶ **The set-up** Our artist is a compulsive drawer and has a great many sketchbooks of scenes that he has come across on vacation. For this painting his inspiration was a small sketch of a Moorish church at Collioure in southwest France. He used a flat Derwent sketching pencil to get a great variety of marks, and took notes of the colors.

▲ Paint on the palette looks much darker than it does when applied to paper. Once the paint is dry it is paler still and bears little resemblance to the color seen in the palette. You'll get used to this as you gain experience.

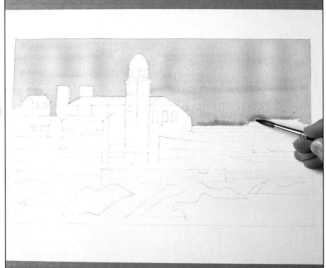

1 Sketch the composition using a fairly soft pencil. Don't make the drawing too tight. The idea is to treat the subject in flat areas of color and then put a little texture over it. Just map in the main shapes.

◀ **2** Dilute some cobalt blue. Wet the paper where the sky will be. Starting at the top of the paper, use your No.10 brush to lay a flat wash. (It helps to angle the board slightly toward you.)

Keep the brush moving so you can complete the sky before the paper dries. Use a dry No.6 brush to catch excess paint collecting at the bottom of the wet area. Let dry.

▶ **3** Dilute some Davy's gray in the palette and, using the No.6 brush, start to put in the main shapes: the buttresses of the church, the tower, church wall, quayside and the rocks in the foreground. Leave some of the white of the paper to represent bricks in the quayside wall. Let dry.

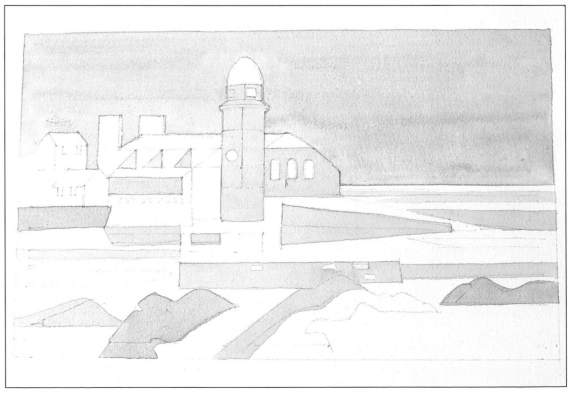

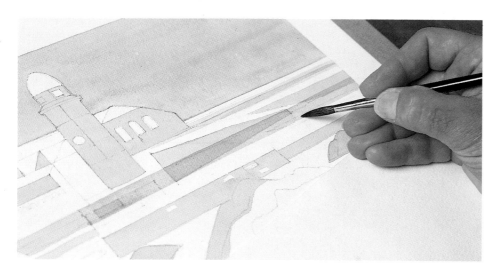

◄ **4** Paint in the water using cobalt blue and the same brush. Rest your hand on a piece of clean scrap paper to protect the watercolor paper from grease and excess paint.

You can make freehand strokes or use a ruler if you wish. Our artist did both. If you find it difficult to get into the corners, turn the board around. Let dry.

► **5** Here you can see how the dry Davy's gray shows through the layers of transparent blue. If you look at the horizontal blue strip across the middle, you can see how the edges have dried slightly darker, creating the clean, crisp shape typical of the wet-on-dry technique.

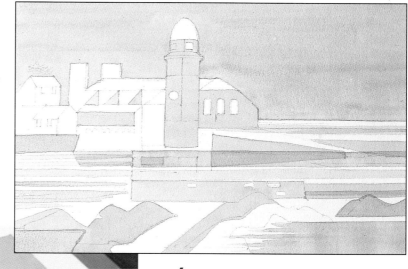

◄ **6** Dilute some yellow ocher and add a little Payne's gray to make it less intense. Still with the same brush, use this mix to put in the remaining triangles between the buttresses and the church wall.

Now strengthen some of the previous grays – the strips to the right of the church, the quayside wall and the shadow up the side of the tower. Don't be afraid to go outside the original areas and to leave some gaps so the existing gray shows through. Let dry.

DID YOU KNOW?

Davy's gray

So far Payne's gray has been used a lot in our demonstrations. Davy's gray is another useful one for your palette. Made from powdered slate, it is much lighter than Payne's gray and dries to a slightly warmer – greenish – hue.

7 Dilute some Payne's gray and, using the same brush, darken the rocks and the wall next to the church.

Try to avoid solid blocks of color. Notice how the artist leaves gaps in the wall to represent bricks and in the rocks to create the impression of an even undulating surface.

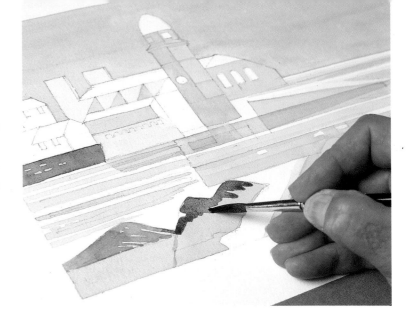

8 Using the No.3 brush and the same gray, paint in the church windows and a few of the bricks on the end of the quay. Flecks of white in the rock on the right serve as foam and help to break up this dark, dominating shape.

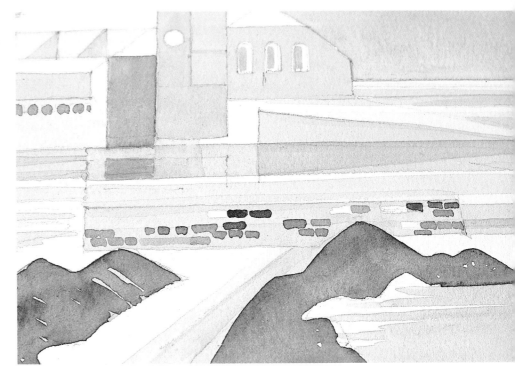

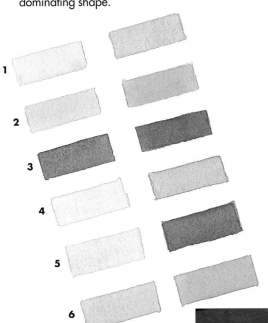

▲ The artist made this sample sheet of the colors in his painting. He sometimes laid several washes of the same color one over the other.

Here he has repeated a stronger tone on the right to give an idea of the range: cobalt blue (1), Davy's gray (2), Payne's gray (3), yellow ocher and Payne's gray (4), cadmium orange and cadmium red (5), sap green and Payne's gray (6). Compare these dry painted colors with the paint on the palette two pages back and you can see how much lighter they are when dry.

9 Assess the tones in your painting. Unless your first washes of cobalt blue were exceptionally strong you'll need to intensify them. If you still have some on your palette, make sure that it is well mixed and, using the full width of the No.10 brush, put some bold strips of color over the sky.

Now do the same for the sea using thinner strips and the No.6 brush. Notice how paler strips left in the sky lend depth to the painting.

◄ **10** Mix some cadmium red and cadmium orange in roughly equal proportions. This exciting tangerine color placed among the cool grays and blues really brings the painting to life. Use your No.3 brush to paint the roofs. Let the paint dry.

► **11** Check the tones. You might find – as our artist did – that some of the reds need another wash. Don't overdo it, though. Try leaving the dome – the most prominent form – palest of all.

You might have to intensify some of the grays too. The artist used his No.3 brush and Davy's gray to strengthen the base of the church tower, wall, windows and the causeway in the foreground. Let dry.

▼ **12** Dilute some sap green and soften it with just a hint of Payne's gray. Using the No.3 brush, put in the parasol pine to the left of the buildings and the wedge shape to the right of the church. A broad band of green around the edge of the rocks in the foreground suggests weeds.

Tip

Flat color
Because the artist wanted to exploit flat, uniform areas of color, he added ox gall solution to the paint. Just one drop added to diluted paint in the palette breaks the surface tension of the paint and actually improves the "wetability" of the paper itself, helping the pigments to disperse evenly over it.

◀ **13** So far, most of the shapes are geometric and flat. Now use some freer brushwork to give a looser feel. With the tip of your No.3 brush and some Payne's gray, work some texture into the rocks in the foreground. Let dry.

▼ **14** The few slight adjustments needed to finish the picture are more a matter of personal choice than necessity. Perhaps the most significant are laying another wash over the water to make it the most intense of the blues and strengthening the shadow on the left side of the tower. Detailing on the church turrets and the tower's reflection – using Davy's gray – and a second wash over the green wedge, help to attract your attention.

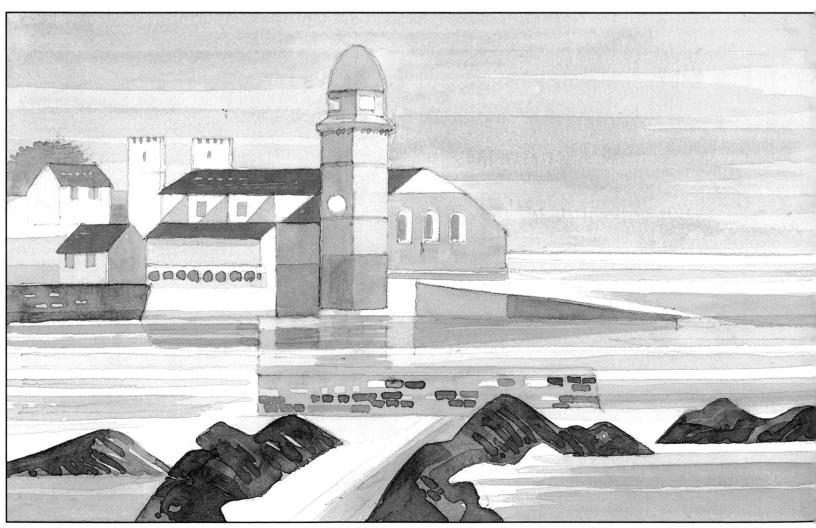

USING A LIMITED PALETTE

One of the delights of watercolor is the way the white of the support shines through the translucent washes of color, so that the medium appears to trap the light. Try to retain this quality when you apply your washes.

You will find it easier to take advantage of the special freshness and clarity of watercolor if you stick to a limited palette of no more than seven or eight colors. By using your knowledge of color and color mixing (see Chapter 2) you will be able to mix all the shades you need. This method of working has many advantages. It will save you money because you don't have to rush out and buy dozens of extra colors. Using a selective range has great advantages. For a start, your painting is much more likely to harmonize, particularly if you let the colors flit over the painting. You're also less likely to have jarring elements because you aren't tempted to dip into colors that are not harmonious. Of course, experienced artists often limit the colors they use automatically, even if they have a huge range on the palette in front of them, but for beginners it can help to be selective from the start.

The range of colors you select should suit your subject, mood and style of painting. Choose only the colors you think you really need – you can always mix them to make new ones.

For her painting of the Australian bush (next page) our artist chose strong colors to capture the light, hot atmosphere and vegetation of the area. Her palette comprised cadmium yellow, two reds and two blues plus a good strong green and one earth color. To these she added two inks to increase the vibrancy of the painting.

In rendering this scene, our artist maintained a freshness that is often lost when working from a photograph in the absence of natural light. She avoided this problem by making a note of the colors on site, so it didn't matter if they were changed by the photographic process. In addition, she worked fairly quickly, without breaks, combining many techniques with a spontaneous approach.

▼ A carefully selected palette of blues, greens and grays plus a basic yellow is all you need to paint a landscape like this one. As usual in transparent watercolor, the white of the paper provides the highlights.

"AMBERLEY CHALK PITS, SUSSEX" BY ROGER SAMPSON, WATERCOLOR ON PAPER

Australian landscape

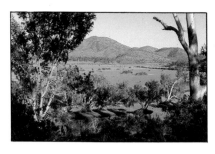

▲ **The set-up** Our artist used a photograph and some quick color references as her starting point. She made the color references on site, in case the colors in the photograph didn't come out true to life.

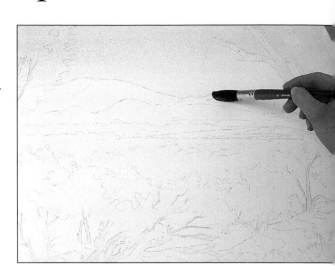

▶ **1** Lightly pencil in the main elements of the landscape. When you're happy with the composition, use the masking fluid and your old brush to block out areas you wish to leave white, such as the stems of the bushes and the tree trunks. Clean the brush immediately in warm, soapy water.

Mix ice blue ink with French ultramarine and cerulean blue, adding plenty of water. Fill in the sky with your wash brush, starting at the top and adding more water as you go down – this line of lightest blue on the horizon helps to create a sense of distance.

About three-quarters of the way down, dab your brush with a touch of permanent rose to create a sunset mood. Blot off any excess water with a paper towel and blend over the hills so you don't create a hard, unnatural edge.

◀ **2** Add a touch more blue ink to your wash and use it to paint in the rivers, aiming for a flat finish to suggest still evening water. Take the color to the very edges so that when the foliage is laid on top, the river can be seen through it. Again, blot with a paper towel if the painting becomes too wet.

For reflections in the water, use the clean ½in flat to lift off a little blue.

YOU WILL NEED

- [] A 30 x 23in sheet of 140gsm stretched NOT Bockingford watercolor paper
- [] A drawing board
- [] Masking tape
- [] Two jars of water
- [] White plate or palettes
- [] A craft knife
- [] Pencil eraser
- [] Hair dryer
- [] Masking fluid
- [] Paper towels
- [] HB pencil
- [] Four brushes: ½in flat, No.6 round wash, No.4 round and an old brush for the masking fluid
- [] Seven watercolors: cadmium yellow, cadmium red, permanent rose, Hooker's green dark, cerulean blue, French ultramarine, burnt sienna
- [] Two Ecoline inks: olive green and ice blue

▶ **3** Use the wash brush to apply a loose wash of burnt sienna to the mountains. Working wet-in-wet, dab in a little cadmium red, mixing right on the paper. This darkens the mountains and sends them into the distance. Quickly dab on some ultramarine and Hooker's green to suggest the gum trees on the mountains. See how they have already taken shape.

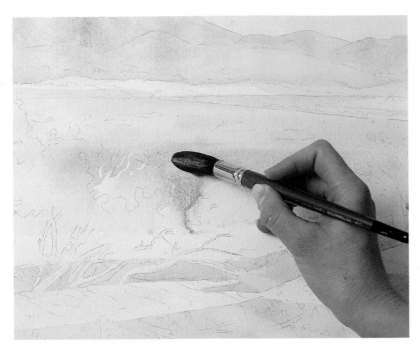

◀ 4 When you move on to a new area and don't want the colors to bleed into each other, make sure that the first color is absolutely dry. A hair dryer is handy to speed things up.

When the rivers are dry, apply a wash of burnt sienna to the land, including the islands in the river. While this is wet, add extra touches of burnt sienna to the main land area so that you create a marbled effect.

▲ An ordinary white plate makes a perfectly acceptable palette, although you'll need something deeper if you want to mix large washes.

▶ 5 When the mountains are dry, add more details with the same four colors used earlier – burnt sienna, ultramarine, Hooker's green and cadmium red. You can be adventurous with this, turning and dabbing the brush freely to create interesting color combinations. Let dry, then soften and blend the colors with clean water. If the mountains create a hard line where they meet the sky, soften the edges when dry with clean water, using your ½in flat.

▼ 6 Deck the hills with greenery using your ½in flat and mixes of Hooker's green, cadmium red and olive green ink. Rinse your brush, then add clean water to blend the edges into the plain.

Now you can try flicking paint to give an impression of scrubby foliage. Charge your ½in flat with paint and flick it at the paper with your fingers from about 6in away. Use less water where you want more detail. This natural-looking effect helps add form and dimension to the hills.

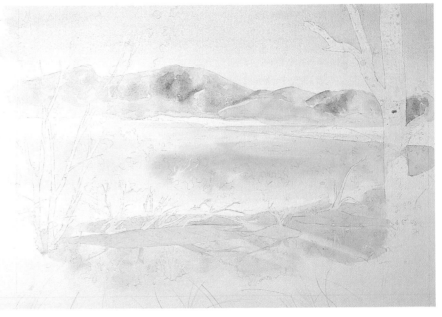

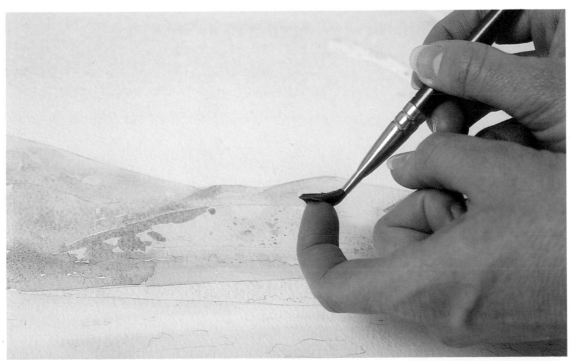

▶ 7 To create darker greens, add more ultramarine to the mix; add more cadmium red for warmer greens. Where the foliage is dense along the side of the river, use a strong, dark green wash and your flat brush, wet-on-dry.

Once the specked hills are dry, add more details with the same washes.

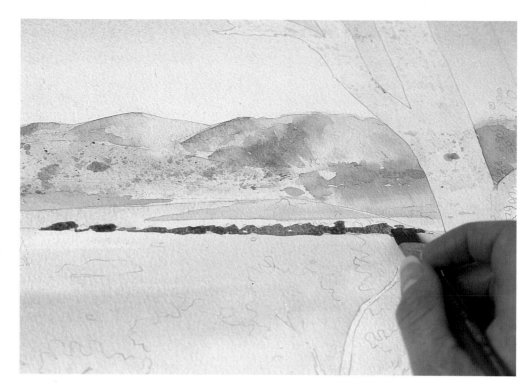

Tip

When accidents happen

In step 4 you can see that our artist accidentally washed blue over an island in the foreground. To rectify this she lifted off a little color with the ½ in flat, then cleaned the brush and scrubbed over it again to lighten the tone. You can use this method to rectify any mistakes you make – but you must act quickly, before the paint has a chance to dry.

◀ 8 Here's another chance to experiment with your palette. Be bold in your approach and work quickly to maintain freshness. For the eucalyptus bushes in the foreground, dampen the paper, then drop cadmium yellow onto the sunlit areas and ultramarine onto the shadows, wet-in-wet. You can work freely because the masking fluid protects the bush twigs from the paint.

▶ 9 Our artist now stippled over the bushes with the clean, wet edge of her ½in flat to blend and soften the colors. Other colors can be added using the same technique to block in shady areas.

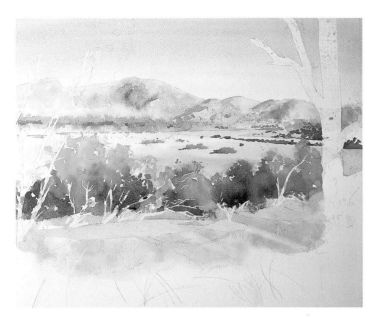

◀ **10** Stand back and look at your painting. See how the different techniques have created depth and texture. Notice, especially, how the clear water blending has created atmosphere and the way the blues combine to send the mountains back into the distance.

▼ **11** Now start work on the foreground. Dampen the paper with clean water, then use a fairly dry brush to dab on strong blue and green washes. Aim to create a variety of tones and textures, adding green ink for vibrancy, and ranging from wet to dryish paint.

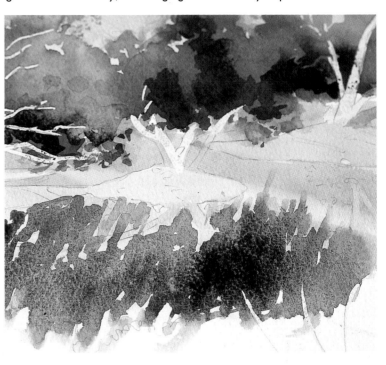

▲ ▶ **12** Add shadows to the river by dampening the area with water, then adding pure ultramarine with your ½in flat. Add cadmium yellow to areas that need lightening, then dampen your brush in clean water and use it to blend the edges of the colors.

Use your greens – mixed from Hooker's green, ultramarine, cadmium red, cadmium yellow and burnt sienna – to paint the leaves of the gum tree (above). Dab on some color with your ½in brush, then spatter on more color with a fairly watery mix to suggest individual leaves (right). Work into the splatters, wet-on-wet, adding cadmium red for darker areas and cadmium yellow for lighter ones.

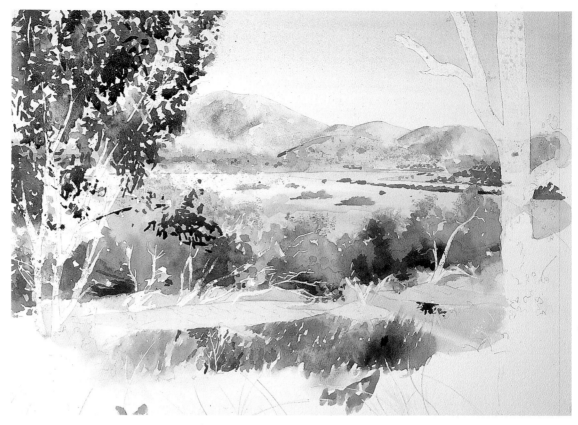

▲ **13** Continue working into the tree foliage wet-on-wet, adding olive green ink for darker shades and softening the edges of the foliage with a clean, wet brush. Use the sides and flat edge of the brush for greater variety. Finally, paint in the fine lines of the branches with olive green ink, making use of the flat edge of the brush.

Notice how you can create a wide range of greens by remixing the colors of your palette. All the greens go well together because they have the same sources.

◄ **14** Now work on the foreground foliage again, dampening the paper so that you can work wet-on-wet. Don't be afraid to drop in pure color, such as Hooker's green dark, shown here, to create exciting combinations.

► **15** To create the shimmering reflections of low evening light, our artist used a clean, wet brush to scrub off color, then dabbed the area with a paper towel.

Stand back and assess your painting, then refine any areas that you think need work.

▶ **16** Now comes the exciting moment when you can remove the masking fluid – but first make sure that the painting is completely dry or you will smudge it. Use a hair dryer if necessary to accelerate drying.

Rub off the masking fluid with clean fingers, then erase any unwanted pencil lines. The eraser may lighten the surrounding paint color, but you can use this to your advantage.

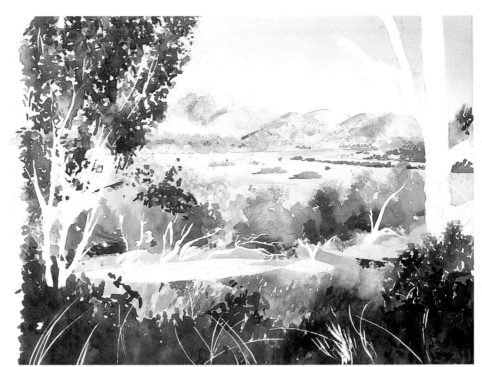

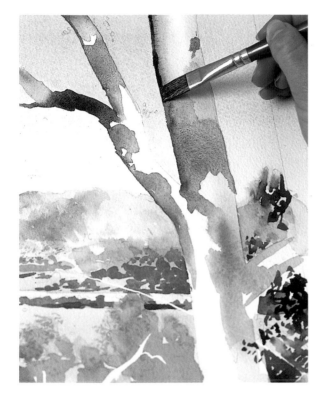

▲ **17** Mix various warm purple washes of ultramarine and burnt sienna with clean water, then use your ½in flat to block in the colors of the trunk on the right, starting with the lighter areas. Make bold use of your brush, changing the angle to create different lines. Work into dry areas, then work wet-in-wet. Our artist used the edge of her brush to put in the shadow on the side of the trunk, blending it with a little water.

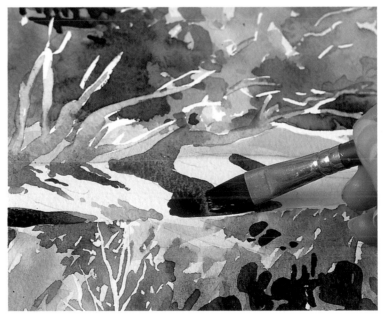

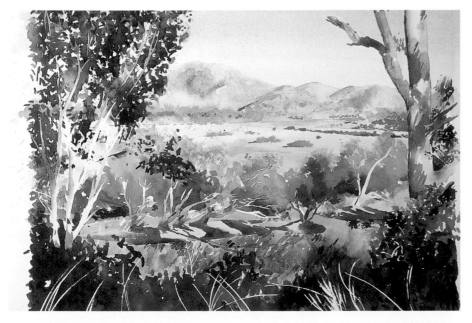

▲ **18** Use burnt sienna to add shadows to the islands and the branches of the bushes on them. Add ultramarine to the mix for areas of deep shadow. The contrast with the light areas creates the impression of bright sunlight.

◀ **19** Now work on the trunks of the trees on the left, using a watered-down mix of the same colors. For fine lines you can use the flat edge of the brush. Leave a lot of white showing through, but blend the paint at the ends of the trunks where the masking fluid creates hard lines. Work quickly, moving the brush back and forth, wet-on-dry to blend the color.

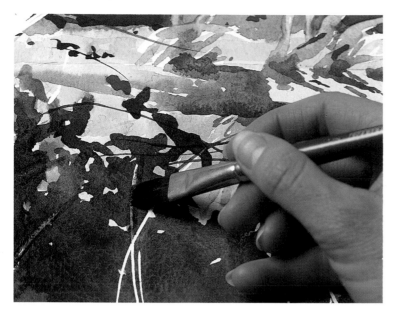

◄ 20 To paint the wispy foliage in the foreground, use your No.4 brush and a mix of ultramarine and cadmium red with olive green ink. Rest the side of your hand on a dry area of the paper to steady it while you add the foliage with swift, flowing movements.

Now load your brush with burnt sienna to define the tree trunks on the left and touch in shady leaves. Change to the ½in flat to paint the unmasked grass in the foreground with olive green ink and cadmium yellow.

► 21 While the paint is still wet, add burnt sienna and yellow highlights to the grass. Load your brush with cadmium red and add touches of pure color to the grasses. Let it blend into the wet burnt sienna.

Add any final details, but be careful not to overwork things. If in doubt, leave the painting for a while so you can be more objective about it.

▼ 22 Finish by scratching in fine lines of grass with the end of your brush or a craft knife, working from the bottom up with swift movements.

See how much variety has been created with just a few colors. Some washes have been enriched when dry by going over them with another wash; others are marbled by adding pools of color to the wet paint, letting them blend on the paper. The ink adds more depth.

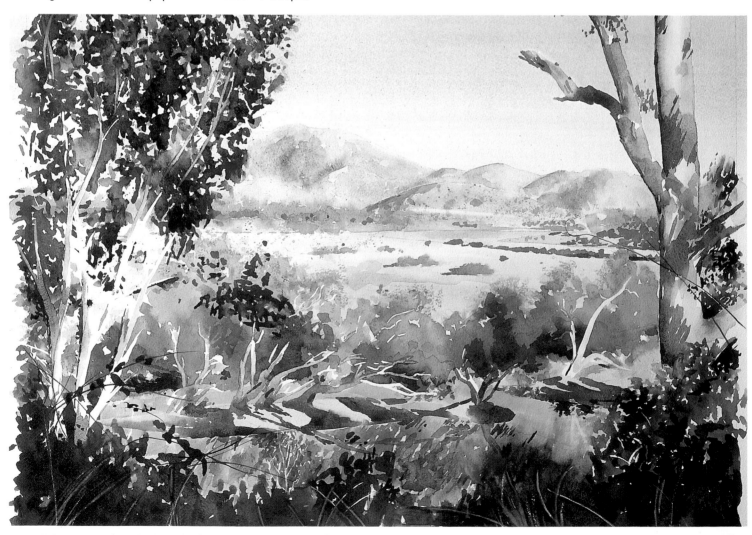

INTRODUCING GOUACHE

Gouache – opaque watercolor – has great versatility. You can paint from dark to light with it and cover up mistakes, it's excellent on tinted paper and it can be used for semi-transparent washes.

◀ You can buy gouache paints in a variety of forms – tubes, or pans, which all come in a number of different sizes.

▼ Watercolors are usually done on white paper, which is left blank for white areas or highlights, but with gouache, where you use white paint, you have the option of using some of the wonderful tinted papers available.

Put simply, gouache is watercolor paint with white pigment added. As with pure (transparent) water-color, finely ground pigments are mixed with distilled water and bound with gum arabic. The difference is that chalk is added. This creates the opacity for which gouache is famous. (Adding white to transparent watercolor makes what is known as body color – it's opaque and similar to gouache, but slightly more subtle in effect.)

Along with this opaque quality, the white pigment gives gouache substantial covering power. The two combined produce effects quite different from those of transparent watercolor.

When it is used opaque (or thick), gouache produces an effect similar to acrylics or matte oils, but it dries much faster, so you can work quickly. And you can dilute the paint to create the delicate washes so typical of watercolor. In a nutshell, gouache offers the best of both worlds.

This medium is also known for its rich, deep colors. The reflectivity of the white pigment gives the hue great vibrancy, resulting in strong, energetic colors.

Although never highly fashionable, gouache has always had its admirers.

CREATING TEXTURE

You can use just about anything you can get your hands on to create interesting textural effects with gouache. Try different objects to see what you can achieve.

use a sponge

or crumpled paper

or even a toothbrush

COMPARING WATERCOLOR WITH GOUACHE

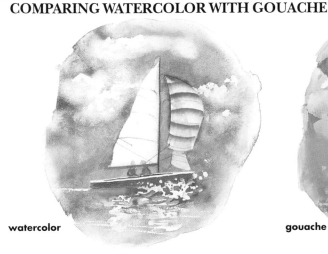
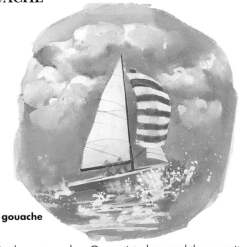

watercolor

gouache

Although the subject of these paintings is identical, you can see the opacity of gouache in the sky behind the yacht. This area is much more transparent in the watercolor. Our artist also used the opacity of gouache to add the white foamy water last – an area he had to mask out on the watercolor.

Famous Old Masters, including Rubens, van Dyck and Dürer, used it. And, in more recent times, Picasso, Burne-Jones, Egon Schiele and Henry Moore have all seen the appeal of gouache.

Gouache in practice

Gouache is probably one of the most versatile and "user-friendly" mediums available to the beginner. If you've had some experience with watercolor, then most of the basic techniques will be familiar to you. Watered down, gouache creates thin, delicate, semi-transparent washes that you can blend wet-in-wet on the paper, or build up by laying one flat wash of color over another.

FOUR WAYS WITH GOUACHE

Gouache is extremely versatile, especially when it comes to texture. Here the same paint has been used in four different ways to create some interesting effects.

impasto

scumbled

a wash

opaque paint (with white added)

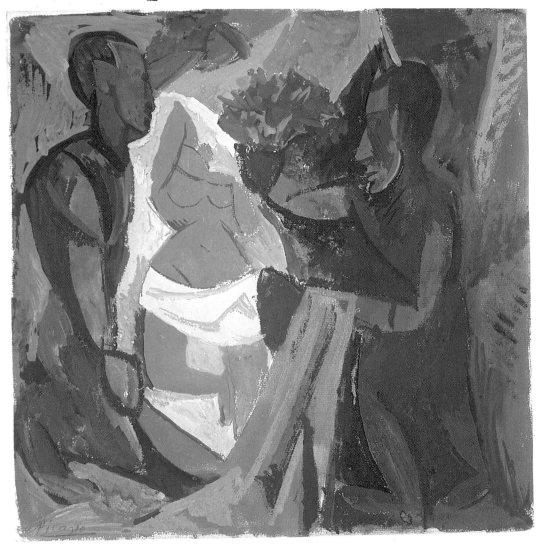

◀ Here the dense, flat quality of gouache serves to focus attention on the emotional intensity of the artist's subject.

The opaque quality of gouache allows you to work from dark to light, adding white to the paint to lighten the color rather than having to add more water. One of the main advantages of painting light tones over dark is that you're not forced to leave spaces of blank white paper for highlights. So, in a still life, for example, you can paint the scene in any order you like, adding highlights at the end. This freedom may be just what you need if you find working from light to dark is too limiting or inappropriate for a particular subject.

Although mixing white with your paints lightens the tone, you'll find that adding black doesn't necessarily give the result you would expect. Often the color is radically altered. Most notably, red tends to turn brown, and yellow adopts a green tinge. The best way to work around this is to experiment.

After all, gouache is a medium to experiment with. This is seen best when it's applied quite thickly. In fact, gouache comes into its own when used for its opacity and ability to create texture.

When using fairly thick gouache, the paint behaves very much like oils. You can use many of the same techniques – impasto, scumbling and sgraffito (scratching into the paint). Thick, near-dry paint can be applied with any number of items to produce surprising textural effects. You can dab on the paint with a tissue, rough it up with an old toothbrush, press dried leaves into it or even roll up your sleeves and let your fingers do some work – virtually anything goes.

When using gouache, it's important to make sure you consult manufacturers' color charts for guides to the permanence of the colors you use. Some colors are fugitive.

▲ In this delightful painting the magnificent canopy of the blossoming tree – rendered freely and expressively in body color – contrasts gracefully with the simple figure of the woman walking underneath.

"IN A SHOREHAM GARDEN" BY SAMUEL PALMER, WATERCOLOR AND BODY COLOR, 11¹⁄₁₆ X 8¾IN

◄ The matte white window frame traps small areas of individual activity – garden chair, flower pots and plants. Working from a dark green to a light green, the artist has created some lively areas of foliage.

"KITCHEN WINDOW WITH GERANIUMS" BY CAROLYNE MORAN, GOUACHE ON PAPER, 17 X 13IN

The basic ingredients

To get started with gouache, all you need are some paints, two jars of water, a few brushes and some paper. The water is easy, but unfortunately the three other elements can easily confuse the novice.

Gouache colors are normally sold in tubes, although the more popular colors also come in large jars. Pans of solid color are yet another option. The range of colors is huge, except possibly with pans, but fortunately a small variety of well-chosen colors can produce almost every hue under the sun. You can buy tubes separately, but major manufacturers produce beginners' sets containing a few basic colors. These are an excellent value for the money, and can easily be added to when necessary.

Brushes used for watercolor work well with gouache. Round brushes are the most useful, so it's well worth collecting a few different sizes. For smaller sizes you should stick to soft hair since these are much more responsive when adding fine details. With larger sizes, choose both soft hair and bristle brushes. Bristle brushes are ideally suited to gouache since they allow you to put the paint on thickly to achieve textural effects.

You can use a greater variety of supports for gouache than perhaps any other medium. Paper, cardboard, board, wood and even fabric are all good – as long as the surface is grease free.

As with watercolor, however, the most common support is paper. There is a huge range available, in various sizes, weights, textures and colors. Weights range from the lightest at 90lb to the heaviest at 300lb. All papers up to 140lb need to be stretched before use, but heavier papers shouldn't need stretching unless you're really going to drench them with some very wet washes. The most useful variety are NOT papers, which have a good all-purpose surface.

Since gouache is opaque, you'll find you can use tinted papers to great effect – especially the grays, which provide a good middle tone. Because the paint contains white pigment, the colors actually stand out better on a tinted background. However, be sure to select colored papers that are compatible with your subject matter.

With just these basic ingredients, and a little practice, you can let your imagination take you away!

Mixing your media

Gouache is particularly well suited to mixed-media work. Many artists have created beautiful effects by mixing gouache with pure watercolor, ink, charcoal, pastels, acrylics and even pencil. Acrylics are especially compatible since they're wonderfully vibrant and, once dry, are not water-soluble. You can lay down a loose underpainting with bright acrylics, allow it to dry and then paint over it with gouache. The gouache colors become even more intense in their play against the strong acrylic hues.

Patches of transparent watercolor can work very well in a painting that's predominantly gouache, and the opposite – small amounts of opaque gouache in a transparent watercolor – works well, too.

GOUACHE ON TINTED PAPER

There's a long tradition of using tinted paper with gouache. Applying the opaque paint in thin washes allows the paper color to show through in places, adding warmth or coolness to your work.

Since gouache is opaque, it has excellent covering power, enabling you to work from dark to light. Many artists commonly paint on colored paper or on white paper tinted with watercolor or acrylic. Obviously if you pour the paint on, gouache will cover up everything. But used fairly thinly, it allows the medium-toned ground to show through.

Beige, yellow ocher, pale green and even light gray are suitable medium-tone colors to use. There are many more options available. Don't pick a paper color at random – choose one to suit the mood or color composition of your painting. If you're working on a dull winter landscape, for instance, try using a light gray paper. Allow the paint to build up in some areas, but let the paper show through in others.

◀ **The set-up** These small, bright flowers are challenging to capture in the opaque colors of gouache. The hand-painted glazed pitcher has a smooth, round surface that contrasts with the asymmetrical flowers. The background is a piece of natural hessian, not unlike the beige tinted paper our artist chose.

▼ **1** Use the 2B pencil to draw the pitcher and mass of flowers on the paper. Roughly indicate the line separating foreground from background.

Make a loose wash with permanent white and paint in the pitcher with the No.12 brush. While this is wet, add some warm gray No.5 mixed with a little cobalt blue pale to darken the bottom and side.

YOU WILL NEED

☐ A 14 x 20in sheet of stretched beige-tinted 140lb NOT watercolor paper

☐ A 2B pencil

☐ Three round sable/ synthetic brushes – Nos.4, 5 and 12

☐ Two jars of water

☐ One or two palettes

☐ Thirteen gouache colors: primary yellow, spectrum yellow, golden yellow, lemon yellow, yellow ocher, permanent light green, Winsor green, scarlet lake, cadmium red, cobalt blue pale, permanent white, cool gray No.5 and warm gray No.5

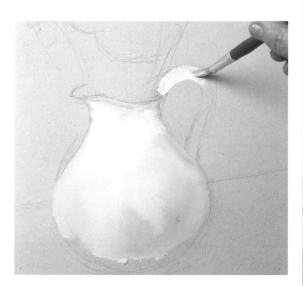

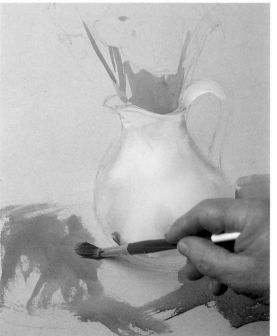

◀ **2** Mix some permanent light green and Winsor green, and form the stems rising from the pitcher with the No.12 brush. Map out the foreground in yellow ocher. Add a little white to yellow ocher for variety. Allow the color of the paper to show through here and there.

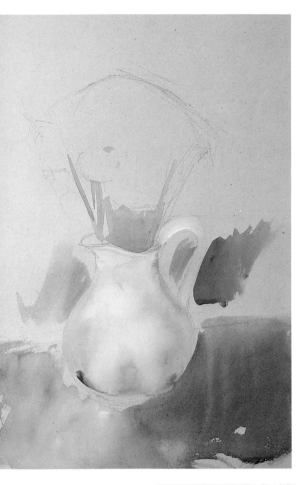

◄ 3 Add a little warm gray No.5 to some yellow ocher to darken it. Continue working on the foreground and background with the same brush, interplaying light and dark areas.

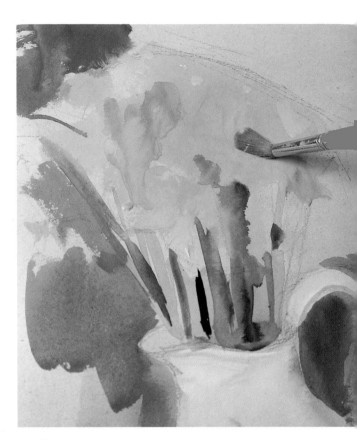

► 4 Mix Winsor green with a touch of warm gray No.5, and create more green tones on the stems with the No.12 brush.

Use the same brush to block in the general area of the flowers with a mix of primary yellow and golden yellow. The color isn't painted on uniformly – our artist has made some dark, impasto-like marks and allowed areas of the paper to show through for variety.

Mix cobalt blue pale, warm gray No.5 and diluted white and darken part of the handle.

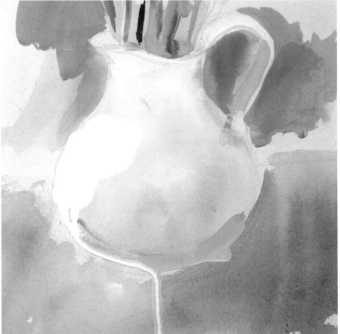

◄ 5 Still with the same mix, darken the base of the pitcher. Use some diluted white to highlight the side of the pitcher, blending it with the No.12 brush. Let the paint flow freely; you can add detail later on. Don't panic if the paint runs – it's easy to correct at this stage of the painting.

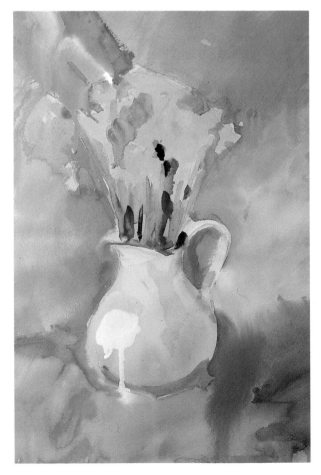

► 6 Return to the background. Mix yellow ocher with warm gray No.5, and paint in some areas at random. Add white to the mix to lighten it and apply to other areas to vary the background tone. Paint around the bunch of flowers – don't be afraid to redefine the shape if you wish. For the shadow areas on the right side of the pitcher, use a mix of yellow ocher, white and cobalt blue.

Darken the rim of the pitcher with a little Winsor green mixed with cobalt blue pale and cool gray No.5. Vary the greens within the flower stems with a mix of Winsor green and permanent light green. Now adjust the tones of the pitcher if necessary. Let dry.

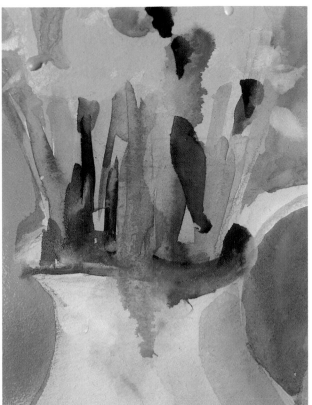

◄ **7** Add another layer of paint to the inside of the pitcher near the handle, using a strong mix of Winsor green. This is important because the stalks of the jonquils must appear to go into the pitcher, not sit on top of it. If the paint runs, simply blend it into the pitcher with a wet No.12 brush.

Mix primary yellow with a touch of cadmium red and apply a few blobs to the flower area for tonal contrast.

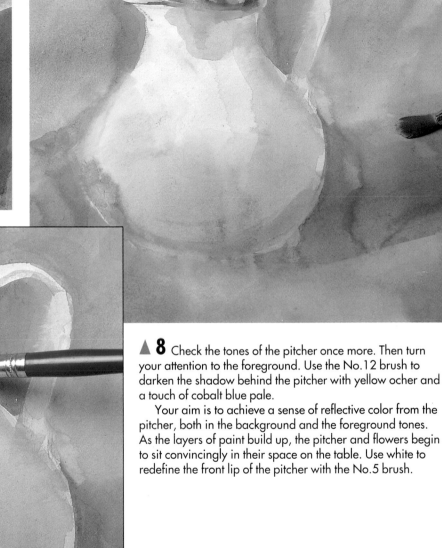

▲ **8** Check the tones of the pitcher once more. Then turn your attention to the foreground. Use the No.12 brush to darken the shadow behind the pitcher with yellow ocher and a touch of cobalt blue pale.

Your aim is to achieve a sense of reflective color from the pitcher, both in the background and the foreground tones. As the layers of paint build up, the pitcher and flowers begin to sit convincingly in their space on the table. Use white to redefine the front lip of the pitcher with the No.5 brush.

◄ **9** Continue adding white paint to the lip of the pitcher. Lighten the side of the pitcher with your No.12 brush and a loose blob of white, and blend again.

Then blend the colors beneath the lip and around the handle with your No.12 brush dipped in a little water.

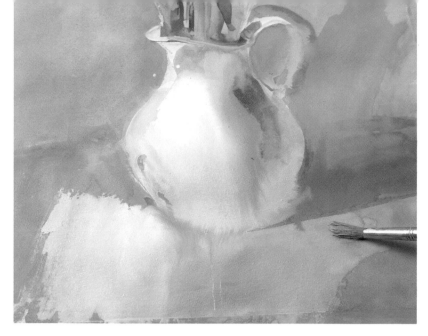

▲ **10** Add a dark reflection near the handle with cobalt blue pale mixed with warm gray No.5. Then soften the edges with the No.12 brush, and continue to blend the colors on the pitcher. Don't overwork this area – you'll end up with a very flat gray. Blend selectively around its sides, leaving white in the middle. Our artist then blended the colors that ran down the paper. Lighten the foreground beneath the pitcher using white, yellow ocher and warm gray No.5.

▲ **11** With the No.5 brush lighten some of the flower petals with primary yellow mixed with white. Flick these on using quick brushstrokes, keeping the painting's surface lively and interesting. Mix a little scarlet lake and golden yellow, and paint in the trumpet-shaped centers of the jonquils.

◀ **12** To suggest roundness and depth, neaten the stems using the same brush and three colors: Winsor green and cobalt blue pale; permanent light green; and Winsor green and lemon yellow. Then, using your thumb, merge the colors around the pitcher handle where the reflected light on the ceramic meets the color of the background.

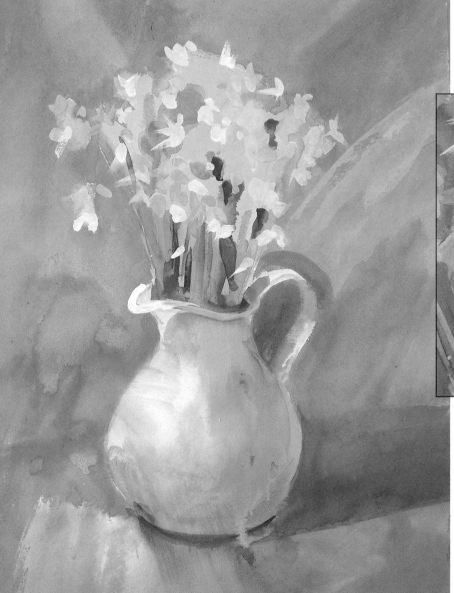

▲ **13** Mix cadmium red with spectrum yellow to intensify the color in the flower centers. Add more detail to the stems and the leaf tips appearing through the blossom with the three green mixes from step 12. Use your No.5 brush.

Wash your brush, then add thick blobs of primary yellow mixed loosely with white to the bunch to break up the uniformity of the flower mass and suggest individuals showing through.

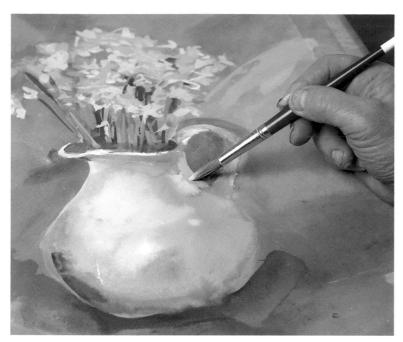

◄ **14** Now that you're nearly finished, move your easel to the flat position or lay the painting on a table to prevent the paint from running. Use your No.12 brush to build up the layers of gray on the pitcher. Apply warm gray No.5 mixed with a little white. Add cobalt blue pale and Winsor green to this mix for the shadows underneath the pitcher.

Tip

A plateful of good advice
Why spend a lot of money on store-bought palettes for watercolors when an ordinary white ceramic plate works equally well, if not better? It's cheap, offers a large working area and is easy to clean under warm running water.

◄ **15** For the pitcher's pattern, our artist used small strips of folded paper as a tool, instead of a brush. Practice applying the paint on a piece of scrap paper before working directly onto the painting.

Dip the folded corners into cobalt blue pale, and print the paint on. Use the paper straight and curved to help you capture the pattern, but don't copy it.

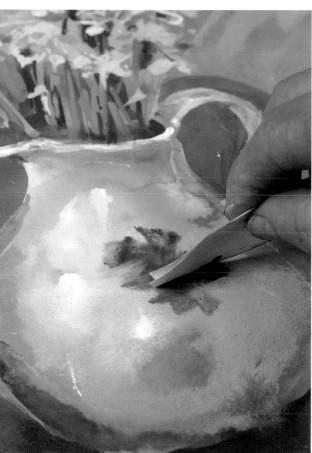

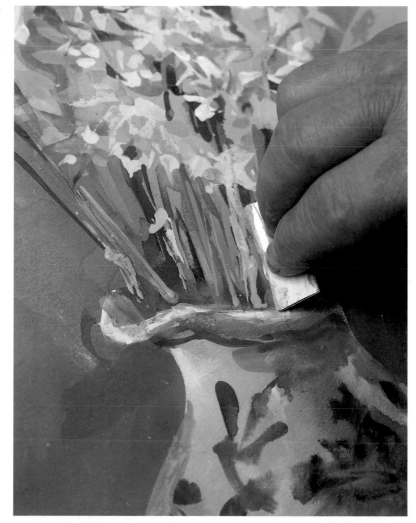

► **16** Mix some permanent light green and primary yellow, and apply this with the paper strips to make extra-fine lines along the stems. Again, resist the temptation to make too many stems, or the painting will look overworked.

Some blobs of paint may accidentally appear. Don't worry – these give your painting spontaneity.

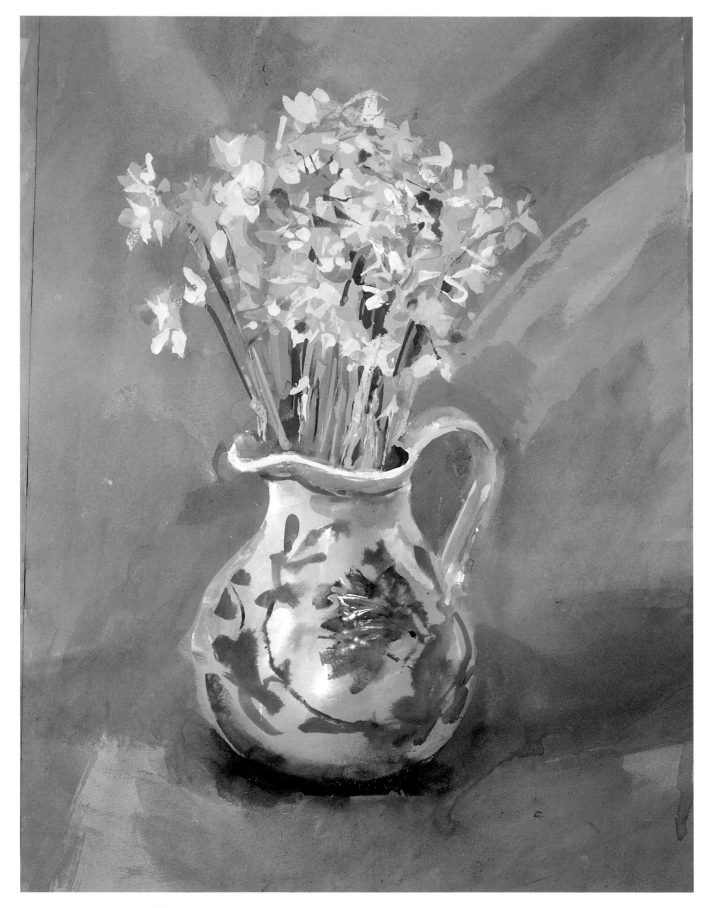

▲ **17** Add pure white highlights to the pitcher and sharpen the blue pattern, using your No.4 brush. Mix cobalt blue pale and a little cadmium red for the darkest area underneath the pitcher.

The finished painting has been left fairly simple.

Our artist overpainted many different yellows to give an overall impression of a vase of flowers without laboring unnecessarily over each one. And parts of the tinted paper show through in areas to add warmth and pull the image together.

OIL PAINTING

TOOLS AND TECHNIQUES

BRISTLE BRUSHES FOR OIL

Brushes – the artist's main tool for applying oil paint – are available in an enormous range of shapes, sizes and materials. Choosing the right one for the job is vital to good results.

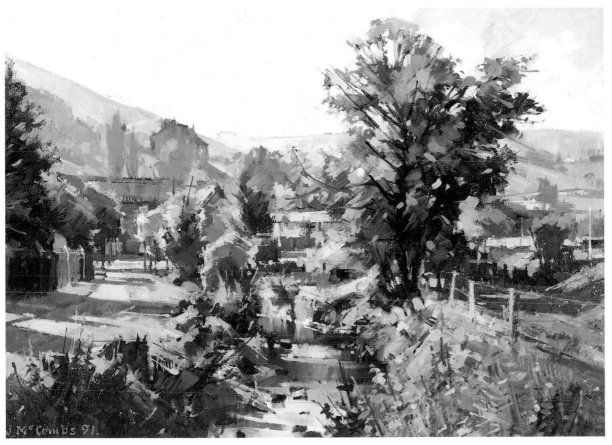

◀ Energetic brushstrokes give life and texture to this painting. Long horizontal strokes and short stabs of color in the foreground foliage create a strong feeling of vigor and growth.

The smoother, less defined strokes in the background aim for impression rather than detail, pushing the hills and trees back, suggesting space and distance.

"BANKS OF THE RIVER TAME, DELPH, LATE SUMMER" BY McCOMBS, 1991, 11⅜ X 16¼IN

▼ This detail of the stream shows how the broad horizontal strokes used to depict water also convey a feeling of calm and serenity.

Every type of brush is suited to one or more tasks and each leaves a different kind of mark. Since they vary greatly in cost as well as versatility, you must choose your basic kit carefully.

When you are selecting brushes, don't be daunted by the large choice available. You don't need a huge variety – start with three or four that satisfy your initial needs. One artist may use a dozen or more brushes, but another may be perfectly happy with just a few. It all depends on the techniques and the effects you want to achieve. So experiment to get a feel for what suits you, and gradually add to your collection of brushes as the need arises.

Types of brushes

Oil painting brushes are made from either bristles or soft hairs (or synthetic substitutes for them). Each has a specific function. Bristle brushes are good for establishing the initial stages of composition and laying down large amounts of

color. Their stiff bristles make them ideal for impasto work. Soft hair brushes are useful for smoother lines and precise details, and are often used for smaller paintings. Restrict yourself to

bristle brushes when you are starting out. They encourage you to work loosely, which is valuable in the early stages of composition.

Bristle brushes

Stiff and hard-wearing, each strand of a bristle brush has split ends that hold large quantities of paint. It's a useful brush for making bold, decisive strokes; bigger sizes are good for covering broad areas with thick color. It's also ideal for larger paintings, but its point is too stiff for details.

Traditionally, bristle brushes are made of hog's hair, which is particularly suitable for oil painting since the strength and flexibility of the bristles are good for the thick, heavy texture of the paint. Look for ones that have a lot of spring and keep their shape when you make a stroke on your hand with them. Avoid synthetic substitutes, which are usually made of nylon and rapidly lose their shape.

Bristle brushes are available in some interesting shapes, but the four most useful ones are flats, brights, rounds and filberts.

Flats are extremely versatile brushes and essential to any basic collection. They have flat ends and long bristles that hold a lot of fluid paint. This makes them ideal for applying broad, rectangular strokes and areas of thick, bold color, as well as for short dabs of color. You can use the side of the brush for thin lines and sharp details. Flats are especially suitable for working up to a clean edge and blending areas of color. Bear in mind that, since the bristles are quite elastic, they won't pick up stiff paint.

Tip

Which size?

Scale your paintbrushes according to the size of your painting. For large pictures or extensive areas of any picture use the biggest brushes you have; for small paintings or precise details switch to a correspondingly small brush. You'll find round brushes are best for fiddly details, while flats and brights are ideal for general areas. A larger brush will also help you loosen up your style if that's what you need.

The brushes at right have been chosen because they make a good, all-purpose range of strokes and marks.

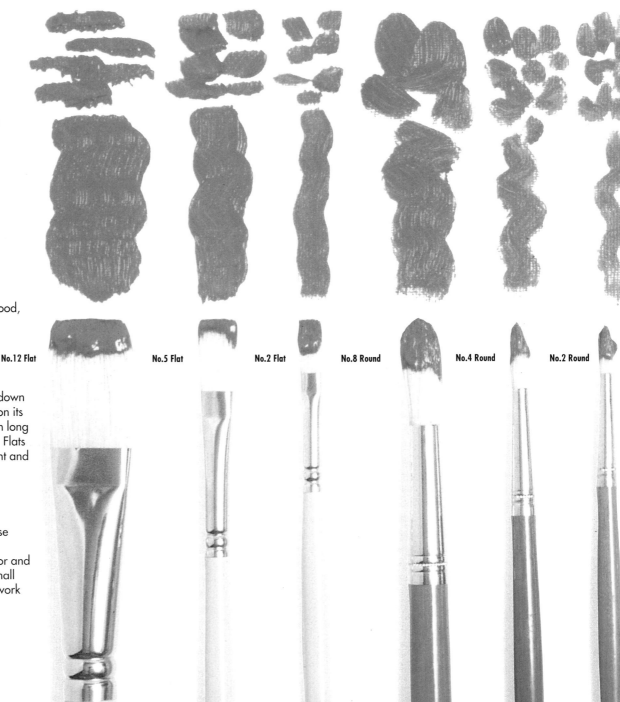

No.12 Flat No.5 Flat No.2 Flat No.8 Round No.4 Round No.2 Round

Flats – Nos.12, 5 & 2

Choose flat brushes for laying down large areas of color. Turn one on its side and you can use it to put in long fine lines or short, neat dashes. Flats are also ideal for blending paint and moving it around the canvas.

Rounds – Nos. 8, 4 & 2

These are good general-purpose brushes. They can be used for brushing in broad areas of color and for scumbling, and the tip of small sizes can be used for fine line work and small dots of color.

Brights (sometimes called short flats) are the same shape as flats but with shorter, stiffer bristles that dig deeper into the paint and leave strongly textured, chunky marks. You'll find them useful if you want to apply stiff, thick paint to create impasto effects. Because of their shorter bristles brights are easier to control, making them better for working on details following a generalized underpainting.

Rounds are exceptionally versatile brushes, indispensable in your basic kit. They have long, thin bristles that curve inward at the ends. With heavily diluted paint, round brushes make soft, thin strokes that are ideal for establishing basic composition in the initial stage of a painting. Alternatively, by loading the brush with a lot of paint, you can make long, bold marks and brush in large areas of color. Rounds are good for the technique of glazing, and also for delicate lines and outlines.

Filberts are similar to flats – they have a flat ferrule but curve inward at the end. They are available in two versions. Filberts with long, springy bristles hold a lot of paint and make soft, tapered strokes. The other type, with short bristles, hold less paint and are easier to control – ideal for applying small dabs of color. Tastes differ, but filberts are generally considered useful but not essential brushes.

Brush sizes

Each type of brush is made in a range of sizes, with each manufacturer offering its own range and numbering system. There are usually 12 sizes

▲ Decorators' brushes – ½in and 1in
Decorators' brushes are cheap, hard wearing and very useful. Because they have many bristles, you can load the brush heavily with paint to cover the entire canvas with a single wash. Or you can use them to block in large areas for a bold underpainting.

Filberts – Nos. 12, 8 (short) & 2 (long)
Filberts produce a wide range of marks. The shape of the tip helps you avoid the blocky, rectangular marks sometimes left by a flat brush. The long-bristled brushes can be used to produce fluid lines. Because they are easy to control, the short-bristled ones are good for building up an impasto effect, and making short dabs of color. The smaller sizes are good for details.

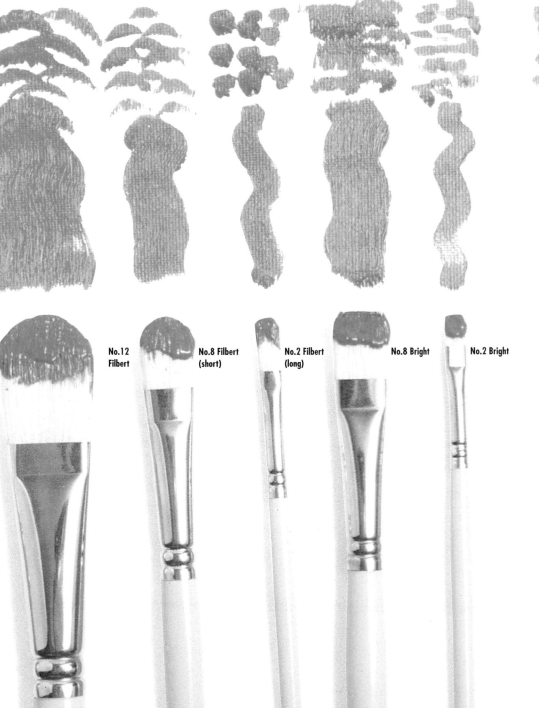

No.12 Filbert
No.8 Filbert (short)
No.2 Filbert (long)
No.8 Bright
No.2 Bright
No.4 Synthetic (round)

Brights – Nos. 8 & 2
Because of the shortness of their bristles, brights are good for building up patches of pure color in a controlled way.

Synthetic – No.4 round
This brush is good for laying in an area of thin color, and for details and fine lines.

in each series, with No.12 the largest and No.00, 0 or 1 the smallest. However, one manufacturer's No.6, say, may not be the same size as another's.

Beginner's selection

When you start oil painting, bristle brushes are generally more useful than soft ones. Not surprisingly, better quality bristle brushes are more expensive than synthetic substitutes. However, their springiness, versatility and long life make the extra expense worthwhile.

It's better to buy only three or four really good bristle brushes than a huge selection of poor-quality ones. Choose brushes with hairs that look

neat and don't splay out from the ferrule (the metal or plastic case that holds the bristles together). A good selection to start with is a No. 8 round, a No.5 flat and a No.2 filbert or bright. You can experiment with other styles and sizes later on, as required.

For small-scale or detailed work, you will need a soft brush. Pure sable ones are extremely expensive and unnecessary for the beginner. Moderately priced synthetic soft-hair brushes provide an adequate alternative. A good size to choose is a No.4 or 5 round brush. You may also find ½in or 1in decorators' brushes useful for laying in large areas of color.

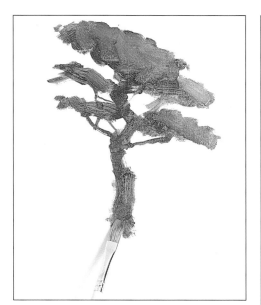

► A medium-sized No.5 flat is large enough to make broad strokes to describe the bark of this Scotch pine, yet small enough to make short dabs of color for the foliage. The flat edge makes thin, angular lines for the branches.

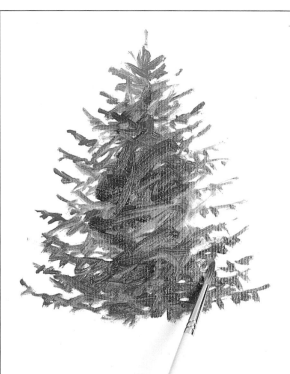

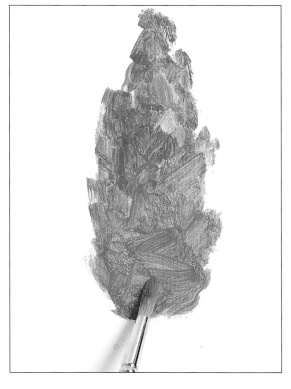

► A large No.8 round brush is ideal for laying in large areas of color. Its flexible bristles allow you to make soft strokes, which, when the brush is angled, create texture for the thick, dense leaves of this cypress.

▲ A smaller brush such as a No.2 round, filbert or bright produces finer, more delicate lines – used here for the small needles on the outer branches of the Norway spruce. The body of the brush, used at an angle, lays in more color for the denser foliage in the middle.

CHECKING UP ON OILS

To get the best out of your paints, it helps to know what their special qualities are and how to exploit both their advantages and their disadvantages.

Easy to work with and readily available, oil paints are extremely versatile, allowing you to create a wide range of superb effects. You can use them right from the tube to make exciting, thickly textured impasto works in a single day, or dilute them with a medium to create layers of scumbles and glazes (which take longer). Opaque and transparent oil paints are available to add further to your options.

What are oil paints?

Generally, identical pigments – made from earth materials, minerals, plant extracts and synthetic chemicals – are used in oils, acrylic and watercolors. The difference is in the binder (or medium) that holds the pigment together and allows it to stick to the support. Linseed oil, the binding agent used in most of today's oil paints, gives an unparalleled richness of color.

► Color selection is an individual matter, but you need both warm and cool colors for versatility. This all-purpose basic palette has a warm and a cool blue, and the same for red and yellow. An earthy green (oxide of chromium) and a sharp green (viridian) produce a wide range of colors for landscapes. White, black and two warm earth colors are also invaluable.

▼ Many artists arrange the paints on their palette from warm to cool colors (or vice versa). Always put your paints in the same order so you automatically know where to dip your brush when you are painting.

The trays (dippers) can contain turpentine, linseed oil or a medium. Use a separate, larger container of mineral spirits for cleaning brushes.

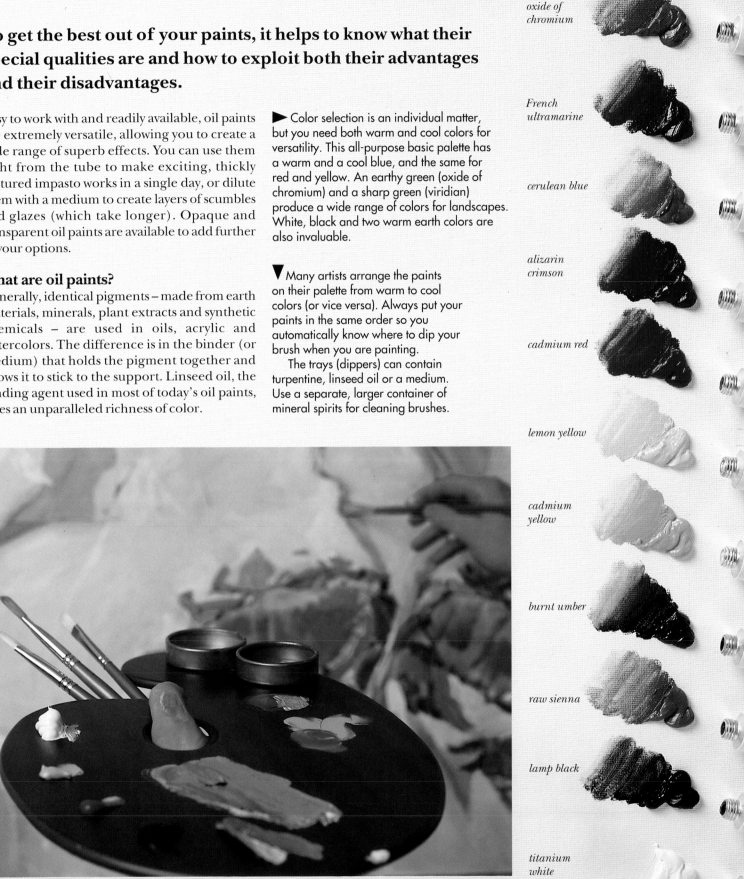

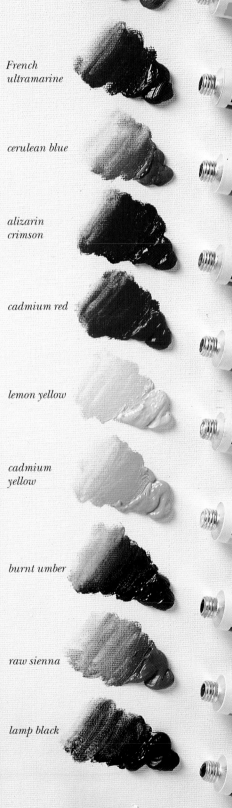

viridian

oxide of chromium

French ultramarine

cerulean blue

alizarin crimson

cadmium red

lemon yellow

cadmium yellow

burnt umber

raw sienna

lamp black

titanium white

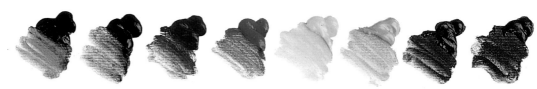

AN ALL-AROUND LANDSCAPE PALETTE

If you know the specific subject you want to paint, then choose your palette accordingly. For example, an all-around landscape palette has earthy colors – yellow ocher and Vandyke brown – along with natural-looking greens (viridian and sap green) for foliage. Use warm and cool blues, white and cadmium yellow on their own or mix them to create other colors. Here, from left to right, are: viridian, sap green, cobalt blue, cerulean blue, cadmium yellow, yellow ocher, Vandyke brown, ivory black.

Tip

Dealing with absorbent oils

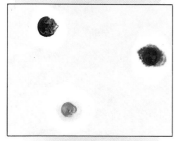

It is advisable to size and treat all supports before painting with oils. If you apply paint on ordinary paper, for instance, the surface absorbs the linseed oil, leaving only pigment and any additives on the surface. (The oil shows up as a ring around the pigment – see above).

Some art scholars believe that artists in Germany in the 12th century were already mixing their pigments with linseed oil. But it was the 15th-century Flemish master, Jan van Eyck, who made oil paints popular.

A special character

Oil paints dry very slowly (unlike watercolor, acrylic and gouache, which are water-based). Depending on the thickness of the paint, oils stay wet and workable for quite a long time, allowing you to try again – or use a different technique – if you aren't achieving the effect you want to create.

This means that, unlike watercolor work, you aren't pressured to get the painting right the first time. All you have to do is simply wipe the paint off or add another layer over the first one. You can even scrape off thick paint with a knife and put it back on the palette – something unique to oils. And if the paint is thin, you can wipe it off with a rag soaked in mineral spirits. Finally, you can blend colors together and work wet-in-wet for a long time.

▼ The colors in the foreground (the figures) are sharp and pure. The artist has used oils in a completely traditional way, building up subtle skin tones with many glazes. To subdue them, background colors are mixed with white and complementaries.

The modern equivalent palette colors shown here, from top to bottom, are: lamp black, Prussian blue, purple madder, alizarin crimson, Venetian red, chrome yellow deep, burnt umber, raw sienna and sap green.

"FAMILY OF DARIUS BEFORE ALEXANDER THE GREAT" BY PAOLO VERONESE, OIL ON CANVAS, 93 X 187IN

It must be said, however, that working quickly with oils can be frustrating. For instance, the colors could blend together if you add a second glaze too quickly over a wet first layer. There's nothing to do but wait until it dries – unless you wish to use the effect in some way.

Using oils

Good quality paints have a class or star system to rate their permanence. Class AA (or three star) colors are permanent and very stable, while class C are fugitive (they fade quickly). Some colors contain hazardous materials, so don't get the paint on your fingers.

You thin oil paint with turpentine and/or linseed oil – don't use mineral spirits because they aren't entirely compatible with oil paints. You can wash your brushes in mineral spirits, then use soap and warm water or dishwashing liquid, and rinse under the tap. Use a cotton rag soaked in mineral spirits to wipe paint off your hands. Some people are allergic to turpentine and mineral spirits. Other products are available,

► Viridian is a cool, sharp green. Here it is used unmixed and also diluted with white to set up a bold contrast with the warm red. In much of the painting the color is scumbled so the texture of the canvas shows through, but there are also many areas of thick impasto.

The equivalent modern palette colors, shown from top to bottom, are: cobalt blue, cerulean blue, cadmium red, yellow ocher, chrome orange, cadmium yellow, viridian and permanent green.

"YOUNG GIRLS IN THE GARDEN AT MONTMARTRE" BY PIERRE-AUGUSTE RENOIR, OIL ON CANVAS, 21¼ X 25½IN

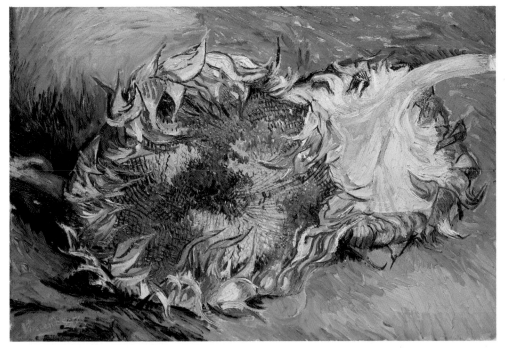

◄ Van Gogh's particular genius was to see – and use – colors in a heightened way. He used many right from the tube, often enhancing the natural color of his subject and thereby intensifying its impact. The blues here are used in pure form or mixed with white. Predominant in the sunflowers is Naples yellow, its chalky opacity contrasting well with the transparent viridian.

Modern palette equivalents, from top to bottom, are: cobalt blue, cerulean blue, Prussian blue, viridian, yellow ocher, Naples yellow, alizarin crimson.

"SUNFLOWERS" BY VINCENT VAN GOGH, 1887, OIL ON CANVAS, 17 X 24IN (METROPOLITAN MUSEUM OF ART)

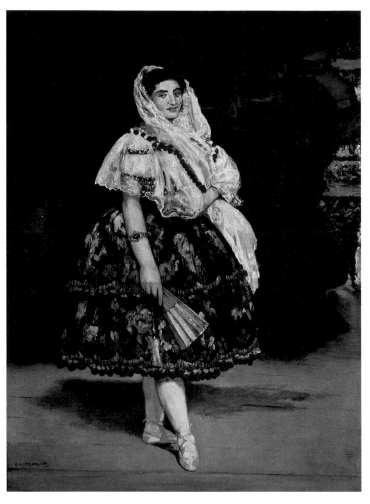

◀ The mostly dark background does a lot to bring this colorful dancer forward in the picture. The reds sparkle against the black of the skirt and the green-gray of the floor, and a thin scumble of opaque white suggests the crisp texture of the lace veil. Modern palette equivalents, from top to bottom, are: lamp black, Payne's gray, cobalt blue, sap green, alizarin crimson, cadmium red, permanent rose, yellow ocher and raw sienna.

"LOLA DE VALENCE" BY EDOUARD MANET, OIL ON CANVAS, 49⅓ X 36⅜IN (MUSÉE D'ORSAY, PARIS)

but they're expensive. Check your local art store for suitable alternatives. Whether you're allergic to turpentine or mineral spirits or not, work in a well-ventilated room.

There are several mediums for use with oil. They can alter the paint in many ways – thin it down, thicken it, make it matte or glossy, speed up or slow down the drying time and increase the flow or transparency of the paint.

It takes a while to get used to these different mediums, and not even professional artists know

▼ Hot, intense colors glow in this painting – they aren't muddied or softened by mixing with earth colors or complementaries, and you can see raw canvas between dabs of pure color. Optical color mixing occurs in the viewer's eyes, making for a shimmering surface.

Modern palette equivalents, from top to bottom: ultramarine, cobalt blue, rose madder, deep yellow, golden ocher, transparent golden ocher, Prussian green and olive green.

"HOUSES OF PARLIAMENT" BY ANDRÉ DERAIN, 1905-6, OIL ON CANVAS, 31⅛ X 38⅜IN,
(© ADAGP, PARIS AND DACS, LONDON 1994)

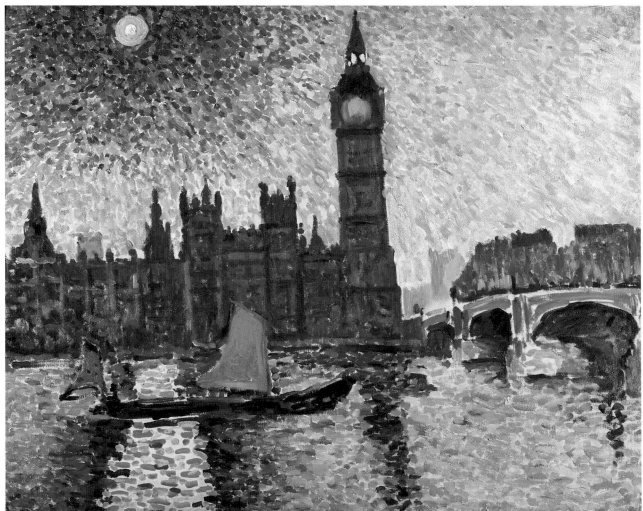

▲ This artist has chosen his reds with great care. The warm reds – oranges and dusky pinks – are concentrated in the center, around the light source (the lamp), but the cooler reds start to appear as you move away toward the edges (particularly in the bottom right corner).

Modern palette equivalents, from top to bottom, are: viridian, ultramarine, cadmium yellow, cadmium red, rose madder and ivory black.

"INTERIOR WITH MME. VUILLARD" BY EDOUARD VUILLARD, 1893-95

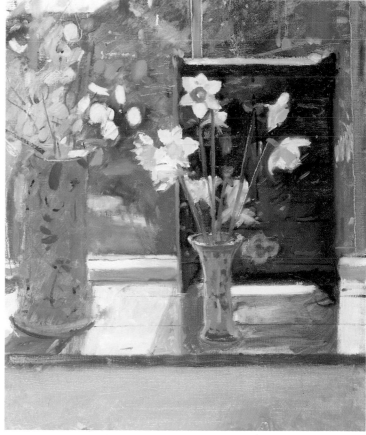

▶ Cool blue-gray neutrals contrast with the bright yellows of the daffodils and the warm, earthy, sienna-based color on the windowsill.

Great delicacy of touch is evident here, both in the very thin layers of paint used in the background and on the windowsill and in the more generous application of paint on the daffodil heads and sprays of honesty.

Palette colors, from top to bottom, are: aureolin yellow, lemon yellow, yellow ocher, cerulean blue, ultramarine, cadmium red, alizarin crimson and burnt sienna.

"SPRING DAFFODILS, MOUSEHOLE" BY KEN HOWARD, OIL ON CANVAS, 24 X 20IN

exactly what they all do. Many artists use "fast-drying" alkyd mediums such as Wingel or Liquin from Winsor & Newton to speed up the paint's drying time and extend its flow. Not all manufacturers use the same names, so ask for more information at an art store.

Supports, brushes, palettes

Canvas is the most popular support for oils, but hardboard, millboard and cardboard are all suitable surfaces. You should treat all supports before you begin painting (unless you buy them already prepared). If oil paint is applied to an absorbent support, the surface soaks it up, which may rot the support.

Brushes come in a wide range of shapes, sizes and materials (see pages 201–204). Limit yourself to 3–6 different brushes and then experiment with them as much as possible. Remember, it's not your materials that count, it's how you use them.

Your palette should be smooth, flat and non-absorbent. A ceramic plate, a sheet of coated hardboard or plate glass, plastic, melamine or Formica is fine. You can also buy pads of non-absorbent, disposable paper palettes.

▼A range of earthy colors in this landscape is offset by a number of cool grays – in the trees on the horizon, the distant hills, the rooftops and the car in the foreground. The road is a soft gray, made from mixing complementary colors; patches of the toned ground show through to warm the whole scene. The season is early spring – cool, but imbued with the promise of returning warmth.

"STONESWOOD, DELPH, EARLY SPRING" BY JOHN McCOMBS, OIL ON CANVAS, 14⅛ X 13¼IN

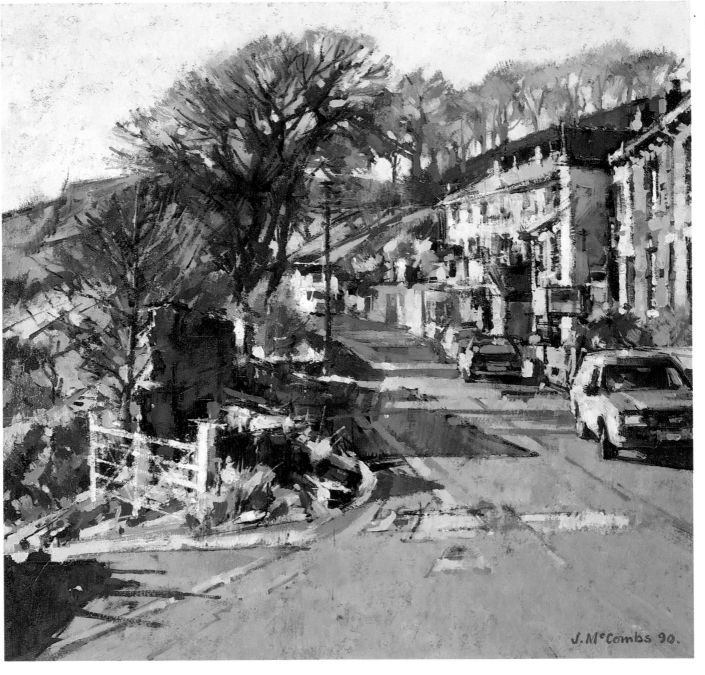

Palette colors, top to bottom: chrome yellow, yellow ocher, chrome orange, flesh tint, alizarin crimson, burnt sienna, Vandyke brown, sap green, Prussian blue.

STRETCHING YOUR OWN CANVAS

Although it takes some practice to get right, learning how to stretch your own canvases gives you a great sense of accomplishment – and in the long run, it will save you money as well.

Linen or cotton canvas, stretched over a wooden frame, is the most popular support available for oil painting. It holds the paint well and gives you a good surface to work on – taut, but with just the right amount of spring. Stretched canvases are available from most art stores, and these save time, but they are expensive – it's much cheaper to stretch your own. The commercially prepared ones often come in a standard range of sizes only, so if you stretch your own you can assemble unusual formats to suit yourself.

The only tricky part of the process is achieving the right amount of tension. As a guide to what to aim for, the canvas should be stretched taut, but not as tight as a drum. If you strike it gently with the end of a brush, or even a pencil, the brush should bounce back very lightly.

The stretcher frame itself imposes a certain amount of strain on the canvas, especially so on the edges where the material is stretched over the wood. The staples or tacks used to secure the canvas should be attached fairly close together to distribute the tension evenly across the stretcher. Keeping the tension at the corners slightly less taut than along the lengths also helps; if the canvas does sag a little over time, less strain is put on it when it's readjusted. But choosing the right equipment, and assembling the stretcher properly, goes a long way toward alleviating problems of incorrect tension.

Follow the steps here and your first attempts at stretching canvas should work, but don't be too disheartened if they don't – you'll soon improve your technique with practice.

▼ The reverse side of the stretched canvas shows the wedges in the top and left corners. These can be tapped with a hammer if further tightening is needed.

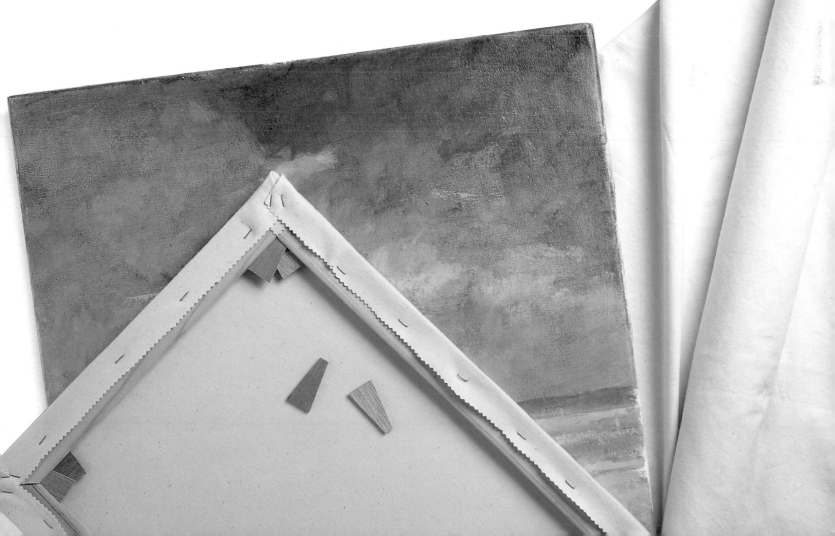

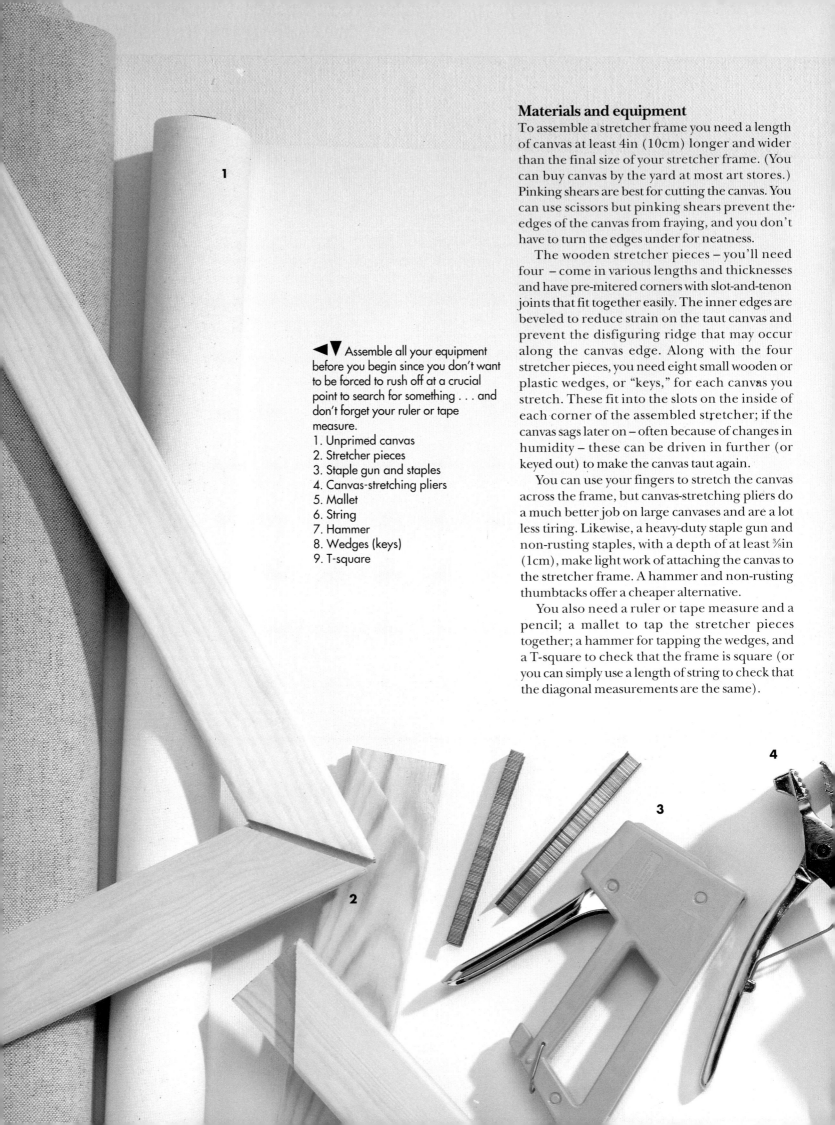

Materials and equipment

To assemble a stretcher frame you need a length of canvas at least 4in (10cm) longer and wider than the final size of your stretcher frame. (You can buy canvas by the yard at most art stores.) Pinking shears are best for cutting the canvas. You can use scissors but pinking shears prevent the edges of the canvas from fraying, and you don't have to turn the edges under for neatness.

The wooden stretcher pieces – you'll need four – come in various lengths and thicknesses and have pre-mitered corners with slot-and-tenon joints that fit together easily. The inner edges are beveled to reduce strain on the taut canvas and prevent the disfiguring ridge that may occur along the canvas edge. Along with the four stretcher pieces, you need eight small wooden or plastic wedges, or "keys," for each canvas you stretch. These fit into the slots on the inside of each corner of the assembled stretcher; if the canvas sags later on – often because of changes in humidity – these can be driven in further (or keyed out) to make the canvas taut again.

You can use your fingers to stretch the canvas across the frame, but canvas-stretching pliers do a much better job on large canvases and are a lot less tiring. Likewise, a heavy-duty staple gun and non-rusting staples, with a depth of at least ⅜in (1cm), make light work of attaching the canvas to the stretcher frame. A hammer and non-rusting thumbtacks offer a cheaper alternative.

You also need a ruler or tape measure and a pencil; a mallet to tap the stretcher pieces together; a hammer for tapping the wedges, and a T-square to check that the frame is square (or you can simply use a length of string to check that the diagonal measurements are the same).

◀▼ Assemble all your equipment before you begin since you don't want to be forced to rush off at a crucial point to search for something . . . and don't forget your ruler or tape measure.
1. Unprimed canvas
2. Stretcher pieces
3. Staple gun and staples
4. Canvas-stretching pliers
5. Mallet
6. String
7. Hammer
8. Wedges (keys)
9. T-square

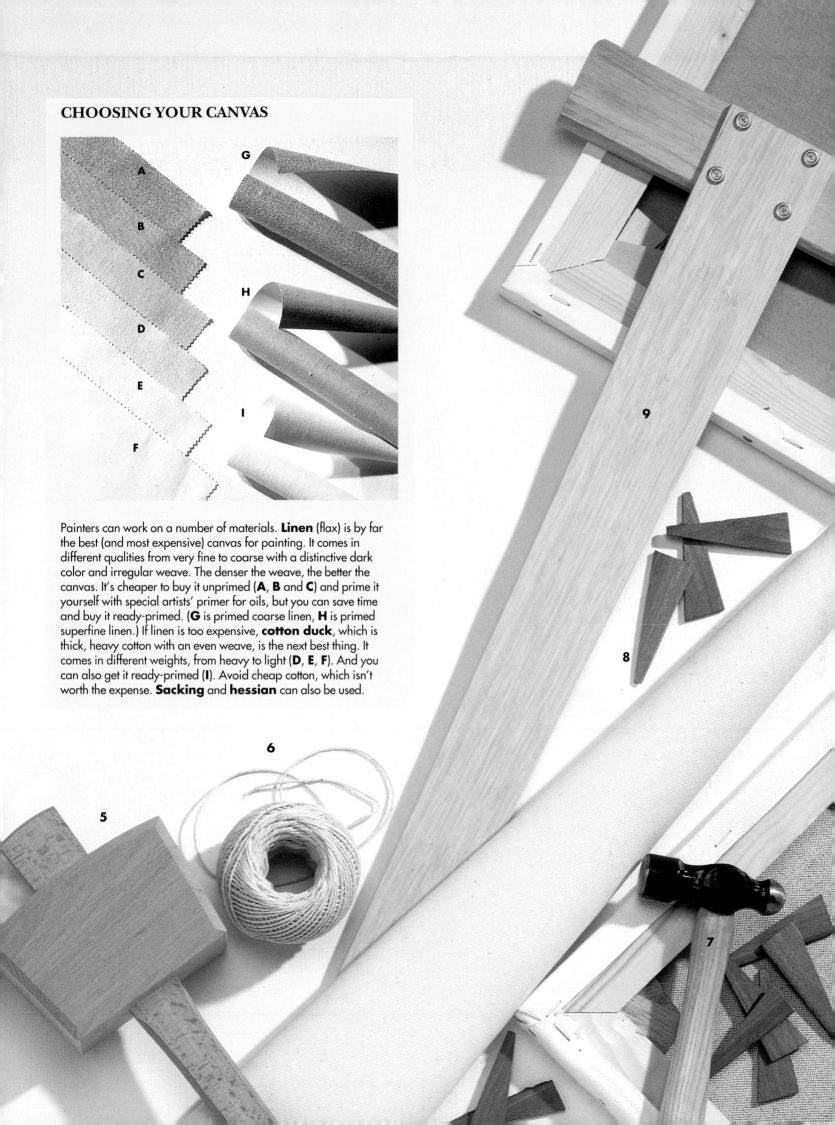

CHOOSING YOUR CANVAS

Painters can work on a number of materials. **Linen** (flax) is by far the best (and most expensive) canvas for painting. It comes in different qualities from very fine to coarse with a distinctive dark color and irregular weave. The denser the weave, the better the canvas. It's cheaper to buy it unprimed (**A**, **B** and **C**) and prime it yourself with special artists' primer for oils, but you can save time and buy it ready-primed. (**G** is primed coarse linen, **H** is primed superfine linen.) If linen is too expensive, **cotton duck**, which is thick, heavy cotton with an even weave, is the next best thing. It comes in different weights, from heavy to light (**D**, **E**, **F**). And you can also get it ready-primed (**I**). Avoid cheap cotton, which isn't worth the expense. **Sacking** and **hessian** can also be used.

Assembling the stretcher frame

▶ **1** Slot the stretcher pieces together, checking that all the beveled edges are on top. This way the surface of each stretcher piece slopes slightly away from the canvas and prevents a ridge from forming along the edge.

▼ **2** Tap the corners together gently with a wooden mallet or a piece of wood for a close fit.

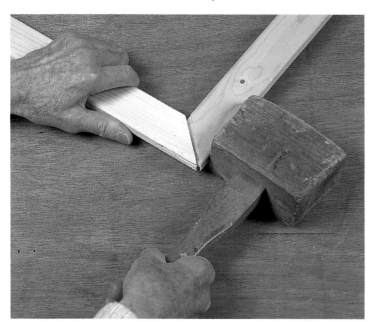

▲ **3** Use a square (shown) or T-square to check that all the angles of the assembled frame make right angles. It's important to get the angles correct right from the start, since you can't alter them once the canvas has been stretched.

◀ **4** Double-check that the corners are true right angles by measuring the diagonals with a length of string; they should be of equal length. If the frame is not true, correct it by gently tapping the corners with the mallet.

Stretching the canvas

◄ 1 Lay the frame bevel-side down on a piece of canvas, aligning the vertical and horizontal weave with the sides of the frame. Cut the canvas to fit the frame, allowing a margin of about 4in (10cm) all around for stapling. Use a metal ruler and pencil to draw guidelines on the canvas if necessary. If you use pinking shears to cut the canvas then you need to allow a margin of only about 2in (5cm) all around since you don't have to fold the edges under when securing it.

► 2 Keeping the frame horizontal and centered on the canvas, push one long side firmly against a vertical surface, such as a wall, to hold it in position. Fold the canvas over the opposite long side, using canvas-stretching pliers to grip the fabric firmly; lowering your wrist as the canvas passes over the back of the frame helps to achieve the right tension.

◄ 3 Insert a staple in the edge (not the back) half-way along the stretcher piece to secure the canvas frame. Turn the frame around, pull the canvas firmly, and secure a staple opposite the first one. Repeat this on the remaining sides so that one staple holds the canvas to the center of each stretcher piece.

► 4 Now add two more staples to each of the four stretcher pieces – one on either side of the center staples, following the numbered sequence shown in the diagram. Pull the canvas taut with one hand and staple with the other, evenly spacing staples at 2in (5cm) intervals. Continue adding pairs of staples to each side, working toward the corners and stopping when you are about 2in (5cm) from the corners.

Tip

A tight stretch?
If the canvas is to be primed for oil painting, be careful not to overstretch it since the canvas contracts slightly when size and primer are applied, which may lead to warping. Acrylic primer, however, does not shrink the cloth as much, so the canvas can be stretched more tightly.

Stapling the canvas to the frame

►**1** Finish the corners neatly – if they are too bulky you'll find it difficult to frame the picture. First pull the canvas tightly across one corner of the stretcher as shown.

▼**2** Now tuck in the flaps on either side smoothly and neatly, and fix with staples. Take care not to staple across the miter join, since this will make it impossible to tighten the canvas later on. Then fix the corner diagonally opposite, followed by the remaining two.

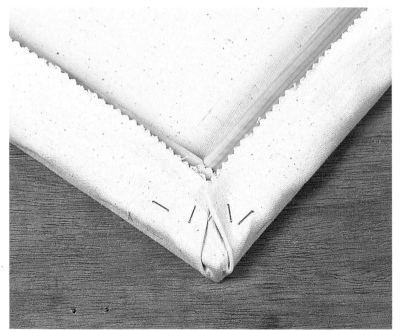

▲**3** Finish with some stapling along the back of the stretcher for extra hold, folding under the cut edges of the canvas if you haven't used pinking shears. Insert two wedges in the slots provided in each inner corner of the frame; for correct fit, the longest edge of each wedge should lie alongside the frame, as shown.

◄**4** Tap the wedges very lightly. If you hammer them too hard the frame will be forced apart slightly. Your canvas is now ready for sizing and priming before painting begins.

OIL – THE FLEXIBLE MEDIUM

There's something about the way oil paints mix on the palette and how they handle on the canvas that is enormously appealing.

Oil has an unjustified reputation for being difficult, but in many ways it is the most forgiving of all the painting mediums. Because it dries very slowly, it gives you plenty of time to think about your approach – and you have the valuable opportunity to rework the paint if you change your mind.

Oil painting is also less technique-led than, say, watercolor. This means that right from the start a would-be artist can produce pleasing images with a richness and depth of color unmatched by any other medium.

In oil paints, the pigment is held in an oil-binding medium. This is usually linseed oil. The paint has a buttery consistency and is sold in metal tubes. You can use the paint directly from the tube but it is usually thinned with turpentine, or a mixture of turpentine and linseed oil.

The choice of whether or not to thin the paint depends on the effect you're after. You can build it up carefully in a succession of thin layers or apply it directly as thick dabs of creamy, textured color. The resulting picture surface is either smooth and glossy or thickly encrusted with swirling paint that holds every detail of brush, rag or knife.

Various surfaces (known as supports) are suitable: these include hardboard, canvas boards, stretched canvas and paper.

▲ There are many finely worked details in this oil painting – note in particular the velvety qualities of the curtain and cushion, the coarse weave of the wicker chair and rug and the smoother surfaces of wall and patio.

"LUNCH TIME" BY ROSEMARY DAVIES, CANVAS, 42 X 46IN

Rag painting: vegetables in a bowl

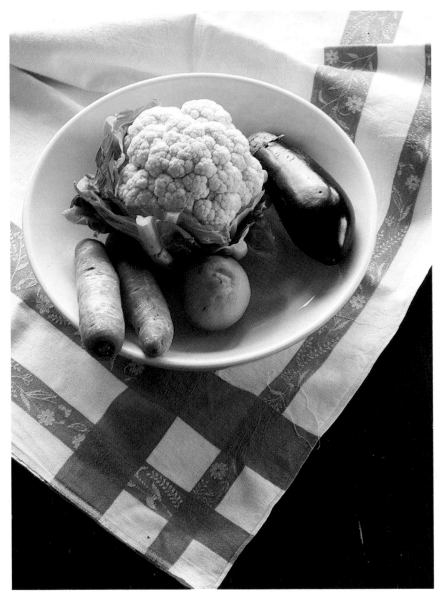

Whether you've used oil paints before or are starting out with them, this project – working with rags rather than brushes – is fun to do and encourages you to paint freely. It's a good discipline to use a limited palette to start with, and this helps to keep costs down as well.

Use a piece of good quality cartridge paper pinned to a board. If you haven't got an easel, prop the board against a chair. You want to be at a comfortable distance from your subject – about 5ft. Position yourself so that you can look easily from the still life group to the paper. Leave enough room behind you so that you can step back from your painting from time to time.

Our artist chose a bowl of vegetables for this demonstration. You can either do the same or pick any interesting group of objects that appeals to you.

Keep to a still life to start with. This provides a subject for interpretation and makes a good picture – and there's no chance of it getting up and walking away.

◀ **The set-up** Note how the roughness of the cauliflower contrasts with the smoothness of the eggplant and the shiny glazed bowl.

The carrots and lemon bring warmth to the overall color scheme, while the dish towel introduces a new texture and a dramatic design (it also reflects light up on to the bowl).

Cool, natural light from both sides illuminates the subject and creates interesting highlights.

▶ **1** Start with a simple underdrawing. Stand at a comfortable arm's length from the paper and use a piece of charcoal to sketch in basic forms and spaces. Remember your sketch is only an underdrawing, so don't get hung up on detail. Flick it with a clean dry cloth to leave a "ghost image" ready for painting.

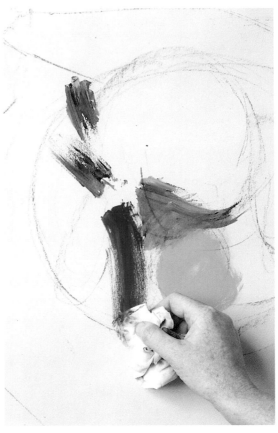

▲ **2** Crumple a piece of clean cotton rag in your hand. (Cotton rag is more absorbent than synthetic material. But make sure that it has no loose fibers that will stick to the painting.)

Dip the rag into the turpentine and moisten the cloth. As a rough guide, just dampen the area of the rag that you want to use so that the turpentine doesn't run down your arm.

Use the rag to thin down some red paint on the palette. Don't use the whole amount at one time – just nick a little from the main blob and thin that by working in the turpentine. Use a good amount of turpentine – the paper tends to absorb it as you work.

▲ **3** Use the rag to rub in the red for the carrots. Do the same with yellow for the lemons and Hooker's green for the cauliflower leaves. Use a new part of the rag for each area so you keep the colors clean.

◀ **4** For the cauliflower – which is mainly white – let the paper show through. Mix a little raw sienna with white to make a pale brown. Use this and a touch of cobalt blue to suggest the darks on the cauliflower.

Leave the eggplant – the darkest object – until more of the medium tones have been established. The table top is important, so rub that in with Payne's gray.

Tip

Clean turpentine
Pour only a little turpentine at a time. If you are using a shallow dish, for example, pour just enough to cover the bottom of the dish. Replace it with fresh turpentine before it starts to get muddy. This helps to keep colors clean and prevents unnecessary waste of turpentine.

► **5** Squint your eyes and look at the light and dark areas of your subject. Try to match these in your painting.

Lighten some Payne's gray with white and use it to paint in the medium tones on the inside of the bowl. Overpaint this with cobalt blue lightened with white. Paint in the gray shadow under the bowl to describe the rim.

Use cobalt blue for the eggplant and fill in the dark area with Payne's gray. Use the same gray for the shadow between the carrots.

Notice how the red from the carrot has been used to shade the lemon, while the lemon lends the vaguest hint of yellow to the carrot.

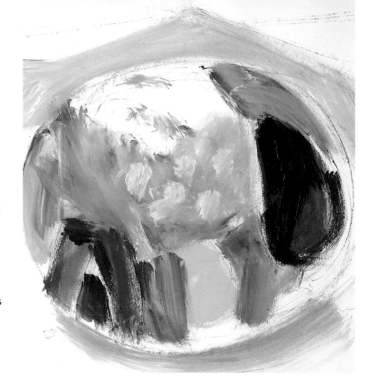

◄ **6** Use your finger to build up a rich crinkly texture with white. (The light area of the cauliflower calls for a thicker ladling of paint – a rag with too much turpentine tends to make it all too thin.)

Don't worry about the white mixing with colors already on the paper – you don't want an unmodified white here anyway, and the mixing adds to the overall effect and texture.

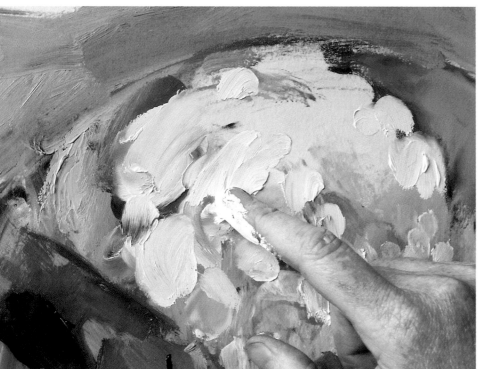

► **7** Look closely at the colors in your subject. Mix some of the same yellow as the lemon into the green of the cauliflower leaves. Tone the red in the carrots down by mixing in a touch of white. Leave a darker red to represent shade. A subtle smudge of warm pink brown on the eggplant turns this dark shape into a shiny, solid object. Make up this color by mixing a little raw sienna, cadmium red and white.

Notice how the cloth forms a deep bank of shade behind the bowl.

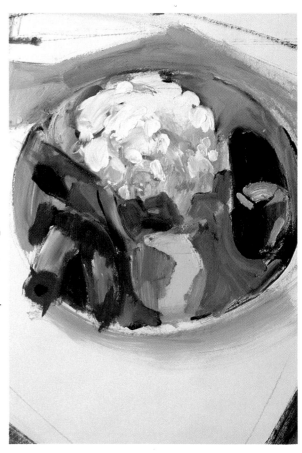

►**8** Use the edge at the end of a flattened cardboard toilet roll tube (or any other thin piece of cardboard) to describe the florets on the cauliflower.

Pick up the red of the carrots and yellow from the lemon, but notice too how the artist has actually left an impression in the surface – removing paint at the same time as adding it.

Now stand back and take a look. The artist decided that the inside of the bowl was too dark, and used a Payne's gray with some white to lighten it.

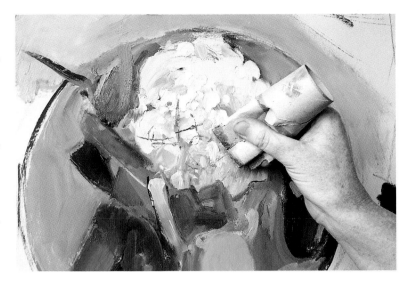

Tip

▼**9** The mere hint of an outline serves to strengthen the composition. Use Payne's gray and cobalt blue to define parts of the oval rim and to suggest the stalkiness of the cauliflower leaves.

See how the colors are working within the bowl now. Yellow from the cauliflower leaves is reflected at the back and red from the carrots at the front.

Mixing on a palette
When mixing colors on a palette (above) it's important to keep them clean. Don't mix patches of color too close together – keep them separate. Once you have mixed a new color, keep a little of it on one side without adding any others to it. You may want to use it again later and it's almost impossible to mix exactly the same color again.

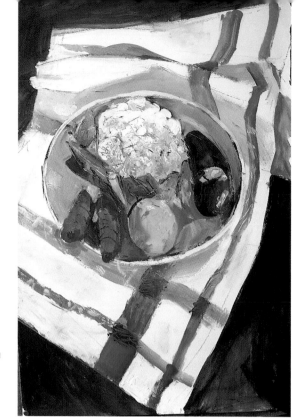

▶**10** Use a pale cobalt blue for the stripes on the dish towel. Don't attempt to describe intricate designs. Here the artist puts in flecks of white to suggest detail on the stripes.

A few carefully observed highlights help to make the surface of the lemon really sing and lend form to the eggplant and the inside of the bowl.

SOLVE IT

Chop and change
The beauty of oil is that you can make changes at any stage. After leaving the painting for a couple of hours, the artist decided to simplify the foreground by removing a stripe on the dish towel with a clean rag and some white to cover the blue.

▼**11** Your painting is finished when you are happy with the result. Here the artist removes one stripe to simplify the picture. But the area of cloth wasn't left a blank white. Instead the artist used pale grays and greens to break up the cloth, making the whole surface of the painting more exciting to look at.

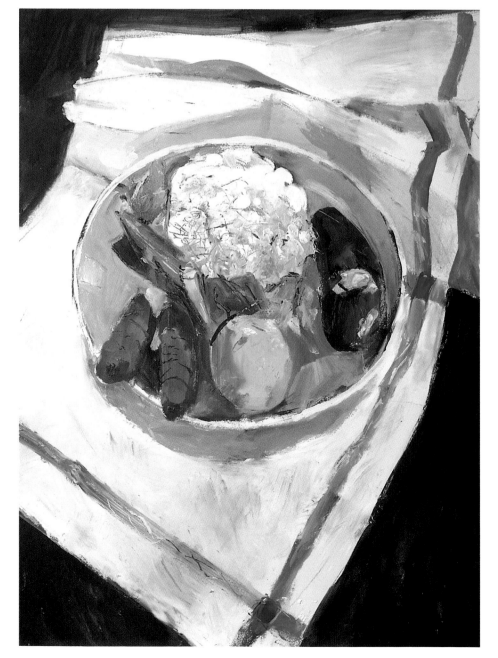

SCUMBLING WITH OIL PAINT

The word scumbling may be strange, but the technique itself couldn't be simpler – it's a straightforward way of introducing texture and broken color effects into your paintings.

To achieve a textural scumbling you drag thick paint lightly across the picture surface so that patches of the underlying color show through the scumbled paint.

You can do this thick scumbling with a brush or painting knife, and it works on any toothy surface – including canvas, oil paper and paint itself. The paint must be as thick as possible, not diluted with turpentine. Good-quality paints are best because they contain less oil and have a stiffer consistency.

The alternative means of scumbling is effectively the reverse of a glaze – it is a film of paint that can be thin or creamy as long as it's also opaque or semi-opaque. With a semi-opaque scumble you modify rather than obliterate the color beneath.

Another way to avoid a complete cover like this is to apply the scumble with a dry brush, so you allow flecks or larger areas of the underlying color to show through.

In the demonstration on the next page we show you textural scumbling with a brush and a painting knife.

▼ In this charming painting of a lavender field in France, the artist has achieved an exciting surface texture by scumbling paint on with fingers, brushes and painting knives.

"LAVENDER IN PROVENCE" BY MADGE BRIGHT, OIL ON CANVAS, 25 X 36IN

SCUMBLING WITH A PAINTING KNIFE AND WITH A BRUSH

1 A knife produces thick wedges of uneven paint that contrast with the thinner color underneath. Scoop up some paint with the underside of the knife and scrape it lightly across the surface, with the edge of the blade tilted.

2 For more regular texture, load a large flat bristle brush with undiluted paint and drag it lightly across the canvas. Hold the brush very close to the canvas, painting with the flattened side of the bristle head.

YOU WILL NEED

☐ 12½ x 16½in piece of primed canvas

☐ Masking tape

☐ Turpentine; palette

☐ Sticks of charcoal

☐ One round No.0 brush and three flats – Nos.12, 10, 4

☐ One 2in flat brush

☐ One painting knife

☐ Nine oil colors: burnt sienna, cadmium red, carmine alizarin, olive green, terra rosa, Naples yellow, French ultramarine, cadmium yellow, white (see palette below)

☐ Two alkyd or acrylic colors: phthalo blue and burnt sienna

Strolling ducks

Scumbling works best on a textured surface, so use primed canvas or cotton duck for this painting. Buy a ready-to-use stretched canvas or simply use a length of primed canvas and fix it to a rigid board with masking tape.

The initial drawing is crucial, so take time getting it right. You'll find it helpful to make a few quick sketches of the subject first, then copy one onto the canvas. Keep the drawing as simple as possible – too much drawn detail is a waste of time because it will get covered up as soon as you start to paint.

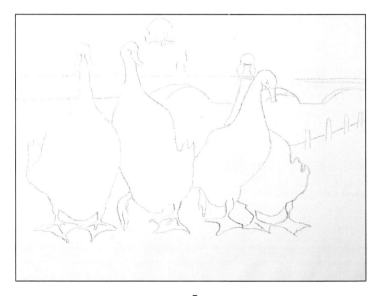

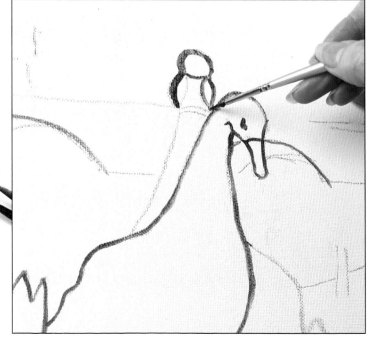

▲**1** Use charcoal for the initial drawing, giving the ducks a single, confident outline. For the background, a few accurate lines are enough to establish the position of the bridge and buildings.

◄**2** By making a textured underpainting in neutral acrylic or alkyd paint you lessen the drying time and can scumble over it in oil paint almost immediately without smudging the painted outline. For the outline, use a No.0 round brush and a mixture of phthalo blue and burnt sienna – this produces a very dark tone that is less stark than black.

► **3** While the outline is drying, squeeze your oil colors onto the palette – burnt sienna, carmine alizarin, terra rosa, Naples yellow, French ultramarine, olive green, cadmium yellow, cadmium red and white.

Using the No.12 flat brush, apply a loose wash mixture of terra rosa, carmine alizarin and burnt sienna across the ground and sky. Don't worry about drips and runs – these quickly become integrated into the picture.

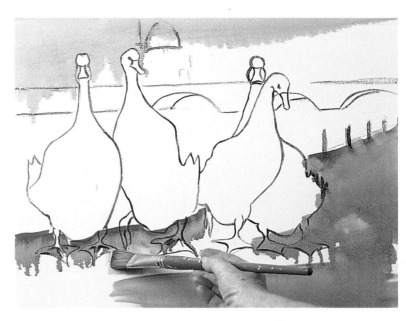

◄ **4** For the river, use the 2in flat brush to apply a thin wash of French ultramarine in short, vertical strokes. Paint over the outline of the ducks, but leave a few patches of white on the lightest parts of the birds.

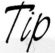*Tip*

Wait a while

If you are scumbling one color over another, you may find it easier to wait until the first color is slightly tacky, otherwise the colors may smudge into each other. The scumble is applied so lightly that the texture of the canvas itself almost drags the paint off the brush.
In fact, you may find it helpful to wait to do your scumbling until the paint is dry to the touch. In this case, you need to exercise a little patience before continuing with the picture.

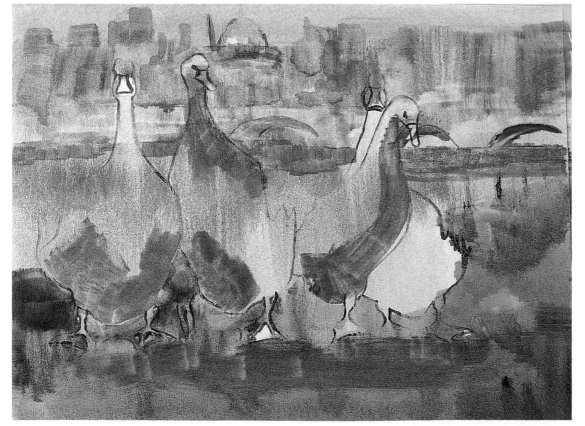

◄ **5** The blue and reddish brown washes look more natural if you allow them to overlap in places. Paint the shadows cast by the ducks and those on the ducks themselves in a darker tone of the blue wash color.

► **6** For the pale background areas, mix a little white and Naples yellow with the blue and brownish red already used in the painting. Bring the ducks to life by painting the light tones in pale blue with your No.10 flat brush.

▼ **7** Paint the black duck with the No.4 flat brush. Real black would be too dominant, so use a mixture of olive green, French ultramarine and a little carmine alizarin.

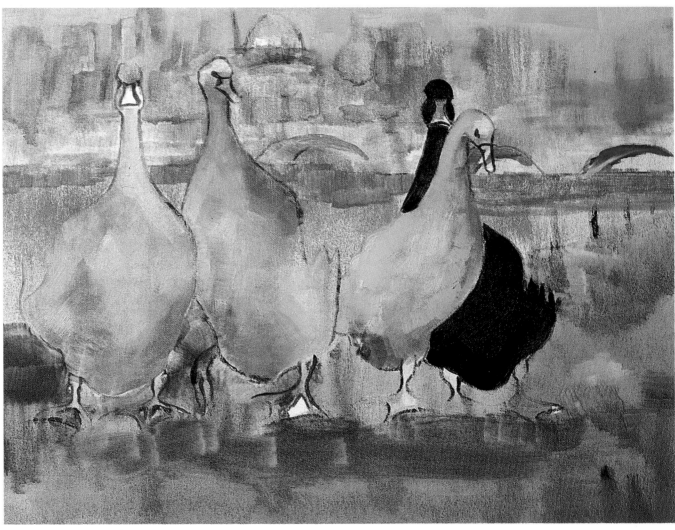

◄ **8** It's almost time to start adding texture – time to start scumbling the ducks! But first you have to re-establish the duck outlines, which have become lost under washes of color. Do this with your No.0 brush and the acrylic or alkyd paint.

◀ **9** For the first layer of scumbled color, dip the No.10 brush into thick white paint – don't add any turpentine – and drag the loaded brush lightly across the canvas inside the outlines of the ducks. The pressure should be light enough to allow patches of under painting to show through the thick paint.

▲ **10** For the beaks and feet, mix a bright orange from cadmium yellow and cadmium red and apply this with your No.4 flat brush.

Tip

Keep it dry
When you are scumbling in this textural way, keep your paint thick but dry – use very little turpentine (preferably none, in fact).
Another point to bear in mind when you start is that scumbling works best on a textured surface.
Don't forget to use your fingers – they're great tools for scumbling.

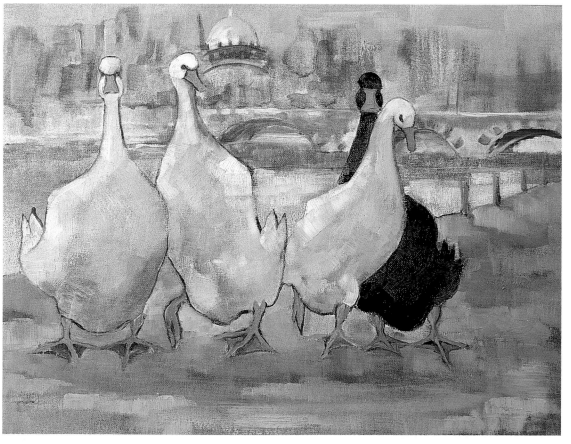

◀ **11** Lighten the shadows underneath the ducks with a light scumble of white and French ultramarine. For the shadows on the feet, use the dark tone – olive green, French ultramarine and a little alizarin carmine – painting them in with the No.0 brush.

▲ 12 You can create the illusion of distance by applying a pale blue scumble across the entire background area. Do this with the No.10 brush, held flat against the canvas, and apply the stiff color in short vertical strokes to indicate the geometric, upright buildings.

◄ 13 Lighten the very pale background areas a bit more by cross-scumbling – pulling the brush horizontally across the previous vertical strokes. Your scumble should be light enough to allow the shapes of the buildings to show through.

► 14 Redefine the light background tones and highlights in white using your No.4 flat brush.

▲ **15** The painting is almost complete, and it's time to stand back and take a critical look at your picture. Notice how the white ducks have become too similar in tone and texture to the background. They need to be brightened and strengthened.

▶ **16** A painting knife is useful here (see page 224). Use it to scumble a thick layer of white onto the ducks. Use the direction of the strokes to describe the curved forms of the birds.

► **17** Take care not to scumble a complete layer of white over the ducks. Retain some shadows on the birds by allowing a few areas of darker underpainting to show through. These dark patches, and the shaded parts of the necks and abdomens, make the birds look solid and real.

▼ **18** In the finished picture the scumbled areas of white on the ducks – with the darker colors showing through – give zest and life to what could otherwise have been areas of dead color. The bright beaks and feet contrast well with the white, while the gentle blues and earth colors of the background give a sense of hazy distance.

CHAPTER EIGHT

ACRYLIC PAINTING

TOOLS AND TECHNIQUES

CHOOSING ACRYLIC PAINTS

Today the range of acrylic paints is vast. With information about the most recent developments, you can use the right paint for the right job, saving yourself time, money and a lot of hard work.

Paint manufacturers are constantly developing and changing their acrylic paints. This is tremendously exciting – but keeping informed about current products is not easy. Even experienced professionals may miss out on new possibilities because they are unfamiliar with recent developments.

Liquid acrylics are a typical example. Fairly new products, they resemble slightly brilliant liquid watercolors or inks (which tend to be fugitive, or fading when exposed to light). Because they all look similar they may often be grouped together – mistakenly, since most liquid acrylics are permanent, not fugitive. If artists don't know about them, they're limiting their creative possibilities.

What is acrylic?

Acrylic paint is pigment dispersed in a film of transparent liquid plastic (technically speaking, an emulsion consisting of plastic acrylic resin and water). You can dilute acrylic paint with water, but remember that it is insoluble once dry.

In its liquid form the emulsion has a milky appearance, but after the water evaporates it becomes transparent. You can test this for yourself with one of the acrylic mediums – just brush some undiluted gloss or matte medium (which is an emulsion without any pigment) onto a tinted support. You'll see that it's rich and creamy right from the bottle, but transparent when dry.

Types of paint

Most paint manufacturers have at least one range of acrylic paint in their catalogs – and some have several. The main differences between one range and another are the consistency and the number of colors.

You can apply acrylics thickly for impasto and thinly for washes and staining techniques. Thick, textured impasto requires a stiff paint that can retain the strong mark of the brush or painting knife. Thinner, more fluid paint is best for washes. Adding brand-name mediums to thicken or thin the paint is one way to increase the paint's versatility.

Some manufacturers, however, produce several ranges of paint with different consistencies to save you the time and trouble of mixing. Here we look at three of the largest acrylic paint manufacturers. Their products are widely available in most art stores.

DID YOU KNOW?

What are alkyds?
Often confused with acrylics, alkyds are fast-drying oil paints (but not as fast as acrylic paints) that do not mix with water. Use them on their own, or combine them with oil paints. To modify the way alkyds behave and to quicken their drying time, use alkyd mediums such as Winsor & Newton's Wingel or Liquin.

▼ The artist's use of opaque acrylic is bold and loose. The scumbled water and the sky give a dramatic sense of depth, helping your eye to travel from the opaque water to the bright red building and into the cityscape and beyond.

"ST PAUL'S FROM THE SOUTH BANK" BY TERRY McKIVRAGAN, ACRYLIC ON HARDBOARD, 36¼ X 44IN

Winsor & Newton

Winsor & Newton Artists' Acrylic Colour is a range of 75 paints available in tubes in 0.7oz (20ml), 2oz (60ml), 4oz (120ml), and 6.75oz. This includes six pearlescent and six metallic colors and an iridescent white. The consistency is similar to Liquitex Tube Color paints. Although it holds a brush mark well, you may want to add gel medium for heavy impasto work.

Galeria, ideal for artists who work on a large scale, flows smoothly and freely but retains the mark of the brush. It's marketed as an economy paint, but the quality is excellent. There are 25 colors in 17fl oz (500ml) tubs.

The six mixing primaries of the Galeria range are particularly interesting. You can mix many colors with the cadmium yellow pale hue, cadmium yellow deep hue, permanent rose, vermilion hue, ultramarine and cerulean blue hue.

Winsor & Newton Designers' Liquid Acrylic Colour is a range of 36 colors supplied in bottles with dropper caps. Water resistant when dry, they have good lightfastness. Use them for all sorts of wash and line techniques, including airbrushing and technical pen work.

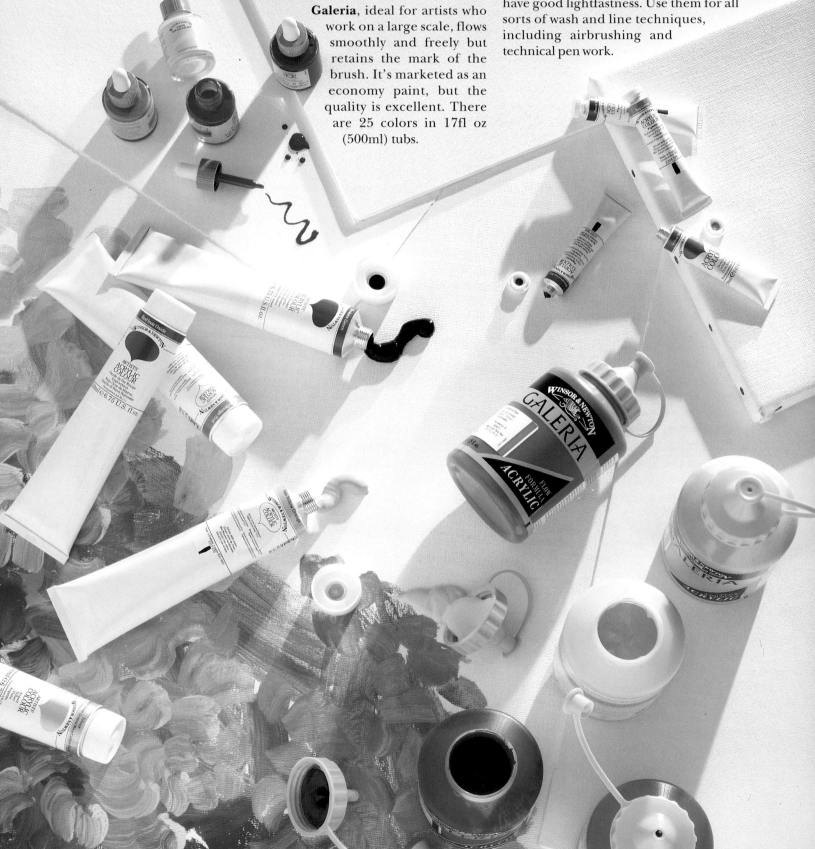

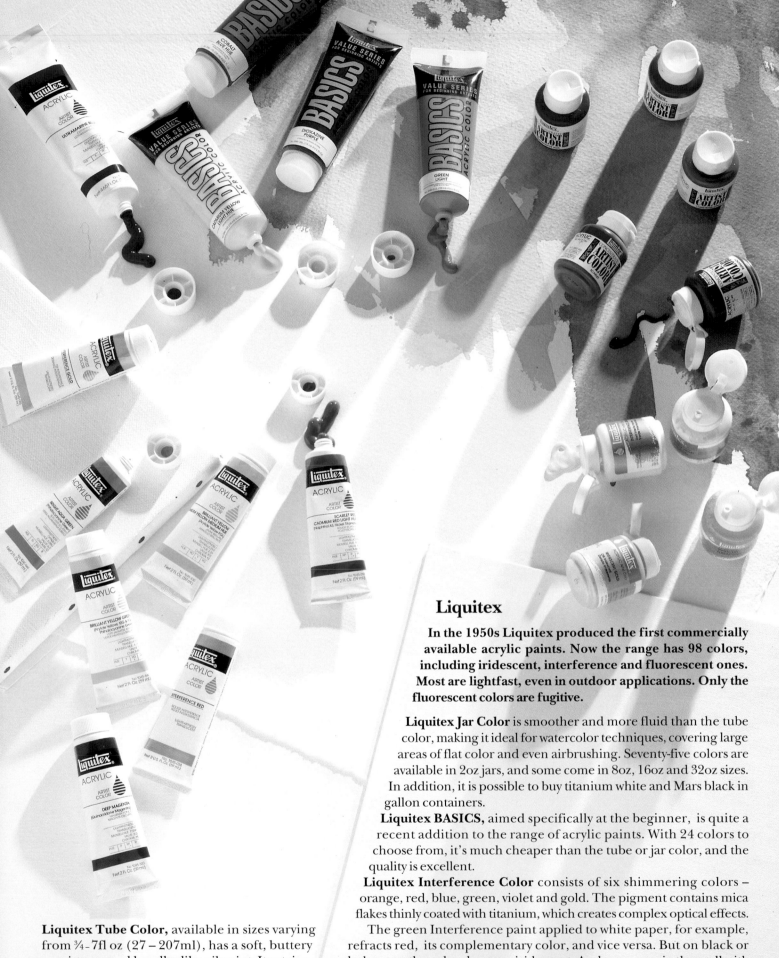

Liquitex

In the 1950s Liquitex produced the first commercially available acrylic paints. Now the range has 98 colors, including iridescent, interference and fluorescent ones. Most are lightfast, even in outdoor applications. Only the fluorescent colors are fugitive.

Liquitex Jar Color is smoother and more fluid than the tube color, making it ideal for watercolor techniques, covering large areas of flat color and even airbrushing. Seventy-five colors are available in 2oz jars, and some come in 8oz, 16oz and 32oz sizes. In addition, it is possible to buy titanium white and Mars black in gallon containers.

Liquitex BASICS, aimed specifically at the beginner, is quite a recent addition to the range of acrylic paints. With 24 colors to choose from, it's much cheaper than the tube or jar color, and the quality is excellent.

Liquitex Interference Color consists of six shimmering colors – orange, red, blue, green, violet and gold. The pigment contains mica flakes thinly coated with titanium, which creates complex optical effects. The green Interference paint applied to white paper, for example, refracts red, its complementary color, and vice versa. But on black or dark paper the colors become iridescent. And you can mix them all with mediums and other colors. Interference Color is useful for capturing the iridescent qualities of some bird plumage, for instance.

Liquitex Fluorescent Color appears to glow even when mixed with other acrylic paints. Don't use it for paintings you want to keep because it's fugitive.

Liquitex Tube Color, available in sizes varying from ¾-7fl oz (27 – 207ml), has a soft, buttery consistency and handles like oil paint. It retains the mark of the knife or brush yet remains flexible when dry. The complete range isn't available in all tube sizes. Mars black and ivory black come in large 8fl oz (237ml) tubes.

Daler-Rowney

Daler-Rowney offers a range of 55 colors in two consistencies – Cryla and Cryla Flow.

Cryla has a creamy consistency and is good for impasto work. Tubes come in two sizes and there is a limited selection of colors in larger tubes.

Cryla Flow is thinner and more suitable for washes, staining techniques and large-scale work. White is available in two sizes of tube. Some colors come in larger tubs.

Rowney System 3 Acrylic is a range of 24 colors in 17fl oz (500ml) nozzle-cap jars. A quality product at an economical price, it is compatible with Daler-Rowney acrylic mediums and is ideal for school and craft work and for large-scale projects such as murals.

PAINTING REFLECTIONS IN GLASS

Glass objects come in many attractive shapes and lend grace to any still life. But conveying the transparency of glass, with all its reflections and highlights, is quite a challenge.

The secret of painting glass lies in resisting the temptation to put in too much detail: the more decisively and simply you paint glass, the more transparent it looks. Bear in mind that faithfully copying every detail you see doesn't work – too much detail destroys the illusion of a smooth, light-reflecting surface. Fewer details, in fact, say more. A few telling highlights and reflections are all you need for a convincing illusion of glass.

Looking at your subject through half-closed eyes cuts out weaker details and points up the stronger tonal contrasts, helping you to see the reflections as an abstract pattern of shapes and colors. (Note how some of these shapes have hard edges and some, soft.) Compare one tone with another as you work – if, say, you are painting a glass half-filled with wine, check whether the rim highlight is brighter or duller than that on the stem. Is the colour of the wine cooler on the surface than in the bowl of the glass?

Only when the basic tones and colors are correct should you add small touches of highlight to give the glass sparkle. Remember too that glass reflects the colors of surrounding objects – both dark and light tones. Paint only the brightest highlights with pure white, modifying the others with a hint of the local color of each object reflected in the shiny surface.

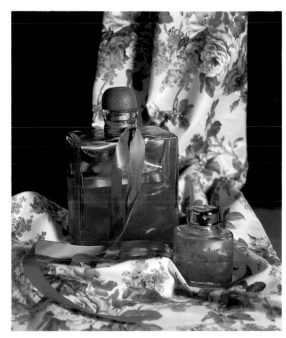

◀ **The set-up** These two elegant perfume bottles make an ideal subject for the study of reflections in glass. The lavender water they contain links them with the pink and green backcloth and adds further interest to the reflections. The sweep of green satin ribbon not only provides a link between the two bottles, but its soft highlights also contrast interestingly with the sharper, brighter highlights in the glass.

◀**1** Lightly draw the bottles, the ribbon and the main folds in the cloth with charcoal, dusting off the excess with a rag so that it doesn't dirty the paint.

Mix a thin wash of cadmium yellow softened with some cobalt blue, and go over the charcoal lines with the tip of the No.5 flat brush.

Tip

Keep it simple
If you include glass objects in your still life, as in this demonstration, try not to have too much overhead light, which causes a confusion of shadows, reflections and highlights. Choose, instead, a strong sidelight, which emphasizes three-dimensional form while creating relatively simple shadows and highlights.

▶ **2** Use the same brush to block in the dark areas of the background in a mix of chromium oxide green and cobalt blue, adding cadmium yellow for the lighter parts. Check the tones in the green ribbon, then use chromium oxide green and cerulean to block in the dark areas on it with the Nos.1 and 5 brushes.

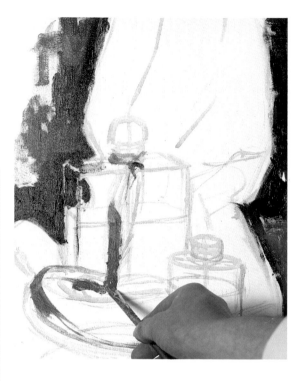

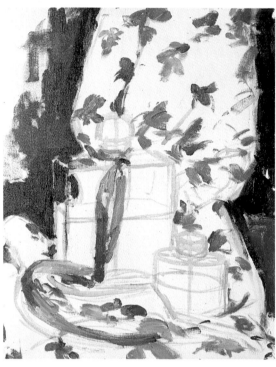

◀ **3** Mix cerulean, titanium white and a little chromium oxide green and block in the lighter parts of the ribbon.

Suggest the pattern of leaves on the cloth using the background green, softened with titanium white or cadmium yellow. Don't go into too much detail – concentrate on how the greens change in tone, becoming lighter or darker as the pattern follows the contours of the cloth.

Tip

Weave your color
As you paint, think of yourself as a weaver, twining threads of color through your picture. Repeating touches of similar color from one area to another all over the picture encourages the eye to explore the composition, while at the same time giving it harmony and unity.

▶ **4** Mix permanent magenta and a little white and use the No.5 flat brush to start painting the lavender water in the large bottle. Add a drop of cerulean to the mix where the tone is slightly darker on the right of the bottle.

Assess the composition in terms of broad areas of color at first – once these are blocked in you can break them down with shadows and highlights.

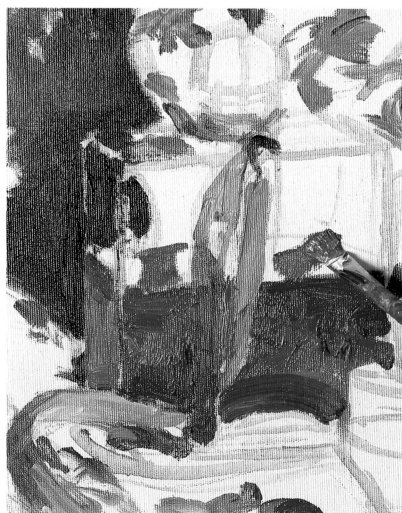

239

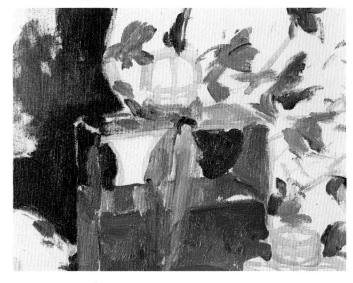

▶6 Before adding any more detail to the reflections, establish the pink flower pattern on the backcloth, using the No.5 flat brush. Again, don't worry about detail at this stage – get the main shapes right, so the pattern follows the curves and folds in the cloth. The basic mix is alizarin crimson and white, darkened with a little magenta and cerulean for the areas in shadow, plus touches of cadmium yellow.

▶8 Now paint the cork stopper on the larger bottle with the No.3 brush. The basic mix is cadmium yellow, alizarin crimson and a touch of cobalt blue – a warm brown. Add more blue for the shadows. So the stopper isn't too dominant, add touches of cadmium yellow, broken with hints of alizarin crimson and cobalt blue among the flowers on the backcloth (see Tip, opposite).

◀5 The hue of the lavender water reflected in the glass appears cooler. Paint broad tonal areas in blocks – magenta and white for medium tones, magenta and cerulean for dark. For the dark patch at the back use cobalt blue, magenta and chromium oxide green. Use magenta and white for the water in the other bottle, adding cerulean for the darker surface and cobalt blue for the violet tones.

◀7 Paint the large rose near the top of the backcloth with curved strokes of the fairly dry No.5 flat brush, using a partially blended mix of magenta and alizarin crimson, broken with white for the light parts.

9 Block in the darks and medium tones on the silver stopper of the small bottle with mixes of chromium oxide green, Mars black and cobalt blue. Use the No.1 brush to enrich the color of the ribbon with thicker paint. Apply chromium oxide green and cerulean, with more blue where the ribbon lies in shadow. For the cool highlights, add permanent green light and a touch of white; for the warm reflections, add cadmium yellow. Blend the edges where the light and dark tones meet to suggest the soft sheen of satin.

10 Now polish up the finer details of pattern and texture. Finish the green velvet backdrop, using the No.5 flat brush and a warm green mixed from cadmium yellow and chromium oxide green, overlaid with drybrush strokes of cerulean and cobalt blue to enliven the shadows. Loosely brush in some pure white between the flowers on the fabric. Then mix a soft gray from cobalt blue, white and a touch of Mars black and put in the fabric's shadows and its folds and creases.

11 Introduce some dark reflections to the lavender water in the large bottle with the No.5 brush. The corners of the bottle reflect the green velvet drapery: put this in with cobalt blue, magenta and chromium oxide green. For the warm reddish reflections in the glass above the water use white and magenta.

For the brightest highlights use the No.1 brush to skim pure white over the wet surface so it blends with the undercolor in places. Add a soft highlight to the cork stopper, blending it gently.

In the finished picture you will see how the glass bottles have been treated quite simply with broad strokes and blocks of color. The key is to assess the tones correctly, then apply the colors decisively.

THE PATTERNS OF NATURE

The patterns and symmetries observed in nature can be the subject of highly decorative yet realistic paintings.

The natural world is full of patterns – everything from a snowflake to a tree has some regularity of structure. Although in day-to-day life we take such symmetries for granted, artists are constantly on the lookout for that element of design that runs through or governs a subject. Repeated symmetrical shapes not only help to organize the composition, they are pleasing to the eye on their own.

Some painters even take the process a step further, seeking to make pattern itself the focus of their work. Using the natural subject (whether still life, landscape or animal) as a reference, they exaggerate its decorative, pattern-making aspects, giving these overwhelming prominence in the picture space. Two-thirds of our artist's painting of a peacock, for example, is devoted to the splendid colors, textures and shapes of its feathers. It's an inventive piece of cropping that deliberately focuses on the pattern inherent in the exotic plumage.

▲**The set-up** A good selection of reference photographs proved essential for this composition. Our artist combined the close-up of the head with the picture dominated by the bird's tail fan to create the best composition from both images.

◀**1** Lay out the four base colors – titanium white, burnt umber, yellow ocher and ultramarine – on the paper palette. Use water and the decorators' brush to mix these colors roughly, making sure you retain some streaks of pure paint. Dip the sponge in the mixture and dab over the entire upper third of the board, creating a marbled cloud. This provides an interesting textured background for the main image, without distracting the eye with unnecessary detail.

▶ **2** Load the No.10 flat brush with the base mixture and start work on the underlying structure of the feathers. Stroke long arcs of paint radiating out from the base of the peacock's tail, set right of center where the background color meets the unpainted board. Try to use single strokes of the brush, turning the board on its side if necessary for ease and fluidity of movement.

◀ **3** Add more burnt umber and ultramarine blue to the base mixture to darken it. Load the No.10 flat brush with paint and, with the board on its side, paint in hoop-like lines across the lines painted in the previous step. Allow these sweeping strokes to fade out toward the right side of the composition to help give the impression of recession.

▲ Our artist's palettes – one for his base mixture, one for his green and blue glazes.

▶ **4** Load the No.10 round brush with pure white as the base color for the "eyes" of the peacock feathers. Dab these in at intervals over the grid created in the previous steps. Remember that the lower section of the painting constitutes the foreground – so make sure the white blotches are large here and decrease in size as they get nearer to the head of the bird.

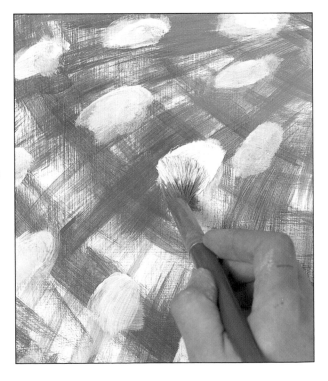

◀ **5** Load the No. 4 round brush with a mixture of ultramarine and burnt umber, and stroke in the downward-slanting, fishbone-like stems of the feathers. Allow these strokes to overlap, giving depth by suggesting feathers underneath.

Load the No. 6 round brush with ultramarine and thickly underscore each "eye" on the feathers.

▶ **6** Stand back from the picture, and let the paint dry for a few minutes. You have now put in the "scaffolding" of the composition; the rest of the painting process largely involves building up the textures and colors of the plumage and, of course, painting in the body of the bird itself.

◀ **7** Load the No. 4 round brush with well-thinned white and stroke in the long quills of the feathers radiating from the back of the peacock. Make these marks slightly rough or fluffy, varying the pressure you exert on the brush as you paint.

Intensify the white on each "eye" of the feathers, using pure, unthinned paint.

▶ **8** Now begin to develop the detail on the feathers, constantly referring to the reference photographs. Load the No. 4 round brush with ultramarine, and paint in the blue rings at the center of each peacock "eye." Vary the dilution of the paint, making those rings farthest away fainter than those closest to you. This helps to suggest depth.

▶ **9** Thin some yellow ocher with water. Load the No.4 round brush with this and paint the rings around the blue centers of each "eye." Follow the process adopted in the previous step – that is, make sure some of the rings are fainter than others to give the impression that the feathers lie at varying depths in relation to the picture surface.

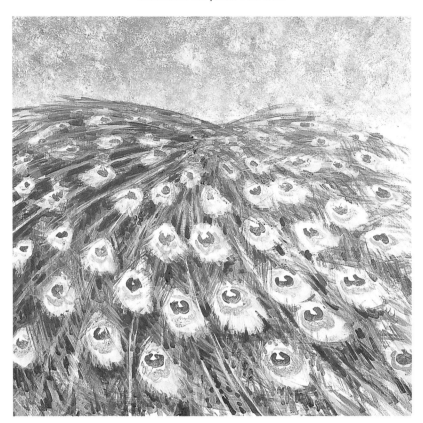

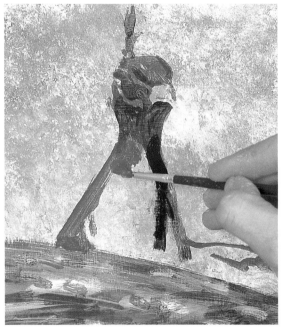

◀ **10** Darken the shadowy areas between the peacock plumes, using the No.4 round brush and a strong mix of ultramarine and burnt umber.

If you stand back from the picture now, you can see how the patterning process (which concentrates on the design) goes hand-in-hand with the normal painterly process of creating an illusion of three-dimensional depth.

▶ **11** Draw the outline of the peacock's head with the No.4 round brush loaded with ultramarine. Use pure ultramarine for the left of the bird's neck, and a mixture of ultramarine and burnt umber in the shadow under the head and on the right.

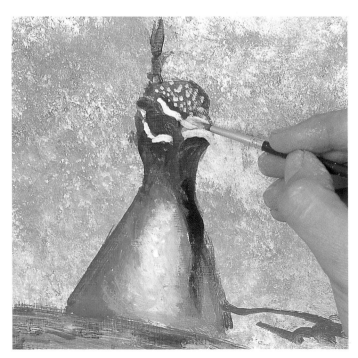

◀ **12** Now lay in the white patterns on the peacock's head, using the No.4 round brush and pure titanium white. Touch in the beak, the spots on the top of the head and the lines around the bird's eye.

Stroke diluted white onto the front portion of the neck, where the light strikes the iridescent feathers.

◄13 Continue to develop the feathers on the peacock's body, using the No.4 round brush loaded with mixes based on ultramarine. Mottle the rear of the bird with white and ultramarine mixed with burnt umber. Outline and highlight the peacock's eye with pure white.

Tip

Reference only
Reference photographs are there to help you create an original painting of your own — so don't feel you have to copy their cropping and composition . Our artist's use of photos for this demonstration is a good case in point; he reversed one image and adapted parts of another until he had found exactly the composition he wanted.

►14 Use the No.3 brush and pure titanium white to highlight the quills of the feathers running between the "eyes." Constantly vary the thickness and intensity of the lines. Use white to detail the "eyes" themselves with strokes radiating from their centers. Let the picture dry.

◄15 Concentrate now on capturing the iridescence of the feathers. Use the decorators' brush to lay a glaze of phthalo green over the whole plumage. Put a ring of light green near the circumference of each "eye" and add more shadows with ultramarine and burnt umber.

►16 Let the picture dry again so you can apply another glaze. Mix a turquoise from phthalo green and blue and, once again using the decorators' brush, lay a thin glaze over the entire plumage. Notice how the bird's plumage now seems to shimmer and glow.

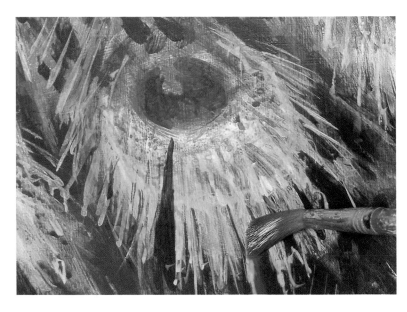

▶ **17** Work on the markings of the "eyes" a little more, using the No.4 round and more green. Intensify the blue in the centers if necessary with pure ultramarine. Finally, use one of your finer round brushes to spread diluted phthalo blue over the tips of the peacock "eyes."

Tip

The real peacock
Inevitably, some of the resplendent colors of the peacock's feathers will look duller in photographs than in real life. To ensure that you capture the full richness of

these colors, try to find a real peacock feather that you can compare with the acrylics you apply as the painting progresses. Here, the painted feather is well able to withstand comparison with the real thing.

▼ **18** The painting is now finished. Note how the final glazes of green and blue add depth and brilliance to the feathers – the acrylic colors are perfect for capturing the deep sheen and jewel-like colors of the bird's exotic plumage.

The artist has made the viewer aware that the natural subject has both a decorative surface and a living depth. By closing in on the bird's plumage he emphasizes its striking pattern, yet his painting techniques help to show recession.

A PLAY OF LIGHT AND DARK

To simplify apparently complicated subject matter, try ignoring superfluous detail and limiting yourself to a small selection of colors that tone well together.

The amazing amount of detail in a close-up study of a forest can be daunting. To depict this sort of subject in a realistic way – capturing every leaf on every tree – is a time-consuming and, some would say, thankless task.

The artist here made a deliberate decision to simplify his Australian forest scene by concentrating only on the features that struck him as most important. In particular, he was interested in the play of lights and darks. Note, for example, the striking horizontal highlights on the tree trunks and how well these work with the diagonal stretches of sunlight on the path. With simplification in mind, he also limited himself to seven colors, building up a series of glazes for a picture with depth and subtlety.

▼**1** Begin by covering your support with phthalo green using the 1in decorators' brush. This gives a dark-toned ground from which the highlights will jump out. Our artist then transferred his initial pencil drawing onto the support using a sheet of yellow transfer paper, which shows up well on a toned ground.

◀ **The set-up** Working from a photograph – rather than from life – can be a distinct advantage when you want to simplify a painting. Photos cannot register all that the human eye can take in – lots of details, as here, are lost in deep shadows and burned-out highlights. This can be a great help when you are trying to be selective, and don't want to over-complicate your painting.

Using this photograph, our artist made a pencil drawing of the forest on a sheet of cartridge paper, bringing out the separate trunks and branches and outlining the main highlights.

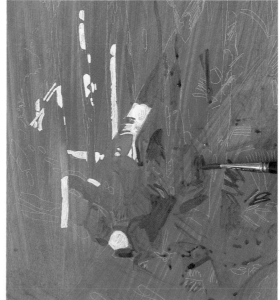

◀**2** Start the painting by plotting a few of the brightest highlights, using a mix of cadmium yellow and titanium white. Then turn to some of the darker vegetation, applying a glaze of phthalo green and raw sienna with the No.3 brush.

▶ **3** Continue working up the lights, using both unmixed titanium white and your mix of cadmium yellow and titanium white. The unmixed titanium white marks may appear a little crude at this stage, but they will be modified by a number of glazes as the painting progresses.

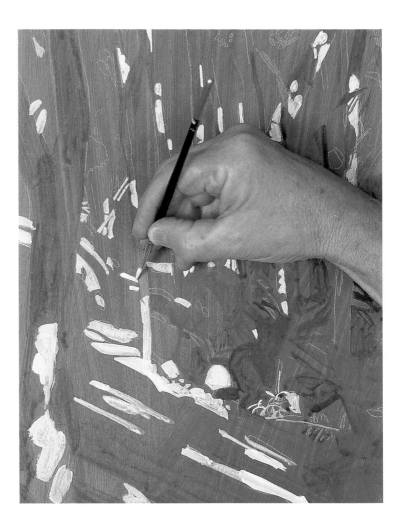

◀ **4** For the patches of sky showing through the dense foliage at the top of the picture, apply a mix of phthalo blue and titanium white. This creates an opaque color that stands out from the green.

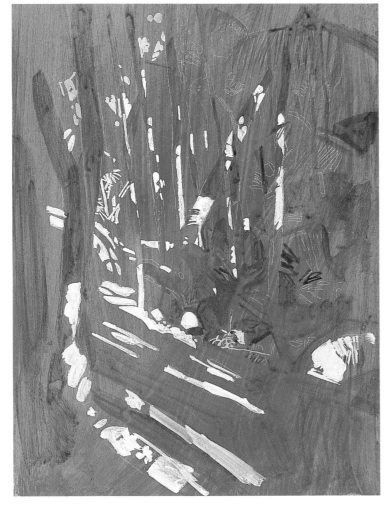

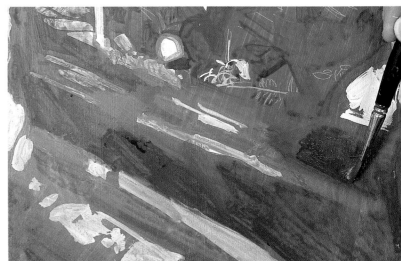

▲ **5** Establish the path at the bottom of the picture with a thin glaze of raw sienna. Apply this over both the green ground and the highlights. Then paint in some of the darker areas with a mix of burnt umber and Mars black.

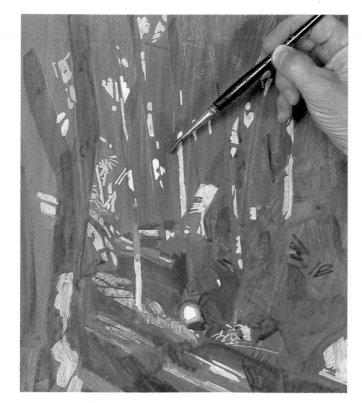

◄ **6** The green ground that still shows now looks too stark and needs to be modified with subtle glazes. Apply a mix of cadmium yellow and phthalo green with the No.3 brush for the lighter vegetation. For the medium tones use glazes of phthalo green and phthalo blue.

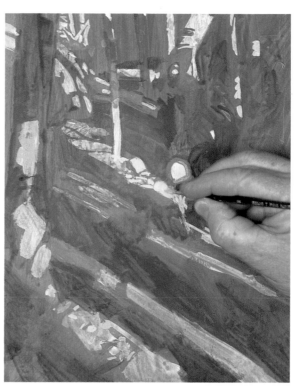

► **7** Now you need to re-emphasize the brightest highlights on the path with titanium white and traces of cadmium yellow and raw sienna. Don't view this merely as correcting mistakes, but as building up layers to give the painting depth and subtlety.

▼ **8** Return to your phthalo blue and titanium white mix to continue building up the sky. Only small fragments of sky show through the dense network of branches and leaves, so work quite meticulously, applying small dabs of paint with the No.2 brush. Gradually add more phthalo blue to your mix to achieve a deep color suitable for the Australian sky.

▼ **9** The painting is now virtually complete. The murky depths of the forest have been rendered well, but as a final touch you need to put in some of the brightest highlights.

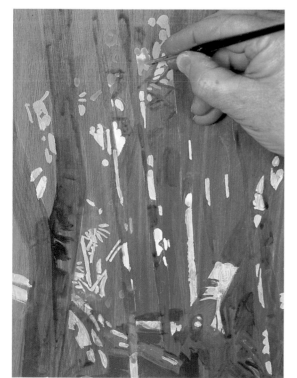

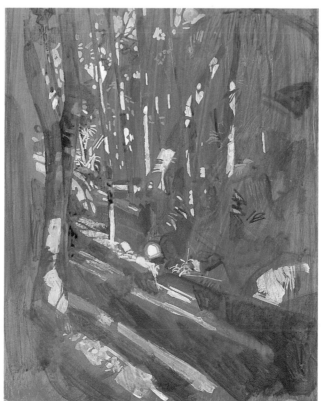

▶ **10** Add more white to the titanium white and cadmium yellow mix and carefully overlay this on some of the highlights on the trees and path – especially those in the foreground. Set against the yellow base color, the new paint will appear almost white.

▶ **11** In the final picture, it is evident how carefully the artist has thought out the composition. Note how the diagonal shafts of sunlight encourage the viewer's eye to travel up the path toward the sky. The sky itself occupies a triangle at the top left of the painting that echoes the triangular shape of the path at the bottom of the picture.

The painting's success, of course, also relies on the startling highlights. The yellows used for these are not particularly hot or deep, but they are warm enough and light enough to jump out from the cool, dark background.

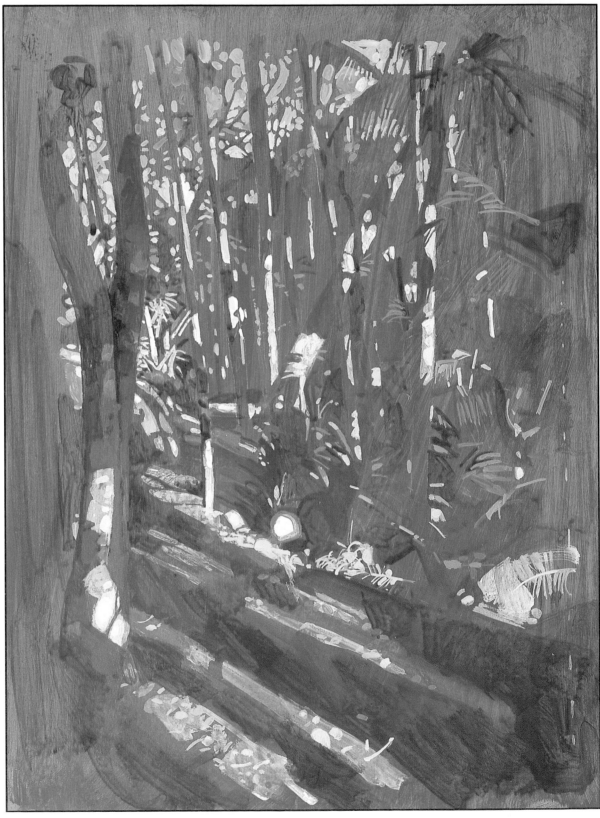

WORKING WITH ONLY ONE BRUSH

Choosing to paint your whole picture with just one brush might seem restricting. But it is a discipline that can actually free up your painting style.

For many artists, the essence of painting is to observe carefully and render faithfully. Others find it more challenging to interpret the world and produce an original and personal view. For those of you who want to take the latter path, often the problem is how to put your distinctive stamp on your paintings.

One way is to limit your equipment. You may, for instance, want to reduce the number of colors you use – Paul Gauguin's Tahitian paintings, even if you ignored the subject, would be recognizable from the palette alone. Alternatively, you may want to limit your brushes – the later work of Post-Impressionist Paul Signac is readily identifiable from the uniform brushstrokes.

In this demonstration, our artist chose to restrict herself to one large brush – a No.10. This

liberated her painting style, forcing her to work in bold, confident strokes. Prevented from meticulously registering detail, she was able to concentrate on the overall effects of shape, color and tone. The expressive possibilities of the brushstroke became as important as the subject it was describing.

Every time our artist felt she was tightening up, she would step back, review the painting and attempt to work backward. Strong lines were softened by lightly brushing color back and forth over them. Dabs of unmixed color – cadmium red, yellow ocher and titanium white – were applied to add to the vibrancy of the picture. These colors are neither entirely arbitrary, nor entirely naturalistic – instead, they can be seen as an imaginative exaggeration of existing color.

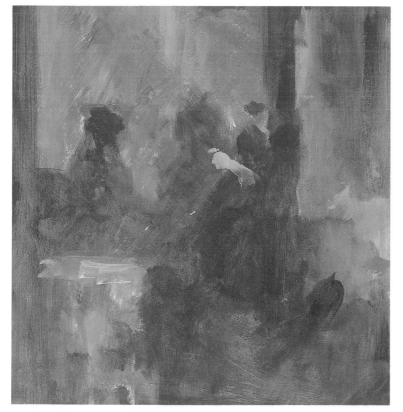

The set-up The choice of a pub as subject matter seemed particularly appropriate for our artist's style of painting. The interior of a lively pub – with low lighting, smoke-filled air and customers constantly moving – seems to demand a loose, imprecise rendition.

The artist used photos and sketches as reference material.

▲ The artist's palettes, showing the generally muted colors she mixed for the demonstration here.

◀**1** Start by establishing the tonal range of the painting. Lay down a base color of cadmium red with touches of transparent brown and yellow ocher. Then broadly mark out the dark areas – the figures and the window frame – with raw umber and burnt sienna, and the highlights with a mix of yellow ocher and titanium white.

▶ **2** Continue to apply dry mixes of yellow ocher and white to build up the light tones, especially on the surface of the table, around the drinkers, and on the side of the window frame on the left. Use Payne's gray to describe the curved backs of the chairs.

At this early stage you can use unmixed color in a somewhat playful way. Dab pure cadmium red near the chair backs and above on the window frame. Also apply small strokes of yellow ocher and then titanium white over the window on the right. As the painting progresses, some of these unmixed colors may appear a little too obtrusive, in which case they can be modified by glazing and scumbling other colors over them.

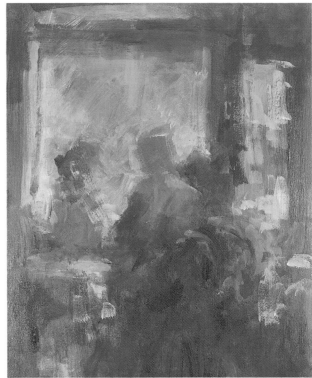

▲ **3** Continue working with unmixed color, reinforcing the backs of the chairs with Payne's gray. Also use Payne's gray to beef up the figure on the right so that she is almost in silhouette. Apply more dabs of cadmium red around the chair backs.

▶ **4** Add more yellow ocher over the glass in the top right of the picture. Also use more Payne's gray to model the arm of the middle figure and to strengthen the shadow tones under the table.

Having established the warm, dark colors, it's time to give an impression of the cool exterior light. Start by scumbling a dry mix of Hooker's green, ultramarine and white over the window.

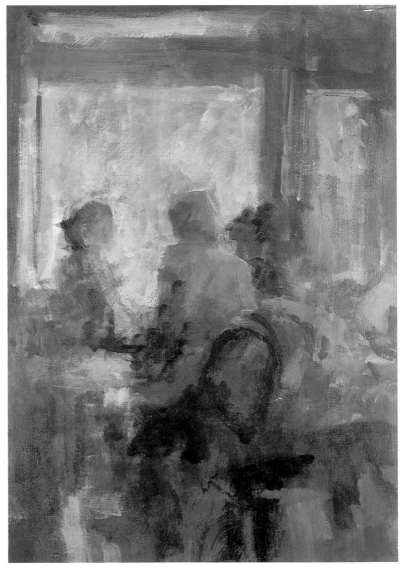

◄5 Continue to lighten the tone in the window with the blue and green mix and with unmixed titanium white. Note that the colors are applied lightly and unevenly so the underlying red still shows through. Apply a strong stroke of white adjacent to the window frame on the left.

▼6 Build up the shadow tone on the central figure's back with a mix of transparent brown and burnt sienna. Also use a mix of yellow ocher and white over the face of the figure on the left.

Scumble on a pale blue tint between the two figures to obtain a strong tonal contrast. Note how painting in the negative shape of the window light allows you to refine the figures' outlines. In keeping with the loose style of the picture, however, make sure you are not too precise.

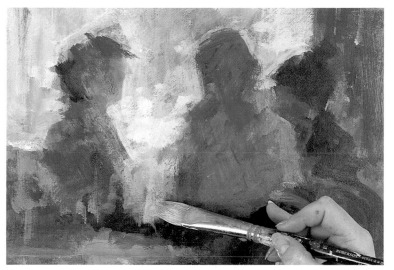

◄7 Apply a dark mix of ultramarine with touches of Hooker's green, Payne's gray and white to continue to build up the shadows on the back of the central figure. Also use this mix to begin the bottle on the table and to give the impression of the light from the window falling under the table.

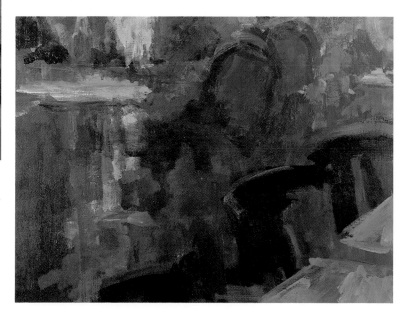

►8 Use yellow ocher to put in two tabletops in the bottom right corner – these help guide the eye into the center of the picture. Paint two chairs next to them with Payne's gray, adding highlights with a mix of white and touches of your blue mix.

Note how the foreground is kept dark and not many forms are discernible so the eye is compelled to travel upward into the scene.

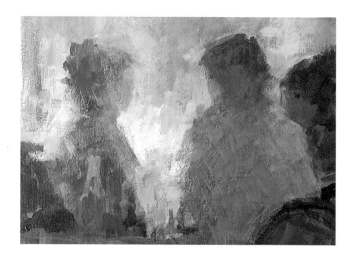

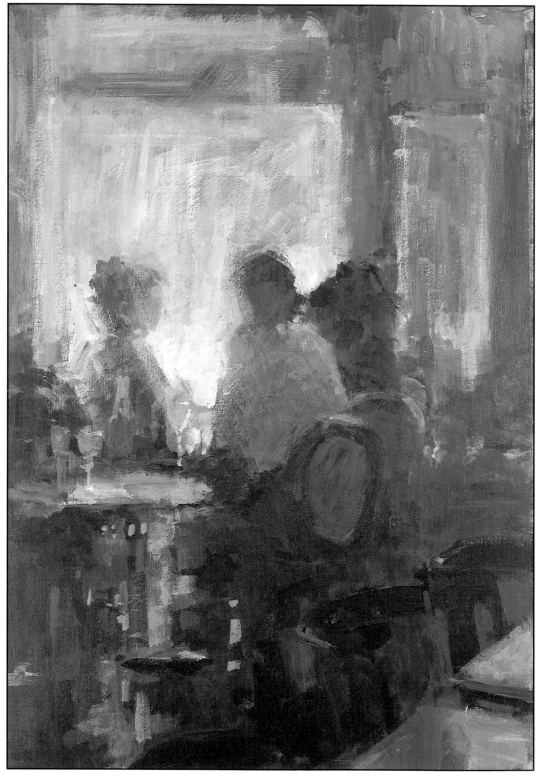

◄**9** Scumble a mix of pale olive green, ultramarine and white over the central figure's back. Note that the light skims across his right shoulder and arm, so leave this area yellow. Use a mix of yellow ocher, white and touches of cadmium red to put in the faces of the two figures on the left. For the central figure's hair, use transparent brown with touches of white, yellow ocher and cadmium red.

Continue working up the bottle with Hooker's green, adding white to render the neck. Add a small stripe of purple (made from cadmium red, ultramarine and Payne's gray) along the left edge of the bottle with the side of the brush. Also begin on the white wine glass by using a mix of yellow ocher with touches of cadmium red and white.

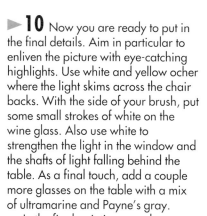

►**10** Now you are ready to put in the final details. Aim in particular to enliven the picture with eye-catching highlights. Use white and yellow ocher where the light skims across the chair backs. With the side of your brush, put some small strokes of white on the wine glass. Also use white to strengthen the light in the window and the shafts of light falling behind the table. As a final touch, add a couple more glasses on the table with a mix of ultramarine and Payne's gray.

In the final painting, note how we are drawn toward the light, from the dark foreground to the table and the figures, and ultimately to the window. We not only contemplate the picture itself, but are encouraged to imagine the view that the drinkers see through the window.

WORKING WITH PASTELS

A GUIDE TO PASTELS

Choosing from the huge range of pastels available can be as confusing as a crossword puzzle! Our guide to pastels outlines the main varieties – and the differences between them.

When you try to learn more about the pastels available, it can seem as if the manufacturers are out to confuse you! You may be stumped immediately by the long list of names – soft pastels, hard pastels, chalk pastels, pastel chalks, Conté crayons, pastel pencils, pastel crayons and square pastels – and by what they all do.

To simplify matters for you, we've divided the wide range of pastels available into three groups – those that are either **round** or **square** in cross-section, and **pastel pencils**. We have chosen this classification because the different shapes are suited to particular ways of drawing, and so determine, to an extent, the way you use them.

Hard and soft

Another determining factor is that of hardness and softness. Pastels are made with powdered pigment and a binder. The higher the binder content, the harder the pastel. Hard and soft pastels are different in the way they feel in use, and in the effects they create.

With soft pastels (like those used in most of the demonstrations shown in this section), the color crumbles smoothly and easily, covering the paper rapidly. It sinks into many of the tiny pits of toothy pastel paper, leaving a film of dust to blow away. With the same amount of pressure on a hard pastel, you'll find it has a slightly scratchy feel and covers the paper less readily. It catches the tooth of the paper, sinking less into the pits and leaving a grainy effect.

Some manufacturers grade their pastels as hard, medium or soft. However, one manufacturer's "hard" can be the same as another's "medium," for instance, so it's best to try them out for yourself on the pads of paper provided in art stores.

Round pastels

These tend to be the softest, and are widely known as artists' soft pastels. Traditionally, they were made by the artists themselves. They come in different widths and range from soft to very

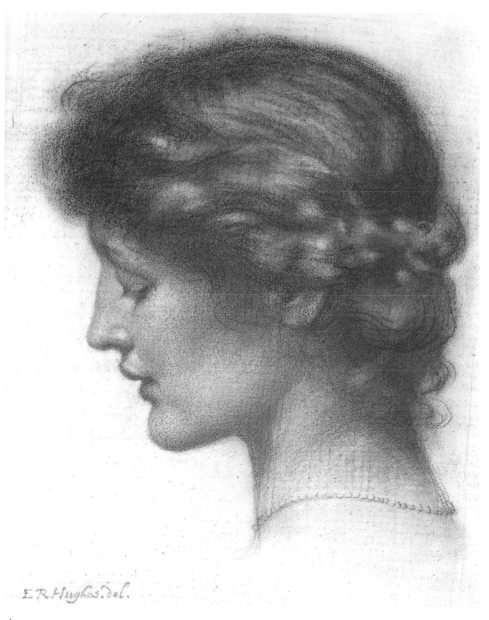

▲ Using just one colored chalk with very careful handling, the artist has created a wide range of tones, producing a convincing three-dimensional image. Notice the contrast between the clear skin and textured hair.

"ROSALIND" BY E.R. HUGHES, RED CHALK ON BOARD, 9¾ X 7¾IN, COURTESY OF PETER NAHUM AT THE LEICESTER GALLERIES, LONDON

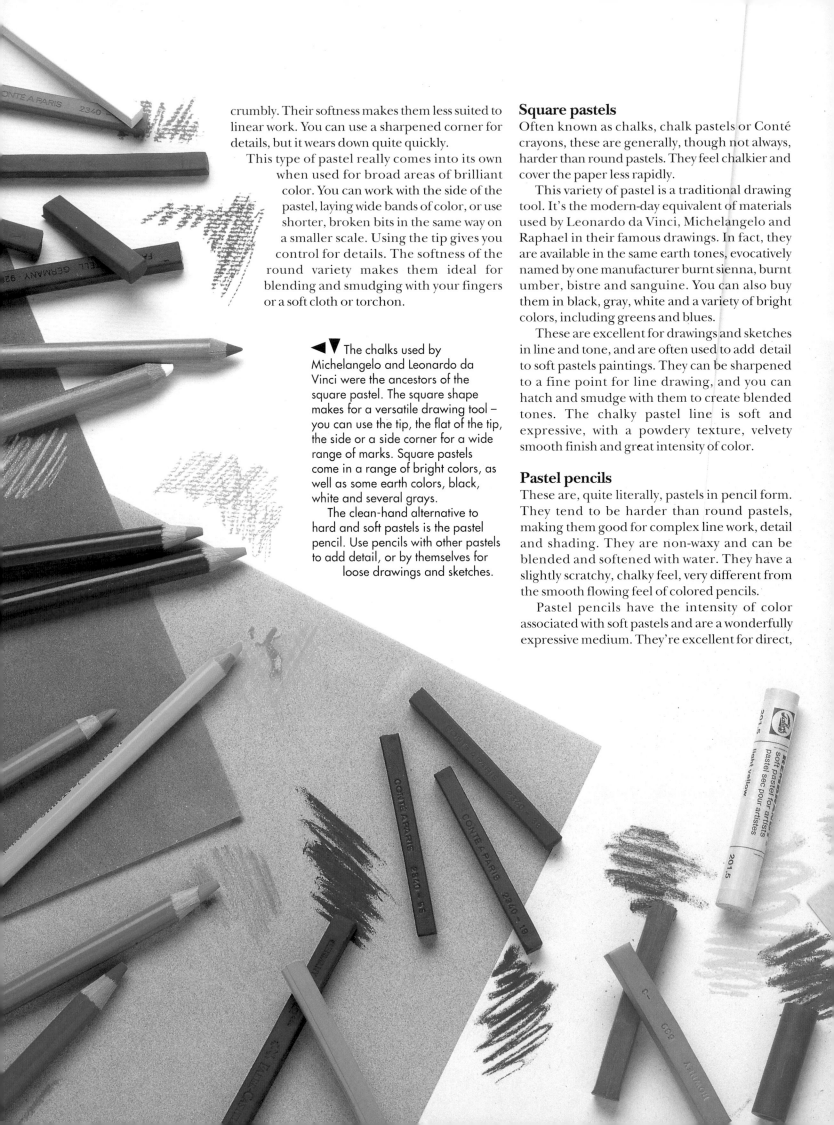

crumbly. Their softness makes them less suited to linear work. You can use a sharpened corner for details, but it wears down quite quickly.

This type of pastel really comes into its own when used for broad areas of brilliant color. You can work with the side of the pastel, laying wide bands of color, or use shorter, broken bits in the same way on a smaller scale. Using the tip gives you control for details. The softness of the round variety makes them ideal for blending and smudging with your fingers or a soft cloth or torchon.

◀▼ The chalks used by Michelangelo and Leonardo da Vinci were the ancestors of the square pastel. The square shape makes for a versatile drawing tool – you can use the tip, the flat of the tip, the side or a side corner for a wide range of marks. Square pastels come in a range of bright colors, as well as some earth colors, black, white and several grays.

The clean-hand alternative to hard and soft pastels is the pastel pencil. Use pencils with other pastels to add detail, or by themselves for loose drawings and sketches.

Square pastels

Often known as chalks, chalk pastels or Conté crayons, these are generally, though not always, harder than round pastels. They feel chalkier and cover the paper less rapidly.

This variety of pastel is a traditional drawing tool. It's the modern-day equivalent of materials used by Leonardo da Vinci, Michelangelo and Raphael in their famous drawings. In fact, they are available in the same earth tones, evocatively named by one manufacturer burnt sienna, burnt umber, bistre and sanguine. You can also buy them in black, gray, white and a variety of bright colors, including greens and blues.

These are excellent for drawings and sketches in line and tone, and are often used to add detail to soft pastels paintings. They can be sharpened to a fine point for line drawing, and you can hatch and smudge with them to create blended tones. The chalky pastel line is soft and expressive, with a powdery texture, velvety smooth finish and great intensity of color.

Pastel pencils

These are, quite literally, pastels in pencil form. They tend to be harder than round pastels, making them good for complex line work, detail and shading. They are non-waxy and can be blended and softened with water. They have a slightly scratchy, chalky feel, very different from the smooth flowing feel of colored pencils.

Pastel pencils have the intensity of color associated with soft pastels and are a wonderfully expressive medium. They're excellent for direct,

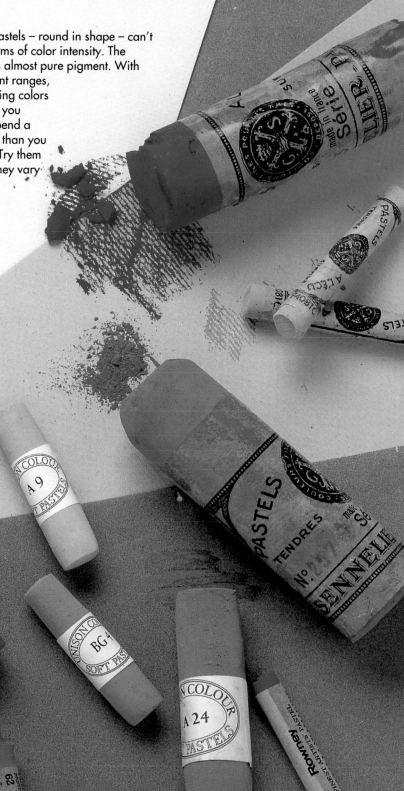

bold sketches or for dense, detailed drawings with subtle nuances of tone rendered with careful shading and broken color. They can be used with round or square pastels, but you'll find yourself in trouble if you try to combine them with colored pencils. The waxy surface created by colored pencils resists the pastel pencil, causing it to slip and slide.

Papers

Traditional pastel paper, available from art stores, is a soft, fibrous paper that helps the pigment to adhere. It comes in different colors and grades. The fine grade is for line work; the coarser grade for broad, free strokes. The colored sheets provide a good toned ground, similar to using a preliminary color wash in painting. Your color choice should enhance the subject of the picture.

You can also buy some specialist papers with coatings to add different textures. Marble dust and velour paper are two examples. (For more on pastel papers, see page 264.)

Storing and sharpening

Pastel pencils are easy to store – just tie them up with a rubber band and place them point up in a jam jar. Round and square pastels cause more of a problem. Storing them together in a box, for example, is a bad idea, since dust comes off the pastels quite easily, which can cause the colors to contaminate each other. The best way to store them is according

to color. Keep your greens and blues separate from your reds and oranges, and so on. Store them in a shallow plastic box or wooden tray filled with dry rice. Any pastel dust comes off on the rice, rather than on the other pastels.

With all varieties of pastel, it's a good idea to avoid pencil sharpeners for sharpening, since they tend to blunt the blade. Use sandpaper or a craft knife.

▼Artists' soft pastels – round in shape – can't be beaten in terms of color intensity. The crumbly color is almost pure pigment. With so many different ranges, sizes and tempting colors to choose from, you may find you spend a lot more money than you bargained for. Try them out first, since they vary in softness.

Portrait in sanguine pencil

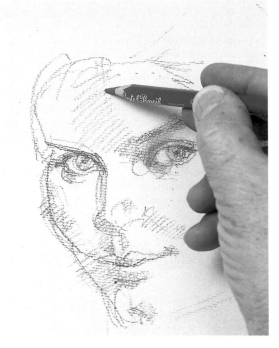

▲ **The set-up** The artist asked the model to shift her position until he found a pose he liked – a three-quarter view, with her head tilted. It's worth spending time finding a pose you find interesting.

In this demonstration our artist used just one classic pastel color – sanguine – with a touch of white for subtle highlights. He picked a warm beige paper – again a traditional choice for this type of drawing.

▲ **1** Use the sanguine pastel pencil to establish the basic inverted triangle of the face – measure from the side of each eye to the chin. Use light marks at first so you're not committed to them. Re-check your proportions until you're sure they're correct, then sketch in the main outlines of the face. Focus on the eyes, blocking in the lights and darks.

▲ **2** Work up the eye and eyebrow to your left, then soften the marks around the eye to your right by smudging them with your finger. Apply loose lines to block in areas of dark tone on the face – on the turn of the cheek and under the nose, lower lip and chin. Use widely spaced but regular lines to indicate the dark tones on the forehead.

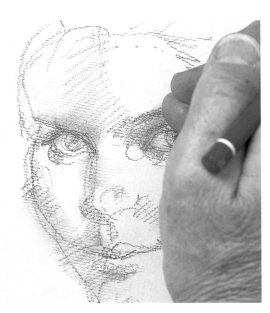

▶ **3** Soften the areas of dark tone around the face by blending the lines with your finger. Pastel pencils are fairly soft and powdery – excellent for smudging and blending.

▶ **4** Sketch in the hair. This is a very distinctive feature so try to avoid the temptation to treat it as a flat, superficial pattern. Notice how, with just a few lines, the artist gives the hair a sense of shape and volume.

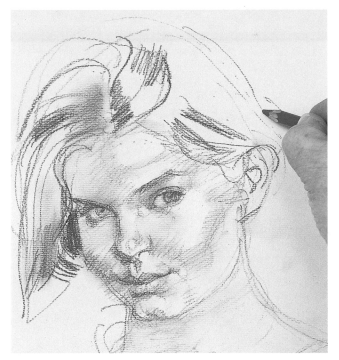

◄ **5** Work on the face as you did before, smudging lines for areas of tone to make it look three-dimensional. Once you're satisfied with the face, start to add detail to the hair. Use less or more pressure on the pastel pencil to make light and dark lines that follow the form of the hair. These tones, especially the dark ones, help to give the model's hair volume.

YOU WILL NEED

☐ A 12 x 16in sheet of warm beige Artemedia art & pastel paper

☐ Conté à Paris sanguine drawing pencil

☐ White square pastel

▼ **6** Add more dark tones to the face to build up its rounded quality, then, using your white square pastel, put on a few subtle highlights where the light catches the model's forehead, nose and eye.

Lightly sketch in the model's shoulder and T-shirt, smudging in a few tones where appropriate. Don't work up this area too much. Let the emphasis remain on the face.

► **7** This traditional monochrome approach creates a charming result in the final drawing. The sanguine line has a natural and seductive appeal, with the few touches of white highlight finishing it off wonderfully.

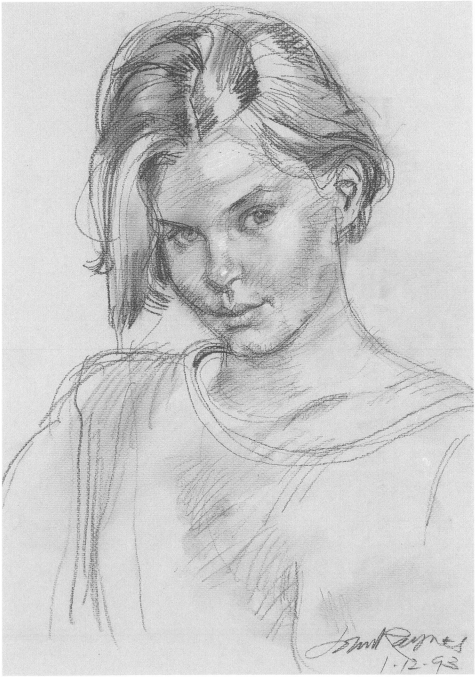

Study of hands

▶**1** Draw the broad outlines of the two hands lightly with the umber pencil, seeing them as a single form. Measure and re-check all the time between one point and another.

▲**2** Begin to suggest details such as the fingernails, the ring and the lines on the hands. Squint your eyes so you can see the planes of light and dark on your subject. Then scribble on the dark tones and smudge them with your finger. As the drawing progresses you can use darker, more emphatic lines.

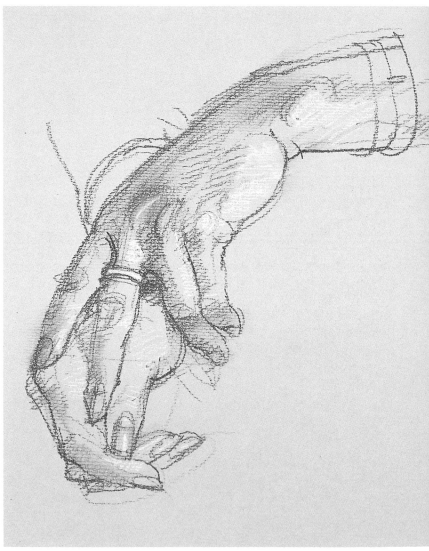

▲**3** Continue to work up the details on the hands, using the white square pastel to add highlights.

▶**4** Hands are very complex subjects and many people find them difficult to draw. The trick is never to make assumptions about what you're looking at, but draw only what you see, starting by simplifying the forms.

The choice of materials here is perfect for the subject. The simplicity of the umber line and white highlights complement the familiar subject. This is an excellent choice of drawing tools for the beginner, since they force you to concentrate on the broad forms.

SOFT PASTELS, PURE COLOR

Artists' pastels provide color in its most intense form, and in a range from soft, powdery pinks to deep velvety purples.

▼ The great attraction of pastels is the freshness and immediacy of their colors – evidence that they are almost pure pigment. Beautifully blended colors give soft flesh tones, complex webs of textured color bring the background to life, while fine linear strokes depict folds in the clothing of mother and child.

"MATERNAL KISS" BY MARY CASSATT, 1896, PASTEL ON PAPER, 22 X 18¼IN PHILADELPHIA ART GALLERY, BEQUEST OF ANNE HINCHMAN

► Almost every imaginable color is available in pastels – this is because you can't mix different colors with others as you do with watercolor and oil paints.

These are artists' pastels, which are much more expensive than the students' range, but you can buy them one at a time and build up your collection gradually.

▼ For the beginner a box of 24 pastel sticks provides plenty of scope.

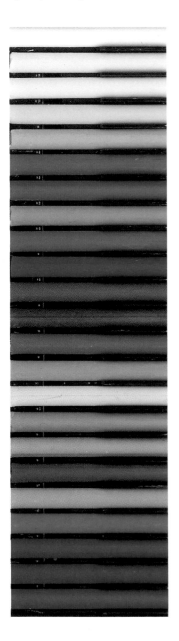

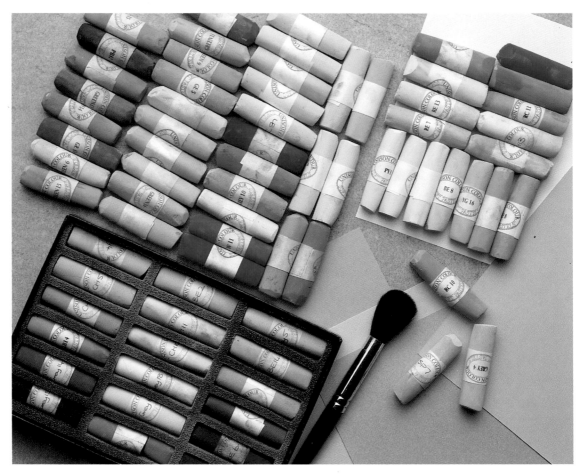

Pastels are pigment powders bound together in stick form with gum or resin. Soft pastels are made with relatively little binder, which is why they have a light, crumbly texture – and why the colors are so pure.

As a sketching and drawing medium, pastels are extremely versatile. By using the broad end of the stick, you can create a wide line of coarse crumbly texture. Or you can work with the edge of the stick to make a mark as fine and delicate as one drawn with a pencil. You can even draw a line of thicks and thins by varying the pressure, or by turning and changing the angle of the pastel stick as you draw.

Soft pastels are available in a vast range of colors and tones, and large expanses present no problem – with the stick laid on its side, you can rapidly fill them in with layer upon layer of rich velvety color.

Color mixing

With pastels, the manufacturer does the mixing for you, which is why they come in such a wide range of colors and tones. One manufacturer makes 60 basic colors, with three to ten darker and paler versions of each one.

Such a choice can be bewildering and is certainly personal. Some artists use an enormous selection of colors and tones, while others are happy with a limited choice.

The basic kit

One of the great advantages of pastels is that you don't need a lot of equipment. Your basic requirements are the pastels themselves and a sheet of paper.

You do need a drawing board or other rigid support for your paper. Whether you also use an easel depends on whether you prefer to work horizontally or vertically. Easels have one main advantage – pastels create a lot of dust, which can fall straight to the ground when the drawing is worked on vertically.

One final thing you need is fixative, available at art stores. This fixes pastel to paper and removes the risk of smudging. Don't overuse it, as it can darken the picture.

Pastel paper

Pastels are a dry medium, so the paper surface must be textured enough to hold the pigment particles in place. Pastel papers have a surface with a definite key ("tooth"), which is designed to capture and hold the tiny particles of color. These papers allow you to build up several layers of pastel to a dense, matte finish.

White chrysanthemums in a vase

This picture demonstrates that you don't need a vast repertoire of pastel drawing techniques to create an attractive result. The image is made up of a few basic marks, which are well worth practicing before you start.

Setting up

To carry out this project, you can either copy our bunch of flowers or set up a subject of your own at home. Our artist chose a glass vase to draw because of the way the light reflects on it, creating interesting patterns. But if you want to make it easier, you could use an opaque vase. (This means you don't have to worry about drawing in the bottom of the flower stems.) Make sure your still life is well lit. And check that you can see it properly. You also need enough light to work in.

The color of the paper should contribute something to the final image. The artist chose green, which holds the whole picture together behind the foliage and flowers. A white background would look too stark.

Before you start drawing, stand well back from the vase. Half-close your eyes and look for its overall shape and form. Look for the lights and darks, too. Now move closer. Have your pastels at hand and look for the colors for the petals, leaves and so on.

Pin the paper to the drawing board. It's worth spending a few minutes now working out where you're going to position the image in the paper area. You don't want the vase slipping off the bottom of the page, for instance. If it makes you feel more comfortable, draw in an outline with charcoal or Conté crayon.

Once you start, keep studying the flowers intently. Try not to concentrate too much on individual areas, though. Instead look at how the whole picture is building up.

▲ **The set-up**

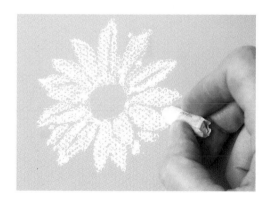

◀**1** Draw circles for the flower centers with white pastel. Follow with some simple petal outlines, then fill them in loosely. If you're working on a horizontal surface, blow away any excess dust.

(To avoid smudging your drawing, roll up your sleeves before starting and try not to rest your hand on the paper.)

▲**2** Continue drawing petal shapes and filling them in until you've completed the first flower. There's no need to make every petal exactly the same size and shape.

THE FIVE BASIC MARKS USED IN THIS PROJECT

1 2 3 4 5

These are the basic pastel marks used in the picture of chrysanthemums. Bear in mind that new pastels have flat round ends, but these soon wear down with use to a blunt shape.

1 Hold pastel at an angle and scribble, using edge of end
2 Hold vertically and draw straight line with blunt end
3 Hold a new pastel at an angle and draw a straight line using the edge of the end
4 Scribble tightly, using the edge of the end
5 Take wrapper off and draw with side

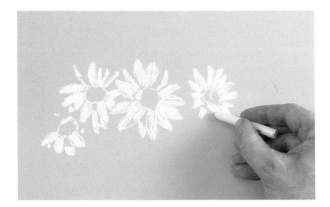

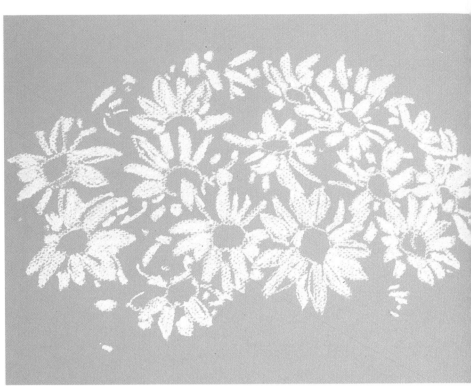

▲ **3** Draw in some more flowerheads, but don't feel you need to reproduce every single one exactly – remember you're not doing a botanical drawing. Quick marks can often trigger the whole image and be effective and lively.

▶ **4** When you've drawn in all the flowerheads, spray the picture with fixative, following the manufacturer's recommendations.

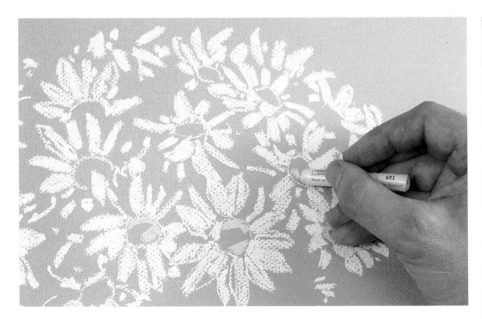

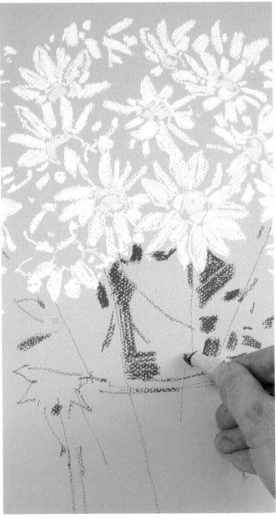

▲ **5** Look closely at the center of the chrysanthemums for lights and darks. Now go across the drawing, putting the centers in with blobs of lemon yellow and cadmium yellow.

Add a blob of lizard green at the very heart of each flower. Notice how the drawing feels as if it's coming together, with the green paper playing its part.

▶ **6** Stand back and half-close your eyes. Look for lights and darks among the stems and leaves. Then, using olive green, roughly draw in some of the leaves and stems and part of the vase. Start to fill in the darker background shapes between the leaves with the olive green.

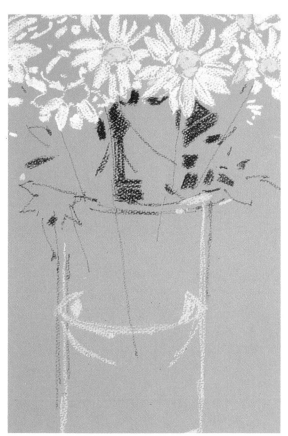

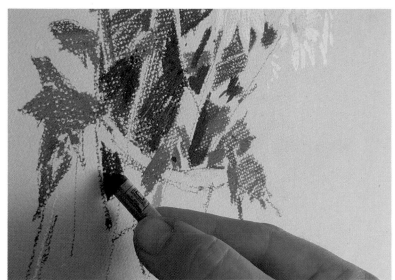

◀ 7 Continue drawing in all the lighter parts of the glass vase using a pale cool gray.

▼ 8 With Hooker's green, draw in some patches of the green stems and leaves in the vase.

▶ 9 Still using Hooker's green, indicate some of the chrysanthemum leaves (but don't try to put in every one!). Now continue the background around the stems with green gray.

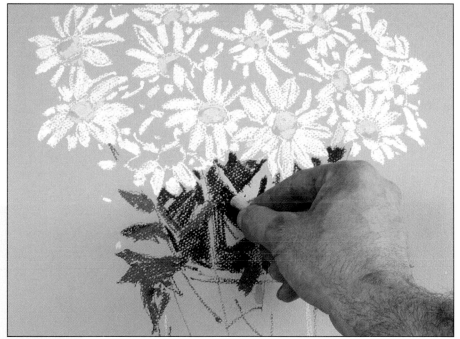

◀ 10 Add emphasis to the stems with yellow green. Put in some of the darker patches of water with a dark cool gray. Now use the green-gray to continue the background among the petals.

With burnt umber, add darker touches to the background showing through the vase. Then using the same pastel on its side, lightly put in all the background above the table top, carefully filling in among all the outside petals. Move the pastel in different directions to build up a web of color with varying lights and darks. Don't worry about the texture of the paper showing through – it adds to the effect.

►**11** Block in the table top with yellow ocher. Again use the side of the pastel, but this time apply more pressure so you end up with solid color.

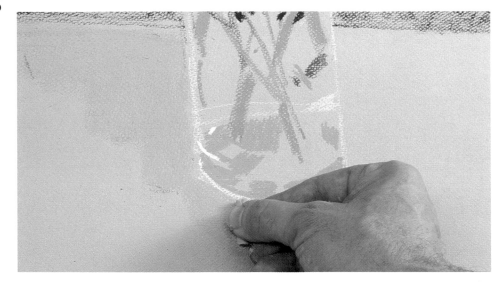

▲**12** To represent the grain of the wood, draw in a few lines with burnt umber. Finish off the bottom of the vase by adding white highlights and green-gray shadows.

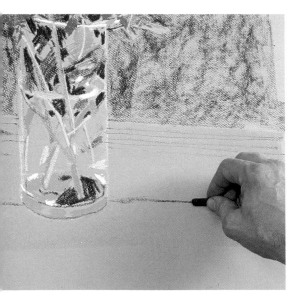

▲**13** Spray the finished picture with fixative, following the manufacturer's instructions.

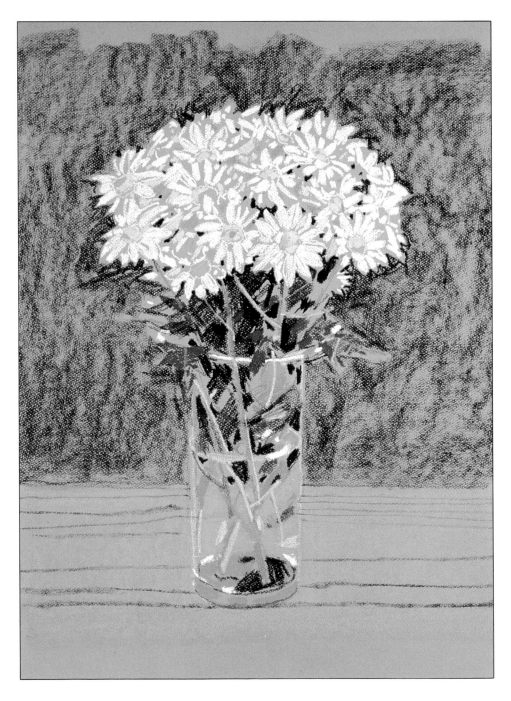

IMPACT WITH PASTELS

Pastels are not only suitable for delicate subjects – they can achieve as bold and striking an effect as any other medium. Choosing a suitable support and being adventurous with your choice of colors is all you need to bring life to your work.

The type of paper you decide to use with pastels can make a huge difference to the impact of the finished picture. With fairly smooth paper the pastel color simply slides off, but with the toothed papers designed specially for pastel drawings, you can build up rich layers of color. For this exercise, our artist chose a Frisk pastel board (formerly known as Rembrandt paper) which has a velvety, toothed surface that feels like very fine-grade sandpaper. These papers are available in 14 subtle colors – choose one that will enhance the tones of your subject.

Using black

Some artists feel that the use of black in a painting is taboo. It doesn't exist in nature, it can muddy your colors and it is easy to misuse, so many artists suggest that beginners avoid it. However, when well used its effect can be stunning. In this example our artist used a lot of black pastel: the yellow centers of the pansies really twinkle out of the velvety rich blacks and luscious blues. You might like to try using black pastels in your drawing too, but bear in mind that it is a strong color, so be careful not to overdo it.

▶ The high-tooth surface of Frisk pastel board was developed specially for use with soft pastels. It comes in four sizes: 26 x 20in (full), 20 x 13in (half), 13 x 10in (quarter) and 16 x 12in (art). Here are just a few of the 14 Frisk colors available (from top to bottom): yellow ocher, raw sienna, light oxide red, permanent red deep, gold ocher, caput mortem red, green gray and raw umber.

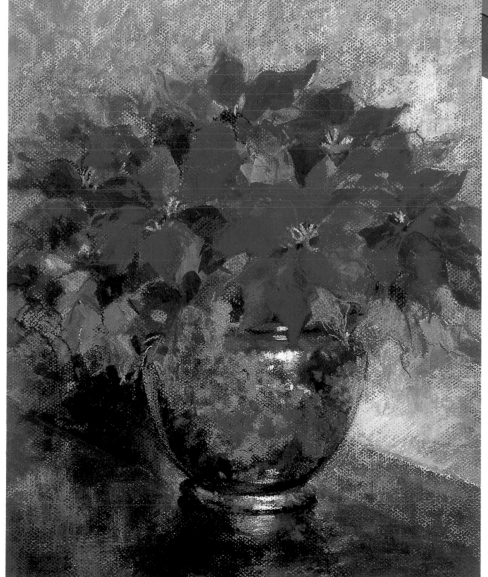

▶ You can build up very strong layers of color on the high tooth provided by special pastel papers. This, added to the fact that pastels provide some of the purest pigments available, partly explains how this artist has managed to build up such a wonderfully vibrant image, with all the richness and sheen of velvet.

"POINSETTIAS IN BLUE POT" BY MAUREEN JORDAN, PASTELS ON GREEN PAPER, 16 X 13IN

Terra-cotta pot of pansies

YOU WILL NEED

☐ A 26 x 20in raw umber Frisk pastel board

☐ Spray fixative

☐ Six Conté hard pastels: scarlet 28, Saturn red 40, St Michael green 44, light green 8, emerald green 34, ultramarine 10

☐ Twenty-seven Rembrandt soft pastels: light yellow 5, deep yellow 9, yellow ocher 3, orange 3, red violet light 5, Prussian blue 3, ultramarine deep 3 and 5, cobalt blue ultramarine 5 and 7, phthalo blue 3 and 5, blue-violet 3, chrome green light 3, 5 and 7, chrome green deep 3, permanent green light 3, permanent green deep 3, olive green 3, light oxide red 5, burnt umber 3, raw umber 5, raw sienna 5, burnt sienna 3, white and black

◄ **The set-up** Our artist worked directly from life, but then rearranged some of the flowers and created a different setting to suit the composition she wanted. She decided to set the pots by the edge of a pond to add depth and provide a range of textures for the picture.

► **1** Using scarlet, St Michael green, light green and ultramarine hard pastels, lightly position the flowers, leaves and pots. Alter the composition to suit your taste, but take care not to overwork the pastels or to apply too much pressure at this stage, since Frisk paper can take only so much pastel before it clogs.

▼ Our artist used different brands of pastels. For ease, we've listed Rembrandt equivalents, but just use whatever pastels you already have.

◄ **2** Use the black pastel to draw in the dark area of the pond behind the pots. This acts as a base into which you can blend other colors later, so continue to use light pressure to avoid clogging. Make quick, scratchy marks to feel your way into the drawing.

SOFT PASTELS: OPTICAL MIXING

Soft pastels are perfect for optical mixing. They're chunky and crumbly, allowing for speedy progress, with bright, brilliant colors that complement the vibrant effects of this technique.

In optical color mixing, instead of blending together two colors to make a third, you place small flecks or dots of two or three colors close together. From a certain distance they blend optically (in the eye) to create the effect of a third color. Being made of many individual marks, the hue you achieve has great vigor and energy.

You can create an infinite variety of color combinations in this way. To make orange you use dabs of red and yellow. More yellow lightens it, more red darkens it. Introducing a different red or yellow dramatically adjusts the shade of orange. And you can modify it more by adding another color, maybe brown, to subdue it.

How you space the marks on the support also controls the shade – the denser the marks, the darker the shade. And changing the size and nature of your pastel marks creates a sense of distance and perspective. Small strokes close together create a clear image with a sharp outline – useful for showing the focal point. Larger, looser strokes make a less defined shape – perfect for background areas, which should recede.

Paper color is vital to optical mixing, since some of it always shows through to affect the final drawing. White or light-toned paper lends an overall brightness; strong colors dominate the final image. Unless you're sure of what you want the paper to do, stay with a medium tone.

Successful optical mixing depends on spacing colors well from the start. Decide how many colors you'll use; as you lay down the first, leave enough room for those to come. If you run out of space you can overlay marks, but do this carefully, or you'll lose the benefits of the tinted paper and your picture will be unbalanced.

YOU WILL NEED

☐ A 12 x 16in sheet of cool gray Artemedia pastel paper

☐ Drawing board and thumbtacks

☐ Stick of brown Conté crayon

☐ Spray fixative

☐ Twenty-three soft pastels – our artist used Rowney Artist's Soft Pastels (for colors see pages 276 and 277)

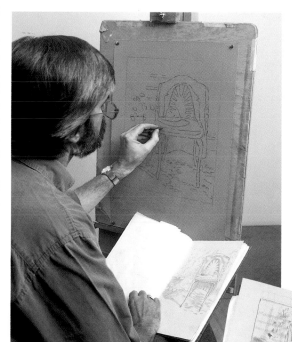

◀ **The set-up** Our artist worked from a few sketches (see inset) of a hat and jacket left on a chair on a warm sunny patio.

He chose to work on the less textured "wrong" side of the paper to produce a smoother finish. Most pastel techniques involve building up colors over each other, for which you need the toothy side. But optical mixing requires no overlaying, so you have the choice of using either side.

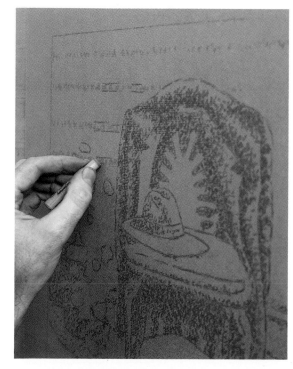

◀ **1** Lightly sketch the main outlines with your brown Conté crayon. Dot in the darkest tones on the jacket, hat and chair with indigo dark, adding flecks of indigo medium and crimson lake medium. Keep your marks small for the jacket, hat and chair for clearly defined edges. Use indigo dark for the deepest shadows on the pots and ground. Loosely indicate the trellis with Vandyke brown, leaving the edges fuzzy so it doesn't dominate.

Your palette

Vandyke brown

Cadmium orange medium

Cadmium orange pale

Cadmium tangerine

Naples yellow

Cadmium yellow

Indigo dark

Indigo medium

Crimson lake medium

Crimson lake pale

Rose madder pale

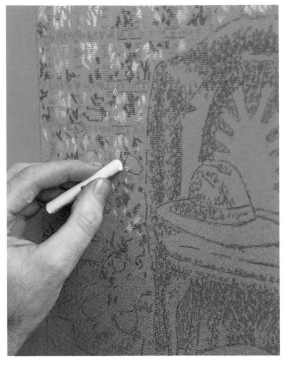

2 Now start on the foliage behind the trellis, using larger, looser flecks to help it recede. For this, use cadmium orange very pale, adding flecks of olive green dark, grass green, olive green medium, sap green and coeruleum blue. Keep the colors sparsely scattered, with patches of paper showing through.

3 It's important to stand back and take a good look at your progress from time to time so you get an overall view of your drawing. Think about the colors you intend to use so you can leave enough paper space for them.

Dot in the terra-cotta flower pots with Indian red, burnt umber pale and cadmium orange medium.

4 Use widely spaced blue-green flecks to add the light tone on the chair's back and legs, with indigo dark and Hooker's green for the darker shadows.

Apply cadmium orange very pale to the ground – use loose, horizontal strokes to give an impression of flatness.

Tightening up your marks, use cadmium orange pale and very pale for the hat. For deeper shadow tones, use Vandyke brown.

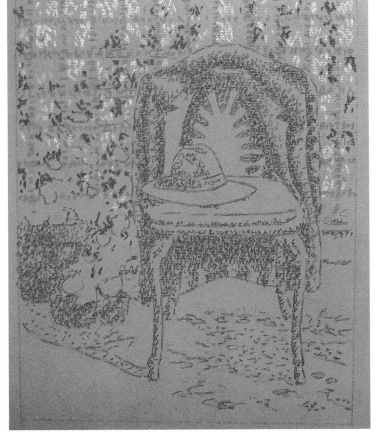

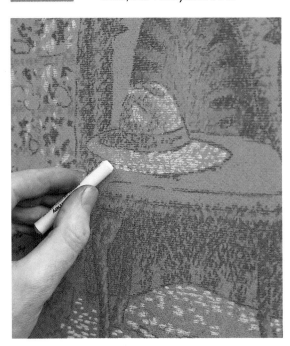

5 Indicate the geranium flowers by laying bold strokes of crimson lake medium, cadmium orange medium, rose madder pale and crimson lake pale side by side. Notice how these bright colors put a little more emphasis on the background, bringing out the colors of the foliage.

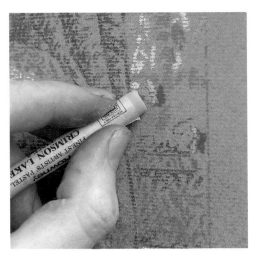

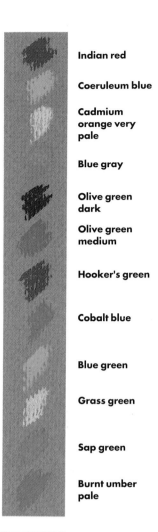

Indian red

Coeruleum blue

Cadmium orange very pale

Blue gray

Olive green dark

Olive green medium

Hooker's green

Cobalt blue

Blue green

Grass green

Sap green

Burnt umber pale

◄ **6** Put in the chair cushion with cadmium orange pale and dots of blue green and crimson lake pale, using Hooker's green to work into the initial indigo for the dark tone on the edge of the cushion.

The sunlight on the terra-cotta flower pots makes a much lighter area of tone – put this in with dabs of Naples yellow and cadmium orange medium. Work up the leaves of the potted geraniums with flecks of blue green, grass green, Indian red and crimson lake pale, using coeruleum blue for the light areas.

► **7** Develop the lighter tones of the jacket with indigo medium, cobalt blue, coeruleum blue and blue gray. Lightly strengthen the trellis with loose strokes of burnt umber pale, adding dots of cadmium yellow to the background foliage to the left of the chair. Here, our artist corrected the position of the hat by softening the outline with flecks of cadmium orange pale.

► **8** It's important to keep an overall sense of harmony by repeatedly stepping back and assessing your work as a whole.

The shadows cast by the chair and terra-cotta pots are an important element in this composition – develop these with cobalt blue and Hooker's green, with the occasional dab of rose madder pale and crimson lake pale. Our artist used gentle, feathery strokes of coeruleum blue to soften the edges of the shadows and integrate them with the other colors on the ground (see inset below).

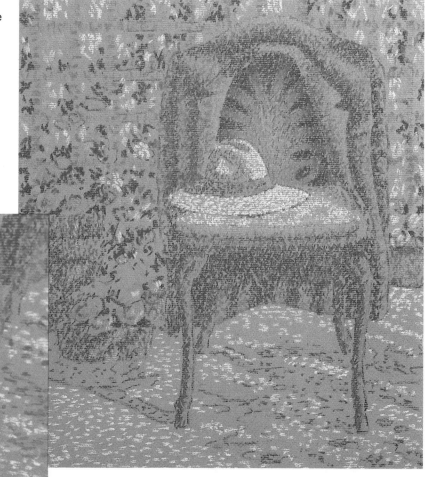

▶ **9** Notice how the cool gray paper is still clearly visible between the pastel marks. It acts as a unifying element, drawing all the colors and shapes in the composition together.

▲ **10** Add touches of coeruleum blue to the pale areas on the chair legs so they stand out from the surroundings.

Strengthen the light tones on the ground with more horizontal flecks of cadmium orange very pale, then add touches of crimson lake pale and coeruleum blue to the ground. Since these colors are used all over the picture, they give an overall harmony.

Now make any necessary adjustments. Add touches of cadmium tangerine to the terra-cotta pots and define the shadows around the pots and leaves; indicate the pattern on the chair back; darken the bottom of the jacket, using indigo dark just below the chair seat and adding indigo medium and cobalt blue at the bottom of the jacket.

Spray the finished work with a light coating of fixative to stop it from smudging.

◀ **11** Optical mixing is perfect for this subject. The many touches of color add a shimmering quality to the surface, making it dance and vibrate. All the colors play together and unite to form the picture – a process similar to the way the eye sees things in life.

Hazy summer afternoon sunlight is successfully created by the fuzzy outlines and the many dots and dabs.

PASTEL DUST BACKGROUNDS

Save those tiny pieces of pastel that break off your sticks as you draw – they are worth their weight in gold.

Soft pastels are so crumbly that small pieces often break off as you draw – and the pieces are invariably too small to grasp comfortably for drawing. But don't throw them away – crush them with a mortar and pestle or a hammer, and use the pastel dust to create exciting, unusual backgrounds for your drawings.

Simply wet your sheet of paper and sprinkle the powder on it, then spread the pigment around with a wet paintbrush, finally blotting excess water with a piece of paper towel. The colors settle unevenly to leave an irregular background, to which the different colors and visible brushstrokes give added zest.

You can create a background using any colors you like. Whether the effects you're after are bright and colorful or muted, two-tone or multicolored, the possibilities are virtually endless, and the results unique each time.

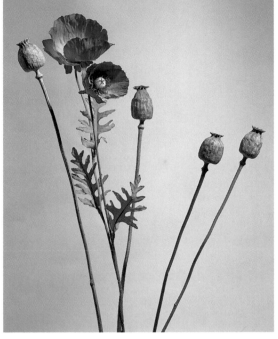

◀ **The set-up** These poppies make a pleasing subject, with the soft, bright silk petals contrasting texturally and tonally with the dried seed heads. Our artist chose a mixture of greens and grays, spiked with blue, red and yellow for her background – they contrast well with the simple yet attractive subject.

Choose colors that complement those of your subject. This enhances the composition and makes the background an important element within the picture as a whole.

CREATING YOUR BACKGROUND

▲ Crush the pastel pieces using a mortar and pestle or a hammer. Don't grind them down too much, since the small gritty bits tend to leave streaks that create some exciting effects.

▲ Lay your paper flat and apply acrylic matte medium solution in broad brushstrokes (this makes the picture permanent). Tip the pastel dust onto the wet paper and brush it over the surface.

▲ Colors dry a lot lighter than they look at this stage, but if you find the colors too strong, blot off the excess pigment with paper towel. This technique creates a weathered look.

▲ Blot more color from areas that will fall behind the subject so you don't lose it in the background. Let dry. (Or try blocking out these areas with masking fluid before you start.)

YOU WILL NEED

☐ A 22 x 15in sheet of stretched 200lb Bockingford watercolor paper

☐ Mortar & pestle or hammer and wooden tray

☐ A solution of ½ teaspoon acrylic matte medium to 1 cup of water

☐ 2in sable/synthetic flat brush

☐ Paper towels

☐ Easel

☐ Pastel pieces for crushing

☐ Spray fixative

☐ Six Conté pastels: beige light, burnt umber, chrome green medium and dark, carmine medium, purple dark

☐ Eleven Schminke or Rembrandt pastels: lemon yellow light, Naples yellow light, yellow ocher, chrome green light, sap green medium, grey light, white, mauve medium, alizarin medium and light, indigo dark (if you don't have these colors, try to match them with the ones you already have)

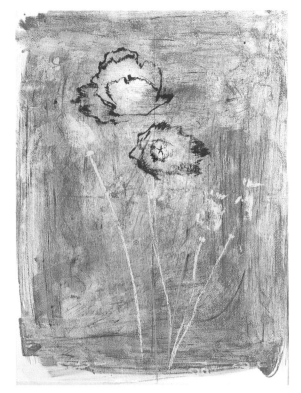

2 Now for the leaves. Use the flattened side of the tip of each pastel to block them in. Apply chrome green light for the lighter tones and chrome green medium for the medium tones. Work over the darkest lower leaves with chrome green dark.

3 Work up the dried seed head to the left. Run the tip of your burnt umber along the left of the stem over the existing line. Twist your stick to create an undulating line for distinct areas of light and shade. Use burnt umber for the seed head shadows – under it, on its left side and around the top. Then touch in a little color on the head and stem with mauve medium.

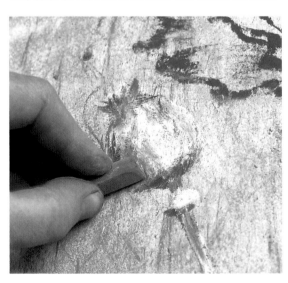

4 Turn your attention to the dried seed heads to the right. Work on them the same way as before, drawing into the stems and heads with burnt umber. Use indigo dark to flick in the darkest areas on all three seed heads, blending the colors slightly with your finger to give them roundness. Return to the burnt umber to draw into the flower stems.

1 Outline the poppies on the prepared paper with beige light, and draw the frilly petals with carmine medium. Apply heavy pressure on a sharp edge of the stick for intense color, rotating it as it wears down. Put in the center of the lower flower with burnt umber.

Use the flat side of a small piece of Naples yellow light for the dried seed heads, and apply sweeping, continuous strokes for the stems. (Our artist drew the tallest dried poppy lightly at this stage, but didn't return to it until later.)

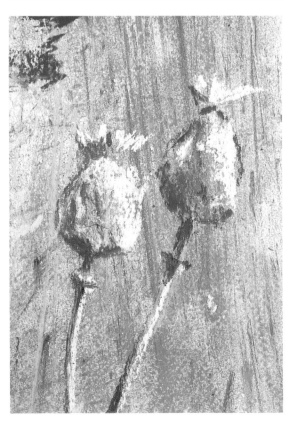

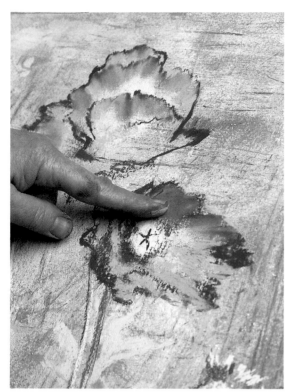

◄ **5** Use indigo dark to indicate the darker tones around the center of the lower flower and the sepals (the leafy parts directly beneath the petals) of the higher one. Make jagged movements with alizarin light on the petals, dragging the color into the darker outlines to give them a crumpled look. Add a little carmine medium to darken the pinks, then blend the colors together. Leave some background areas within the petals to work as a medium tone.

Our artist took advantage of the indigo on her finger to merge it with a touch of purple dark on the lower flower to create a bluish shadow.

► **6** A touch of alizarin medium beneath the center of the lower flower gives depth. Add some white highlights to the same flower. Work around its center with yellow ocher, and edge some petals on both flowers with purple dark. Touch in Naples yellow light to the pale areas of the upper flower to bring them out.

Now the flowers are almost complete. Stand back and look at the picture to judge the overall balance of harmony and tone.

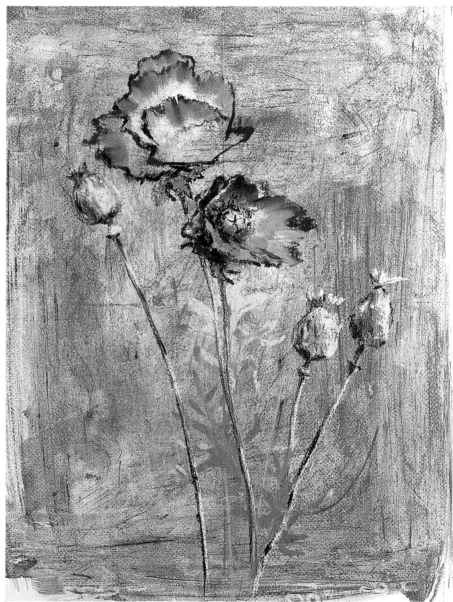

7 Introduce light tones to the leaves and stems with lemon yellow light and sap green medium. Edge some leaves with chrome green medium and burnt umber, and use burnt umber to darken the flower stems too.

8 At this point, our artist decided to feature the missing dried seed head. She worked over its remaining ghost image subtly with lemon yellow light, raising its position slightly at the same time. Blend some gray light into the yellow on the darker side.

Add a lighter tone to both seed head and stem with Naples yellow light, blending it with the side of your finger, then work on the stem with burnt umber as before.

Tip

Dust buster
Clean air dusters, available from photographic suppliers, are an excellent way of

blowing pastel dust from your drawings without the danger of choking. The pressurized container contains compressed air, which is released from the steel nozzle when you press down on the trigger.

9 Make any final adjustments to your picture. Our artist gave the background a few streaks of beige light to add more interest and to disguise the positioning lines she began with. Spray your drawing with a coat of fixative.

In the finished painting, the beautiful subjects emerge from an exciting, abstract background. The background textures and colors contrast with the delicate petals and complement the dried seed heads, and provide an entertaining backdrop to offset the flowers.

Glossary

Abstract art Art in which the accurate or realistic depiction of objects is unimportant or entirely discarded. Abstract art is concerned with formal qualities, such as composition, line, and color.

Acrylic paint Paint in which the pigment is bound with a synthetic, acrylic binding medium. Acrylic paints are diluted with water but, unlike watercolor, the paint film is insoluble once dry.

Advancing colors Colors that appear to be closer to the viewer. Warm colors and dark tones seem to advance while cool colors and pale tones appear to recede. These qualities can be exploited in aerial perspective.

Aerial perspective The use of color, tone and texture to create an illusion of space in a painting. As objects recede towards the horizon they appear paler and bluer, and their edges become less defined. This is because they are viewed through a veil of atmospheric particles.

Alkyds Alkyds are fast-drying oil paints and mediums. The binder is a synthetic resin derived from a combination of alcohol and acid. Alkyd mediums can be used with oil paint to reduce its drying time.

Alla prima Direct painting in which the picture is completed in a single session.

Binder or **binding medium** A liquid medium that is combined with a pigment to form a paint. Linseed oil is the most common binding medium for oil paint, gum arabic is the binding medium for watercolor.

Bleed The effect achieved when a wash of watercolor, or other thin medium, runs into an area of wet color. Creates a softly blurred and blended mix of color.

Blending Merging adjacent colors so that the transition between the colors is imperceptible.

Blocking-in The first stage of a painting in which the main forms of the composition are laid down as approximate areas of color and tone.

Body color Describes pure transparent watercolor that has been rendered opaque by adding Chinese white to the mix. Sometimes also used to describe gouache.

Broken color (1) A pure color (primary or secondary) to which a third color has been added. The result is a muted, grayed, or knocked back color. (2) Paint applied as small dabs or dashes, or scumbles so that when viewed from a distance it creates an optical mix.

Chiaroscuro The use of light and dark in a painting or drawing. Applied especially to the work of painters, such as Rembrandt and Caravaggio, who used strong contrasts of light and dark.

Cold pressed Watercolor paper with a medium-textured surface achieved by pressing the paper between cold rollers in the manufacturing process.

Complementary colors Colors that are opposites on the color wheel. The three primaries are complemented by a secondary: red by green; blue by orange; yellow by violet. The complementary pairs have a special relationship. When placed side by side they enhance each other, so that red appears redder alongside green than if it stands on its own. A color can be knocked back by adding a touch of its complementary pair.

Composition The organization of color, tone, and form within a picture area.

Cool colors The cool colors are blue, violet, and green, with blue the coldest. Cool colors appear to recede.

Cross-hatching Tone created by layers of parallel, criss-crossing lines.

Dilutent A liquid, such as turpentine (oil paint) or water (watercolor or acrylic), which is used to dilute paint. It evaporates completely and does not become part of the final paint film.

Dry brush In this technique, a brush with very little paint on it is dragged across the support to create areas of broken color or texture.

Earth colors Pigments derived from naturally occurring clays, rock or earths – the ochres and umbers, for example.

Ferrule The metal collar of a brush that secures the bristles to the handle.

Figurative art Art that depicts recognizable subjects, such as the human figure or landscape, in a realistic way.

Fixative A transparent liquid that is applied to works executed in mediums, such as pastel and charcoal, which do not have good adhering qualities. The fixative helps to attach the particles to the support and protects the fragile surface.

Flow improver A medium that is added to a paint to reduce surface tension so as to create even washes of color.

Fugitive Pigments that fade on exposure to light.

Glazing The application of a thin, transparent film of color over another color.

Golden section A proportion that has been used by artists in composition for centuries. It is based on a division of a line so that the ratio between the shorter section and the longer section is the same as that between the longer section and the whole. This can be expressed as the 0.618:1 or approximately 5:8.

Gouache An opaque form of watercolor, sometimes described as body color.

Graphite A type of carbon used in the manufacture of lead pencils.

Ground A substance applied to any support to isolate it from the paint film and to provide a pleasant surface on which to paint.

Gum arabic A watersoluble gum derived from a species of acacia tree. It is used as a binder in watercolor and gouache paint. It can also be added to watercolor to enhance color and texture.

Hatching A system of parallel lines used to create tone.

H.P. (Hot Pressed) Watercolor paper that has a smooth surface created by pressing between hot rollers during the manufacturing process.

Hue The color of a color – its redness or blueness.

Impasto Paint applied thickly so that it retains the mark of the brush or knife.

Impressionism A movement that originated in France in the 1870s. Artists such as Monet, Renoir, and Pissarro were concerned with capturing the fleeting effects of light. They worked out of doors and used pure color applied as unblended dabs and dashes.

Lean Oil paint that has very little or no added oil.

Linear perspective A method of creating the illusion of depth and three dimensions on a flat surface through the use of converging lines and vanishing points.

Local color The actual color of the surface of an object unmodified by light, shade, or distance.

Mahl stick A cane used to steady the arm when painting fine detail. One end is covered with a soft pad to prevent the tip from damaging the support.

Mask (1) Tape, paper, or fluid used to isolate an area of a painting while paint is applied. (2) A card frame that is used as an aid to composition. It can be dropped over a sketch to isolate a section so that the artist can decide which area to use and what format the final image should be.

Masking fluid A liquid rubber solution that is painted onto a support to protect that area from subsequent paint applications. It can be removed when the paint is dry.

Masking tape A low-tack tape that can be applied to a support to mask an area. Especially useful for creating crisp, straight lines. It can be peeled off when paint is dry.

Medium (1) The material used for a painting or drawing, such as watercolor, acrylic or pencil. (2) A substance that is added to paint to modify the way it behaves.

Mixed media A work executed in more than one medium.

Monochrome A drawing or painting made in a single color.

Negative space The spaces between and around the main elements of a subject. Observation of the negative spaces can be a useful aid to accurate drawing – they are also an important aspect of composition.

NOT Another term for cold pressed watercolor paper applied because it has 'not' been hot pressed.

Optical color mixing Creating new colors by placing separate patches of color side by side on the canvas so that they blend in the eye of the observer.

Painting knife A knife with a thin, flexible steel blade available in a range of shapes and sizes, and a cranked handle. The knife is used to apply paint to the support.

Palette (1) A tray or dish in which paint is mixed. (2) A selection of colors.

Palette knife A knife with a straight steel blade used for mixing oil paint or acrylic on a palette.

Photorealism A painting style that imitates the detail and sharp definition of photography.

Picture plane The imaginary vertical plane that separates the viewer from the world of the picture. The picture plane is an important concept in linear perspective.

Pigment The coloring substance in paint. May be derived from natural materials, such as earths and minerals, or from synthetic sources.

Planes The flat surfaces of an object. These are revealed by light and can be seen in terms of light and dark or tone.

Plein air A French term meaning 'open air' used to describe pictures painted out of doors.

Primary colors Colors that cannot be created by mixing other colors. For painters the primaries are red, yellow and blue.

Priming Applying a ground to a support.

Resist A technique that involves two materials that do not mix. For example, if wax crayon or oil pastel is applied under watercolor, the crayon or pastel will 'resist'

or repel the watercolor to create an interesting effect.

Retarder A medium which slows the drying time of paint. Most often used with acrylic paint that dries very fast.

Rough A watercolor paper with a noticeably textured surface. Handmade paper has a rough surface.

Scumbling An oil or acrylic painting technique in which a thin, broken layer of opaque paint is applied over an existing color. The underlying paint shows through the top layer creating an optical color mixing effect.

Secondary colors Colors created by mixing two primaries. Red and yellow gives orange; blue and yellow gives green; blue and red gives violet. Each secondary color forms a complementary pair with a primary color.

Size A gelatinous solution, such as rabbit skin glue, which was traditionally used to seal a canvas for oil painting.

Sketch A quick, spontaneous drawing.

Spattering A watercolor technique in which texture is created by flicking color from a brush onto the support.

Stippling Dabbing the tip of the brush onto the support to create dots of color. Stippling can also be created with a special stippling brush that has short, stiff bristles that have been cut to create a flat end. The brush is held upright and tapped onto the support to create a stipple effect.

Support Any surface used for painting or drawing.

Tertiary colors A range of intermediate colors created by mixing a primary color with an equal quantity of one of the secondaries. For example, by mixing blue with green you can create a bluish-green and a greenish-blue.

Thumbnail sketch A small, simple sketch, generally used to explore aspects of composition, such as tone.

Tone The lightness or darkness of a color.

Tooth The texture of a paper that affects its ability to hold the particles of a medium, such as pastel or charcoal. Very smooth paper has no tooth and is not suitable for work in pastel.

Underdrawing A preliminary drawing for a painting, executed on the support. Can be made in a drawing medium or in paint.

Underpainting The preliminary blocking-in of the main forms, colors, and tonal masses.

Vanishing point In linear perspective the point at which parallel lines appear to meet at the horizon.

Warm colors The warm colors are red, orange, and yellow, with red being the

hottest. Warm colors appear to advance.

Wash In watercolor painting diluted color applied thinly to the support to create a transparent film.

Watermark A design that is impressed into paper during the manufacturing process. It can be seen when the paper is held up to the light. The watermark helps identify the right side of the paper because the design is right-reading on the right side.

Wet in wet A watercolor technique that involves applying paint to a wet support to create soft edges and blended colors.

Wet on dry In watercolor, applying paint to a dry support, or over paint that has been allowed to dry. This technique creates crisp edges.

Index